Art Education

ART AND ARCHITECTURE INFORMATION GUIDE SERIES

Series Editor: Sydney Starr Keaveney, Associate Professor, Pratt Institute Library

Also in this series:

AMERICAN ARCHITECTS TO THE FIRST WORLD WAR—*Edited by Lawrence Wodehouse*

AMERICAN ARCHITECTS FROM THE FIRST WORLD WAR TO PRESENT—*Edited by Lawrence Wodehouse*

AMERICAN DECORATIVE ARTS AND OLD WORLD INFLUENCES—*Edited by David M. Sokol**

AMERICAN DRAWING—*Edited by Lamia Doumato**

AMERICAN PAINTING—*Edited by Sydney Starr Keaveney*

AMERICAN SCULPTURE—*Edited by Janis Ekdahl*

ANCIENT EGYPTIAN ART AND ARCHITECTURE—*Edited by Eleanore Wedge**

ARCHITECTURAL PRESERVATION AND RESTORATION—*Edited by Arnold L. Markowitz**

BRITISH ARCHITECTS, 1840-1976—*Edited by Lawrence Wodehouse**

COLOR THEORY—*Edited by Mary Buckley*

INDUSTRIAL DESIGN—*Edited by J. Roger Guilfoyle**

EUROPEAN PAINTING, 1870-1910—*Edited by Timothy Daum**

TWENTIETH-CENTURY EUROPEAN PAINTING—*Edited by Ann Marie Bergholtz**

POTTERY AND CERAMICS—*Edited by James E. Campbell**

STAINED GLASS I—*Edited by William Serban and Darlene A. Brady**

STAINED GLASS II—*Edited by William Serban and Darlene A. Brady**

VICTORIAN ART: ARCHITECTURE, SCULPTURE, DECORATIVE ARTS—*Edited by Marlene A. Palmer**

VICTORIAN ART: PAINTING, DRAWING, GRAPHIC ART—*Edited by Marlene A. Palmer**

*in preparation

The above series is part of the
GALE INFORMATION GUIDE LIBRARY

The Library consists of a number of separate series of guides covering major areas in the social sciences, humanities, and current affairs.

General Editor: Paul Wasserman, Professor and former Dean, School of Library and Information Services, University of Maryland

Managing Editor: Denise Allard Adzigian, Gale Research Company

Art Education

A GUIDE TO INFORMATION SOURCES

Volume 6 in the Art and Architecture Information Guide Series

Clarence Bunch

Associate Professor of Art Education
Queens College of the City University of New York
New York, New York

Visiting Professor of Graduate Art
Pratt Institute
New York, New York

Gale Research Company
Book Tower, Detroit, Michigan 48226

167069

Library of Congress Cataloging in Publication Data

Bunch, Clarence.
 Art education.

 (Art and architecture information guide series ;
v. 6) (Gale information guide library)
 Includes indexes.
 1. Art--Study and teaching--Bibliography.
I. Title.
Z5818.A8B85 [N85] 016.707 73-17518
ISBN 0-8103-1272-7

VITA

Clarence Bunch is an associate professor of art education at Queens College of the City University of New York, and visiting professor of graduate art at Pratt Institute, New York. He holds undergraduate and graduate degrees from the University of Missouri, and a doctorate from Teachers College, Columbia University. He is a founding member and past president of the University Council for Art Education, and sits on the governing board of the Institute for the Study of Art in Education.

His sculpture has been exhibited in Europe and America, and he is represented in many public and private collections in England and the United States. Recently a video presentation about his work and teaching was filmed in his studio by ART/DOC ARLIS/NA (Art Libraries Society, North America) for school and museum use here and abroad.

Bunch is a consultant to Harcourt Brace Jovanovich, the editor of FORUM, the author of ACRYLIC FOR SCULPTURE AND DESIGN, and the coauthor of WORKING BIG.

CONTENTS

Contents

Contents

ACKNOWLEDGMENTS

The author is grateful to Janice Whitener for weeks of library work and alpha-betizing; Katy Whitener for being a ten-year-old whiz when it comes to the Library of Congress card catalog system, and for being such a willing and cheer-ful worker; John Lidstone for reading parts of the manuscript and making many helpful suggestions; Sydney Keaveney and Dedria Bryfonski for a first-rate edit-ing job; Megan Mery, Tim Oliver, and Lin Snider of the Bel Canto Typing Ser-vice for typing the manuscript; John Cates, Mike Desiano, Jane Fowler, Martha Hall, Jean Koefoed, and Larry Molloy for help in many and various ways; and to Don McIntosh for the suitcase. Also, the author would like to acknowledge his indebtedness to the following libraries and organizations: Children's Book Council; Davis Publishing Company; Educational Arts Association; Harvard Uni-versity Library; Harwood Foundation of Taos, New Mexico Library; Helene Wurlitzer Foundation of New Mexico; Library of Congress; Massachusetts Insti-tute of Technology Library; National Art Education Association; New York City Public Library; New York University Library; Philadelphia College of Art Library; Pratt Institute Library; Princeton University Library; Queens College of the City University of New York Library; Teachers College, Columbia University Library; University Council for Art Education; University of New Mexico Library; and Van Nostrand Reinhold Publishing Company.

PREFACE

This guide is an organization of the literature in the varied and diverse field of art education. Subject matter content of the published material has changed considerably over the years. It has varied from teaching drawing as a vocational skill in the early part of the century, to today's art educational use of nonproduct art participation, such as events and happenings as tools for learning.

Because there does not seem to be any generally accepted definition of art education, and because no compilation of this type has been attempted before, selecting publications for a comprehensive bibliography was a difficult task. However, it seems obvious that while many readers have catholic interests, the public for art education literature generally falls into two categories.

There are those books which appeal to art teachers who are basically interested in the elements of art as the core of their instruction. These teachers perceive their function as being one of preparing a student to be an artist, and they think in terms of aesthetic education. They feel they are teaching skills and attitudes that will be used by the student to make a living, as a leisure time activity, or to increase his enjoyment of life through appreciation of art objects. Such a reader audience is inclined toward professional literature which is artist- and museum-oriented rather than child-centered. These readers look to authors for signals within the arts themselves to orient their teaching. They appreciate critical and informational analysis rather than an investigation of the act of teaching, methodology, and child development.

Then there are those books useful to art educators who see people rather than art objects as central to their teaching. This group uses art acts from painting to participation, to work with children and adults in schools, hospitals, nursing homes, prisons, parks, streets, and in any of the many and varied places where people carry on their lives. Their expectations are that children and adults who participate in art will benefit from creative involvement, and that subject matter information learned in that active, physical way becomes a part of one's normal reaction to life. The attitude about art gained as a result of participation in art acts, they feel, is more important than any "fact" learned. It be-

Preface

comes a part of the integral personality and helps sustain the student through-
out his lifetime.

Art education began in the United States as utilitarian education. It was a
practical matter when drawing was selected as a subject to be taught in schools.
The teacher was not concerned with encouraging the student toward an artistic
revelation, expressing a philosophy, making a statement about contemporary
times, or his state of mind. He was engaged in vocational training in its most
direct form.

Gradually this direction changed into one of concern for beauty, and aesthetics
came to the forefront in the teaching of art.

Later in the century, educators became more concerned with how the student
was to conduct his life in a democracy, and art education became, by and
large, education for living in an industrial society, with an emphasis on "doing"
rather than "appreciating."

Early research in the field was experimental in the trial and error sense and was
usually carried out by classroom teachers. The Second World War marked the
end of a cultural era, and when government monies became available, art edu-
cation financing changed--bringing research into sharp focus. As a result,
leadership in the field began to shift from classroom teachers and art specialists
to college and university professors. That, in turn, altered the direction and
emphasis of publications in the field.

Educators credit research with many of the changes in contemporary art educa-
tion, but, in fact, a strong argument can be made that such material and equip-
ment as Elmer's glue, Scotch tape, metal and paper lithographic plates, water-
base printing ink, acrylic paint, inexpensive cameras, and the development of
video changed the practice, and thus the philosophy, of art education in more
determined and realistic ways than has paper-and-pencil research.

Other factors affecting change in art teaching are that individuals mature ear-
lier today than in the past, and they are exposed to a greater degree of sophis-
tication about art subject matter and media in general than were their elders.
These cultural determinants shape the discipline and in turn are reflected in its
publications.

One interesting and encouraging change in present-day art education thinking
and publishing that might be pointed out is that serious art educator-writers are
now redeveloping the "how-to" book. They are using a work-directed format
in which philosophy is combined with practical discussions of art activities.
Fewer exclusively philosophical books are being printed today, and we are see-
ing more of this new, hybrid form of art education publication.

Given the great diversity of theory and practice in the field it was difficult to

decide which publications to include in this volume. This author finally devised as a rule of thumb: if a book was about art or art methods, and if its author in any substantial and serious way discussed using the book's content with children and/or adults, then it qualified as an art education book. Therefore, there are few books which deal exclusively with art, craft, or "how-to" instructions annotated here, even though they make up a substantial body of work that publishers today direct toward teachers in the field.

Historical material was far easier to come by than more recent publications. Almost every library the author used has a relatively complete historical collection, but their collections of contemporary art education books vary greatly and there are fewer of these books on the shelves.

Libraries have curtailed buying art education books drastically. The deterioration of this source of art education information could pose both a threat and danger to the profession. Even the Library of Congress does not have a comprehensive collection, and many college and university libraries have cut back their art education purchases to the quick. The main research branch of the New York City Public Library has stopped buying art education books altogether.

It is disheartening to discover this national lack of enthusiasm for art education literature, which is not typical of other western countries; and disquieting to realize that American authors, particularly those writing on the leading edge of art education philosophy, find a more receptive public outside the United States than at home.

The books annotated here are published both in the United States and England, and occasionally in other countries. There is no distinction made in categorizing the English-language books, and the Great Britain section under International Art Education contains special material that did not fit into other headings.

This author hopes teachers and researchers in the field of art education and allied disciplines find this listing helpful.

Chapter 1
GENERAL REFERENCE SOURCES

BIBLIOGRAPHIES

Arnone, Vincent, and Neil, Hugh M. ANNOTATED BIBLIOGRAPHY OF ART EDUCATION. Buffalo, N.Y.: State University College at Buffalo, 1969. 70 p. Paper.

ART BIBLIOGRAPHIES: CURRENT TITLES. Santa Barbara, Calif.: Clio Press, 1972-- . Monthly.

> Reproduces the contents pages of some 100 international art and art education journals.

ART RESOURCES. Columbus, Ohio: Capital University Library, 1970. 84 p. Paper.

> A bibliography of basic art material (books, film strips, tapes and recordings, pamphlets) which can be found in the Capital University Library.

Beelke, Ralph G. CURRICULUM DEVELOPMENT IN ART EDUCATION; AN ANNOTATED LISTING OF PUBLICATIONS PREPARED FOR THE TEACHING OF ART. Washington, D.C.: National Art Education Association (NAEA), 1962. 32 p. Paper.

> An annotated bibliography of art education curriculum guides that the NAEA feels is a representative cross-section reflecting the variety and current practice of art education in the United States.

Besterman, Theodore. ART AND ARCHITECTURE; A BIBLIOGRAPHY OF BIBLIOGRAPHIES. Totowa, N.J.: Rowman and Littlefield, 1971. 216 p.

> A list of bibliographies including art, architecture, and film.

A BIBLIOGRAPHY OF RESEARCH IN THE FINE ARTS COMPLETED AT MISSISSIPPI COLLEGES AND UNIVERSITIES. Hattiesburg: University of Southern

Mississippi, 1967. 9 p. Paper.

> A list of art (including art education), music, and drama theses
> completed in Mississippi colleges in 1967.

Busfield, Roger M., Jr., ed. THEATRE ARTS PUBLICATIONS AVAILABLE IN
THE UNITED STATES. 1953-1957. Evanston?, Ill.: American Educational
Theatre Association, 1964. 201 p.

> A title listing of articles about drama, including educational drama,
> art films, and films for children.

Chamberlin, Mary W. GUIDE TO ART REFERENCE BOOKS. Chicago: Ameri-
can Library Association, 1959. 418 p.

Clapp, Jane. MUSEUM PUBLICATIONS, PART 1: ANTHROPOLOGY, AR-
CHAEOLOGY AND ART. New York: Scarecrow, 1962. 434 p. Index.

> A bibliography of materials published by Canadian and U.S. mu-
> seums.

Clark, Marion Elizabeth, comp. ART IN HOME ECONOMICS; A BIBLIOG-
RAPHY OF COSTUME, HISTORY OF COSTUME, INTERIOR DECORATING,
HISTORY OF FURNITURE, ARCHITECTURE, ART PRINCIPLES, AND ART AP-
PRECIATION. Chicago: University of Chicago Press, 1925. 66 p.

> An annotated bibliography of art material related to home econom-
> ics.

Crothers, J. Frances. THE PUPPETEER'S LIBRARY GUIDE: THE BIBLIOGRAPHIC
INDEX TO THE LITERATURE OF THE WORLD PUPPET THEATRE. 6 vols. Metu-
chen, N.J.: Scarecrow Press, 1971. 475 p. Index.

> Published and unpublished material regarding all types of puppets.
>
> Vol. 1 - THE HISTORICAL BACKGROUND OF PUPPETRY AND
> ITS RELATED FIELDS
> Vol. 2 - THE PUPPET AS EDUCATOR
> Vol. 3 - THE PUPPET AS AN ENTERTAINER
> Vol. 4 - THE PUPPET SHOW IN PRODUCTION
> Vol. 5 - PUBLISHED MATERIAL ABOUT PUPPETEERS, THEIR COM-
> PANIES AND THEIR THEATRES AROUND THE WORLD
> Vol. 6 - GENERALIZATIONS ON THE MATERIAL LISTED, AND
> KEYS, ABBREVIATIONS USED, SOURCES, AUTHOR INDEX, ETC.

Foster, Donald L. A CHECKLIST OF U.S. GOVERNMENT PUBLICATIONS IN
THE ARTS. University of Illinois Graduate School of Library Science Occasion-
al Papers, no. 96. Urbana: University of Illinois Graduate School of Library
Science, 1969. 48 p. Subject index.

> A compilation of some 600 publications (for the most part, pam-

phlets) issued by various U.S. government agencies having to do with
the arts.

Gowan, John Curtis. ANNOTATED BIBLIOGRAPHY ON CREATIVITY AND
GIFTEDNESS. Northridge, Calif.: San Fernando Valley State College Founda-
tion, 1965. 197 p. Paper.

> Annotation of articles, research projects, and books about creativ-
> ity in art and related areas.

Hunt, DeWitt. ART EDUCATION IN JUNIOR HIGH SCHOOLS: A BIBLIOG-
RAPHY. U.S. Office of Education Circular, no. 434. Washington, D.C.:
Office of Education, U.S. Department of Health, Education and Welfare, 1955.
8 p. Paper.

Johnson, Thomas J. REVIEW AND INDEX TO RESEARCH IN FILM RELEVANT
TO AESTHETIC EDUCATION, 1900-1968. St. Louis, Mo.: Central Midwestern
Regional Educational Laboratory (CEMREL), 1970. 102 p. Paper.

_____. REVIEW AND INDEX TO RESEARCH IN LITERATURE RELEVANT TO
AESTHETIC EDUCATION, 1900-1968. St. Louis, Mo.: Central Midwestern
Regional Educational Laboratory (CEMREL), 1970. 226 p. Paper.

Kiell, Norman, ed. PSYCHIATRY AND PSYCHOLOGY IN THE VISUAL ARTS
AND AESTHETICS. Madison: University of Wisconsin Press, 1965. 250 p.

> A list of printed materials covering a wide range of art. Included
> are articles about children and art, finger painting, and art testing.

Lanier, Vincent. REPRODUCTIONS AND PAPERBACK BOOKS ON ART.
Washington, D.C.: National Art Education Association, 1967. 64 p. Paper.

Lawson, Mildred H., comp. AN ANNOTATED LIST OF BOOKS ON THE ARTS
FOR THE TEACHER AND STUDENT. Rev. by Royal B. Farnum. University of
the State of New York Bulletin no. 633. Albany: University of the State of
New York, 1917. 87 p.

Lucas, Edna Louise. ART BOOKS: A BASIC BIBLIOGRAPHY. Greenwich,
Conn.: New York Graphic Society, 1968. 205 p.

> This basic bibliography, meant to form the core of an undergraduate
> art library, is indexed by authors and artists.

Marantz, Kenneth. A BIBLIOGRAPHY OF CHILDREN'S ART LITERATURE.
Washington, D.C.: National Art Education Association, 1965. 24 p. Paper.

> Annotated bibliography of art books for children.

General Reference Sources

Milliken, Russell A., and Epling, Christine Fraley. ANNOTATED BIBLIOG-
RAPHY FOR THE EDUCATION OF GIFTED CHILDREN. Athens: College of
Education, Ohio University, 1960. 35 p. Paper.

> Generally, a "gifted" child is thought of as having a high I.Q.;
> however, this pamphlet contains material about the "talented" child
> as well.

Prieve, E. Arthur, and Allen, Ira W. ADMINISTRATION IN THE ARTS: AN
ANNOTATED BIBLIOGRAPHY OF SELECTED REFERENCES. Madison: Regents
of the University of Wisconsin, 1973. 111 p.

Rothenberg, Albert, and Greenberg, Bette. THE INDEX OF SCIENTIFIC WRIT-
INGS ON CREATIVITY: CREATIVE MEN AND WOMEN. Hamden, Conn.:
Shoe String Press, 1974. 117 p. Index.

> Bibliography of the world's literature on personality studies of crea-
> tive persons in the arts.

Schultz, Harold Arthur. ART EDUCATION FOR ELEMENTARY TEACHERS; A
SELECTED BIBLIOGRAPHY. Washington, D.C.: National Art Education Asso-
ciation, 1959. 4 p. Paper.

THE SHOREWOOD ART REFERENCE GUIDE. New York: Shorewood Publishers,
1966. 276 p.

> Selected bibliographies and background information about artists and
> schools of art.

Sims, Lowery S. "Black Americans in the Visual Arts: A Survey of Biblio-
graphic Material and Research Resources." ARTFORUM 11 (April 1973): 66-70.

> A bibliography of articles, books, exhibition catalogs, and films re-
> lating to art created by black Americans. Included are painting,
> crafts, photography, and architecture. In addition, there is a list
> of museums, galleries, and published sources of information.

Winebrenner, Kenneth. "Book Choices by 141 Art Educators." SCHOOL ARTS
56 (October 1956): 9-12.

Young, Arthur Raymond. ART BIBLIOGRAPHY. Rev. ed. New York: Bureau
of Publications, Teachers College, Columbia University, 1947. 92 p. Paper.

> A list of books covering a broad scope of the arts including art
> education and children's art books.

Ziegfeld, Edwin, ed. INTERNATIONAL LISTING OF TEACHING MATERIALS
IN ART EDUCATION. 3d ed. [New York?]: UNESCO, for the International
Society for Education through Art, 1959. xii, 88 p.

INDEXES AND DIRECTORIES

AMERICAN ART ANNUAL. 37 vols. New York and Washington, D.C.: American Federation of Arts, 1898-1948. Frequency varies.

> Lists art organizations, schools, and museums. Also contains obituaries and auction information. After 1952 continued as separate volumes: AMERICAN ART DIRECTORY (see below) and WHO'S WHO IN AMERICAN ART.

AMERICAN ART DIRECTORY. New York: R.R. Bowker for the American Federation of the Arts, 1952-- . 3/year.

> An annotated list of art organizations, schools, museums, magazines, newspapers carrying art news, scholarships and fellowships, traveling exhibitions, and names of directors and supervisors of art in school systems across the country.

ART INDEX. New York: H.W. Wilson, 1929-- . Quarterly, with annual cumulations.

> Subject and author index of nearly 200 art periodicals.

Bloom, Benjamin S., et al., eds. TAXONOMY OF EDUCATIONAL OBJECTIVES; THE CLASSIFICATION OF EDUCATIONAL GOALS. Vol. 2. AFFECTIVE DOMAIN. New York: David McKay Co., 1964.

Carrick, Neville. HOW TO FIND OUT ABOUT THE ARTS; A GUIDE TO SOURCES OF INFORMATION. Oxford and New York: Pergamon Press, 1965. 164 p. Illus.

DIRECTORY OF SCHOOLS IN NEW YORK STATE, CONNECTICUT, MASSACHUSETTS, NEW JERSEY, PENNSYLVANIA AND VERMONT OFFERING ADVANCED STUDY IN ART. Ossining: New York State Teachers Association, 1965. 63 p.

EDUCATION INDEX. New York: H.W. Wilson, 1929-- . Quarterly, with annual cumulations.

> Several art education publications are included in this subject and author index.

McCoy, Garnett. ARCHIVES OF AMERICAN ART; A DIRECTORY OF RESOURCES. New York: R.R. Bowker, 1972. 163 p. Index.

> Description of materials available to scholars from the archives. This includes individual artist's personal papers and institutional records of art organizations and museums.

Park, Joseph C., ed. WHO'S WHO IN PRACTICAL ARTS AND VOCATIONAL EDUCATION IN NEW YORK STATE. Vol. 1, 1939-40. Oswego, N.Y.: Sequoyah Publishing Co., 1940. 139 p.

> A directory of art teachers and administrators in New York State.

READERS' GUIDE TO PERIODICAL LITERATURE. New York: H.W. Wilson, 1900--*. Twice a month September to June, monthly in July and August. Cumulated annually.

> This periodical index covers general interest magazines and some art and art education magazines not in ART INDEX, such as SCHOOL ARTS.

Scott, Thomas J. GREATER NEW YORK ART DIRECTORY. New York: Center for Urban Education, 1968. 314 p. Index. Paper.

> Organizations and people in art education in New York City, Long Island, New Jersey, and Connecticut.

DICTIONARIES AND ENCYCLOPEDIAS

ENCYCLOPEDIA OF WORLD ART. 15 vols. New York: McGraw-Hill Book Co., 1959-69. Illus. Index.

> Covers all places and periods, and each article is accompanied by bibliographic material in this exhaustive reference work. Many of the illustrations are in color.

INSTITUTE OF WOMAN'S PROFESSIONAL RELATIONS DIRECTORY OF COLLEGES, UNIVERSITIES AND PROFESSIONAL SCHOOLS OFFERING TRAINING IN OCCUPATIONS CONCERNED WITH ART IN INDUSTRY. New London: Connecticut College, 1940. 390 p. Index. Paper.

> Summary information about art schools and courses across the United States. A WPA project.

Keaveney, Sydney Starr, ed. AMERICAN PAINTING: A GUIDE TO INFORMATION SOURCES. Detroit: Gale Research Co., 1974. 260 p. Index.

> A useful annotated listing of general reference sources, periodicals, museums, library collections, and other information sources about American painting and painters.

La Mancusa, Katherine C. SOURCE BOOK FOR ART TEACHERS. Scranton, Pa.: International Textbook Co., 1965. 175 p. Illus.

> A dictionary from A to Z of terms, materials, and processes used by art teachers.

Murray, Peter, and Murray, Linda. A DICTIONARY OF ART AND ARTISTS. Baltimore: Penguin Books, 1968. 455 p. Paper.

Thumbnail sketches of artists and definitions of art terms.

Runes, Dagobert D., and Schrickel, Harr G., eds. ENCYCLOPEDIA OF THE ARTS. New York: Philosophical Library, 1946. 1,064 p.

Contains a definition of "art education" and a discussion of children's art.

Chapter 2

PERIODICALS AND SERIALS

AMERICAN ART DIRECTORY. New York: R.R. Bowker Co., 1936/37-- .
Annual.

> Lists museums, art schools, and art associations in the United States
> and Canada along with data on special collections and names of
> officials.

AMERICAN ARTIST ART SCHOOL DIRECTORY. New York: Billboard Publica-
tions, 1964-- . Annual.

> Subscribers to AMERICAN ARTIST receive the directory as part of
> the March issue. It lists names, addresses, courses, degrees granted,
> and faculty of over 1500 schools, colleges, and art workshops in
> the United States.

ART AND CRAFT IN EDUCATION. London: Evans Brothers, 1946-- . Monthly.

> A magazine about teaching arts and crafts in school.

ART EDUCATION, JOURNAL OF THE NATIONAL ART EDUCATION ASSO-
CIATION. Reston, Va.: National Art Education Association, 1947-- . In-
dexed in: EDUCATION INDEX. 8/year.

> General information and articles about the philosophy and practice
> of art education.

ART EDUCATION BULLETIN. Kutztown, Pa.: Eastern Arts Association, Janu-
ary 1942-62. 9/year.

> See EASTERN ARTS QUARTERLY, below.

ART EDUCATION TODAY. New York: Bureau of Publications, Teachers Col-
lege, Columbia University, 1935-52, no issues 1944-47. Annual.

> Because the concerns treated are basic to art and education this
> publication is still relevant to the field today. Therefore, each
> issue is briefly annotated below.

ART EDUCATION TODAY. Edited by Belle Boas. 1935. 85 p.
Illus.

A variety of articles about art teaching, including using
the motion picture in art education; art education as a
social study; and textile design.

ART EDUCATION TODAY. Edited by Belle Boas. 1936. 118 p.
Illus.

Articles about art education, including costuming and
personality, art education in primitive societies, city
planning, and an article by John L. Tildsley, who was
then assistant superintendent of schools in New York
City.

ART EDUCATION TODAY. Edited by Belle Boas. 1937. 100 p.
Illus.

One article describes art education classes at Teachers
College, another the role of art in a rural school, still
another discusses art in an Indian school. There are
other articles by such people as Arthur Young, Florence
Cole, and W.H. Schaefer-Simmern.

ART EDUCATION TODAY. Edited by Belle Boas. 1938. 134 p.
Illus.

Articles by Thomas Munro, Ray Faulkner, and others,
dealing with city planning, art as an approach to
children's emotional problems, dance, as well as more
general coverage of the teaching of printing and design.

ART EDUCATION TODAY. Edited by Belle Boas. 1939. 94 p.
Illus.

Contains interesting and still timely articles on teach-
ing photography; Bauhaus education, by Moholy-Nagy;
Teachers College murals; and sculpture by the blind,
by Viktor Lowenfeld.

ART EDUCATION TODAY. Edited by Belle Boas. 1940. 85 p.
Illus.

This issue is devoted to art appreciation, primarily paint-
ing and sculpture, but does contain short articles about
crafts and flower arranging.

ART EDUCATION TODAY. Edited by Belle Boas. 1941. 102 p.
Illus.

Devoted to the practice and teaching of design, this
issue contains an article about the psychology of design
by B.F. Skinner.

ART EDUCATION TODAY. Edited by Belle Boas. 1942. 86 p.
Illus.

Concerned with art and its role in the community, there

are articles about department stores and their contribution to art, as well as about the role of museums and community centers and other art education resources. One excellent article is by (the then painter) George Rickey.

ART EDUCATION TODAY. Edited by Belle Boas. 1943. 72 p. Illus.

Subtitled "Art Education and the War," this issue contains articles on Soviet printing, art education in England, and how art educators are coping with war.

ART EDUCATION TODAY. Edited by Edwin Ziegfeld. 1948. 92 p. Illus.

This issue, after a five-year lapse due to World War II, takes a broad overview of the field of art education. Included are articles by Marion Dix (art education in a city), Ruth Allcott (communication arts), Italo De Francesco (crafts), and others.

ART EDUCATION TODAY. Edited by Edwin Ziegfeld. 1949-50. 92 p. Illus.

Using "The Teacher" as a central theme, this issue has articles by Herbert Read, Viktor Lowenfeld, Mervin Jules, Ivan Johnson, Mary McKibben, Manual Barkan, Mildred Fairchild, and others. The subjects they write about are art as a discipline, democracy, school environment, teaching resources, pre-service training, evaluation, and community involvement of the art teacher. All-in-all, a forward-looking issue, touching on concerns that were to become even more important than they were in 1949.

ART EDUCATION TODAY. Edited by Edwin Ziegfeld. 1951-52. 102 p. Illus.

This issue considers the secondary school art program. Some articles are general statements about the art experience and its importance; others deal with the then-current developments of secondary art programs and implications for art education. Also, there are discussions of methods of working with adolescents, development of specific programs, and descriptions of successful teaching. The authors include Edwin Ziegfeld, Jerome Hausman, Pearl Shecter, and others.

ART IN ACTION. Merrick, N.Y. 1960-63. 9/year.

Art news and articles about art for junior and senior high school students.

Periodicals and Serials

ART INSTRUCTION. New York: American Artist, 1972-- . Annual.

> Describes new products and is directed toward high school and college art teachers. Free.

ARTIST JR. New Haven, Conn.: Artist Jr., 1959-- . 6/year.

> For grades 5 through 12. This magazine, primarily about appreciation, contains stories of artists, discussions of their work, and articles about art history and design elements.

ART JOURNAL. New York: College Art Association, 1941-- . Quarterly. Indexed in: ART INDEX.

> Directed to art teachers in colleges and universities, this magazine contains articles, news, and book reviews. Formerly called COLLEGE ART JOURNAL (1941-60).

ART MATERIAL BUYER'S GUIDE. New York: Billboard Publishing Co., 1966-- . Annual.

> Tells where to buy art supplies; includes an art school directory.

ARTS AND ACTIVITIES: THE TEACHER'S ARTS AND CRAFTS GUIDE. Skokie, Ill.: Publishers' Development Corp., 1935-- . Monthly, September-June. Indexed in: EDUCATION INDEX.

> Articles and news of interest for art teachers in elementary and secondary schools.

ARTS AND EDUCATION. Paris: UNESCO, vol. 1, June 1949; vol. 2, December 1949.

> Only two numbers of this publication appeared. They contain articles on art education by leading educators of member nations.

ARTS IN SOCIETY. Madison: University of Wisconsin, 1958-- . 3/year. Indexed in: CURRENT INDEX TO JOURNALS IN EDUCATION.

ARTS MANAGEMENT. New York: Radius Group, 1962-- . 5/year.

> Case histories of cultural organizations' activities written for art administrators.

ART STUDENTS LEAGUE NEWS. New York: Art Students League of New York, 1948-- . 8/year.

> News of people associated with the league; also book reviews.

ART TEACHER. Reston, Va.: National Art Education Association, 1971-- . 3/year. Indexed in: ART INDEX.

ATHENE. London: International Society for Education Through Art, 1939-- . Semiannual. Indexed in: BRITISH EDUCATIONAL INDEX.

BCA NEWS. New York: Business Committee for the Arts, 1968-- . Quarterly.
News of business involvement in, and support of, the arts in the United States.

CATALOGUE OF COLOR REPRODUCTIONS OF PAINTINGS AFTER 1860. New York: UNESCO Publications Center, 1950-- . Biennial.
Black and white photographs of some of the 1500 color reproductions of paintings available from UNESCO.

CATALOGUE OF COLOR REPRODUCTIONS OF PAINTINGS TO 1860. New York: UNESCO Publications Center, 1950-- . Biennial.
Black and white photographs of a thousand color reproductions of paintings available from UNESCO.

COLOUR REVIEW: ART TEACHERS JOURNAL. Wealdstone, Engl.: Winsor and Newton, 1960-- . 3/year.

CULTURAL AFFAIRS. New York: Associated Councils of the Arts, 1964-71. Quarterly.
Contains articles on new developments in the arts and education and discussions about the practical aspects of managing arts councils.

DESIGN. Indianapolis, Ind.: Review Publishing Co., 1899-- . 6/year.
Articles and suggestions for secondary teachers.

DIRECTORY OF ARTS AND CRAFTS MATERIALS. Chicago: Art Material Trade News, 1961-- . Annual.
A listing of manufacturers and distributors of arts and crafts materials.

EASTERN ARTS ASSOCIATION, RESEARCH BULLETIN. Kutztown, Pa.: Eastern Arts Association, 1950-55. Annual.
A bulletin about research in art education.

Vol. 1: No title. Edited by Viktor Lowenfeld. 1950. 28 p. Illus.

This first issue contains articles about the relationship of reading and art, integration, art and the community, and suggests avenues for further research.

Vol. 2: THE MEANING OF INTEGRATION FOR ART EDUCA-
TION. Edited by Viktor Lowenfeld. 1951. 23 p. Illus.

Vol. 3: WORKBOOKS AND ART EDUCATION. Edited by Viktor
Lowenfeld. 1952. 27 p. Illus.

This issue deals with workbooks and art education. One
article is about reading.

Vol. 4: ART EDUCATION AT THE JUNIOR HIGH SCHOOL. Edit-
ed by Viktor Lowenfeld. 1953. 24 p. Illus.

Vol. 5: ASPECTS OF CREATIVITY. Edited by Viktor Lowenfeld.
1954. 27 p. Illus.

Vol. 6: ART EDUCATION FOR THE EXCEPTIONAL CHILD. Edit-
ed by Ernest Ziegfeld. 1955. 27 p. Illus.

EASTERN ARTS ASSOCIATION YEARBOOK. Kutztown, Pa.: Eastern Arts As-
sociation, 1944-54. Annual.

Vol. 1: TOMORROW CHALLENGES ART EDUCATION. Edited
by Margaret F.S. Glace. 1944. 141 p. Illus.

This conference had lectures about "air arts" and community art centers.

Vol. 2: ART EDUCATION AND THIS OUR TOWN. Edited by
Dana P. Vaughan. 1945. 175 p. Illus.

The major address of this conference about art educa-
tion and the environment was delivered by Margaret
Mead.

Vol. 3: ART EDUCATION FOR ONE WORLD. Edited by Dana
P. Vaughan. 1946. 192 p. Illus.

Conference theme was "One World, A Problem in De-
sign."

Vol. 4: ART EDUCATION IN A FREE SOCIETY. Edited by Italo
L. De Francesco. 1947. 184 p. Illus.

Democracy was the theme of lectures by Lowenfeld and
others. Of particular interest is the lecture entitled
"Developing Children--Not Artists" by Agnes E. Bene-
dict.

Vol. 5: ART: THE BALANCE WHEEL IN EDUCATION. Edited
by Ruth W. Coburn. 1948. 152 p. Illus.

Includes Herbert Read's address, "Education in Things."

Vol. 6: ART IN GENERAL EDUCATION. Edited by Gordon L.
Reynolds. 1949. 108 p. Illus.

A reprint of conference addresses about the role of arts
in general education.

Vol. 7: THE INTEGRATIVE FUNCTION OF ART EDUCATION.
Edited by Marion Quin Dix and Italo L. DeFrancesco. 1950.
180 p. Illus.

This reprint of some of the conference papers includes one by Margaret Mead about the role of art in a culture and another by Carleton Washburne entitled "Art in the Life of the School."

Vol. 8: ART EDUCATION IN A SCIENTIFIC AGE. Edited by Italo L. De Francesco. 1952. 112 p. Illus.

Essays on the relationships between science and art, and group planning in art education.

Vol. 9: SOURCES AND RESOURCES FOR ART EDUCATION. 1954. 191 p. Illus.

Subjects emphasized were film, television, and the United Nations.

EASTERN ARTS BULLETIN. See: EASTERN ARTS QUARTERLY, below.

EASTERN ARTS QUARTERLY. Kutztown, Pa.: Eastern Arts Association, September, 1962-- . 4/year.

In 1910 the Eastern Arts Association began publishing the EASTERN ARTS BULLETIN, which in 1942 was supplanted by the ART EDUCATION BULLETIN. That in turn became the EASTERN ARTS QUARTERLY in 1962. The QUARTERLY contains research oriented articles about art teaching and Eastern Arts conference reports.

EVERYDAY ART. Sandusky, Ohio: American Crayon Co., 1922-- . 3/year.

Articles on art and news of activities in art education.

FACTA NEWSLETTER. Edmonton: Fine Arts Council of the Alberta Teachers' Association, 1963-- . 3/year.

FAEM (FLORIDA ART EDUCATION MAGAZINE). Hollywood: Florida Art Education Association, 1967-- . Quarterly.

FEDERAL FUNDS AND SERVICES FOR THE ARTS. Washington, D.C.: Government Printing Office for the Office of Education, 1967-- . Annual.

A listing of all programs sponsored by the National Endowment for the Arts, and reports of funded programs for individuals, private and public groups, educational institutions, and other arts organizations.

FINE. Edmonton: Fine Arts Council of the Alberta Teachers' Association, 1963-- . Semiannual.

FOCUS ON MEDIA. Milwaukee: Instructional Media Laboratory, University of Wisconsin. Quarterly.

Research and new media products.

Periodicals and Serials

FREE AND INEXPENSIVE LEARNING MATERIALS. Nashville, Tenn.: Division of Surveys and Fields Services, George Peabody College for Teachers, 1941–– . Biennial.

> An annotated list of 3,000 free or inexpensive materials.

HUMANITIES IN THE SOUTH. Ruston, La.: Southern Humanities Conference, 1951. 24/year.

> News of the humanities in the southern United States.

INTERNATIONAL GRAPHIC ARTS EDUCATION ASSOCIATION YEARBOOK. Washington, D.C.: International Graphic Arts Education Association. Annual.

JOURNAL OF AESTHETIC EDUCATION. Urbana: University of Illinois Press, 1966–– . Quarterly. Indexed in: EDUCATION INDEX.

> Articles about the role of aesthetics in education (mostly higher education) by art critics, artists, and art educators.

JOURNAL OF AESTHETICS AND ART CRITICISM. Cleveland, Ohio: American Society for Aesthetics, Cleveland Museum of Art, 1941–– . Quarterly. Indexed in: ART INDEX, PSYCHOLOGICAL ABSTRACTS, MUSIC INDEX.

> Contains articles on all aspects of the arts and related experiences looked at from a philosophic, scientific, or other theoretical standpoint including those of psychology, sociology, cultural history, art criticism, and education.

NATIONAL ART EDUCATION ASSOCIATION NEWSLETTER. Reston, Va.: National Art Education Association, 1960–– . 6/year.

NATIONAL ART EDUCATION ASSOCIATION YEARBOOK. Reston, Va.: National Art Education Association, 1949-59. Annual.

> Vol. 1: ART EDUCATION ORGANIZES. Edited by Italo L. De Francesco. 1949. 199 p.
>
>> Various papers dealing with art in general education, international art education, and art and adolescence; as well as a report to the members.
>
> Vol. 2: THIS IS ART EDUCATION. Edited by Arthur R. Young. 1951. 126 p.
>
>> There are articles by Arthur Young, Manual Barkan, and Ernest Ziegfeld in this yearbook devoted to individualism and the arts.
>
> Vol. 3: THIS IS ART EDUCATION. Edited by Italo L. De Francesco. 1952. 137 p.
>
>> Consists of papers delivered at the 1951 convention.

They are primarily concerned with democracy and the
function of art in a free society.

Vol. 4: ART EDUCATION AND HUMAN VALUES. Edited by
Ernest Ziegfeld. 1953. 122 p.

Briefly explores human values implicit in a democracy
which provides a basis for discussing art and individu-
ality, and art in society.

Vol. 5: RESEARCH IN ART EDUCATION. Edited by Manual Bar-
kan. 1954. 151 p.

An attempt to make art education research respectable
and accepted by teachers, this book contains six studies
which demonstrate research needs in the field. Those
needs are defined as: supplies, teacher placement, cer-
tification requirements, art in the elementary classroom,
purposes of art education, and behavioral modification.

Vol. 6: ART A FRONTIER FOR FREEDOM. Edited by Horace F.
Heilman. 1955. 52 p.

In an attempt to show that the problems of teaching art
are not isolated from the problems of society, this issue
contains addresses from the 1954 convention by Wayne
Morse, Melvin Tumin, and Edwin Ziegfeld.

Vol. 7: RESEARCH IN ART EDUCATION. Edited by Manual Bar-
kan. 1956. 141 p.

Presents twelve studies using various research methods.
Areas explored are the gifted child, art for elementary
school children, creativity, art teacher education, and
color.

Vol. 8: ART AND THE ADOLESCENT. Edited by Youldon C.
Howell. 1957. 77 p.

Students had a voice in this symposium.

Vol. 9: RESEARCH IN ART. Edited by Jerome Hausman. 1959.
132 p.

Research dealing with philosophy, psychology, creative
behavior, including an interesting group reaction study
by Chandler Montgomery and teaching of atypical chil-
dren. An attempt is made to reflect the diversity of con-
cerns current in the field of art education.

National Association of Schools of Art. NATIONAL ASSOCIATION OF
SCHOOLS OF ART DIRECTORY. New York: 1944-- . Annual.

Short descriptions of art programs and degrees offered by the mem-
ber schools.

NEW WAYS. Cambridge, Mass.: Educational Arts Association, 1972-- . Quarterly.

A newsletter.

NYSATA. Troy: New York State Art Teachers Association. 3/year.

Contains articles about teaching art in New York State elementary and high schools.

DER PELIKAN. Hannover, West Germany: Gunther Wagner, 1955-- . Semi-annual.

Dealing with problems of education in the visual arts, this maga-zine is published in German but contains English, Norwegian, and French translations.

PROBLEMS IN ART EDUCATION AND CONSTRUCTIVE DESIGN. Tallahassee: Graduate Group, Department of Art Education, Florida State University. Quar-terly.

PROGRAMS OF THE NATIONAL ENDOWMENT FOR THE ARTS. Washington, D.C.: National Foundation on the Arts and Humanities, 1968-- . Annual.

Describes programs sponsored by the foundation.

REVIEW OF RESEARCH IN VISUAL AND ENVIRONMENTAL EDUCATION. Champaign-Urbana: Continuing Education and Public Service and the Depart-ment of Art and Design, University of Illinois, 1973-- . Annual.

The journal reports on psychological research dealing with visual and environmental factors. Its primary sources are dissertations and government reports.

SCHOOL ARTS. Worcester, Mass.: Davis Publications, 1901-- . Monthly, September-June.

Project-oriented magazine for art teachers, with an emphasis on junior high and secondary activities.

SHANKAR'S WEEKLY, CHILDREN'S ART NUMBER. Edited by K.S. Pillai. New Delhi, India: Shankar's Weekly, 1956-- . Annual.

See Pillai, K.S. on p. 130.

SOUTHEASTERN ARTS ASSOCIATION BULLETIN. Johnson City, Tenn.: South-eastern Arts Association, 1947-- . Quarterly.

STUDIES IN ART EDUCATION. Reston, Va.: National Art Education Associa-tion, 1959-- . 3/year. Indexed in: EDUCATIONAL INDEX.

The NAEA research journal.

24 LIVING ART IDEAS. Skokie, Ill.: Arts and Activities Magazine. Annual.

Art activities for elementary, junior, and senior high school classes.

UNIVERSITY COUNCIL FORUM. New York: University Council for Art Education. 1975-- . Annual.

UNIVERSITY COUNCIL NEWSLETTER. New York: University Council for Art Education. 1974-- . 3/year.

VIEWPOINT. Melbourne: New Zealand Art Teachers Association. Monthly.

This journal deals with the arts in education in New Zealand.

VIEWPOINTS, DIALOGUE IN ART EDUCATION. Normal: College of Fine Arts, Illinois State University, 1968-- . Quarterly.

WESTERN ARTS ASSOCIATION BULLETIN. Nashville, Tenn.: George Peabody College for Teachers, 1938-- . Quarterly.

Articles and art education news for regional members of the National Art and Education Association. Some of the issues are described below.

22 (September 1, 1938): 1-148.

A report of the 1938 convention held in Milwaukee. Home economics art, and art in elementary, secondary, and adult education were featured along with sessions about industrial arts and art in Catholic colleges.

23 (September 1, 1939): 1-138.

This year the convention was in Grand Rapids and there were sessions about federal aid to artists, motion pictures, and an address by Thomas Hart Benton, "Painting in America Today."

24 (September 1940): 1-300.

Featured at the Cincinnati meeting was a discussion of "Young Teachers."

25 (September 1941): 1-190. Illus.

"Humanizing the Arts for Service in Contemporary Life" was the theme of the Chicago conference.

33 (March 1949): 1-126.

Describes making plastic molds in the classroom.

33 (September 1949): 1-94.

Papers about art in the community, human growth, and so forth.

Periodicals and Serials

34 (January 1950): 1-97.

This bulletin contains an article about Chicago art educators.

34 (March 1950): 1-86.

William Stanley Hayter was involved in this year's Chicago convention.

35 (January 1951): 1-112.

Discusses the place of art museums in American education. There are articles by Munro, Beymer, and others.

35 (March 1951): 1-96.

Articles by Hoover, Hastie, and Masley about "Teacher Training in Art Education."

37 (November 1952): 1-46.

An art education bibliography.

37 (January 1953): 1-52.

A materials and equipment directory.

Chapter 3

ORGANIZATIONS AND PUBLISHERS

ORGANIZATIONS

AMERICAN COUNCIL FOR THE ARTS IN EDUCATION. 60 East 42nd Street,
Suite 638, New York, N.Y. 10017.

> This federation of national arts education associations was formed
> in 1958 to define the roles, problems, and challenges to arts edu-
> cation; and to promote public understanding of and support for the
> arts as an educational force.

ARCHIVES OF AMERICAN ART. Administration Headquarters, 41 East 65th
Street, New York, N.Y. 10021.

> A national research institute whose purpose is to collect and put
> on microfilm basic documentary source materials on American
> painters, sculptors, and craftsmen.

CENTRAL MIDWESTERN REGIONAL EDUCATIONAL LABORATORY, INC.
(CEMREL), St. Ann, Mo. (Also: CEMREL Institute, 3120 59th Street, St.
Louis, Mo. 63139).

> CEMREL issues publications regarding their own experimental pro-
> gram.

COLLEGE ART ASSOCIATION OF AMERICA (CAA). 16 East 52nd Street, New
York, N.Y. 10022.

> Founded in 1912, the CAA is an organization of fine art educators,
> museum personnel, scholars, and artists devoted to raising standards
> of scholarship and art teaching. It is art history oriented and pub-
> lishes ART BULLETIN and ART JOURNAL, both quarterlies (see
> chapter 2).

EDUCATIONAL ARTS ASSOCIATION. 90 Sherman Street, Cambridge, Mass.
02140.

> This international arts association sponsors conferences and publishes

NEW WAYS, an art education newsletter for members.

EDUCATIONAL DEVELOPMENT CENTER. 55 Chapel Street, Newton, Mass. 02158.

Issues publications about learning environments and working with children and materials.

EDUCATIONAL FACILITIES LABORATORIES. 850 Third Avenue, New York, N.Y. 10017.

This group studies and issues publications about planning facilities for education and the arts.

HARVARD PROJECT ZERO. 94 Prescott Street, Cambridge, Mass. 02138.

A research group organized to study creativity and comprehension in the arts.

INSTITUTE FOR THE STUDY OF ART IN EDUCATION. Art Department, Kean College of New Jersey, Union, N.J. 07083.

A national art education organization whose purpose is to look at current practice in the field and to suggest methods of improvement through conferences and publications.

INTERNATIONAL SOCIETY FOR EDUCATION THROUGH ART. 106 Rue du Point du Jour, Boulogne-sur-Seine, 92100, France.

The aim of this international art education organization, founded in 1951, is to promote the exchange of information in the field through publications, conferences, and study groups; and to encourage and advance creative art education.

MID-AMERICA COLLEGE ART ASSOCIATION. University of New Mexico, Albuquerque, N.M. 87131.

Established in 1938 to promote better teaching of art and art history in college and universities.

NATIONAL ART EDUCATION ASSOCIATION. 1916 Association Drive, Reston, Va. 22070.

Organized in 1947 to study problems of teaching art and to encourage research and experimentation, this national group of elementary, secondary, and college art teachers serves as an art education clearinghouse. Publications are ART EDUCATION (8/year), ART TEACHER (3/year), STUDIES IN ART EDUCATION (3/year), and a newsletter.

NATIONAL ASSOCIATION OF SCHOOLS OF ART. One DuPont Circle N.W., Suite 650, Washington, D.C. 20036.

An organization of independent and college-affiliated art schools whose purpose is to improve instructional techniques and standards. The group acts as an accrediting agency for member schools. There is an annual directory.

SOUTHEASTERN COLLEGE ART CONFERENCE. Post Office Box 1026, Chapel Hill, N.C. 27514.

Sponsors an annual conference concerned with college art and art education topics and publishes abstracts of papers presented.

UNION OF INDEPENDENT COLLEGES OF ART. 4340 Oak, Kansas City, Mo. 64111.

Consortium of private and independent colleges of art and design, organized to strengthen educational programs of each member school through cooperative effort.

UNIVERSITY COUNCIL FOR ART EDUCATION. 939 Madison Avenue, New York, N.Y. 10021.

Organized in 1969 this group of college and university art educators from the New York City metropolitan area (Long Island, Connecticut, and New Jersey) holds regular seminars concerned with current issues and problems in the field. Each spring a conference on a pragmatic theme is directed primarily to college art education students. Publications are a newsletter and the UNIVERSITY COUNCIL FORUM.

PUBLISHERS

ALLYN AND BACON. 470 Atlantic Avenue, Boston, Mass. 02110.

ARCO PUBLISHING CO. 219 Park Avenue S., New York, N.Y. 10003.

This company publishes study aids for teacher examinations.

ATHENEUM PUBLISHERS. 122 East 42nd Street, New York, N.Y. 10017.

Atheneum issues children's art books.

B.T. BATSFORD PUBLISHERS. 4 Fitzhardinge Street, London W1H, England.

CHARLES A. BENNETT CO. 809 West Detweiller Drive, Peoria, Ill. 61614.

R.R. BOWKER CO. 1180 Avenue of the Americas, New York, N.Y. 10036.

Publishes art reference books.

WILLIAM C. BROWN CO. 135 South Locust Street, Dubuque, Iowa 52001.
Most books are by west coast authors and are paperback.

THOMAS Y. CROWELL. 666 Fifth Avenue, New York, N.Y. 10003.
Publishes children's art books.

DAVIS PUBLICATIONS INC. 19-73 Printers Building, Worcester, Mass. 01608.
A leader in the field of art education publishing.

DOUBLEDAY AND CO. 501 Franklin Avenue, Garden City, N.Y. 11530.
Publishes juvenile and adult art education books.

E.P. DUTTON AND COMPANY. 201 Park Avenue S., New York, N.Y.
10003.

EDUCATIONAL MATERIALS AND EQUIPMENT CO. P.O. Box 63, Broxville,
N.Y. 10708.
Publishes books on the arts for children and the lay adult.

FABER AND FABER, PUBLISHERS. 3 Queens Square, London W.C.3N, En-
gland.

FEARON PUBLISHERS. 6 Davis Drive, Belmont, Calif. 94002.
A relatively new firm, Fearon publishes materials which view art as
a tool for learning. Many of their books are about interdisciplin-
ary art education.

HARCOURT BRACE JOVANOVICH. 757 Third Avenue, New York, N.Y.
10017.
Publishes college art education books.

HARVARD UNIVERSITY PRESS. 79 Garden Street, Cambridge, Mass. 02138.

INTEXT EDUCATIONAL PUBLISHERS. 257 Park Avenue S., New York, N.Y.
10010.

LITTLE, BROWN AND CO. 34 Beacon Street, Boston, Mass. 02106.
Publishes art books for children.

MCGRAW-HILL BOOK CO. 1221 Avenue of the Americas, New York, N.Y. 10036.

MACMILLAN PUBLISHING CO. 866 Third Avenue, New York, N.Y. 10022.

M.I.T. PRESS. 28 Carleton Street, Cambridge, Mass. 02142.

NATIONAL ART EDUCATION ASSOCIATION. 1916 Association Drive, Reston, Va. 22070.

> Publishes various materials having to do with teaching art at all school levels. Research is emphasized.

PENNSYLVANIA STATE UNIVERSITY PRESS. 215 Wagner Building, University Park, Pa. 16802.

PRENTICE-HALL. Englewood Cliffs, N.J. 07632.

STUDIO VISTA, PUBLISHERS. 35 Red Lion Square, London W.C. 1R, England.

U.S. OFFICE OF EDUCATION. 415 12th Street, N.W., Washington, D.C. 20005.

> The Office of Education publishes pamphlets about many areas of art education including research reports.

UNIVERSITY OF CALIFORNIA PRESS. 2223 Fulton Street, Berkeley, Calif. 94720.

UNIVERSITY OF LONDON PRESS. St. Paul's House, Warwick Lane, London EC 4T, England.

VAN NOSTRAND REINHOLD CO. 450 West 33rd Street, New York, N.Y. 10001.

> Van Nostrand Reinhold seems to be making a concentrated effort to develop the field of art education. For the most part, their books are substantial, timely, and generally well designed.

WATSON-GUPTILL PUBLICATIONS. One Astor Place, New York, N.Y. 10012.

> Publishes how-to-do-it painting, sculpture, crafts, and design books.

Chapter 4
HISTORY OF ART EDUCATION AND
EARLY INDUSTRIAL DESIGN

Bailey, Henry Turner. INSTRUCTION IN THE FINE AND MANUAL ARTS IN
THE UNITED STATES: A STATISTICAL MONOGRAPH. Washington, D.C.:
Government Printing Office, 1909. 184 p. Index. Paper.

> Statistical information about the status of art education in the
> United States during 1906-7.

_____. A SKETCH OF THE HISTORY OF PUBLIC ART INSTRUCTION IN
MASSACHUSETTS. Boston: Wright and Potter Printing Co., 1900. 53 p. Il-
lus.

> A history of art education in elementary schools, secondary schools,
> and colleges in Massachusetts.

Bennett, Charles Alpheus. HISTORY OF MANUAL AND INDUSTRIAL EDUCA-
TION UP TO 1870. Peoria, Ill.: Manual Arts Press, 1926. 461 p. Illus.
Index.

> As a core for his history the author couples labor, or hand work,
> and learning. There is a chapter relating art education to industry.

Blayney, Thomas L. THE HISTORY OF ART IN THE COLLEGE CURRICULUM.
Washington, D.C.: American Federation of Arts, 1910. 32 p.

Brattinga, Pieter. PLANNING FOR INDUSTRY, ART AND EDUCATION. New
York: Van Nostrand Reinhold Co., 1970. 191 p. Illus.

> Contains a section about an educational program at Pratt Institute
> where the author was a departmental chairman.

Brown, Frank Percival. SOUTH KENSINGTON AND ITS ART TRAINING.
London: Longmans, Green and Co., 1912. 66 p. Illus.

> A history of state-aided art education in England.

Carline, Richard. DRAW THEY MUST: A HISTORY OF THE TEACHING AND EXAMINING OF ART. London: Edward Arnold, 1968. 325 p. Illus. Index. Biblio.

A history of art education in British schools.

Clark, John Spencer. ART IDEAS IN EDUCATION AND IN PRACTICAL LIFE. Art Educational Paper no. 4 [Address given before the Department of Manual and Art Education of the World's Congress Auxiliary, Chicago, July 18, 1893.] Boston: Prang Educational Co., n.d. 15 p. Paper.

_____. SOME VITAL PRINCIPLES IN EDUCATION. [A discussion on the Place of Art in Education, Between John S. Clark and Francis W. Parker. At the meeting of the National Educational Association, Denver, July 1895.] Boston: Prang Educational Co., 1896. 50 p.

A historically interesting debate between John S. Clark and Francis W. Parker about the value of art in education at the meeting of the National Educational Association in Denver, July 1895.

Clarke, Isaac Edwards. ART AND INDUSTRIAL EDUCATION. Albany, N.Y.: J.B. Lyon Co., 1904. 63 p.

In this history of art education in the United States, the author makes many comparisons to art education as it existed in Europe in the early part of the century.

_____. ART AND INDUSTRY: THE DEMOCRACY OF ART, WITH SUGGESTIONS CONCERNING THE RELATIONS OF ART TO EDUCATION, INDUSTRY, AND NATIONAL PROSPERITY. Washington, D.C.: W.H. Morrison, 1886. 258 p.

Essays suggesting that art should have a more central role in vital areas of life in the United States, such as industry, political economy, education, and the church. Author's concern is the rapidly increasing population.

Columbia University. Teachers College Arts and Crafts Club. ART AND INDUSTRY IN EDUCATION: A BOOK ILLUSTRATIVE OF THE PRINCIPLES AND PROBLEMS OF THE COURSES IN FINE AND INDUSTRIAL ARTS AT TEACHERS COLLEGE, MAY 1912. New York: 1912. 119 p. Illus.

_____. ART AND INDUSTRY IN EDUCATION: A BOOK ILLUSTRATIVE OF THE PRINCIPLES AND PROBLEMS OF THE COURSES IN THE FINE AND INDUSTRIAL ARTS AT TEACHERS COLLEGE, 1913. New York: 1913. 103 p. Illus.

CULTURAL EDUCATION UNDER THE CARNEGIE GRANTS FOR THE ADVANCEMENT OF ART AND MUSIC IN THE PUBLIC SCHOOLS. Baltimore, Md.: De-

partment of Education, 1944. 46 p. Illus. Paper.

> A descriptive narrative of the progress made in the public school art and music programs from 1939 when the Carnegie money became available until 1945.

Ebken, Ruth M., ed. PROSPECT AND RETROSPECT. [Kutztown, Pa.?]: Eastern Arts Association, 1960. 94 p. Illus.

> An illustrated summary of the history of art education as seen through the Eastern Arts Association members' eyes from 1910 to 1960, with a nod to the future.

Farnum, Royal Bailey. ART EDUCATION: THE PRESENT SITUATION. Department of the Interior Bulletin no. 13. Washington, D.C.: Government Printing Office, 1923. 20 p. Paper.

> Contains a brief background of art education in the United States, then discusses the situation in 1923.

_____. PRESENT STATUS OF DRAWING AND ART IN THE ELEMENTARY AND SECONDARY SCHOOLS OF THE UNITED STATES. U.S. Bureau of Education Bulletin no. 13. Washington, D.C.: Government Printing Office, 1914. 375 p. Illus. Index. Paper.

> A thorough look at art in selected American public schools.

Fourth International Congress for Art Education. DRAWING AND ART APPLIED TO INDUSTRIES: GENERAL REPORT. Dresden, East Germany: Herausgegeben Von Der Kongress Leitung Durch Karl Elssner, 1912. 476 p. Illus.

> Although printed in German, there is a synopsis of conference activities and a few lectures in English. The English-language papers include "Art Education for the Masses" by Henry Turner Bailey; "Art Training in American Universities" by John S. Ankeney; "Elementary Drawing According to Nature and Development" by E. Cooke; and "The Application of Art to Printing" by F.J. Tresie.

Haney, James Parton, ed. ART EDUCATION IN THE PUBLIC SCHOOLS. New York: American Art Annual, 1908. 432 p. Illus., some color.

> Essays about art education at elementary through college levels in the United States. The opening article is concerned with the history of art education in public schools.

Hiss, Priscilla Fransler, and Fansler, Roberta Murray. RESEARCH IN FINE ARTS IN THE COLLEGES AND UNIVERSITIES OF THE UNITED STATES. New York: Carnegie Corp., 1934. 223 p. Index. Biblio. Paper.

> In this history of fine arts instruction in the United States, much attention is paid to graduate work.

29

Langl, Joseph. MODERN ART EDUCATION: ITS PRACTICAL AND AESTHETIC
CHARACTER EDUCATIONALLY CONSIDERED. Translated by S.R. Koehler.
Boston: L. Prang & Co., 1875. 161 p.

> A world history of art education including a very short chapter on
> America.

Logan, Frederick Manning. GROWTH OF ART IN AMERICAN SCHOOLS. New
York: Harper and Brothers Publishers, 1955. 310 p. Index. Biblio.

> A history of art education in the United States with some compari-
> sons to European developments. There are discussions of major
> philosophic statements and books in the field with extensive bibliog-
> raphies at the end of most chapters.

Macdonald, Stuart. THE HISTORY AND PHILOSOPHY OF ART EDUCATION.
New York: American Elsevier Publishing Co., 1970. 400 p. Illus. Index.
Biblio.

> A thorough history of art teaching, both elementary and college,
> in Europe (with emphasis on Great Britain) and the United States.
> Also contains a table of dates, and a list of colleges offering
> art education courses.

National Endowment for the Arts. OUR PROGRAMS (1972). Washington,
D.C.: 1972. 83 p. Paper.

> A history of the endowment program and description of the various
> arts programs it funds.

Nichols, George Ward. ART EDUCATION APPLIED TO INDUSTRY. New
York: Harper and Brothers Publishers, 1877. 211 p. Illus. Index. Biblio.

> A history which discusses art education in England, France, Belgium,
> Austria, Italy, and the United States. The author sees drawing as
> being central to education through art.

Palmer, Archie MacInnes, and Holton, Grace. COLLEGE INSTRUCTION IN
ART. New York: Association of American Colleges, 1934. 62 p. Paper.

> A narrative description of art teaching in American colleges in the
> late 1800s.

Philadelphia Board of Public Education, Division of Art Education. REPORT
(1930-31). Philadelphia: 1931. 46 p.

> Contains a brief history of art education in Philadelphia.

Pratt Institute and Prang Educational Co. ART AND INDUSTRIAL EDUCATION.
Boston: 1891. 12 p. Paper.

> A description of Prang-sponsored art education classes at Pratt.

Sargent, Walter. INSTRUCTION IN ART IN THE UNITED STATES. Bulletin no. 43. Washington, D.C.: Government Printing Office, 1919. 31 p. Paper.

> Discusses art education in elementary, high schools, and museum schools in the United States in 1919.

Savage, Eugene Francis. ON ART EDUCATION. New York: Carnegie Corp., 1929. 20 p. Paper.

> The author is happy to note that art education is increasing in the schools, but sees much need for reform.

Sawyer, Charles Henry. ART INSTRUCTION IN ENGLISH PUBLIC SCHOOLS. Andover, Mass.: Addison Gallery of American Art, Phillips Academy, 1937. 73 p. Illus.

> Looks at twelve English schools and reports on their art programs. In addition the author discusses the history of art education in England, schools, museums, and art examinations. The illustrations are of art studio buildings.

Sparkes, John C.L. SCHOOLS OF ART: THEIR ORIGIN, HISTORY, WORK, AND INFLUENCE. London: William Clowes & Sons, 1884. 152 p.

> A history of English art schools.

Sutton, Gordon. ARTISAN OR ARTIST? A HISTORY OF THE TEACHING OF ART AND CRAFTS IN ENGLISH SCHOOLS. Oxford: Pergamon Press, 1967. 328 p. Illus. Index. Biblio.

> A thorough discussion of how art education developed in English schools. The chapter about child art is especially interesting.

Sykes, Frederick Henry. SCHOOLS OF THE ART INDUSTRIES: A PLEA FOR A NEW TYPE OF SCHOOL IN THE PUBLIC SCHOOL SYSTEM. Teachers College Technical Education Bulletin no. 16. New York: Teachers College, Columbia University, 1912. 11 p. Paper.

Tomlinson, Reginald R. CHILDREN AS ARTISTS. New York: King Penguin Books, 1947. 32 p. Illus., some color.

> An informal essay dealing with the historical development of art in elementary schools.

_____. PICTURE AND PATTERN MAKING BY CHILDREN. Rev. ed. New York: Studio Publications, 1950. 144 p. Illus.

> A picture book of children's paintings from around the world. Also contains a short history of art education.

_____. PICTURE MAKING BY CHILDREN. New York: Studio Publications, 1934. 120 p. Illus., some color.

Basically a history of art teaching in schools around the world.

Turner, Ross Sterling, et al. ART IN THE SCHOOLROOM: PICTURES AND THEIR INFLUENCE. ART EDUCATION IN AMERICAN LIFE. New York: Prang Educational Co., n.d. 36 p. Paper.

Papers delivered before the 1892 Prang Educational Conference in Boston.

Chapter 5

ART SCHOOLS

Academy of Fine Arts. FIRST ANNUAL CATALOGUE OF THE TEACHERS AND
STUDENTS OF THE WORCESTER SCHOOL OF DESIGN AND ACADEMY OF
FINE ARTS FOR THE ACADEMIC YEAR ENDING JULY, 1857. Worcester,
Mass.: Henry J. Howland, 1857. 16 p. Illus. Paper.

American Federation of Arts. THE EDUCATIONAL ALLIANCE ART SCHOOL
RETROSPECTIVE ART EXHIBIT. New York: 1963. Unpaged. Illus.
Paper.

> In this exhibition catalog there is a history of the Alliance Art
> School, and an article by a former student, Moses Soyer.

"The Artist and His Education." HARVARD ART REVIEW, Summer, 1969. pp.
1-36.

> Contains descriptions of art schools in the United States.

Art Students League of New York. THE COS COB SUMMER SCHOOL UNDER
THE AUSPICES OF THE ART STUDENTS LEAGUE OF NEW YORK. New York:
1903. 4 p. Paper.

> Inflation has begun. This year, room and board is $6-$10 per
> week.

_____. REPORT. New York: 1878. 55 p.

> A descriptive report issued by the league. Eakins had just been
> hired to teach a series of twelve anatomy lessons.

_____. REPORT ON ART SCHOOLS. New York: 1879. 46 p.

> Short descriptions of art schools in Europe.

_____. SUMMER SCHOOL OF THE ART STUDENTS LEAGUE OF NEW YORK
AT NORWICH, CONN. New York: 1898. 4 p. Paper.

The league's summer school catalogue. A student could have room and board for $5.00 a week.

Art Workshop for College and Industrial Women. THE ART WORKSHOP: THE FIRST YEAR, 1929-1930. New York: 1930. 28 p. Illus. Paper.

A narrative account of the school's accomplishments.

Bayer, Herbert; Gropius, Walter; and Gropius, Ise, eds. BAUHAUS 1919-1928. New York: Museum of Modern Art, 1938. 224 p. Illus. Index. Biblio.

A description of the Bauhaus course of study, a look at its teacher-artists, and a summation of Bauhaus influences on other schools. A well written and documented introduction to the Bauhaus.

Bell, Quentin. THE SCHOOLS OF DESIGN. London: Routledge & Kegan Paul, 1963. 290 p. Illus. Index. Biblio.

A history of the first state-supported art schools in England.

Boime, Albert. THE ACADEMY AND FRENCH PAINTING IN THE NINETEENTH CENTURY. London: Phaidon, 1971. 330 p. Illus. Index. Biblio.

A history of the Beaux-Arts. Included are discussions of curriculum, landscape painting, and copying.

Boston Art Students Association. THE ART STUDENT IN PARIS. Boston: 1887. 52 p. Paper.

A discussion of schools and student life in Paris. Sounds marvelous.

Cantor, Gilbert. THE BARNES FOUNDATION: REALITY VS. MYTH. 1933. Reprint. Philadelphia: Chilton Books, 1963. 219 p.

The book depicts the origin of the Barnes Foundation, its aesthetic theory, educational philosophy, and methods, but mostly is concerned with justifying the foundation after accusations by the Attorney General of Pennsylvania.

Clark, Eliot. HISTORY OF THE NATIONAL ACADEMY OF DESIGN, 1825-1953. New York: Columbia University Press, 1954. 296 p. Illus. Index.

Department of Science and Art of the Committee of the Council on Education. LIST OF (1) SCHOOLS OF ART AND OF (2) ART CLASSES AND COURSES TAKING ATTENDANCE GRANTS DURING SESSION 1896-97. London: Wyman and Sons, 1898.

Duberman, Martin B. BLACK MOUNTAIN: AN EXPLORATION IN COMMUNITY. New York: E.P. Dutton and Co., 1972. 527 p. Illus.

Duffus, Robert Luther. THE AMERICAN RENAISSANCE. New York: Alfred
A. Knopf, 1928. 321 p.

> The author inquires into the various ways in which the arts are
> taught in this lively history of art schools in the United States.
> There is a section about community arts.

Edlmann, Edith. EDUCATION AND PEASANT INDUSTRY: SOME STATE AND
STATE-AIDED TRADE SCHOOLS IN GERMANY. Board of Education, Educa-
tional Pamphlet no. 26. London: H.M. Stationery Office, 1912. 62 p. Bib-
lio., pp. 59-61. Paper.

> A description of crafts education in Germany in the early part of
> this century.

Edwards, Edward. THE ADMINISTRATIVE ECONOMY OF THE FINE ARTS.
London: Saunders and Otley, 1840. 376 p. Index.

> A general treatise about the state of art in England at the mid-
> point of the nineteenth century. There are chapters on schools of
> design and the Royal Academy.

England, Board of Education. ENGLAND AND WALES, TECHNICAL SCHOOLS
AND SCHOOLS OF ART: LIST OF THE MORE IMPORTANT TECHNICAL
SCHOOLS AND SCHOOLS OF ART RECOGNIZED BY THE BOARD OF EDU-
CATION, LIST THREE, 1922-23. London: His Majesty's Printing Office, 1925.
74 p.

EXHIBITION OF PAINTINGS AND SCULPTURE BY THE ART SCHOOL ALUMNI
OF THE EDUCATIONAL ALLIANCE. New York: Associated American Artists
Galleries, 1940. 64 p. Illus.

> Photographs of distinguished alliance alumni and their work. In-
> cluded are Peter Blume and the Soyer brothers. There is a short
> essay about the school and biographical material about each of the
> twenty-five artists in this show.

Federated Council on Art Education. SUMMER ART SCHOOLS. Washington,
D.C.: 1936. 32 p. Paper.

> A list of summer art sessions in the United States in 1935-36.

Franciscono, Marcel. WALTER GROPIUS AND THE CREATION OF THE BAU-
HAUS IN WEIMAR: THE IDEALS AND ARTISTIC THEORIES OF ITS FOUND-
ING YEARS. Urbana: University of Illinois Press, 1971. 336 p. Illus. In-
dex. Biblio.

> A scholarly examination of Gropius and the men he chose to run
> the Bauhaus. Includes a chapter about Johannes Itten and the in-
> fluence of his elementary teaching experience and ideas of child
> education on the Bauhaus curriculum.

Fundaburk, Emma Lila, and Davenport, Thomas G. ART AT EDUCATIONAL INSTITUTIONS IN THE UNITED STATES. Metuchen, N.J.: Scarecrow Press, 1974. 670 p. Illus. Index. Biblio.

A documentation through photographs and text of art at colleges in the United States, with suggestions for acquiring art work for educational institutions.

Geelhaar, Christian. PAUL KLEE AND THE BAUHAUS. Boston: New York Graphic Society, 1973. 176 p. Illus., some color.

After an introductory chapter about the history of the Bauhaus, the author discusses Klee's relationship with the school and its artists, particularly Kandinsky, and explores the development of Klee's art theories.

Grohmann, Will. PAINTERS OF THE BAUHAUS. London: Marlborough Fine Art, 1962. 85 p. Illus. Paper.

An examination of painting at the Bauhaus.

Gropius, Walter. THE NEW ARCHITECTURE AND THE BAUHAUS. Translated by P. Morton Shand. Cambridge, Mass.: The M.I.T. Press, 1965. 112 p. Illus.

A discussion of Bauhaus architecture and teaching methods thereof.

_____, ed. THE THEATER OF THE BAUHAUS. Translated by Arthur S. Wensinger. Middletown, Conn.: Wesleyan University Press, 1961. 116 p. Illus.

Itten, Johannes. DESIGN AND FORM: THE BASIC COURSE AT THE BAU-HAUS. Translated by John Maass. New York: Van Nostrand Reinhold Publishing Corp., 1964. 190 p. Illus. Index.

A description of the Bauhaus basic design course and a discussion by Itten of his teaching methods. Very direct and human.

Klee, Paul. PEDAGOGICAL SKETCHBOOK. Translated, and with an introduction by Sibyl Moholy-Nagy. New York: Frederick A. Praeger Publishers, 1960. 62 p. Illus.

Klee's notes for his course in design theory at the Bauhaus.

Landgren, Marchel E. YEARS OF ART: THE STORY OF THE ART STUDENTS LEAGUE OF NEW YORK. New York: Robert M. McBride & Co., 1940. 267 p. Illus. Index.

A history of the Art Students League.

Moholy-Nagy, Laszlo. THE NEW VISION: FROM MATERIAL TO ARCHITEC-

TURE. Translated by Daphne M. Hoffman. New York: Brewer, Warren & Putnam, 1932. 191 p. Illus. Index.

> Moholy's Bauhaus lectures form the basis of this book dealing with educating for personal expression.

_____. 'THE NEW VISION' AND 'ABSTRACT OF AN ARTIST.' Translated by Daphne M. Hoffmann. New York: Wittenborn and Co., 1946. 80 p. Illus. Biblio.

> A statement about the underlying art education philosophy of the Bauhaus. Text is taken from the third revised edition of THE NEW VISION and the fourth edition of ABSTRACT OF AN ARTIST.

_____. VISION IN MOTION. Chicago: Paul Theobald & Co., 1956. 371 p. Illus; Index.

> Describes educational methods used at the Institute of Design, Chicago, and takes as its basic premise the unity of art and life. Subjects included are group poetry, space-time problems, movies, as well as other art and art education topics and projects.

Morse, Samuel Finley Breese. ACADEMIES OF ART. New York: G. and C. Carvill, 1827. 60 p. Paper.

> Two addresses (one to academy members and the other to students) by Morse, who was president of the National Academy of Design, on the necessity of education in the arts. His theme is a history of art academics.

Mulvany, George F. THOUGHTS AND FACTS CONCERNING THE FINE ARTS IN IRELAND AND SCHOOLS OF DESIGN. Dublin, Ireland: Cumming and Ferguson, 1847. 60 p. Paper.

> Broad principles to help put art education on a firmer footing.

Naylor, Gillian. THE BAUHAUS. London: Studio Vista, 1968. 159 p. Illus. Paper.

> A brief look at the Bauhaus.

Neumann, Eckhard, ed. BAUHAUS AND BAUHAUS PEOPLE. Translated by Eva Richter and Alba Lorman. New York: Van Nostrand Reinhold Co., 1970. 256 p. Illus.

> Reminiscences, opinions, and analyses by forty-eight people who intimately knew and obviously loved the Bauhaus in an attempt to further explain Bauhaus influence on architecture, industrial design, visual communication, and teaching.

Owen, Arthur C. ART SCHOOLS OF MEDIAEVAL CHRISTENDOM. Edited by J. Ruskin. London: H.M. Stationery Office, 1876. 502 p.

Art Schools

Pevsner, Nikolaus. ACADEMIES OF ART PAST AND PRESENT. 1940. Reprint. New York: Da Capo Press, 1973. 323 p. Illus. Biblio.

A description of artists' education linked with political, social, and aesthetic data from fifth-century Greece to twentieth-century Europe. This reprint of the 1940 book contains a new preface by the author.

Royal Academy of Arts. 50 YEARS BAUHAUS. London: 1968. 365 p. Illus. Paper.

An exhibition catalog concerned with the accomplishments of Bauhaus people.

Scheidig, Walther. CRAFTS OF THE WEIMAR BAUHAUS 1919-1924. London: Studio Vista, 1967. 150 p. Illus., some color. Index. Biblio.

A short essay about industrial design at the Bauhaus with many exciting photographs.

Scottish Academy of Painting, Sculpture, and Architecture. LAWS AND REGULATIONS FOR THE STUDY OF THE ANTIQUE AND OF THE LIVING MODEL. Edinburgh: H. and J. Pillans, 1836. 16 p. Paper.

Admission requirements and regulations. If you were under twenty and unmarried you couldn't draw from the live model.

Skowhegan School. THE FIRST TEN YEARS, 1946-1956. Skowhegan, Maine: 1956. 20 p. Paper.

A brief history of the Skowhegan school.

Steigman, Benjamin Morris. ACCENT ON TALENT: NEW YORK'S HIGH SCHOOL OF MUSIC AND ART. Detroit: Wayne State University Press, 1964. 370 p. Illus. Index.

A history of the High School of Music and Art by a man who was its principal for twenty-two years.

Stevens, Thaddeus. SPEECH IN FAVOR OF THE BILL TO ESTABLISH A SCHOOL OF ARTS. Harrisburg, Pa.: Theophilus Ferin, 1825. 12 p. Paper.

A speech Stevens delivered in the House of Representatives in support of establishing an art school.

Strange, Robert. AN INQUIRY INTO THE RISE AND ESTABLISHMENT OF THE ROYAL ACADEMY OF ARTS. London: E. and C. Dilly, 1775. 141 p.

The author argues for including engraving in the academy.

U.S. Army Art Training Center. REPORT OF THE AMERICAN E.F. ART TRAIN-ING CENTER. Paris: U.S. Army, 1919. 113 p.

A report of a U.S. Army art school in France where officers learned architecture, painting, sculpture, and interior decoration.

Wingler, Hans M. THE BAUHAUS; WEIMAR, DESSAU, BERLIN, CHICAGO. Translated by Wolfgang Jabs. Cambridge, Mass.: M.I.T. Press, 1969. 653 p. Illus., photos.

A heavily illustrated, definitive monograph on the Bauhaus.

_____. GRAPHIC WORK FROM THE BAUHAUS. Translated by Gerald Onn. Greenwich, Conn.: New York Graphic Society, 1969. 112 p. Illus.

Chapter 6

GENERAL PHILOSOPHY AND METHODS

Alber, Josef. SEARCH VERSUS RE-SEARCH. Hartford, Conn.: Trinity College Press, 1969. 85 p. Illus.

> Three lectures given at Trinity College in April 1965 in which Alber presented his ideas of art education illustrated with examples from his Yale basic design class.

Andrews, Michael, ed. AESTHETIC FORM AND EDUCATION. Syracuse, N.Y.: Syracuse University Press, 1958. 156 p.

> See entry on p. 147.

Arnheim, Rudolph. ART AND VISUAL PERCEPTION. Berkeley and Los Angeles: University of California Press, 1967. 408 p. Illus.

> Chapter 4 deals with pictorial form and why the author thinks children draw.

_____. TOWARD A PSYCHOLOGY OF ART. Berkeley and Los Angeles: University of California Press, 1966. 226 p. Biblio.

> A collection of essays on creativity, Gestalt theory of expression, and form. Some are helpful in understanding the basics of art, others are more specific analysis of artists and their work.

ART: AS THE MEASURE OF MAN [by George D. Stoddard]; AS EDUCATION [by Irwin Edman]; A PERSONAL VISION [by Bruno Bettelheim]. New York: Museum of Modern Art, 1964. 64 p. Paper. (Distributed by Doubleday and Co., Garden City, N.Y.)

> Three lectures delivered in 1963, 1950, and 1962, respectively, at the annual conferences of the National Committee on Art Education.

Ashbee, Charles R. A FEW CHAPTERS IN WORKSHOP RE-CONSTRUCTION AND CITIZENSHIP. London: Guild and School of Handicraft, 1894. 166 p. Illus., with line drawings.

> Art education seen as a force to aid democracy.

Bailey, Henry Turner. ART EDUCATION. New York: Houghton Mifflin Co., 1914. 102 p. Illus.

> The author sees appreciation as the main concern of art education and believes it is best achieved through the complete school environment. He would broaden the base of education through the use of art.

_____. THE FLUSH OF DAWN, NOTES ON ART EDUCATION. New York: Atkinson, Mentzner, and Grover, 1910. 142 p.

_____. INSTRUCTION IN THE FINE AND MANUAL ARTS IN THE UNITED STATES; A STATISTICAL MONOGRAPH. Bureau of Education Bulletin, no. 6. Washington, D.C.: Government Printing Office, 1909. 184 p.

Baldwin, John. PSYCHOLOGY APPLIED TO ART TEACHING. New York: D. Appleton and Co., 1892. 134 p.

Baltimore, Maryland. Board of School Commissioners. CULTURAL EDUCATION UNDER THE CARNEGIE GRANTS FOR THE ADVANCEMENT OF ART AND MUSIC IN THE PUBLIC SCHOOLS, 1939-1945. Baltimore: Department of Education, 1944. 46 p. Illus. Paper.

> A descriptive report of art and music education in Baltimore under Carnegie grants.

Barkan, Manual. A FOUNDATION FOR ART EDUCATION. New York: Ronald Press Co., 1955. 235 p. Index. Biblio.

> Attempts to identify some of the basic problems in art teaching and relates them to concepts developed out of research in other fields concerned with human behavior.

_____. VIKTOR LOWENFELD: HIS IMPACT ON ART EDUCATION. Introduction by Kenneth Beittel. NAEA Research Monograph, no. 2. Washington, D.C.: National Art Education Association, 1966. 24 p. Paper.

> A paper delivered at the 1965 National Art Education Association conference honoring Lowenfeld and discussing his work in the context of current art education ideas.

Barnes Foundation. JOURNALS OF THE BARNES FOUNDATION. Merion, Pa.: Barnes Foundation Press, 1925-26. 169 p.

> Articles about art and art education by people active in the field.

Battcock, Gregory, ed. NEW IDEAS IN ART EDUCATION; A CRITICAL ANTHOLOGY. New York: E.P. Dutton and Co., 1973. 289 p. Illus. Paper.

> Essays about art education by Allan Kaprow, Harold Rosenberg, Howard Cenant, Irving Kaufman, Al Hurwitz, and others.

Beelke, Ralph G., ed. PROCEEDINGS OF THE THIRD NATIONAL CON-
FERENCE IN THE ARTS IN EDUCATION. Lafayette, Ind.: Purdue University,
1964. 60 p. Paper.

Papers delivered at the conference about aesthetic education in
high school, relationship of humanities and the arts, national foun-
dation for the arts, and other topics.

Bergson, Henri. AN INTRODUCTION TO METAPHYSICS. Translated by
T.E. Hulme. New York: G.P. Putnam's Sons, 1955. 62 p. Paper.

A philosophical essay about the meaning of intuition as thought
activity necessary for aesthetic experience to occur.

Birney, William. ART EDUCATION. Washington, D.C.: Washington Art
Club, 1878. 32 p.

Brouch, Virginia M. ART EDUCATION: A MATRIX SYSTEM FOR WRITING
BEHAVIORAL OBJECTIVES. Phoenix, Ariz.: Arbo Publishing Co., 1973. 124 p.

Presents a guide for writing the "silly things."

Brouch, Adolph Armand. THE CHILD IN ART AND NATURE. London: Postal
University, n.d. 175 p. Illus. Paper.

A curious book combining techniques of how-to-draw children with
a historical look at children in painting, sculpture, and photo-
graphic figure studies.

Bryce, Mayo J., and Beelke, Ralph [G.]. CONFERENCE ON INTERNATION-
AL EXCHANGE OF CHILDREN'S ART. Washinton, D.C.: Office of Educa-
tion, U.S. Department of Health, Education and Welfare, 1959. 29 p. Paper.

Conference papers about exchanging exhibitions of children's art
works by Ziegfeld, D'Amico, McKibbin, and others.

Bucher, Richard Hubert Lestoq de Castelnau. THE TEACHING OF ART. Lon-
don: Blackie and Son, 1953. 198 p. Illus., part color. Biblio.

Contains a discussion of Cizek's teaching methods in addition to
discussions of the role of art in education and suggestions of art
projects.

Burgart, Herbert J. CREATIVE ART: THE CHILD AND THE SCHOOL. Rev.
ed. Athens: University of Georgia Printing Department, 1964. 139 p. Bib-
lio.

About a quarter of this book is a listing of resources (publications,
visual materials, etc.) for art educators. In the remaining section
the author discusses developmental growth, the school, and other
areas. There is a strong emphasis on research.

Burgess, Lowry. FRAGMENTS; A WAY OF SEEING, A WAY OF SEEKING. Watertown, Mass.: Workshop for Learning Things, 1970. Unbound.

Burkhart, Robert Christopher. SPONTANEOUS AND DELIBERATE WAYS OF LEARNING. Scranton, Pa.: International Textbook Co., 1962. 260 p. Illus. Index. Biblio.

> Reports the results of research to analyze personality structure and related patterns of learning. There are sections on teacher-pupil relationships, types of student teachers, evaluation, as well as descriptions and discussions about spontaneous and deliberate students.

Burnham, Jack. ART IN THE MARCUSEAN ANALYSIS. Monograph no. 6. University Park: Pennsylvania State University Press, 1969. 21 p. Paper.

> Discusses the schism between art and society.

Cane, Florence. THE ARTIST IN EACH OF US. New York: Pantheon Books, 1951. 370 p. Illus.

> The author believes every person has creative ability, and sees its release coming about through basic bodily experiences. One section is devoted to the "healing" properties of art activities. There are many case studies.

Carnegie Corporation of New York. PROCEEDINGS OF THE INFORMAL CONFERENCE ON THE ARTS. New York: 1940. 300 p. Paper.

> Transcript of a two-day conference dealing with research in aesthetics, art education in colleges and universities, and art education tomorrow.

Carolina Art Association. ART IN EDUCATION AND IN INDUSTRY. Charleston, S.C.: 1950. 63 p. Illus. Paper.

> A study of the ways art is used in elementary, secondary, adult, and higher education in South Carolina.

Chesneau, Ernest Alfred. EDUCATION OF THE ARTIST. Translated by Clara Bell. New York: Cassell and Co., 1886. 327 p. Index.

> In these essays about the fine and decorative arts with an emphasis on educating artists for the future, the author is upset by what he sees as a commercialization and popularization of art.

Clark, John Spencer. THE ART IDEA IN EDUCATION AND IN PRACTICAL LIFE. New York: Prang Educational Co., 1893. 15 p.

> Stresses art as beauty and as a philosophy for living.

Clarke, Isaac Edwards. THE DEMOCRACY OF ART. Washington, D.C.: W.H. Morrison Publisher, 1886. 257 p.

> Argues that art should be an essential part of the life of individual man and a part of the life of the nation. Also discusses the role of art in education.

Collingwood, William Gershom. THE ART TEACHING OF JOHN RUSKIN. London: Rivingtons, 1900. 376 p.

Colton, Mary-Russell Ferrell. ART FOR THE SCHOOLS OF THE SOUTHWEST: AN OUTLINE FOR THE PUBLIC AND INDIAN SCHOOLS. Flagstaff: Northern Arizona Society for Science and Art, 1934. 34 p. Illus. Biblio.

> An outline guide for teaching art in Indian and public schools.

Colwell, Richard. AN APPROACH TO AESTHETIC EDUCATION. 2 vols. Washington, D.C.: Office of Education, Department of Health, Education and Welfare, 1970. 705 p. and 680 p.

> Much attention is paid to dance and architecture in this two-volume publication about art education teaching techniques.

Conant, Howard. ART EDUCATION. Washington, D.C.: Center for Applied Research in Education, 1964. 116 p. Biblio.

> Discusses the nature of art, what elements contribute to a work of art, and what constitutes an art experience. The author concerns himself with the role of art in our lives and education and suggests directions for the future of art education.

_____. SEMINAR ON ELEMENTARY AND SECONDARY SCHOOL EDUCA-TION IN THE VISUAL ARTS. New York: New York University, 1965. 234 p. Illus. Biblio. Paper.

> Report of a seminar with participants who were not art educators but who had expressed interest in the condition of art teaching. They talked about art in society, looked at art programs in schools, and made recommendations.

_____, ed. ART WORKSHOP TEACHERS PLANNING GUIDE. Based on studies in a series of art workshop teachers seminars conducted by the Art Education Department of New York University. Worcester, Mass.: Davis Publications, 1958. 43 p. Biblio. Paper.

> A brief, clearly presented guide to setting up art workshops in the community. There is a list of films and slides about art education.

Conant, Howard, and Randall, Arne, W. ART IN EDUCATION. Peoria, Ill.: Charles A. Bennett, 1963. 345 p. Illus. Index. Biblio.

> A practical look at art education, considering teacher preparation,

job problems, professional art education organizations, evaluation, art facilities, art materials, and the role of art in the community.

Conrad, George, ed. ART AND EDUCATION. Glassboro, N.J.: Department of Art, Glassboro State College, 1968. 117 p.

Stated purpose of the book is "to explore ways art processes contribute to the processes of growing and becoming. . . ." The five articles discuss humanistic art education in terms of society, developing art programs, art for the disadvantaged, and the visual-haptic continuum.

COUNCIL OF SUPERVISORS OF MANUAL ARTS YEARBOOK, 1901. New York: Press of Clarence S. Nathan, 1902. 80 p. Illus.

Articles about teacher education, supervision, testing, and color by such people as James Hull, Henry Bailey, Victor Shinn, and others in this first yearbook of the Council.

COUNCIL OF SUPERVISORS OF THE MANUAL ARTS YEARBOOK, 1902. Worcester, Mass.: Press of Gilbert G. Davis, 1902. 161 p. Illus.

Articles by Bailey, Perry, Haney, and others about color, drawing, design, picture-study, and supervision make up this yearbook.

Dahlke, H. Otto. VALUES IN CULTURE AND CLASSROOM. New York: Harper and Brothers, Publishers, 1958. 116 p.

D'Amico, Victor Edmond. DOES CREATIVE EDUCATION HAVE A FUTURE? Montreal: International Institute for the Study of Education Through Art (INSEA), 1963. 6 p. Paper.

An essay based on an address given at the 1963 conference of INSEA, Montreal.

Davidson, Thomas. THE PLACE OF ART IN EDUCATION. Boston: Ginn and Co., 1885. 44 p. Paper.

An argument for art centered education as the most logical way to the good life and an enobled spirit.

Davies, Eltom M. ARTS AND CULTURES OF MAN. Scranton, Pa.: Intext Educational Publishers, 1972. 212 p.

Davies, Henry. ART IN EDUCATION AND LIFE. Columbus, Ohio: R.G. Adams and Co., 1914. 334 p. Index. Biblio.

Good taste and art education in a democratic society.

Davis, Beverly Jeanne, ed. EDUCATION THROUGH ART: HUMANISM IN A TECHNOLOGICAL AGE. Washington, D.C.: National Art Education Association, 1969. 184 p.

A Selection of conference papers covering areas from administration to child art presented to the nineteenth World Conference of the International Society for Education Through Art in 1969 by art educators from around the world.

Davis, Donald J., ed. BEHAVIORAL EMPHASIS IN ART EDUCATION. Reston, Va.: National Art Education Association, 1975. 202 p.

Articles by Mary Rouse, Marylou Kuhn, Guy Hubbard, and others about writing behavioral objectives, evaluation, research, and other areas of art education.

De Francesco, Italo Luther. ART EDUCATION: ITS MEANS AND ENDS. New York: Harper and Row, 1958. 652 p. Illus. Index. Biblio.

Discusses art education from the elementary grades through high school. Also there are sections on administration, exceptional children, creative adults, and descriptions of exemplary art education programs.

_____, ed. ART EDUCATION IN A SCIENTIFIC AGE: THE 1952 YEARBOOK. Kutztown, Pa.: Eastern Arts Association, State Teachers College, 1952. 111 p. Illus. Paper.

See entry on p. 15.

Dewey, John. "The Aesthetic Element in Education." In NATIONAL EDUCATION ASSOCIATION, ADDRESS AND PROCEEDINGS, 1897. Pp. 329-30, 346.

An address delivered before the association in Milwaukee in July 1897.

_____. ART AS EXPERIENCE. New York: Minton, Balch and Co., 1934. 355 p. Index.

Lectures given by the author at Harvard in 1931 on the philosophy of art. Dewey sees art as resulting from man's response to, and interaction with his environment.

_____. "Art in Education--and Education in Art." NEW REPUBLIC 46 (February 24, 1926): 11-13.

Considerations of Whitehead's "Science and the Modern World."

_____. "Culture and Industry in Education." Proceedings of the Joint Convention of the Eastern Art Teachers Association and the Eastern Manual Training Association. New York: Columbia University, 1906. Pp. 21-30.

A paper read at the convention held at Horace Mann School, Teachers College, Columbia University, May 31, 1906.

_____. DEMOCRACY AND EDUCATION. 1916. Reprint. New York: Macmillan. 242 p.

Dewey connects the growth of democracy with the development of experimental methods in science, evolutionary ideas in biological sciences, and industrial reorganization.

_____. THE PSYCHOLOGY OF DRAWING--IMAGINATION AND EXPRESSION--CULTURE AND INDUSTRY IN EDUCATION. Teachers College Bulletin, no. 10. New York: Teachers College, Columbia University, 1919. 18 p.

Reprints of three articles.

Dewey, John, et al. ART AND EDUCATION--A COLLECTION OF ESSAYS. 3d ed. Merion, Pa.: Barnes Foundation Press, 1954. 316 p. Biblio.

A collection of essays dealing with the philosophy of art education in rather broad generalized terms. It is partly an attack on art schools and college art faculties, partly art history, psychology and aesthetic essays, but mostly an explanation and defense of the Barnes Foundation.

Dow, Arthur Wesley. COMPOSITION, A SERIES OF EXERCISES IN ART STRUCTURE FOR THE USE OF STUDENTS AND TEACHERS. 13th ed. Garden City, N.Y.: Doubleday, Doran and Co., 1931. 127 p. Illus., some color.

Design philosophy and art exercises by an early art educator. Dow's art theories and teaching influenced both art teachers and artists in the early part of the century.

_____. COMPOSITION; A SERIES OF EXERCISES SELECTED FROM A NEW SYSTEM OF ART EDUCATION. Part 1. 5th ed. New York: Baker and Taylor, 1903. 83 p. Illus.

_____. CONSTRUCTIVE ART TEACHING. Teachers College Technical Bulletin, no. 17. New York: Teachers College, Columbia University, 1913. 10 p. Paper.

_____. ILLUSTRATED CATALOGUE OF OIL PAINTINGS AND DRAWINGS, IPSWICH PRINTS FROM WOOD BLOCKS--AND JAPANESE COLLECTION. New York: American Art Association, 1923. 32 p.

_____. THE THEORY AND PRACTICE OF TEACHING ART. New York: Teachers College, Columbia University, 1912. 54 p. Illus., some color. Paper.

> A discussion of the purpose of art education and some curriculum suggestions. The essay gives one an idea of the Teachers College art education program in the early part of the century.

Durham University and Leeds College of Art. THE DEVELOPING PROCESS. London: 1959. 48 p. Illus. Paper.

> Thoughts about teaching art by English artist-teachers.

Eastern Art Teachers Association. PROCEEDINGS: FIRST AND SECOND ANNUAL CONVENTIONS, 1910 AND 1911. Newark, N.J.: Baker Printing Co., 1912. 213 p.

> A lot of attention was paid to industry and vocational training at each meeting.

_____. PROCEEDINGS OF 1908-09 MEETING. Newark, N.J.: Baker Printing Co., 1910. 317 p. Illus.

> Papers delivered on drawing and art in normal schools and in high schools by James Haney, Walter Sargent, and other art educators at this joint convention with the Eastern Manual Training Association.

_____. PROCEEDINGS OF THE JOINT CONVENTION OF THE EASTERN ART TEACHERS ASSOCIATION AND THE EASTERN MANUAL TRAINING ASSOCIATION AND THE EASTERN MANUAL TRAINING ASSOCIATION. Asbury Park, N.J.: Kinmouth Art Press, 1906. 244 p.

> Henry T. Bailey read a paper on college entrance exams in art and John Dewey lectured about culture and industry at this convention mostly concerned with art in American life.

_____ REPORT OF THE FIRST MEETING. New York: 1899. 70 p.

> The meeting was held at Pratt Institute and one of the speakers was Arthur Dow who talked about composition in elementary schools and in art schools. After each main presentation there was a series of three or four ten-minute discussions led by various art educators.

Eastlake, Martha Simpson. ART IS FOR EVERYONE. New York: McGraw-Hill Book Co., 1951. 173 p. Illus.

Eisner, Elliot W. CULTURAL ARTS: PROJECT DESIGN. Washington, D.C.: Office of Education, Department of Health, Education and Welfare, 1968. 72 p.

> Planning for art education and cultural enrichment in urban areas.

_____. EDUCATING ARTISTIC VISION. New York: Macmillan Publishing Co., 1972. 306 p. Illus., part color. Index. Biblio.

The author begins with a discussion of why art should be taught and continues with an examination of contemporary art education, a look at the history of art in the schools, and sections on curriculum building, evaluation, and research.

Farnum, Royal Bailey. ART EDUCATION IN THE UNITED STATES. Washington, D.C.: Bureau of Education, Department of the Interior, 1925. 32 p. Paper.

_____. "Art Education Number." EDUCATION, November 1939, pp. 129-91.

The entire issue of this Harvard-sponsored magazine is devoted to art education and has articles about the relationship of music and visual art, color, justification of art in the college curriculum, and art education philosophy.

Federated Council on Art Education, Committee on Terminology. REPORT OF THE COMMITTEE ON TERMINOLOGY. Boston: Berkeley Press, 1929. 79 p. Illus. Biblio. Paper.

The purpose of the study was to present suggestions for improving art vocabulary and to attempt to define "art education."

Feldman, Edmund Burke. BECOMING HUMAN THROUGH ART: AESTHETIC EXPERIENCE IN THE SCHOOL. Englewood Cliffs, N.J.: Prentice-Hall, 1970. 389 p. Illus., some color. Index. Biblio.

The author believes education occurs through what is seen and heard as well as through reading. He discusses this idea in the four parts of this book: "The Nature of Art," "The Character of Learning," "The Creativity of Children," and "A Curriculum for Art Education."

Field, Dick. CHANGE IN ART EDUCATION. London: Routledge & Kegan Paul, 1970. 138 p. Index. Biblio.

The author considers relationships between current ideas on children and art, on creativity, on learning, and on technological developments in education. He sees art education as a mode of thinking and ordering experience and discusses general practices in the teaching of art in schools and colleges.

Field, Dick, and Newick, John, eds. THE STUDY OF EDUCATION AND ART. London: Routledge & Kegan Paul, 1973. 244 p. Index.

The theme of this book is the relationship between the function of education and the function of art. There is a symposium entitled "Is it necessary to make art in order to teach art?"

Gaitskell, Charles Dudley. ART EDUCATION IN THE PROVINCE OF ON-
TARIO. Toronto: Macmillan of Canada, 1948. 136 p. Biblio.

A description of art education in Ontario schools and a brief his-
torical outline comprise the core of this book.

Gezari, Temima [Nimtzowitz]. FOOTPRINTS AND NEW WORLDS: EXPERI-
ENCES IN ART WITH CHILD AND ADULT. New York: Reconstructionist Press,
1957. 169 p. Illus.

The author writes in an impressionistic manner about her experi-
ences teaching art to children and adults.

Glace, Margaret F.S., ed. TOMORROW CHALLENGES ART EDUCATION:
1944 YEARBOOK OF THE EASTERN ARTS ASSOCIATION. Kutztown, Pa.:
Eastern Arts Association, State Teachers College, 1944. 140 p. Illus. Paper.

See entry on p. 14.

Goodman, Nelson. BASIC ABILITIES REQUIRED FOR UNDERSTANDING AND
CREATION IN THE ARTS. Washington, D.C.: Office of Education, Depart-
ment of Health, Education and Welfare, 1972. 100 p.

Art education learning processes examined.

Groszman, Maximilian. SOME FUNDAMENTAL VERITIES IN EDUCATION.
Boston: Gorham Press, 1911. 118 p. Illus.

The author sees education as a matter of stimulating natural expres-
sion, therefore he would base it on manual training and art.

Haggerty, Melvin Everett. ART: A WAY OF LIFE: Minneapolis: University
of Minnesota Press, 1935. 43 p.

The philosophic basis and objectives of the Owatonna Art Educa-
tion Project are discussed by its director.

_____. ENRICHMENT OF THE COMMON LIFE. Minneapolis: University of
Minnesota Press, 1938. 36 p. Paper.

This essay by the director of the Owatonna Art Education project
is a discussion of the role of art in man's life.

Hardman, Maud Romona. NECESSITIES AND OPPORTUNITIES FOR ART IN
THE PUBLIC SCHOOLS. Salt Lake City: University of Utah, 1925. 15 p.
Biblio. Paper.

An essay arguing for the inclusion of art in the public school
curriculum.

Hartman, Gertrude, ed. CREATIVE EXPRESSION THROUGH ART: A SYM-POSIUM BY HUGHES MEARNS AND OTHERS. Washington, D.C.: Progressive Education Association, 1926. 192 p. Illus.

Harvard University Press. THE CREATIVE ARTS IN AMERICAN EDUCATION. Cambridge, Mass.: 1960. 60 p.

See entry on p. 58.

Hastie, W. Reid, ed. ART EDUCATION: THE SIXTY-FOURTH YEARBOOK OF THE NATIONAL SOCIETY FOR THE STUDY OF EDUCATION. Chicago: University of Chicago Press, 1965. 358 p. Index.

Part of this volume is concerned with changes in art education since the last yearbook was published some twenty years earlier. Other sections are about art teaching, research, and the future of art in American education from elementary years to graduate school.

Hausman, Jerome J., ed. REPORT OF THE COMMISSION ON ART EDUCA-TION. Washington, D.C.: National Art Education Association, 1965. 148 p. Biblio.

General essays on art education today, the teaching of art, and what it means to be an art education professional, by Barker, Beit-tel, Fieldman, Hausman, Johnson, Kaufman, Logan, McKibbin, Schultz, and Ziegfeld.

Hayes, Bartlett H., Jr. THE NAKED TRUTH AND PERSONAL VISION: A DIS-CUSSION ABOUT THE LENGTH OF THE ARTISTIC ROAD. Andover, Mass.: Addison Gallery of American Art, 1955. 111 p. Illus.

Henri, Robert. THE ART SPIRIT. Philadelphia: J.B. Lippincott Co., 1923. 292 p. Index.

Holmes, Kenneth, and Collinson, Hugh. CHILD ART GROWS UP. New York: Studio Publications, 1952. 95 p. Illus.

Discusses art and the environment, the place of art in general education, pattern, lettering, and other art education activities.

Horn, George. ART FOR TODAY'S SCHOOLS. Worcester, Mass.: Davis Publications, 1967. 272 p. Illus. Index. Biblio.

In an attempt to relate child art to the general world and the art world outside the classroom, the author explores space using sculpture, images through printmaking, form and function through crafts,

logos, and packaging by examining commercial art, and the aesthetic world beyond the studio in addition to discussing art program organization in our schools. The book is well illustrated with works of artists from the past and present and children's art work from a range of grades. Includes motivational and supply suggestions.

Howard, Vernon A. A FRESH LOOK AT ART EDUCATION. Cambridge, Mass.: Graduate School of Education, Harvard University, 1972. 20 p. Biblio.

This monograph, which is mostly about music, deals with the symbolic structure of media.

Hurwitz, Al, ed. PROGRAMS OF PROMISE: ART IN THE SCHOOLS. New York: Harcourt Brace Jovanovich, 1972. 163 p. Illus. Biblio. Paper.

A series of case histories written by the people associated with eleven nontraditional art programs which range from preschool to high school.

I NEVER SAW ANOTHER BUTTERFLY. New York: McGraw-Hill Book Co., 1964. 80 p. Illus.

A very moving and beautiful book of poems and pictures by children who were interned during 1942-44 at Terezen, a concentration camp in Czechoslovakia. The collages are more accomplished artistically, but all the visual work is expressive of the place and conditions under which the children lived--and died.

International Federation for Art Education. FEA-CONGRESS REPORT. Ravensburg, West Germany: Otto Maier Verlag, 1959. 410 p. Illus., some color.

Lectures delivered at the tenth annual meeting by such people as Itten, Lowenfeld, Klager, Schaefer-Simmon, and other international art educators covering a wide range of art education topics.

Kaelin, Eugene F. AN EXISTENTIAL-PHENOMENOLOGICAL ACCOUNT OF AESTHETIC EDUCATION. University Park: Pennsylvania State University, 1968. 42 p. Paper.

A conceptual model for the teaching of art as a humanity.

Kagan, Pauline Wright. FROM ADVENTURE TO EXPERIENCE THROUGH ART. San Francisco: Chandler Publishing Co., 1959. 76 p. Illus. Index. Biblio. Glossary. Paper.

Using color as a starting point, the author explores powder paint, crayons, and water color through painting and printmaking. Included are discussions about art teaching and planning an art program and a section about brushes.

Kaufman, Irving. ART AND EDUCATION IN CONTEMPORARY CULTURE. New York: Macmillan, 1966. 531 p. Illus. Index.

A book about teaching art based on major philosophical concepts from contemporary life, by a leading art educator.

Keiler, Manfred L. THE ART IN TEACHING ART. Lincoln: University of Nebraska Press, 1961. 247 p. Illus. Index.

Art is presented for elementary, junior high, and high school teachers in a historical context. The author discusses art as symbol, communication, value, order, and illusion; and the creative process in terms of perception, empathy, imagination, fantasy, experience, and skill. There are sections about the function of art in general education, the art teacher, art media, and related arts.

Kelley, Earl C. EDUCATION FOR WHAT IS REAL. Foreword by John Dewey. New York: Harper and Brothers, Publishers, 1947. 119 p. Illus., diagrams.

An attempt to more closely relate perception to education.

Kelley, Earl C., and Rosey, Marie I. EDUCATION AND THE NATURE OF MAN. New York: Harper and Brothers, Publishers, 1952. 209 p.

The book is aimed at attitudes and beliefs, which the author sees as controlling behavior. It deals with many separate disciplines and there is a chapter on creativity.

Kent, Rockwell, and Zigrosser, Carl. ROCKWELLKENTIANA: A FEW WORDS AND MANY PICTURES. New York: Harcourt, Brace & Co., 1933. 64 p. Illus. Biblio.

This collection includes an article by Kent written in 1918 about child art.

Kepes, Gyorgy, ed. EDUCATION AND VISION. New York: George Braziller, 1965. 233 p. Illus.

Essays by Arnheim, Itten, Rand, Hayes, and others about nature as the basis for aesthetic experience.

_____. THE NATURE AND ART OF MOTION. New York: George Braziller, 1965. 195 p. Illus.

A book about motion, simulated on two-dimensional surfaces and real in sculpture and films.

_____. THE NEW LANDSCAPE IN ART AND SCIENCE. Chicago: Paul Theobald & Co., 1956. 383 p. Illus. Name index.

The new landscape in invisible nature made visible through technology and science.

Keppel, F.P., and Duffus, Robert Luther. THE ARTS IN AMERICAN LIFE. New York: McGraw-Hill Book Co., 1935. 227 p.

 Discusses art education in and out of schools and art in the daily life of Americans.

Kiell, Norman. PSYCHIATRY AND PSYCHOLOGY IN THE VISUAL ARTS AND AESTHETICS. Madison: University of Wisconsin Press, 1965. 250 p.

Kilpatrick, W.H. SOME BASIC CONSIDERATIONS AFFECTING SUCCESS IN TEACHING ART. New York: Bureau of Publications, Teachers College, Columbia University, 1931. 89 p.

 See entry on p. 135.

Klager, Max. LETTERS, TYPE AND PICTURES: TEACHING ALPHABETS THROUGH ART. New York: Van Nostrand Reinhold Co., 1975. 88 p. Illus., some color. Biblio.

 Suggestions for the use of calligraphy and typography from kindergarten through high school as an art tool to stimulate learning in other subject areas and as an art product complete within itself.

Klar, Walter Hughes, et al. ART EDUCATION IN PRINCIPLE AND PRACTICE. Springfield, Mass.: Milton Bradley Co., 1933. 422 p. Illus. Index.

 Contains sections about the history of art education, supervision, curriculum, administrative problems, and the value of publicity.

Lacey, Jeannette. YOUNG ART: NATURE AND SEEING: A FUNDAMENTAL PROGRAM FOR TEACHERS. New York: Van Nostrand Reinhold Co., 1973. 96 p. Paper.

Landor, R.A. THE EDUCATION OF EVERY CHILD. Berea, Ohio: Liberal Arts Press, 1974. 150 p.

 A suggestion for an alternative elementary school based on math, music, and the visual arts.

Lanier, Vincent. ESSAYS IN ART EDUCATION: THE DEVELOPMENT OF ONE POINT OF VIEW. New York: Mss Educational Publishing Co., 1970. 145 p. Illus. Paper.

 Reprints of some of the author's essays from 1950 to 1970 illustrating his changing ideas about the teaching of art. He discusses creativity, media, experimental high school programs in art appreciation, films, objectives of teaching art, and other subjects.

Lark-Horovitz, Betty; Lewis, Hilda; and Luca, Mark. UNDERSTANDING CHILDREN'S ART FOR BETTER TEACHING. Columbus, Ohio: Charles E. Merrill Publishing Co., 1973. 357 p. Illus., part color. Index. Biblio.

Describes the course of development of art expression from its be-
ginnings in infancy through adolescence. The authors deal with
the child's pictorial language, how he handles space and depth in
composition, visual memory, teaching, and other areas.

Lecoq de Boisbaudran, Horace. THE TRAINING OF THE MEMORY IN ART
AND THE EDUCATION OF THE ARTIST. Translated by L.D. Luard. New
York: Macmillan, 1911. 185 p. Illus. Index.

Essays about art training and education for artists by a teacher of
Rodin.

Leland, Charles Godfrey. PRACTICAL EDUCATION. London: Whittaker &
Co., 1888. 280 p.

The author feels education is best based on perception. There is
a section about American art education.

Lidstone, John, and Bunch, Clarence. WORKING BIG. New York: Van
Nostrand Reinhold Co., 1975. 96 p. Illus. Biblio. Paper.

Alerts teachers to the positive value of working with projects and
materials of a larger dimension than the traditional. Explores both
the relationship between children's art and the fine arts and the
psychological reasons that prompt youngsters to be enthusiastic
about "working big." Profusely illustrated with sequential photo-
graphs that help the teacher relate theory to practice.

Littlejohns, John. ART IN SCHOOLS. Introduction and additional notes by
R.R. Tomlinson. London: University of London Press, 1928. 170 p. Illus.
Index. Biblio., pp. 147-52.

Following a discussion of the place of art education in the school
curriculum, this book also examines its history, presents a psycho-
logical basis for art in school, and discusses methods and design
elements.

Lowenfeld, Viktor. CREATIVE AND MENTAL GROWTH. 2d rev. ed. New
York: Macmillan, 1952. 408 p. Illus., some color. Index. Biblio.

This book, one of the foundation publications of art education,
has a strong psychological slant and the author deals with the
growth of children in art, gives the characteristics of children's
art work at various age levels, and suggests ways in which teachers
can encourage creative growth.

_____. THE NATURE OF CREATIVE ACTIVITY. 2d ed. London: Routledge
& Kegan Paul, 1965. 272 p. Illus. Index.

An examination of children's drawings with reference to haptic and
kinaesthetic problems, weak sighted pupils, and a discussion of sub-
jective versus objective attitudes in art.

_____. YOUR CHILD AND HIS ART. New York: Macmillan, 1954. 186 p.
Illus.

> Consists of answers to parents' questions and discusses the parents'
> role in the promotion of children's creative activity.

Lowenfeld, Viktor, and Brittain, W. Lambert. CREATIVE AND MENTAL
GROWTH. 6th ed. New York: Macmillan, 1975. 430 p. Illus., some
color. Index. Biblio.

> There are many new illustrations and an emphasis on research in
> this new edition of one of the books central to the literature of
> art education.

Madeja, Stanley S. ALL THE ARTS FOR EVERY CHILD. Foreword by Kathryn
Bloom. St. Louis, Mo.: Central Midwestern Regional Educational Laboratory,
1973. 111 p. Paper.

_____, ed. EXEMPLARY PROGRAMS IN ART EDUCATION. Washington,
D.C.: National Art Education Association, 1969. 124 p. Paper.

> The people involved discuss their art education programs. Com-
> munity resources, special programs, and art appreciation are stressed.

Marcouse, Renee. USING OBJECTS: TEACHING VISUAL AWARENESS. Lon-
don: Van Nostrand Reinhold Co., 1974. 80 p. Illus., some color.

> The author discusses how visual awareness can be encouraged and
> developed through contact with objects of various sorts.

Marshall, Sybil. AN EXPERIMENT IN EDUCATION. Cambridge, Mass.: Har-
vard University Press, 1963. 222 p. Illus., some color.

> The author's account of her life working with children and art.
> She discusses her "symphonic method" of teaching which empha-
> sizes art as a natural element in the complete process of educa-
> tion. She is especially interested in the link between art and
> reading.

Mattil, Edward L. THE SELF IN ART EDUCATION. Research Monograph, no.
5. Washington, D.C.: National Art Education Association, 1972. 19 p.
Paper.

> Individual development, self-concept, and expression in art educa-
> tion are the central concerns of this research study.

Meilach, Dona Z. THE ARTIST'S EYE. Chicago: Henry Regnery Co., 1972.
104 p. Illus., color. Index.

> The author describes her art teaching methods.

Mendelowitz, Daniel E. CHILDREN ARE ARTISTS: AN INTRODUCTION TO
CHILDREN'S ART FOR TEACHERS AND PARENTS. Stanford, Calif.: Stanford
University Press, 1957. 140 p. Illus. Biblio.

> Writing for parents, the author begins with a discussion of scrib-
> bling and guides the reader on through the characteristics of adoles-
> cent art work in a clear, direct manner.

Mock, Ruth. PRINCIPLES OF ART TEACHING: A HANDBOOK FOR TEACH-
ERS IN PRIMARY AND SECONDARY SCHOOLS. Foreword by A.B. Clegg.
London: University of London Press, 1955; New York: Philosophical Library,
1956. 95 p. Illus., some color. Index.

> The author believes that the teacher's major job is to help the
> child to "see." She discusses materials and subjects for drawing
> (stressing observation and memory) and teaching methods. There
> is a short section on handwriting in this straightforward readable
> book.

Morris, William. AN ADDRESS DELIVERED BY WILLIAM MORRIS TO STU-
DENTS OF THE BIRMINGHAM MUNICIPAL SCHOOL OF ART, ON FEBRUARY
21, 1894. London: Longmans & Co., 1898. 25 p.

Munro, Thomas. ART EDUCATION: ITS PHILOSOPHIES AND PSYCHOLOGY.
New York: Liberal Arts Press, 1956. 387 p. Index.

> Essays the author wrote between 1925 and 1956. The art museum
> is central to his thinking about art education and the key theme
> recurring throughout the essays is the importance of education in
> art for the development of a balanced harmonious personality, and
> as a vehicle for transmitting the world's cultural heritage. Dis-
> cusses creativity, art in general education, children's art, the
> Cizek teaching method, adolescent art, and college art programs
> as well as museum art education.

Munro, Thomas, and Read, Herbert. THE CREATIVE ARTS IN AMERICAN EDU-
CATION. Cambridge, Mass.: Harvard University Press, 1960. 65 p.

> Two lectures concerning the philosophic basis of elementary and
> secondary education in the arts. Munro stresses arts in general
> education and Read points out the importance of play.

Munsterberg, Hugo. PRINCIPLES OF ART EDUCATION: A PHILOSOPHICAL,
AESTHETICAL, AND PSYCHOLOGICAL DISCUSSION OF ART EDUCATION.
Boston: Prang Educational Co., 1905. 114 p.

> The author attempts to help the teacher make a connection between
> philosophy, aesthetics, and psychology in his/her mind and in
> turn help the child develop through art. Art in those days was
> drawing.

Museum of Modern Art. ART. New York: 1964. 64 p. Paper.

> Contains an essay by Irwin Edman entitled "Art as Education" which deals with perception.

National Art Education Association. THE ESSENTIALS OF A QUALITY SCHOOL ART PROGRAM. Washington, D.C.: 1972. Unpaged. Biblio. Paper.

> Contains a position statement about elementary and secondary art programs in schools.

_____. WHY ART EDUCATION: Reston, Va.: 1975. Unpaged. Paper.

> Directed to parents, administrators, and others outside the profession, this pamphlet discusses the values of art in public education.

National Society for the Study of Education. ART IN AMERICAN LIFE AND EDUCATION. Bloomington, Ill.: Public School Publishing Co., 1941. 112 p.

Newport, Esther, ed. RE-EVALUATING ART EDUCATION. Washington, D.C.: Catholic University of America Press, 1960. 106 p.

New York State Commission on Cultural Resources. ARTS AND THE SCHOOLS: PATTERNS FOR BETTER EDUCATION. Albany: 1972. 100 p.

> This committee report contains a narrative description of the state's educational system and its successes and failures in regard to aesthetic education. The committee found that there is an appreciation of the value of the arts in education but yet it is possible for students to graduate without being exposed to them; that more than half the students in the state are not receiving minimum art instruction.

Outis [pseud.]. HIATUS: THE VOID IN MODERN EDUCATION, ITS CAUSES AND ANTIDOTE. London: Mamillan and Co., 1869. 251 p.

> The author expresses his concern about the lack of aesthetic values in education.

Paddey, Whannel, ed. ARTIST, CRITIC, AND TEACHER. London: Joint Council for Education Through Art, 1958. 116 p. Paper.

> Essays by Lindsay Anderson, Kenneth Tynan, and others on art and education.

Pappas, George, ed. CONCEPTS IN ART AND EDUCATION: AN ANTHOLOGY OF CURRENT ISSUES. New York: Macmillan, 1970. 473 p. Illus.

Essays about the history of art education, its philosophical founda-
tions, art education practices, research, and student teachers by
leaders in the field.

Pasto, Tarmo. THE SPACE-FRAME EXPERIENCE IN ART. New York: A.S.
Barnes & Co., 1964. 440 p. Illus. Index. Biblio.

Art of the child, the schizophrenic, and the artist, approached
from an examination of the expressive biological nature of the
creator rather than the object.

Payant, Felix. OUR CHANGING ART EDUCATION. Columbus, Ohio: Keram-
ic Studio Publishing Co., 1934. 93 p. Illus.

Art education seen in relation to the child-centered curriculum
and the social and economic conditions of the mid-1930s.

Pearce, Jane, and Newton, Saul. THE CONDITIONS FOR HUMAN GROWTH.
New York: Citadel Press, 1969. 467 p. Index. Paper.

The authors' theories of personality structure, psychic growth,
creativity, communication, and validation are of much interest to
teachers.

Pearson, Ralph M. THE NEW ART EDUCATION. 2d rev. ed. New York:
Harper & Brothers, Publishers, 1953. 272 p. Illus. Index. Biblio.

The author's ideas about art teaching grew out of his workshop at
the New School for Social Research in the 1930s. He stresses an
emotional approach to art as opposed to an intellectual one. The
book is an earnest argument for the place of art in life and edu-
cation, and that the art teacher must be an artist as well as a
teacher.

Perkins, Charles Callahan. ART EDUCATION IN AMERICA. Cambridge,
Mass.: Riverside Press, 1870. 21 p.

This paper was given before the American Social Science Associa-
tion at the Lowell Institute in Boston on February 22, 1870.

Petrie, Marie Zimmern. ART AND REGENERATION. London: Paul Elek,
1946. 142 p. Illus., part color. Index. Biblio.

The author relies heavily upon art as a kind of general spiritual
therapy in this book.

Pierce, Anne E., and Hilpert, Robert S. INSTRUCTION IN MUSIC AND ART.
Bulletin no. 17, Monograph no. 25. Washington, D.C.: Government Printing
Office, 1933. 68 p. Paper.

This bulletin reports on a number of schools with exemplary art pro-
grams. Measurement and research are also discussed.

Piper, David Warren, ed. READINGS IN ART AND DESIGN EDUCATION. 2 vols. London: Davis-Poynter, 1973. 374 p. Illus.

See entry on p. 130.

Poore, Henry Rankin. ART'S PLACE IN EDUCATION. New York: G.P. Putnam's Sons, 1937. 236 p. Index.

A philosophical discussion of art in the life of man.

Pope, Arthur. ART, ARTIST, AND LAYMAN: A STUDY OF THE TEACHING OF THE VISUAL ARTS. Cambridge, Mass.: Harvard University Press, 1937. 152 p.

Pope discusses educating the artist and the layman from elementary school through graduate university work. In an appendix, he explains what he means by teaching the theory of space arts.

Pound, Ezra Loomis. PATRI MIA. Chicago: Ralph Fletcher Seymour, Publisher, 1950. 97 p.

An early essay in which Pound expresses optimism and hope for education in the arts in America.

Poynter, Edward John. TEN LECTURES ON ART. 2d ed. London: Chapman and Hall, 1880. 281 p.

The author says it's easier to write about art than to practice it. Of the ten pieces here, two are about art education--"Systems of Art Education" and "The Training of Art Students."

PRANG ART EDUCATIONAL PAPERS. Nos. 2-5. Boston: Prang Educational Co., 1896.

No. 2. ART IN THE SCHOOLROOM: PICTURES AND THEIR INFLUENCE, by Rose Turner and others.

No. 3. THE PRINCIPLES OF THE KINDERGARTEN, by M.D. Hicks.

No. 4. THE ART IDEA IN EDUCATION AND IN PRACTICAL LIFE, by J.S. Clark.

No. 5. SOME VITAL PRINCIPLES IN EDUCATION, by J.S. Clark.

Rank, Otto. ART AND ARTIST: CREATIVE URGE AND PERSONALITY DEVELOPMENT. Translated by Charles Francis Atkinson. Preface by Ludwig Lewisohn. New York: Agathon Press, 1968. 431 p. Illus. Biblio.

Read, Sir Herbert Edward. ART AND SOCIETY. 1936. Reprint. New York: Schocken Books, 1966. 282 p. Illus. Index.

As well as discussing art as magic and mysticism, in religion and

secular life, and as a psychological unconscious drive, the author also writes about education in art. Among other topics, he discusses the gifted child and Plato's theories.

_____. ART AS A UNIFYING PRINCIPLE IN EDUCATION. Berkeley and Los Angeles: University of California Extension Media Center, 1965. Phonotape, 48 min.

_____. CULTURE AND EDUCATION IN WORLD ORDER. New York: Museum of Modern Art for the Committee on Art Education, 1948. 14 p. Paper.

An address concerned with moral education given to the Committee on Art Education at its sixth annual conference. in 1948.

_____. THE EDUCATION OF FREE MEN. London: Freedom Press, 1944. 32 p. Paper.

Read sees freedom in education coming through discipline, and sees art as the discipline and core of education.

_____. EDUCATION THROUGH ART. 1943. Reprint. London: Faber and Faber, 1970. 320 p. Illus., some color. Index. Biblio. Paper.

The thesis of this major book in the field of art education is that art should be the basis of all education. There is a section on environment. Also discusses the creative abilities of individuals from the earliest years to late adolescence.

_____. THE FORMS OF THINGS UNKNOWN. London: Faber and Faber, 1960. 102 p.

_____. THE GRASS ROOTS OF ART. New York: Wittenbom, Schultz, 1949. 92 p. Illus. Paper.

Four essays (one entitled "The Aesthetic Method of Education") delivered at Yale in 1946.

_____. ICON AND IDEA: THE FUNCTION OF ART IN THE DEVELOPMENT OF HUMAN CONSCIOUSNESS. London: Faber and Faber, 1955. 98 p.

Essays about the author's idea that art symbolism is related to historical background.

_____. THE MEANING OF ART. London: Faber and Faber, 1936. Reprint. New York: Pittman, 1951. 134 p.

A guide to art and artists from primitive through modern times, with an emphasis on the creative process.

_____. PINTURE D'ENFANTS ANGLAIS: PREFACE TO AN EXHIBITION OF THE BRITISH COUNCIL. Perpignon: Union Nationale des Intellectuels, 1945. 33 p.

> Emphasis is given to the fact that pictures by children present no national identities, but are concerned with universal characteristics, free from social and academic standards.

_____. PRESIDENTIAL ADDRESS TO THE FOURTH GENERAL ASSEMBLY OF THE INTERNATIONAL SOCIETY FOR EDUCATION THROUGH ART. Montreal: International Society for Education Through Art, 1963. Unpaged.

_____. THE REDEMPTION OF THE ROBOT: MY ENCOUNTER WITH EDUCATION THROUGH ART. New York: Trident Press, 1966. 254 p.

> Read urges that we pursue education through art not as another subject to be learned, but as a method of aesthetic education in all subjects.

_____. (1) THE SIGNIFICANCE OF CHILDREN'S ART AND (2) ART AS SYMBOLIC LANGUAGE. Vancouver: University of British Columbia, 1957. 162 p.

_____. TO HELL WITH CULTURE: AND OTHER ESSAYS ON ART AND SOCIETY. New York: Schocken Books, 1965. 193 p. Paper.

> Fifteen essays written over a period of several years analyzing popular culture.

Reynolds, Sir Joshua. A DISCOURSE DELIVERED TO THE STUDENTS OF THE ROYAL ACADEMY. London: Thomas Davies, 1769. 23 p. Paper.

> Reynolds advises young painters to compare their work to the best artists of the past.

_____. DISCOURSE DELIVERED TO THE STUDENTS OF THE ROYAL ACADEMY. London: Thomas Cadell, Printer, 1784. 32 p. Paper.

> Reynolds' text was that it takes discipline and dedication to be an artist.

Richardson, Marion Elaine. ART AND THE CHILD. Introduction by Sir Kenneth Clark. London: University of London Press, 1948. 88 p. Illus., some color. Index.

> In this charmingly written personal reminiscence about teaching art, the author discusses her childhood influences, her work in schools and prisons, and the London County Council as well as other topics related to art education.

Rubin, Louis J., ed. FACTS AND FEELINGS IN THE CLASSROOM. New York: Viking Press, 1974. 288 p. Paper.

> Essays by educators which suggest that one thing wrong with American education is a neglect of the emotional lives and needs of children.

Rugg, Harold F. CULTURE AND EDUCATION IN AMERICA. New York: Harcourt, Brace Co., 1931. 243 p.

Rusk, William Sener, ed. METHODS OF TEACHING THE FINE ARTS. Chapel Hill: University of North Carolina Press, 1935. 220 p.

> Essays by twelve art educators about art teaching from primary through graduate school.

Russell, Mabel, and Gwynne, Elsie Wilson. ART EDUCATION FOR DAILY LIVING. Peoria, Ill.: Manual Arts Press, 1946. 248 p. Illus. Biblio.

> Directed at home economics college teachers and students, this book discusses the elements of art in relation to the home, and art education methods. There are chapters on color used in dress, and classes for boys. The book was originally published as ART TRAINING THROUGH HOME PROBLEMS, in 1933.

_____. ILLUSTRATIONS FOR ART TRAINING THROUGH HOME PROBLEMS. Peoria, Ill.: Manual Arts Press, 1935. 20 p. Illus., some color.

> Illustrative material prepared for use with the authors' book ART TRAINING THROUGH HOME PROBLEMS.

Saarinen, Eliel. SEARCH FOR FORM. New York: Reinhold Publishing Co., 1948. 354 p.

> A personal analysis of modern art forms with a chapter on art education which includes a section on the objectives of art education.

Sawer, Daisy D. ART IN DAILY LIFE FOR YOUNG AND OLD. New York: Charles Scribner's Sons, 1935. 192 p. Illus., some color. Index.

> Written with an eye to history, the author discusses drawing, pottery, casting, and design in the schools. Emphasis is on drawing.

Schafer-Simmern, Henry W. CREATIVE ART EDUCATION. New York: Nierndorf Galleries, n.d. 11 p. Illus. Paper.

> There is a short art education essay in this catalogue of an exhibition of Schafer-Simmern's students' work.

_____ . THE UNFOLDING OF ARTISTIC ACTIVITY: ITS BASIS, PROCESSES, AND IMPLICATIONS. Berkeley and Los Angeles: University of California Press, 1961. 201 p. Illus.

> A clearly-written book about creativity and the healing power of art. The author discusses the human need for creative expression and describes working with mental patients, delinquents, refugees, and business and professional people.

Schorr, Justin. ASPECTS OF ART. South Brunswick, N.Y.: A.S. Barnes and Co., 1967. 162 p. Illus. Index. Biblio, pp. 156-60.

> In this book about "being an artist," the author deals with the education of the painter and other areas of art that form an artist's life.

Schultz, Larry T. STUDIO ART: A RESOURCE FOR ARTIST-TEACHERS. New York: Van Nostrand Reinhold Co., 1973. 103 p. Illus.

> See entry on p. 216.

Schwartz, Fred. STRUCTURE AND POTENTIAL IN ART EDUCATION. Waltham, Mass.: Ginn-Blaisdell, 1970. 414 p. Illus. Index. Biblio.

Silverman, Ronald H. ALL ABOUT ART. Washington, D.C.: Office of Education, 1967. 76 p.

_____ . A SYLLABUS FOR ART EDUCATION. Los Angeles: The Foundation, California State University, 1972. 236 p. Biblio.

> This syllabus is both an introduction to and an outline of the theory and practice of art education. There are sections about the history of art education, social and psychological factors, measurement and evaluation, teaching plans, ideas and materials sources, and several bibliographies.

Sloan, A. Antolin. PICTORIAL EXPRESSION IN SCHOOLS. London: Sir Isaac Pitman & Sons, 1953. 64 p. Illus. Biblio.

> Humanistic and psychological in its approach to picture making in school, this book contains chapters about inspiration, children's representation of form, color, and design, and figure drawing as well as an interesting discussion of visual and nonvisual experiences.

Sloan, John. GIST OF ART: PRINCIPLES AND PRACTICE EXPOUNDED IN THE CLASSROOM AND STUDIO, RECORDED WITH THE ASSISTANCE OF HELEN FARR. 2d ed. New York: American Artists Group, 1944. 346 p. Illus., with reproductions of Sloan's painting, part color.

> The first of a series of books undertaken by the American Artists Group about contemporary American art. The authors of the various ous books in the series were to be, whenever possible, the artists

themselves. Here Sloan presents his ideas about life, art, and teaching. His practical advice to the young artist is much out of jibe with today's art world.

Sloane, Joseph C., ed. PROCEEDINGS OF THE FIRST NATIONAL CONFER-ENCE ON THE ARTS IN EDUCATION SPONSORED BY THE NATIONAL COUNCIL OF THE ARTS IN EDUCATION. Cleveland, Ohio: Case Institute of Technology, 1962. 76 p. Paper.

An account of the conference proceedings including papers deliv-ered about the various arts and their roles in education. Topics ranged from "Art in Russia" to scholarship and art.

Smith, Bernard William, ed. UNESCO SEMINAR ON THE ROLE OF THE VISUAL ARTS IN EDUCATION. Introduction by Herbert Read. Melbourne, Australia: Melbourne Press, 1954. 98 p. Illus. Bibliographical footnotes.

Smith, Ralph Alexander, ed. AESTHETIC CONCEPTS AND EDUCATION. Ur-bana: University of Illinois Press, 1970. 445 p.

Articles by Beardsley, Broudy, Sparshott, and others about aesthetic concepts in education such as metaphor, style, intention, and play.

_____. AESTHETICS AND CRITICISM IN ART EDUCATION: PROBLEMS IN DEFINING, EXPLAINING, AND EVALUATING ART. Chicago: Rand McNally & Co., 1966. 513 p. Biblio., pp. 493-501. Paper.

A series of essays toward a definition of art education without an art educator in the lot. There is a section on film.

_____. AESTHETICS AND PROBLEMS OF EDUCATION. Urbana: University of Illinois Press, 1971. 581 p. Biblio.

Includes papers from "The Journal of Aesthetic Education" about curriculum design and the aim of aesthetic education.

Smith, Walter. ART EDUCATION: SCHOLASTIC AND INDUSTRIAL. Boston: James B. Osgood & Co., 1872. 398 p. Illus., some color. Index.

Discusses art teaching, art schools (presenting floor plans in some cases), management of schools, and art methods.

Sparkes, Roy. TEACHING ART BASICS. New York: Watson-Guptill Publica-tions, 1973. 96 p. Illus., some color. Biblio., pp. 90-92.

Suggestions on the teaching of art concepts (line, form, color, pattern, etc.) to children.

Steveni, Michael. ART AND EDUCATION. New York: Atherton Press, 1968; London: Batsford, 1968. Illus. Index. Biblio.

Steveni discusses the history of art education, child art, creativity, materials, and teaching methods.

Stickler, Fred. AN ART APPROACH TO EDUCATION. New York: A.G. Seiler Publishing Co., 1941. 216 p.

See entry on p. 122.

Stimson, John Ward. THE GATE BEAUTIFUL: BEING PRINCIPLES AND METHODS IN VITAL ART EDUCATION. Trenton, N.J.: Albert Brandt Publisher, 1921. 42 p. Illus., some color.

"Inspirational" art education.

_____. PRINCIPLES AND METHODS IN VITAL ART EDUCATION. 5th ed. New York: Lotus Press, 1899. Unpaged. Illus.

A plea for a more substantial art education based on "Beauty."

Tannahill, Sallie Belle. FINE ARTS FOR PUBLIC SCHOOL ADMINISTRATORS. New York: Teachers College, Columbia University, 1932. 145 p. Illus. Biblio.

A general discussion of the purpose of art in the school, followed by the problems of the elementary school, the junior high school, and the senior high school.

TEACHING OF ART IN PRIMARY AND SECONDARY SCHOOLS. Geneva, Switzerland: International Bureau of Education, 1955. 312 p.

A comparative art education study which discusses teaching methods and materials, teacher training, curriculum, and other topics in sixty-five countries.

U.S. Board for Vocational Education. THE TEACHING OF ART RELATED TO THE HOME. Washington, D.C.: Government Printing Office, 1931. 87 p. Index. Biblio. Paper.

Suggested teaching methods and course content for home economics art classes.

University of London Institute of Education. STUDIES IN EDUCATION: THE ARTS AND CURRENT TENDENCIES IN EDUCATION. London: 1963. 153 p. Index.

Essays about music, literature, painting, movement, drama, and crafts by people in the field, including Seonaid Robertson who writes about children and crafts.

Volk, Douglas. ART INSTRUCTION IN THE PUBLIC SCHOOL. Ethical Cultural Educational Pamphlets, no. 1. New York: Working-Man's School, 1895. 15 p. Paper.

The object of art education is seen by the author as developing a
love of beauty.

Whipple, Guy Montrose, ed. ART IN AMERICAN LIFE AND EDUCATION:
THE FORTIETH YEARBOOK OF THE NATIONAL SOCIETY FOR THE STUDY OF
EDUCATION. Introduction by Thomas Munro. Bloomfield, Ill.: Public School
Publishing Co., 1941. 819 p. Biblio.

An encyclopedic book about art education by leaders in the field
--Ziegfeld, Cheney, Munro, Faulkner, Farnum, Moholy-Nagy,
Gregg, and others.

Whitford, William Garrison. AN INTRODUCTION TO ART EDUCATION. 2d
ed. New York: D. Appleton & Co., 1937. 337 p. Index. Biblio.

Intended as a college art education text, this book presents a his-
tory of art education in the United States. Discusses trends in
art education, courses of study in elementary and high schools,
supervision, museums, art testing, and research. The author in-
cludes industrial art as well as fine art.

Wickiser, Ralph Lewanda. AN INTRODUCTION TO ART ACTIVITIES. New
York: Henry Holt & Co., 1947. 275 p. Illus., part color.

_____. AN INTRODUCTION TO ART EDUCATION. Yonkers-on-Hudson,
N.Y.: World Book Co., 1957. 342 p. Illus., some color. Index.

Written primarily for beginning teachers, this book combines theory
and practices. Discusses the role of art in education; the nature
of an art experience; and planning, guiding, and developing ele-
mentary and secondary school art experiences.

Wiest, Donald K. THE FOURTH "R": ART, THE VISUAL LANGUAGE. Edu-
cational Research Service Bulletin, no. 5. Laramie: College of Education,
University of Wyoming, 1949. 26 p. Illus. Paper.

Wilenski, Reginald Howard. THE STUDY OF ART. London: Faber & Faber,
1934. 236 p. Index.

The author tells us what he thinks happens when an artist creates,
what happens when the layman views the work, and the implica-
tions for education of those two events. Examined are style, cri-
ticism, and writing about art.

Winslow, Leon Loyal. ORGANIZATION AND TEACHING OF ART: A PRO-
GRAM FOR ART EDUCATION IN THE SCHOOLS. Rev. ed. Baltimore,
Md.: Warwick & York, 1928. 243 p.

The author discusses why art should be part of the elementary and

secondary school curriculum, and makes suggestions concerning class-
room decoration. Includes a chapter devoted to industrial arts.

Wolff, Robert Jay. ESSAYS ON ART AND LEARNING. New York: Gross-
man Publishers, 1971. 100 p.

Essays about teaching art written over a number of years by one of
the first teachers at the School of Design in Chicago.

Wyman, Jenifer D., and Gordon, Stephen F. PRIMER OF PERCEPTION. New
York: Van Nostrand Reinhold Co., 1967. 87 p.

Yochim, Louise Dunn. BUILDING HUMAN RELATIONSHIPS THROUGH ART.
Chicago: L.M. Stein, Publishers, 1954. 157 p. Illus. Biblio.

A series of case studies describing emotional development through
art.

Zaidenberg, Arthur. YOUR CHILD IS AN ARTIST. New York: Grosset &
Dunlop Publishers, 1949. 192 p.

Chapters on writing and play, as well as color, composition, and
teaching tips.

Ziegfeld, Edwin, and Smith, Mary Elinore. ART FOR DAILY LIVING: THE
STORY OF THE OWATONNA ART EDUCATION PROJECT. Minneapolis: Uni-
versity of Minnesota Press, 1944. 155 p. Biblio., pp. 154-55.

A description of the five-year Owatonna Art Education Project
which was an attempt to find new materials and methods for art
education in the schools, and to develop a closer relationship
between the schools and community.

Chapter 7

EARLY CHILDHOOD PHILOSOPHY AND METHODS

Alschuler, Rose H., and Hattwick, La Berta Weiss. PAINTING AND PERSON-
ALITY: A STUDY OF YOUNG CHILDREN. 2 vols. Chicago: University of
Chicago Press, 1947. 290 p. Illus.

> A valuable, almost exhaustive, study of the art work of 150 children
> between the ages of 2 and 5 1/2 years in normal school settings.
> The investigators studied the children's choice of materials and their
> behavior during usage to help understand the significance of the fi-
> nal product to the child and something of the educative changes
> occurring while the child worked. The study demonstrates that
> children express in painting their emotional experiences, feelings,
> and ideas that they are not yet ready to convey in words.

> Volume 1 lays a basis for understanding children's creative work
> and discusses the significance of color, line, form, and space.
> Volume 2 contains a biography of each child and quantitative data
> and interpretative summaries.

American Institute of Child Life. THE PICTURE HOUR IN THE HOME. Phila-
delphia: n.d. 16 p. Biblio. Paper.

> Stories for mothers to tell their children about pictures.

Bland, Jane Cooper. ART OF THE YOUNG CHILD: 3 to 5 YEARS. New
York: Museum of Modern Art, 1957. 47 p. Illus., some color.

> Addressed to teachers and parents of preschool children, this book
> explores creative expression as an important aspect of child growth.
> The author discusses the child's first art experience and what to
> expect from him at ages three, four, and five; how children create
> and how adults can help, as well as materials and work space. The
> book grew out of the author's experiences at the Museum of Modern
> Art People's Art Center.

Cherry, Clare. CREATIVE ART FOR THE DEVELOPING CHILD: A TEACHER'S
HANDBOOK FOR EARLY CHILDHOOD EDUCATION. Photographs by Samuel
A. Cherry. Belmont, Calif.: Fearon Publishers, 1972. 186 p. Illus. Paper.

A practical manual for conducting creative art activities to en-
hance the preschool child's physical, perceptual, and emotional
development. The author is interested in the role art plays in the
entire growth process of the child, and is also concerned with the
teacher's creative development. She discusses the qualities of a
creative arts program and gives suggestions. There is an interesting
section at the end of the book dealing with parties and movement.

Crandall, Joy M. EARLY TO LEARN. New York: Dodd, Mead & Co.,
1974. 128 p. Illus. Biblio.

Suggestions for physical creative activities to stimulate learning.

Dean, Joan. ART AND CRAFT IN THE PRIMARY SCHOOL TODAY. London:
A & C Black, 1968. 192 p. Illus. Index. Biblio., pp. 187-90.

The author begins with a discussion of why art is important and
the teacher's task. She then explains the development of primary
children's work and discusses a variety of media to use with them.

Downey, Douglas W., and Wisiol, Karin. THINGS TO MAKE AND DO.
Chicago: Standard Educational Corp., 1974. 192 p. Illus., some color.
Index.

Edmonds, Ursula Margaret, and Waterfall, Edith A. PRACTICAL AND ARTISTIC
ACTIVITIES IN THE SCHOOLS: THEIR FUNCTION, PSYCHOLOGICAL BASIS
AND PRACTICE. London: George Allen & Unwin, 1931. 211 p. Index.
Biblio.

A discussion of art as central to the life and education of the
young child.

Eisner, Elliot. TEACHING ART TO THE YOUNG. Stanford, Calif.: Stanford
University, 1969. 139 p.

Farnworth, Warren. FIRST ART. London: Evans Brothers, 1973. 112 p. Illus.

The author discusses child development, the importance of play,
and why and how to use art media with youngsters.

Gaitskell, Charles Dudley, and Gaitskell, Margaret R. ART EDUCATION IN
THE KINDERGARTEN. Peoria, Ill.: Chas. A. Bennett Co., 1962. 40 p.
Paper.

Based on an examination of the kindergarten art education programs
in the province of Ontario, this book is a digest of the research
report and presents an outline of the most significant discoveries.
Topics included are: what a young child produces in art, how he
works, supplies and equipment needed, teacher's role, and how to
evaluate progress.

Gilbert, Dorothy. CAN I MAKE ONE? A CRAFT BOOK FOR THE PRE-SCHOOL CHILD. London: Faber & Faber Co., 1970. 55 p. Illus., diagrams.

See entry on p. 234.

Golomb, Claire. YOUNG CHILDREN'S SCULPTURE AND DRAWING: A STUDY IN REPRESENTATIONAL DEVELOPMENT. Foreword by Rudolph Arnheim. Cambridge, Mass.: Harvard University Press, 1974. 193 p. Illus. Index. Biblio.

The author is a psychologist who studied 300 children between the ages of two and seven. She presents her views about children's execution of the human figure in a three-dimensional medium and in drawing.

Griffiths, Roth. A STUDY OF IMAGINATION IN EARLY CHILDHOOD. London: Routledge & Kegan Paul, 1935. 176 p.

Herberholz, Barbara. EARLY CHILDHOOD ART. Dubuque, Iowa: William C. Brown Co., 1974. 174 p. Illus. Index. Biblio. Paper.

The author presents art tasks to develop the beginnings of art skills and attitudes in young children in this open, excellent book. Areas discussed are sources for the teacher, artistic behavior and development, photography, celebrations, as well as the usual painting and modelling.

Hicks, Mary Dana. THE PRINCIPLES OF THE KINDERGARTEN: THE FOUNDATION FOR ART EDUCATION IN THE PUBLIC SCHOOLS. Prang Art Educational Paper, no. 3. Boston: n.d. 24 p.

Hoover, Francis Louis. ART ACTIVITIES FOR THE VERY YOUNG, FROM 3 TO 6 YEARS. Worcester, Mass.: Davis Publications, 1966. 77 p. Illus.

Written for parents and teachers, this book contains teaching hints and suggests twenty—one projects and materials to use with three- to six-year-old children.

Horn, George F. EXPERIENCING ART IN KINDERGARTEN. Dallas, Tex.: Hendrick-Long Publishing Co., 1971. 48 p. Illus., some color. Paper.

Using the environment as stimulation for drawing, painting, print making, construction, and weaving with young children.

THE IDEA BOX. Washington, D.C.: National Association for the Education of Young Children, 1973. 290 p.

A set of five booklets containing art education suggestions for young children.

Jameson, Kenneth. PRE-SCHOOL AND INFANT ART. London: Studio Vista, 1968. 156 p. Illus., some color. Biblio., p. 154.

Kellogg, Rhoda. BABIES NEED FATHER TOO. New York: Comet Press, 1953. 256 p.

_____. NURSERY SCHOOL GUIDE. Boston: Houghton-Mifflin, 1949. xi, 501 p.

_____. WHAT CHILDREN SCRIBBLE AND WHY. San Francisco, Calif.: Golden Gate Nursery Schools, 1955. 137 p. Illus.

> From a study of 100,000 drawings and paintings the author noted scribbles that recurred most frequently and the sequence in which they occurred but has avoided discussing psychological meanings.

Lewis, Hilda Present, ed. ART FOR THE PREPRIMARY CHILD. Washington, D.C.: National Art Education Association, 1972. 172 p. Illus. Biblio.

> Nine articles about the young child's relation to the world; creative power in children; early education in the visual arts; presenting art materials effectively; the role of parent and teacher in encouraging art expression and other topics by early childhood art education specialists.

McIntyre, Barbara M. SOURCE BOOK OF SELECTED MATERIALS FOR EARLY CHILDHOOD EDUCATION IN THE ARTS. Washington, D.C.: Office of Education, Department of Health, Education and Welfare, 1969. 265 p. Biblio.

Perlstein, Ruth, ed. CRAFT IDEAS FOR PRESCHOOLERS: PAINT, PASTE AND PROJECTS. Annandale, Va.: Annadale Pre-School, 1971. 74 p.

> Instructional materials, curriculum suggestions, and art activities for preschool children.

Pile, Naomi F. ART EXPERIENCES FOR YOUNG CHILDREN. New York: Macmillan, 1973. 120 p. Illus., part color. Biblio. Paper.

> A book about painting, drawing, working with clay, and other art education activities for young children which grew out of the author's experience at the Bank Street College of Education. Pile introduces each medium, discusses presenting it to the children, and suggests ways to work and organize space. There is a section that discusses each age level in terms of child abilities and development.

Stephens, Ada Dawson. PROVIDING DEVELOPMENTAL EXPERIENCES FOR YOUNG CHILDREN. New York: Bureau of Publications, Teachers College, Columbia University, 1952. 107 p.

> A series of mini-case studies about the use of visual art, writing, music, and science with kindergarten and first grade children.

Chapter 8

ELEMENTARY PHILOSOPHY AND METHODS

Alkema, Chester Jay. ALKEMA'S COMPLETE GUIDE TO CREATIVE ART FOR YOUNG PEOPLE. New York: Sterling Publishing Co., 1971. 192 p. Index. Illus., part color.

> Deals with school trips and looking at nature through microscopes or magnifying glasses as motivation for art work in addition to discussing media for use in the elementary classroom.

Allen, Arthur Bruce. THE TEACHING OF ART TO INFANTS AND JUNIOR CHILDREN. New York and London: Fredrick Warne & Co., 1937. 113 p. Illus., some color.

> The author discusses using art in the education of children five to ten years old. There are suggestions for teachers about how to plan for lessons and organize classes.

Anderson, Warren H. ART LEARNING SITUATIONS FOR ELEMENTARY EDUCATION. Belmont, Calif.: Wadsworth Publishing Co., 1969. 181 p. Biblio., pp. 178-81. Illus. Paper.

> In this book directed to elementary classroom teachers, the author discusses sixteen behavioral objectives for art learning he feels are more or less universal and worth knowing. He emphasizes developing art related behavior, perceptual learning, and visual organization.

ART EDUCATION: ELEMENTARY. Washington, D.C.: National Art Education Association, 1972. 230 p.

> See entry on p. 91.

Ash, Beryl, and Rapaport, Barbara. CREATIVE WORK IN THE JUNIOR SCHOOL. London: Methuen & Co., 1957. 156 p. Biblio. Illus.

> The authors explore movement, music, language, textiles, pictures, and modelling as bases for early education. They also discuss physical and emotional characteristics of eight- to eleven-year olds; their interests and why it is important to build curricula around them; and lastly, the value of creative work.

Elementary Philosophy and Methods

Association for Childhood Education International. ART FOR CHILDREN'S GROWING. Washington, D.C.: 1955. 48 p. Illus. Paper.

> Short articles by art educators (including Barkan, Jackson, and Mendelowitz) about the value of art in education, children's maturation sequences, the art consultant, and evaluation of child growth through art education.

_____. ART FOR TODAY'S CHILD. Washington, D.C.: 1935. 32 p. Biblio. Illus. Paper.

> Essays about the role of art in kindergarten and elementary school, and a plea for a greater degree of self-expression.

_____. ART GUIDE: LET'S MAKE A PICTURE. Washington, D.C.: 1969. 76 p. Biblio. Illus., some color. Paper.

> Teaching hints about two dimensional work using a variety of media.

_____. THE ARTS AND CHILDREN'S LIVING. Washington, D.C.: 1945. 28 p. Paper.

> A series of short and mostly inspirational articles about art in education for the most part by art educators associated with Teachers College, Columbia University.

Bannon, Laura. MIND YOUR CHILD'S ART: A GUIDE FOR PARENTS AND TEACHERS. New York: Pelligrini & Cudahy, 1952. 62 p. Illus., some color.

> The author speaks directly to her reader in a conversational tone about children and their art work. Included are photographs of children's drawings and paintings and comments about each.

Barkan, Manual. THROUGH ART TO CREATIVITY: ART IN THE ELEMENTARY SCHOOL PROGRAM. Boston: Allyn and Bacon, 1960. 365 p. Illus.

> Directed at beginning teachers, this beautifully written book consists of clear, cognitive records of discussions between teachers and children, tape recorded and photographed in their classrooms. Following each is an analysis of the children's art work, content the teacher gave the children, and her use of time, classroom space, and equipment. Included are practical suggestions about equipment use and classroom management as well as a discussion of what constitutes good art teaching.

Berry, Ava. ART FOR CHILDREN. London: Studio Publications, 1934. 124 p. Illus.

Boas, Belle. ART IN THE SCHOOL. Garden City, N.Y.: Doubleday, Page & Co., 1927. 128 p. Illus. Index. Biblio.

> A record of art teaching in the Horace Mann School, Teachers College, Columbia University, which was based on Arthur Wesley Dow's theories. There is a discussion of the purpose of teaching art to children and the function of a teacher as well as sections about design elements and principles, color, subject matter for lessons, how to prepare a course of study, art appreciation, and the use of museums.

Bonser, Frederick G., and Mossman, Lois C. INDUSTRIAL ARTS FOR ELEMENTARY SCHOOLS. New York: Macmillan, 1923. 491 p. Illus.

> The purpose and subject matter of industrial arts, with a brief history of the use of industrial arts materials in the school.

Bowerfind, Ibby Hallam. LET'S MAKE A PICTURE. Washington, D.C.: Association for Childhood Education International, 1969. 160 p. Illus.

> Art activities stressing individual expression for children and teaching suggestions for teachers.

Brearley, Molly, et al. THE TEACHING OF YOUNG CHILDREN. New York: Schocken Books, 1970. 192 p. Illus. Index. Biblio. Glossary.

> Written by a group chaired by Molly Brearley, this book discusses and reports on some applications of Piaget's learning theory. The section on art deals with expression and representation.

Browne, Sibyl, et al. ART AND MATERIALS FOR THE SCHOOLS: ACTIVITIES TO AID THE WAR AND THE PEACE. New York: Progressive Education Association, 1943. 112 p. Biblio. Paper.

> The activities described in this book (work with plastics, map-making, flight, photograms, weaving, etc.) are based on the author's belief that the post-World War II world would be a global community. It is a clearly written book, and the author attempts to integrate art with other subjects.

Burnham, Jack. THE STRUCTURE OF ART. New York: George Braziller, 1971. 195 p. Index. Biblio. Illus.

> The essay about Jean Piaget's ideas of the way children learn should be of interest to classroom teachers and art educators.

Cacace, Philip Cecil. THE TEACHING OF ART AND CRAFTS IN PRIMARY SCHOOLS. London and New York: Macmillan, 1962. 95 p. Illus.

Caucutt, Allen, ed. FOCUS: ELEMENTARY ART EDUCATION. Reston, Va.: National Art Education Association, 1975. 96 p. Illus.

> Nineteen articles, many from ART TEACHER, about art and open education; self-concept; perceptual experiences in the kindergarten; painting and poetry; and other topics.

Christensen, Fred. RECIPES FOR CREATIVE ART. New York: Creative Teaching Press, 1967. 50 p.

> A collection of basic ideas on cards for promoting art expression in the classroom.

Christ-Janer, Albert. ART IN CHILD LIFE. Iowa City: University of Iowa, 1939. 14 p. Paper.

Cole, Natalie Robinson. THE ARTS IN THE CLASSROOM. New York: John Day Co., 1940. 137 p. Illus.

> An account of the author's teaching techniques in "firing" children to creative work. In addition to painting, clay work, design, and block printing, she discusses movement and creative writing with children.

_____. CHILDREN'S ARTS FROM DEEP DOWN INSIDE. New York: John Day Co., 1966. 210 p. Illus.

> The author states her purpose in this book is to ". . . give psychological stimulus and provide a simple means of bridging the gulf between the creative philosophy in the mind of the teacher and the children in the classroom." She does so by describing what happens in the classroom when she works with line, color, clay, and dancing. In addition, there are sections about using the flag as motivation, the environment, and "Our Secret Crimes." Normal and low I.Q. children from six to ten years old are the central focus.

Conrad, George. THE PROCESS OF ART EDUCATION IN THE ELEMENTARY SCHOOL. Englewood Cliffs, N.J.: Prentice-Hall, 1964. 296 p. Index. Biblio. Illus., some color.

> The author takes as his thesis that art can invigorate the whole process of learning. He deals with why art is an important part of the elementary school curriculum; the history of art in schools; and attempts to define art education and describe how it works. The appendices are meant to serve as teacher guides to evaluation and record-keeping.

Craig, Jennie E. CREATIVE ART ACTIVITIES: A HANDBOOK FOR THE ELE-
MENTARY TEACHER. Scranton, Pa.: International Textbook Co., 1967. 302 p.
Biblio. Illus.

> Writing for the elementary classroom teacher, the author discusses
> the purpose of art in education and presents clear directions on
> how to go about many different kinds of art activities with chil-
> dren.

Crofton, Kathleen, and Denty, Margaret. SOURCES OF INSPIRATION. Lon-
don: Educational Supply Association, 1955. 14 p. Illus., drawings. Paper.

> Aesthetic education through looking at and using objects from
> nature.

D'Amico, Victor Edmund. CREATIVE TEACHING IN ART. Rev. ed. Scranton,
Pa.: International Textbook Co., 1953. 257 p. Index. Illus.

> The author sees the child as an artist and art as a means of his
> education. He discusses the child as an inventor, painter, sculp-
> tor, potter, craftsman, designer, and graphic artist. Also discusses
> the child's relationship to materials and tools as an aid to expres-
> sion at various ages.

_____. DEVELOPING CREATIVE CHILDREN FOR A CREATIVE WORLD. Berkeley
and Los Angeles: University of California Extension Media Center, 1965. Phonotape.

D'Amico, Victor Edmund; Wilson, Frances; and Maser, Moreen. ART FOR THE
FAMILY. New York: Museum of Modern Art, 1954. 110 p. Index. Illus.

> Discusses art activities, such as painting, construction, and mobiles
> to use with children. Part of the book is written for children and
> all activities are things parents and children can do together.

Dean, Joan. ARTS AND CRAFTS IN THE ELEMENTARY SCHOOL. New York:
Philosophical Library, 1963. 184 p. Index. Illus.

> The author discusses ideas central to art education: why teach art,
> the characteristics of elementary school children, and ways of work-
> ing with the usual kinds of media. Included are chapters on book-
> craft, classroom decorations, and planning for teaching.

Dewey, John. THE ELEMENTARY SCHOOL RECORD NO. 1: ART. Chicago:
University of Chicago Press, 1900. 30 p. Illus. Paper.

> This first of nine monographs edited by John Dewey stresses the
> development of imagination and self-expression in terms of the
> civic life of children. One of the art activities reported was a
> raft made of branches.

Dimondstein, Geraldine. EXPLORING THE ARTS WITH CHILDREN. New York: Macmillan, 1974. 320 p. Index. Biblio. Illus., some color.

> A book about using painting, sculpture, poetry, and dance to help teachers as well as children exercise their sensory perceptions and creativity. The author is concerned with arts education and she describes the interplay of cognitive and affective learning.

Dobbs, Ella Victoria. FIRST STEPS IN ART AND HANDWORK. New York: Macmillan, 1932. 242 p. Index. Biblio. Illus.

> The author defines art education, explains why it is an important aspect of the curriculum and discusses many activities to do and ways to work with children. Included are food preparation, dramatics, and bookmaking in addition to other more expected art education activities.

Dunnett, Ruth. ART AND CHILD PERSONALITY. London: Methuen & Co., 1948. 72 p. Illus., some color.

> An essay describing teaching art to boys in an evacuation camp in England during World War II.

Erdt, Margaret Hamilton. TEACHING ART IN THE ELEMENTARY SCHOOL: CHILD GROWTH THROUGH ART EXPERIENCES. New York: Rinehart and Co., 1956. 284 p. Index. Biblio. Illus.

> There are sections on finding and using materials, relating art to other subject areas, working with groups, and community involvement in this art education book written for kindergarten and elementary teachers. There are suggestions for reader participation projects after each chapter.

Federated Council on Art Education. REPORT OF THE COMMITTEE ON ELEMENTARY SCHOOL ART. Washington, D.C.: 1926. 32 p. Paper.

> The committee made up of ten art educators from across the country formulated general objectives of art education for the elementary school child and collected data on time allotted to art in the schools. Includes a brief historical sketch by William G. Whitford.

Gailer, Lionel, and Porter, Jim. LIVING WITH ART. New York: McGraw-Hill Book Co., 1973. 163 p. Index. Biblio. Illus.

> Presents the artist and his environment in light of the way children work, the role of the teacher, media, and technique.

Gaitskell, Charles Dudley. ART AND CRAFTS IN OUR SCHOOLS. Peoria, Ill.: Chas. A. Bennett Co., 1949. 62 p. Biblio. Illus.

> Outlines a basic philosophy of art education, discusses arts and

crafts as a part of general education and as an element in child development. One chapter deals with group activities and another is concerned with evaluation of the teacher's performance and the child's art work. Little attempt has been made to present information about art techniques for teacher use.

_____. CHILDREN AND THEIR ART: METHODS FOR THE ELEMENTARY SCHOOL. New York: Harcourt, Brace and Co., 1958. 446 p. Index. Biblio. Illus., some color.

The author presents art-teaching methods and ideas about art education developed over twenty-five years of teaching and supervising. He discusses teacher growth, methods, new developments in art education, the place of art in the general school program, and other topics related to the field.

_____. CHILDREN AND THEIR PICTURES. Toronto: Ryerson Press, 1951. 16 p. Illus. Paper.

Originally a film script for "Creative Hands," this pamphlet is a statement about the nature of picture making in the classroom and the role of the teacher. It is directed to the general classroom teacher.

Gaitskell, Charles Dudley, and Hurwitz, Al. CHILDREN AND THEIR ART: METHODS FOR THE ELEMENTARY SCHOOL. New York: Harcourt, Brace and World, 1970. 507 p. Biblio., pp. 485-96. Illus., part color.

An expanded and updated revision of an elementary art education standard, this book provides clear, practical treatment of professional theory and comprehensive coverage of classroom projects, art techniques, and teaching procedures. The authors discuss the foundations of contemporary art education, the nature of art, the history of art education, creativity, principles of design, teaching methods, psychology of child art, and how to plan and execute a school art program. There are chapters on the art of slow learners, gifted children, and group art activities. A new chapter describes how children use media (films, slides, projections) as art forms and there is an expanded chapter on criticism and art appreciation. The art activities presented have been revised and the new ones reflect more contemporary art trends. Transcripts of classroom sessions illustrate the handling of various teaching situations.

Gibbs, Evelyn. THE TEACHING OF ART IN SCHOOLS: AN ILLUSTRATED DESCRIPTION OF CHILDREN'S IMAGINATIVE PAINTING AND THE EFFECT ON CRAFT. London: Williams and Norgate, 1934. 78 p. Illus.

After a general discussion of children's art abilities, the author deals with the use of materials, crafts, applique, pattern-making, and lino block printing.

Gitter, Lena L. THE MONTESSORI APPROACH TO ART EDUCATION. Seattle, Wash.: Bernie Straub Publishing Co., 1973. 70 p. Illus.

Includes chapters about retardation and poverty.

Gordon, Ira J. CHILDREN'S VIEWS OF THEMSELVES. Washington, D.C.: Association for Childhood Education International, 1972. 40 p.

Children's concepts of themselves and how adults can help.

Green, Arthur S. CREATIVE ARTS AND CRAFTS ACTIVITIES. Minneapolis, Minn.: T.S. Denison & Co., 1960. 96 p. Illus.

Divided into three sections (child's experiences which form basis for art work, art materials, and art techniques) this book suggests seasonal and holiday art projects and categorizes them according to grade level.

Greenberg, Pearl. ART AND IDEAS FOR YOUNG PEOPLE. Photographs by Murray Greenberg. New York: Van Nostrand Reinhold Co., 1970. 152 p. Biblio. Illus., part color.

Discusses various techniques in several art forms including drawing and painting, glass, photography, graphics, textiles, yarns, and sculpture.

_____. CHILDREN'S EXPERIENCES IN ART. New York: Reinhold Publishing Co., 1966. 132 p. Illus., some color.

This book grew out of the author's experiences at New York City's Downtown Community School and in it she explores the relationship pf pupil, parent, and teacher, emphasizing the importance of communication. There are discussions and suggestions for and about student teachers, color, painting, the need for art and planning for it in the curriculum, and planning for trips. It is a well written, personal, lively book.

Gregg, Harold. ART FOR THE SCHOOLS OF AMERICA. Rev. ed. Scranton, Pa.: International Textbook Co., 1947. 203 p. Index. Biblio., pp. 184-86. Glossary. Illus., part color.

Writing for the classroom teacher, the author discusses values expected to result from art education and how to go about using art in the curriculum. His inspiration is nature rather than the city and his book is written for teachers in rural areas. Covers appreciation of art through doing art activities, sections on art techniques to use with children, integration, and planning.

Harrison, Elizabeth. SELF EXPRESSION THROUGH ART. Foreword by Charles D. Gaitskell. Peoria, Ill.: Chas. A. Bennett Co., 1951. 112 p. Illus.

A discussion of art teaching and how to assess children's pictures, with suggestions about how to organize an art program, plus a month-by-month guide of things to do in the art class.

Hart, Florence M. WHAT SHALL WE DO IN ART? Foreword by Charles D. Gaitskell. Maplewood, N.J.: C.S. Hammond & Co., 1957. 160 p. Illus., schematic drawings.

Some philosophy and many suggested activities for children includ-ing lettering and gesso work as well as the usual methods, such as crayon.

Hartman, Gertrude, and Shumaker, Ann, eds. CREATIVE EXPRESSION. Mil-waukee, Wis.: E.M. Hale and Co. for the Progressive Education Association, 1939. 350 p. Illus.

Contains a number of essays by people prominent in the field (Mar-garet Naumburg and Hugh Mearns, among others) dealing with child expression in art, music, literature, and drama.

Haupt, Dorothy, and Osborn, D. Keith. CREATIVE ACTIVITIES. Detroit: Merrill-Palmer School, 1955. 103 p. Illus., schematic drawings. Paper.

A resource manual for teachers which includes sections on rhythm instruments, nature study, and cooking as well as art activities. A number of recipes are presented for both food and art materials.

Heinze, Susi. ART TEACHING FOR UPPER PRIMARY SCHOOLS. Borneo: Borneo Literature Bureau, 1969. 61 p. Illus., part color. Biblio. Glossary. Paper.

No educational discussion but fascinating descriptions of craft works--a woven (raffia) ball, for instance.

Henderson, Anna W., and Palen, H.W. WHAT AND HOW: A SYSTEMA-TIZED COURSE OF HAND WORK. Springfield, Mass.: Milton Bradley Co., 1908. 159 p. Illus., some color.

Art related activities to do with children including "stick laying."

Herberholz, Donald W., and Herberholz, Barbara J. A CHILD'S PURSUIT OF ART: 110 MOTIVATIONS FOR DRAWING, PAINTING, AND MODELING. Dubuque, Iowa: Wm. C. Brown Publishers, 1967. 206 p. Illus. Paper.

The authors are concerned with motivation for creativity and self-expression primarily through body movement and use of the environ-ment in this exciting and useful book.

Hicks, Mary Dana. ART INSTRUCTION FOR CHILDREN IN PRIMARY SCHOOLS. Illustrated by Edith Clark Chadwick. Boston: Prang Educational Co., 1899. 79 p.

See entry on p. 221.

Horn, George F., and Smith, Grace Sands. EXPERIENCING ART IN THE
ELEMENTARY SCHOOL. Worcester, Mass.: Davis Publications, 1971. 240 p.
Illus., part color. Biblio. of books, films, reproductions, and magazines,
pp. 234-39. Glossary.

> A sequential program of art education for children ages six to
> eleven, this book begins with simple skills and progresses to the
> more complex. Activities presented are based on design and dis-
> cussed in relation to what to expect from children at various ages.
> There is also a chapter on classroom environment, and receipts and
> notes on materials.

Horne, Joicey M. THE ART CLASS IN ACTION: A COLLECTION OF TECH-
NICAL INFORMATION AND SUGGESTED ACTIVITIES FOR SCHOOLS. Toron-
to: Longmans, Green & Co., 1941. 136 p. Illus., diagrams. Index.

> Written particularly for rural teachers and with an emphasis on the
> use of cheap or scrap materials, this book contains general infor-
> mation about art elements for teacher self-instruction and suggests
> and explains classroom art activities in a clear intelligent manner.

_____. YOUNG ARTISTS: A HANDBOOK FOR TEACHERS AND PARENTS.
Toronto: Longmans, Green & Co., 1961. 274 p. Index. Biblio.

> The author discusses child development, educational resources,
> methodology, and suggests art activities to use with children in
> grades kindergarten through nine. There is a section about posters.

Hoyland, Michael. ART FOR CHILDREN: SCHOOLING IN THE MIDDLE
YEARS. London: Macmillan and Co., 1970. 128 p. Illus., part color.
Index. Biblio., pp. 120-22. Glossary.

> There is a section on the teacher's relationship to the school in
> this book about drawing, painting, printing, and working with
> clay and scrap material.

Ickis, Margaret, and Esh, Reba Selden. THE BOOK OF ARTS AND CRAFTS.
New York: Dover, 1954. 275 p.

> A book of low-budget, quick and long-term projects including toy
> making, gardening, and musical instrument making.

Jameson, Kenneth. ART AND THE YOUNG CHILD. Foreword by George Kaye.
New York: Viking Press, 1968. 155 p. Illus., part color. Biblio., pp. 154.

> Teaching art to five, six, and seven year olds.

_____. JUNIOR SCHOOL ART. London: Studio Vista, 1971. 144 p. Il-
lus. Index. Biblio.

The author concerns himself with art activities for ages seven through nine which he says are difficult years for the child. The activities presented for the most part are environmental and ones that occupy a child physically.

_____. PRIMARY SCHOOL ART. New York: Van Nostrand Reinhold Co., 1971. 144 p. Illus., some color. Index. Biblio.

For teachers of children seven to eleven years old, this book deals with the role of art in their lives and suggests many things to do.

Jefferson, Blanche Marie Waugaman. THE COLOR BOOK CRAZE. Washington, D.C.: Association for Childhood Education International, n.d. 18 p. Paper.

_____. TEACHING ART TO CHILDREN: CONTENT AND VIEWPOINT. 3d ed. Boston: Allyn and Bacon, 1969. 256 p. Illus., part color. Index. Biblio., pp. 247-50.

Directed to parents and teachers, this book emphasizes the relationship between art and art education and looks at the ways the child's background and personality determine his art. Included are case studies and discussions of methods and materials.

Keiler, Manfred L. ART IN THE SCHOOLROOM. Lincoln: University of Nebraska Press, 1951. 214 p. Illus.

Written for the classroom teacher, this book contains a discussion of art education and suggests art projects to use with children. There is a section about group work and another about holiday activities.

Kellogg, Rhoda. ANALYZING CHILDREN'S ART. Palo Alto, Calif.: National Press Books, 1969. 308 p. Index. Biblio.

The author discusses scribbling, how adults influence a child's work, and describes the child's mental development as he works in art.

Kellogg, Rhoda, and O'Dell, Scott. THE PSYCHOLOGY OF CHILDREN'S ART. New York: CRM Association for Random House, 1967. 112 p. Illus.

The authors suggest there is a similarity between the creative impulse and genealogical age.

Klimo, Joan Fincher. WHAT CAN I DO TODAY? New York: Random House, 1971. 58 p. Illus.

Painting, sculpture, pasting, and stitching activities for children.

Knudsen, Estelle H., and Christensen, Ethel M. CHILDREN'S ART EDUCA-
TION. Peoria, Ill.: Chas. A. Bennett Co., 1957. 208 p. Illus.

Based on the authors' classroom experiences, the book presents
models and suggests materials and ways of working for classroom
teachers. The chapter titled "Summing Up" is a valuable evalua-
tion checklist for a teacher.

Kranz, Stewart Duane, and Deley, Joseph. THE FOURTH "R"--ART FOR THE
URBAN SCHOOL. New York: Van Nostrand Reinhold Co., 1970. 116 p.
Illus., part color. Index. Biblio.

Written for elementary teachers with and without art background,
with and without space to work, with and without supplies and
equipment, this book suggests joyous things to do that help pro-
mote a sense of dignity and worth in urban children. There is a
photo essay on Chicago's "Wall of Respect."

Krinsky, Norman. ART FOR CITY CHILDREN. New York: Van Nostrand
Reinhold Co., 1970. 96 p. Illus.

Beautifully illustrated in brown ink with many pictures of children
working, this book suggests how lively and active the role of art
can be in a child's education. The author presents exciting and
sometimes unusual drawings, paintings, and three-dimensional activ-
ities for children.

Laliberte, Norman, and Kehl, Rickey. 100 WAYS TO HAVE FUN WITH AN
ALLIGATOR AND 100 OTHER INVOLVING ART PROJECTS. Blauvelt, N.Y.:
Art Education, 1969. 100 p. Illus. Paper.

Playful art ideas for teachers and children.

Landis, Mildred M. MEANINGFUL ART EDUCATION. Peoria, Ill.: Chas.
A. Bennett Co., 1951. 185 p. Illus. Index. Biblio.

The nature of creative expression and the development of art ex-
periences for children in terms of growth and development is
stressed in this book. Includes a section on visual readiness.
There are no project suggestions.

Lansing, Kenneth Melvin. ART, ARTISTS, AND ART EDUCATION. New York:
McGraw-Hill Book Co., 1969. 650 p. Illus., part color. Biblio.

Representing a blend of the philosophical and practical aspects of
art education, this book includes sections about the artist, the
student and the nature and value of art. The author describes
in behavioristic terms the objectives of art education, suitable
teaching processes, and recommends a curriculum. In addition
he discusses evaluation, art supervision in schools, and art edu-
cation research. The book is directed to elementary and junior
high school art teachers.

_____. ART, ARTISTS, AND ART EDUCATION. New York: McGraw-Hill Book Co., 1969. 100 2 x 2 slides, color, and 29-page manual.

Teachers' manual and slides for the textbook cited above.

_____. STUDY GUIDE FOR ART, ARTISTS, AND ART EDUCATION. New York: McGraw-Hill Book Co., 1969. 138 p. Illus. Paper.

Philosophical discussions and practical suggestions about art in school. The author discusses evaluation, supervision and research in addition to other areas central to art education.

Lemos, Pedro Joseph. THE ART TEACHER. Worcester, Mass.: Davis Publications, 1931. 491 p. Illus.

Art lessons for classroom teacher's use.

Lewis, Hilda Present. ART EDUCATION IN THE ELEMENTARY SCHOOL. Washington, D.C.: Association of Classroom Teachers of the National Education Association, 1961. 33 p. Biblio. Paper.

Based on research in the field, this pamphlet summarizes ideas about child art for the classroom teacher. Areas covered are the role of the teacher, how representation develops, what sort of child does well in art, evaluation, teaching art appreciation, and emotion and art.

_____, ed. CHILD ART--THE BEGINNINGS OF SELF-AFFIRMATION. Berkeley, Calif.: Diablo Press, 1966. 112 p.

Incorporates presentations by leading art educators (Sir Herbert Read, Rhoda Kellogg, Rudolf Arnheim, H. Schaffer-Simmern, Arno Stern, Frank Barron, Viktor Lowenfeld, Victor D'Amico, A. Heckscher) given at the Berkeley conference in May 1965.

Lidstone, John. DESIGN ACTIVITIES FOR THE ELEMENTARY CLASSROOM. Photographs by Roger Kerkham. Worcester, Mass.: Davis Publications, 1964. 48 p. Illus. Paper.

Visually attractive and easy to use, this book consists of a number of design projects to use with children including slides, blueprints, and see-through sculpture. The chronological sequence photographs that illustrate each activity add to the book's unique character.

_____. SELF EXPRESSION IN CLASSROOM ART. Worcester, Mass.: Davis Publications, 1967. 96 p. Illus. Paper.

Emphasizes materials as the logical core around which to build an art program. Creative techniques suitable for the classroom are illustrated in detail with the objective of helping the teacher move students from "idea" to "action."

Elementary Philosophy and Methods

Linderman, Earl W., and Herberholz, Donald W. DEVELOPING ARTISTIC
AND PERCEPTUAL AWARENESS: ART PRACTICE IN THE ELEMENTARY CLASS-
ROOM. 3d ed. Dubuque, Iowa: Wm. C. Brown Co., 1974. 102 p. Illus.
Index. Biblio.

> The authors discuss child development and readiness, evaluation,
> motivation, in-depth exploration with art materials, our art heri-
> tage, and organization for effective art teaching. They address
> themselves to Head Start and other preschool programs as well as
> to elementary school.

Linderman, Marlene M. ART IN THE ELEMENTARY SCHOOL: DRAWING,
PAINTING AND CREATING FOR THE CLASSROOM. Dubuque, Iowa: Wm.
C. Brown Co., 1974. 200 p. Biblio. Paper.

> This book for classroom teachers has as its central theme the im-
> portance of children understanding the basic principles of art.
> The author is concerned about the impact that work space, environ-
> ment, and manipulation of materials can have on learning and so
> includes a lesson planning guide for teachers. She also presents
> by grade level, characteristics and objectives of art growth in terms
> of perceptual, manipulative, and art appreciation goals. Included
> is a list of twenty-five questions that nonart major classroom teach-
> ers ask about teaching art.

Lindstrom, Miriam. CHILDREN'S ART: A STUDY OF NORMAL DEVELOPMENT
IN CHILDREN'S MODES OF VISUALIZATION. Berkeley and Los Angeles:
University of California Press, 1970. 100 p. Illus., some color. Biblio.

> The stages of development and what children's art means to the
> children themselves.

Logie, Lizzie. SELF-EXPRESSION IN A JUNIOR SCHOOL. London: Oxford
University Press, 1928. 86 p. Illus.

Lord, Lois. COLLAGE AND CONSTRUCTION IN ELEMENTARY AND JUNIOR
HIGH SCHOOLS. Worcester, Mass.: Davis Publications, 1958. 111 p. Il-
lus.

> Organized by grade level this book, intended for art and classroom
> teachers, treats collage, construction, and wire sculpture as means
> of individual creative expression for children. There are also sec-
> tions which explore group projects and all-school activities using
> these materials.

Luca, Mark, and Kent, Robert. ART EDUCATION: STRATEGIES OF TEACH-
ING. Englewood Cliffs, N.J.: Prentice-Hall, 1968. 99 p. Illus. Biblio.,
pp. 89-92.

> The authors attempt to reconcile the schism they feel exists between
> art and art education. There are also discussions of the uses of

art, the qualities of a good teacher, and the use of various art education materials. The bibliography includes school curriculum guides.

MacDonald, Helen Rosabelle. ART AS EDUCATION. New York: Holt, Rinehart and Winston, 1941. 248 p. Illus.

See entry on p. 103.

McFee, June King. PREPARATION FOR ART. 2d ed. San Francisco: Wadsworth Publishing Co., 1970. 341 p. Illus. Index. Biblio. Glossary.

In part one of this art education book, the author develops a theory to help the reader understand the behavior of the child in school. She bases her work on research and experimentation and relates anthropological, psychological, and sociological principles to art teaching procedures.

McIlvain, Dorothy S. ART FOR PRIMARY GRADES. New York: G.P. Putnam's Sons, 1961. 297 p. Illus. Index. Biblio.

Reasons why and things-to-do-with five to eight year olds.

McLeish, Minnie. BEGINNINGS IN ART. New York: Studio Publications, 1946. 96 p. Illus.

McLeish, Minnie, and Moody, Ella. TEACHING ART TO CHILDREN. New York: Studio Publications, 1953. 96 p. Illus.

An art activities book with sections on embroidery, wooden toys, and basketry as well as the usual painting and paper work.

Marshall, Sybil. ASPECTS OF ART WORK WITH 5-9 YEAR OLDS. London: Evans Brothers, 1968. 72 p. Illus.

There are sections on art as "spiritual education" and the use of art with other curriculum areas.

Mathias, Margaret E. ART IN THE ELEMENTARY SCHOOL. New York: Charles Scribner's Sons, 1929. 180 p. Illus., some color. Index.

Basing art education on psychology, the author discusses drawing, design, color, lettering, posters, making booklets, art appreciation, the use of industrial arts materials, and curriculum for the third, fourth, fifth, and sixth grades.

_____. THE BEGINNINGS OF ART IN THE PUBLIC SCHOOLS. New York: Charles Scribner's Sons, 1924. 119 p. Illus., some color. Index. Biblio.

The author thinks of education in terms of child growth and in

this book records development through art experiences in a public school. He discusses the art experiences in a child's life, the steps in artistic development, materials, art appreciation, curriculum, and classroom arrangement.

_____. THE TEACHING OF ART. New York: Charles Scribner's Sons, 1932. 356 p. Illus., some color. Index. Biblio.

This book offers an argument for teaching art; instructs how to go about observing children; discusses general art principles, lettering, drawing, and art appreciation; and suggests unit and lesson plans. The author is very much aware of child concepts and child art and steers away from adult standards.

Mattel, Edward L. THE SELF IN ART EDUCATION. Research Monograph, no. 5. Washington, D.C.: National Art Education Association, 1972. 15 p. Biblio., pp. 14-15. Paper.

See entry on p. 57.

Mearns, Hughes. CREATIVE YOUTH. Garden City, N.Y.: Doubleday and Co., 1925. 112 p.

Melzi, Kay. ART IN THE PRIMARY SCHOOL. Photographs by William Palmer. Oxford: Basil Blackwell, 1967. Illus. Index. Biblio.

The author discusses characteristics of children's art work; suggests observation techniques; and discusses group projects, puppets, and display among other areas to be explored in the primary grades. Appendix contains suggested supplies for classroom use and names and addresses of dealers.

Mendelowitz, Daniel M. CHILDREN ARE ARTISTS. Stanford, Calif.: Stanford University Press, 1963. 140 p.

Discusses what may be expected in the art work of children at various age levels and tells parents and teachers how to help the child without hampering his unique expression.

Merritt, Helen. GUIDING FREE EXPRESSION IN CHILDREN'S ART. New York: Holt, Rinehart and Winston, 1964. 88 p. Paper.

Directed to elementary classroom teachers, this book attempts to clarify the relationship betwen child art and modern art through discussing the aims and problems of art education. The author looks at creativity, environmental influences, the teacher's role, representation, and nonobjectivity in children's art, and stresses teaching art as art and not as subjective or secondary to other subjects.

Montgomery, Chandler. ART FOR TEACHERS OF CHILDREN: FOUNDATIONS OF AESTHETIC EXPERIENCE. 2d ed. Columbus, Ohio: Charles E. Merrill Publishing Co., 1973. 224 p. Illus. Index. Biblio., pp. 201-5.

> The teacher's role in helping children learn creatively is discussed in this excellent art education book based on respect for the child and freedom of approach in teaching. Professor Montgomery pays particular attention to the use of "found materials" (including "found sound") and art activities that require physical movement and involvement.

National Art Education Association. ART EDUCATION: ELEMENTARY. Reston, Va.: 1975. 228 p. Illus. Biblio.

> Headed by Pearl Greenberg, this book was written by a task force of fifty specialists. The authors are concerned with teaching strategies, the art curriculum, materials and facilities, media, community projects, and various alternative approaches to art education.

Nicholas, Florence Williams; Mawhood, Nellie Clare; and Trilling, Mabel B. ART ACTIVITIES IN THE MODERN SCHOOL. New York: Macmillan, 1937. 379 p. Illus., some color. Index. Biblio.

> See entry on p. 188.

Nixon, Arne J. A CHILD'S RIGHT TO THE EXPRESSIVE ARTS. Washington, D.C.: Association for Childhood Education, 1969. 8 p. Paper.

> An essay about the need for free expression in children's lives.

Nyquist, Fredrik Vickstrom. ART EDUCATION IN ELEMENTARY SCHOOLS. Baltimore, Md. Warwick & York, 1929. 160 p. Index. Biblio., pp. 147. Glossary.

> Discusses the aims of art education in the elementary school; drawing, design, construction, and art appreciation.

O'Brien, Francis E. INDIVIDUALISM IN CHILD ART. New York: Ethical Culture Branch School, 1930. 16 p. Illus.

> In this essay about her art education philosophy and teaching methods, the author discusses painting as being a "vital reality" in the inner life of a child and in personality development.

Packwood, Mary M., ed. ART EDUCATION IN THE ELEMENTARY SCHOOL. Washington, D.C.: National Art Education Association, 1967. 111 p. Annotated biblio.

> School and community relationships, the selection of art experiences and evaluation are discussed in this book which also contains

a list of art books for children and sources of supplies and equip-
ment for teachers.

Payant, Felix. CREATE SOMETHING. Columbus, Ohio: Design Publishing
Co., 1939. 97 p. Illus.

Pelikan, Alfred George. THE ART OF THE CHILD. New York: Bruce Pub-
lishing Co., 1931. 123 p. Illus.

> Poorly reproduced examples of children's art work from grades one
> through eight with commentary about the children's motives in pro-
> ducing them. The author believes that children should not create
> freely but should be shown examples of historic art which would
> influence their choice of subject matter and style.

Perrine, Van Deering. LET THE CHILD DRAW. New York: Fredrick A. Stokes
Co., 1936. 88 p. Illus.

Pickering, John M. VISUAL EDUCATION IN THE PRIMARY SCHOOL. New
York: Watson-Guptill Publications, 1971. 87 p. Illus., some color. Biblio.

> The author discusses the importance of texture, time, space, light,
> and color to children, the ways they experience these elements and
> how their art work is affected by them.

Plaskow, Daphne. ART WITH CHILDREN. New York: Watson-Guptill Publi-
cations, 1968. 104 p. Illus., some color. Biblio. Glossary.

> A large part of this book is devoted to a discussion of the stages
> of child development. There is also a section on technique.

Platts, Mary E. CREATE: A HANDBOOK FOR TEACHERS OF ELEMENTARY
ART. Photographs by Gordon H. Platts. Stevensville, Mich.: Educational
Service, 1966. 228 p. Illus.

Pluckrose, Henry Arthur. ART. New York: Citation Press, 1972. 45 p.
Illus., part color. Biblio., pp. 42-43. Glossary. Paper.

> Describes how art is used in British primary schools, also discusses
> materials and tools, the teacher's role, display, and integrating
> art with other subject matter areas, as well as museum work.

_____. CREATIVE ARTS AND CRAFTS: A HANDBOOK FOR TEACHERS IN
PRIMARY SCHOOLS. New York: Roy Publishers, 1966. 232 p. Illus.

> Picture making and sculpture from various kinds of materials for
> children.

_____, comp. THE ART AND CRAFT BOOK. London: Evans Brothers, 1949. 190 p. Illus.

> An anthology selected from issues of ART AND CRAFT IN EDUCATION.

Richards, Karl; Wankelman, Willard; and Wigg, Marietta. ARTS AND CRAFTS FOR ELEMENTARY TEACHERS. Dubuque, Iowa: William C. Brown Co., 1965. 235 p. Illus.

Robbins, Ireene. ARTS AND CRAFTS MEDIA IDEAS FOR THE ELEMENTARY TEACHER. West Nyack, N.Y.: Parker Publishing Co., 1973. 236 p. Illus. Index. Glossary.

> There are a good many recipes in this book of art projects to do with children.

Robertson, Seonaid Mairi. ROSEGARDEN AND LABRYINTH: A STUDY IN ART EDUCATION. Foreword by Herbert Read. New York: Barnes & Noble, 1963. 216 p. Illus. Index. Biblio.

> A very personal account of art teaching centered on the theme of a garden. The author also explores the role materials play in creativeness.

Rueschoff, Phil H., and Swartz, M. Evelyn. TEACHING ART IN THE ELEMENTARY SCHOOL: ENHANCING VISUAL PERCEPTION. New York: Ronald Press Co., 1969. 339 p. Illus., part color. Index. Biblio.

> This book deals with (1) the theory of art education, (2) learning experiences, and (3) practical suggestions for the implementation of art programs. There is also a section on planning the art room.

Sargent, Walter. FINE AND INDUSTRIAL ARTS IN ELEMENTARY SCHOOLS. New York: Ginn and Co., 1912. 132 p. Illus. Index.

> An argument for the use of art in school and suggested curriculum for grades one to eight.

Sawer, Daisy D. EVERYDAY ART AT SCHOOL AND HOME. London: B.T. Batsford, 1929. 243 p. Illus., some color. Index.

> Written for classroom teachers, this book contains clear, concise descriptions of how to work with children. Some of the areas covered are design, lettering, color, drawing, and teaching theories.

Sawyer, John R., and De Francesco, Italo L. ELEMENTARY SCHOOL ART FOR CLASSROOM TEACHERS. New York: Harper and Row, 1971. 239 p. Illus., part color. Biblio., pp. 225-28.

This book contains suggestions for art lessons for the classroom teacher based on the authors' "creative-evaluative" method which is student centered and consistent with learning theories of other subject areas. Sample art lessons intended as instructional aids in curriculum building are also presented.

Schools Council. CHILDREN'S GROWTH THROUGH CREATIVE EXPERIENCE. New York: Van Nostrand Reinhold Co., 1974. 151 p.

See entry on p. 100.

Schultz, Harold Arthur, and Shores, J. Harlan. ART IN THE ELEMENTARY SCHOOL. University of Illinois Bulletin, no. 16. Urbana: University of Illinois Press, 1948. 102 p. Biblio. Paper.

This handbook for elementary classroom teachers describes good and bad art teaching, suggests art activities for grades one through six, and lists basic art equipment and supplies for the elementary classroom.

Schwartz, Fred, ed. ART EDUCATION IN MODERN ELEMENTARY SCHOOLS. Preface by Howard Conant. New York: Otto Schmidt & Son, Publishers, 1957. 102 p. Biblio. Paper.

Issued by the Long Island Art Teachers Association, this publication includes articles about concepts in elementary art (children's readiness for art, workshops for parents, and art rooms) as well as materials and techniques (murals, metal craft, bulletin boards, and stained glass) by a good many authors.

Seville, Renee. BEGINNING ARTS AND CRAFTS. New York: Drake Publishers, 1971. 95 p. Illus.

In addition to the more generally expected discussions of painting, picture making, and modelling, there are sections which deal with sewing, dollmaking, woodwork, classroom organization, and the teacher's role in this book about art in the schooling of primary children.

Smith, F.V. THE SIGNIFICANCE OF CHILDREN'S CREATIVE EFFORTS. Newcastle-on-Tyne, England: King's College, 1951. 32 p. Paper.

Smith, James A. CREATIVE TEACHING OF THE CREATIVE ARTS IN THE ELEMENTARY SCHOOL. Boston: Allyn and Bacon, 1967. 186 p. Illus. Index. Biblio.

The author believes drama, music, and dance as well as visual art should be used to foster creative growth of children.

Smyth, Peter S. ART IN THE PRIMARY SCHOOL. London: Sir Isaac Pitman & Sons, 1932. 99 p. Illus., some color.

Contains a section about "memory drawing."

Snow, Aida Cannarsa. GROWING WITH CHILDREN THROUGH ART. New York: Van Nostrand Reinhold Co., 1968. 150 p. Illus., some color.

Stresses creativity through designing and using puppets, stories and books, movement, film, and clay, with other subject matter areas. The author believes the most effective learning occurs when there is a mutual exchange of experiences and talents between child and teacher.

Sobotka, Grace, ed. ART INSTRUCTION IN THE FIRST SIX GRADES. Ann Arbor, Mich.: Edwards Brothers, 1935. 35 p. Biblio., p. 35.

Sproul, Adelaide. TEACHING ART: SOURCES AND RESOURCES. New York: Van Nostrand Reinhold Co., 1971. 88 p. Illus. Biblio.

An exciting book about looking and seeing that results in art education experiences for children. The author goes way beyond ordinary art materials and suggests that child experience earth, sound, water, light, and color in big bold ways that are expansive and creative.

_____. WITH A FREE HAND: PAINTING, DRAWING, GRAPHICS, CERAMICS, AND SCULPTURE FOR CHILDREN. New York: Reinhold Book Corp., 1966. 144 p. Illus. Index. Biblio., p. 141.

The author discusses a philosophy of art education and suggests lessons in drawing, painting, graphics, ceramics, and sculpture for children in grades kindergarten through eight.

Stevens, Harold. WAYS WITH ART: 50 TECHNIQUES FOR TEACHING CHILDREN. New York: Reinhold Publishing Corp., 1963. 224 p. Illus., part color.

A book of art activities, some of them unusual, for teachers to use with children.

Swerer, Mary Gulick. A DEVELOPMENT PROGRAM FOR THE ELEMENTARY SCHOOL. Cheney: Eastern Washington College of Education, 1948. 320 p. Biblio.

The author uses a poem by Henry Turner Bailey to introduce this thorough program of art education for the elementary school.

Tadd, James Liberty. NEW METHODS IN EDUCATION: ART, REAL MANUAL TRAINING, NATURE STUDY. 3d ed. New York: Orange Judd Co., 1912. 432 p. Illus. Index.

This book about drawing and modelling in schools has interesting and beautiful photographs of children drawing on blackboards and sketching pigs and cows in natural settings. There was also an illustrated student edition published in 1904.

Todd, Jessie Mabel, and Gale, Ann Van Nice. ENJOYMENT AND USE OF ART IN THE ELEMENTARY SCHOOL. Chicago: University of Chicago Press, 1933. 134 p. Illus. Index.

This book presents a compendium of classroom problems in art and suggestions for their solution. Included are: art history, modelling, toys, use of corrugated board, and theatre.

Tomlinson, Reginald R. CHILDREN AS ARTISTS. London: Studio Publications, 1943. 112 p. Illus.

See entry on p. 31.

_____. PICTURE MAKING FOR CHILDREN. London: Studio Publications, 1934. 96 p. Illus.

See entry on p. 32.

Trucksess, Fran. CREATIVE ART: ELEMENTARY GRADES. Boulder, Colo.: Pruett Publishing Co., 1970. 108 p. Illus., some color. Biblio. Paper.

Children's art discussed in terms of art elements and child growth in the home, church, and school. The author suggests specific projects using traditional art supplies and equipment.

Viola, Wilhelm. CHILD ART. Reprint. Peoria, Ill.: Chas. A. Bennett Co., 1945. 206 p. Illus. Index.

Compares child art to art of primitive people and discusses it in relation to puberty. The author devotes a large part of the book to a discussion of Cizek and his "lessons."

_____. CHILD ART AND FRANZ CIZEK. Vienna: Austrian Junior Red Cross; New York: Reynal & Hitchcock, 1936. 111 p. Illus., some color.

Teaching methods of Professor Franz Cizek are discussed in the first section of this book. The second part contains reproductions of work from his children's classes.

Wachowiak, Frank, and Ramsay, Theodore. EMPHASIS: ART: A QUALITATIVE ART PROGRAM FOR THE ELEMENTARY SCHOOL. 2d ed. Scranton, Pa.: Intext Educational Publishers, 1971. 255 p. Illus., much color. Biblio. Glossary.

The authors discuss the characteristics of children, how they grow in art, their environment, and describe for the reader an art program in action. They believe the teaching of art techniques, art

vocabulary, and the use of tools to be an essential part of a child's education. The bibliography includes children's books and a list of films.

Wankelman, Willard F.; Richards, Karl; and Wigg, Marietta. ARTS AND CRAFTS FOR ELEMENTARY TEACHERS. Dubuque, Iowa: William C. Brown Co., 1954. 133 p. Illus. Paper.

After a short discussion of the general characteristics of child art and motivation, the authors present a series of projects using traditional classroom media. There are sections on unit plans and materials (including recipes) as well.

Wankelman, Willard F.; Wigg, Philip; and Wigg, Marietta. A HANDBOOK OF ARTS AND CRAFTS FOR ELEMENTARY AND JUNIOR HIGH SCHOOL TEACHERS. Dubuque, Iowa: William C. Brown Co., 1961. 193 p. Illus. Paper.

A series of art projects based on various materials. There are suggested classroom units, plans, and recipes.

Welling, Jane Betsey. SUGGESTIONS ON ART EDUCATION FOR ELEMENTARY SCHOOLS. Washington, D.C.: Government Printing Office, 1923. 18 p. Illus.

Wen, Chao-t'ung. MATERIAL AND METHOD FOR THE TEACHING OF ART IN ELEMENTARY SCHOOL. Shanghai, China: Commercial Press, 1948. 174 p. Illus.

Wigginton, Eliot. CREATING WITH MATERIALS FOR WORK AND PLAY. Washington, D.C.: Association for Childhood Education International, 1969. 48 p.

Twelve leaflets about puppet making, working with wood, drama, science.

Wilson, Della Ford. PRIMARY INDUSTRIAL ARTS. Peoria, Ill.: Manual Arts Press; London: G.T. Batsford, 1926. 194 p. Illus. Index. Biblio.

Stick-printing and sandtables are presented by the author for use in art education as well as more traditional media.

Winslow, Leon Loyal. ART AND INDUSTRIAL ARTS: A HANDBOOK FOR ELEMENTARY TEACHERS. University of the State of New York Bulletin, no. 761. Albany: University of the State of New York Press, 1922. 64 p. Illus.

_____. ART AND INDUSTRIAL ARTS IN GRADES 1 TO 6 INCLUSIVE. Albany: University of the State of New York Press, 1922. 64 p. Illus. Biblio. Paper.

Art is presented as an integral part of all the work that goes on in a school.

_____. ART IN ELEMENTARY EDUCATION. New York: McGraw-Hill Book Co., 1942. 294 p. Illus. Index. Biblio. Glossary.

Discusses art in general education, the qualities that make a good art teacher, visual aids, teaching units, and evaluation. There are sample unit plans.

_____. ELEMENTARY INDUSTRIAL ARTS. New York: Macmillan, 1928. 224 p.

Wiseman, Ann. MAKING THINGS: THE HAND-BOOK OF CREATIVE DISCOVERY. Boston: Little, Brown and Co., 1973. 163 p. Illus.

See entry on p. 260.

Wood, Grant. ART IN THE DAILY LIFE OF THE CHILD. Iowa City: University of Iowa, 1939. 10 p. Paper.

Chapter 9

MIDDLE SCHOOL PHILOSOPHY AND METHODS

Brittain, W. Lambert. AN INVESTIGATION INTO THE CHARACTER AND EX-
PRESSIVE QUALITIES OF EARLY ADOLESCENT ART. Washington, D.C.: Of-
fice of Education, 1967. 32 p.

Churchill, Angiola R. ART FOR PREADOLESCENTS. New York: McGraw-
Hill Book Co., 1971. 455 p. Illus. Index. Biblio., pp. 425-36.

> Professor Churchill describes the preadolescent (including the dis-
> advantaged) in terms of his self-reliance, anxieties, curiosity, and
> his performance as an artist. She discusses teaching in terms of
> the child's interest in the group and various kinds of media, and
> points out the advantage in using media such as happenings and other
> activities that involve the child physically. An excellent book about
> an age group which is neglected in art and education literature. Also
> includes a teacher's manual and set of one hundred slides.

Hathaway, Walter, et al. ART EDUCATION: MIDDLE-JUNIOR HIGH
SCHOOL. Washington, D.C.: National Art Education Association, 1972.
127 p. Biblio. Paper.

> Written by a task force headed by Walter Hathaway, this book is
> concerned with teaching strategies, the student, art teacher, art
> supervisor, and the curriculum.

Marquart, Marguerite. THEORY AND PRACTICE OF TEACHING ART IN
JUNIOR HIGH SCHOOLS. Newark, N.J.: W. Meyer, Printer, 1922.

Michael, John Arthur. ART EDUCATION IN THE JUNIOR HIGH SCHOOL.
Washington, D.C.: National Art Education Association, 1964. 169 p. Bib-
lio. Paper.

> A thorough book about the junior high school student, his nature
> and needs and ways the teacher can begin to fill those needs.
> Discusses curriculum, evaluation, scheduling, the art room, supplies
> and equipment, and the art teaching profession. In addition, there

is an important chapter about public relations through exhibits and
a list of films and art material resources. Includes a list of books
for teachers and pupils.

Mickesh, Verle. CREATIVE ART: A GUIDE FOR ART INSTRUCTORS, JUNIOR
HIGH GRADES. Boulder, Colo.: Pruett Press, 1962. 119 p. Illus. Glos-
sary. Biblio.

Written for junior high school art teachers, this book has a section
addressed to administrators; other sections about display and bulletin
boards, art elements and contests, evaluation, and supply and
equipment sources.

Rannells, Edward Warder. ART EDUCATION IN THE JUNIOR HIGH SCHOOL.
Bureau of School Service Bulletin, no. 4. Lexington: University of Kentucky,
1946. 127 p. Biblio., pp. 116-25. Paper.

Problems of teaching junior high children, art education philoso-
phy, the needs of society, and art education literature are dis-
cussed in this book.

Reed, Carl. EARLY ADOLESCENT ART EDUCATION. Peoria, Ill.: Chas.
A. Bennett Co., 1957. 205 p. Illus.

Concise, practical suggestions about teaching art to middle school
children, based on changing social, physical, and psychological
needs of the child.

Schools Council Art and Craft Education Project. CHILDREN'S GROWTH
THROUGH CREATIVE EXPERIENCE. London: Van Nostrand Reinhold Co.,
1974. 176 p. Illus., part color.

Written by a team of British art educators, this book explores the
nature of children's creative experiences in an attempt to reach a
finer understanding of the conditions which encourage creativity
and imaginative growth. The authors were especially interested
in bridging the gap between elementary and secondary school edu-
cation. They state clearly the aims they believe fundamental to
art education and lay particular emphasis on the importance of
a child's own ideas.

Chapter 10

SECONDARY PHILOSOPHY AND METHODS

Allen, Arthur Bruce. THE TEACHING OF ART IN SENIOR SCHOOLS. New York and London: Frederick Warne & Co., 1938. 135 p. Illus., part color. Biblio., pp. 135-36.

> Discusses the role of art in education and suggests projects for high school art classes. Among the topics discussed are design, various ways of using line, wash, lettering, circles, paper cutting, interior decoration, crafts, and commercial art.

American Education Fellowship. THE VISUAL ARTS IN GENERAL EDUCATION: A REPORT OF THE COMMITTEE ON THE FUNCTION OF ART IN GENERAL EDUCATION FOR THE COMMISSION ON SECONDARY SCHOOL CURRICULUM. New York: D. Appleton-Century Co., 1940. 166 p. Index. Biblio.

> See entry on p. 121.

Anderson, Glenn I. PROJECTS IN ART FOR HIGH SCHOOLS. Chicago: University Publishing Co., 1929. 64 p. Illus.

ART EDUCATION: SENIOR HIGH SCHOOL. Washington, D.C.: National Art Education Association, 1972. 102 p.

> See entry on p. 104.

ART IN SECONDARY SCHOOLS. Edinburgh: Scottish Education Department, Her Majesty's Stationery Office, 1971. 39 p. Illus. Paper.

Berger-Hamerschlag, Margareta. JOURNEY INTO A FOG. London: Victor Gollancz, 1955. 254 p. Illus.

> A diary about teaching adolescents in a London slum by a student of Franz Cizek who believed that only the gifted should be taught art and then only by artists.

D'Amico, Victor Edmund. CREATIVE TEACHING IN ART. Scranton, Pa.: International Textbook Co., 1942. 261 p. Illus. Index.

Theory is interwoven with practice in this book and methods, media, and techniques are used as means of both enriching the child's personality and developing art concepts. The child is seen as an innate artist using traditional art materials. Projects illustrated are mostly for upper grades. Looking at the photographs today one is impressed with how fresh and unsophisticated, how much younger--both in subject matter chosen and manner of execution--these youngsters appear when compared to today's adolescents.

_____. CREATIVE TEACHING IN ART. Rev. ed. Scranton, Pa.: International Textbook Co., 1953. 257 p. Illus. Index.

The revision consists mostly of new photographs and a couple of chapters rearranged.

_____. THE VISUAL ARTS IN SECONDARY EDUCATION. New York: Progressive Education Association, 1937. 240 p.

This study by the Art Committee of the Commission on Secondary School Curriculum attempts to discover the fundamental values of art in education and to suggest teaching methods to help bring these values into existence. There are sections about the education and qualifications of secondary art teachers, relating art to other subjects, factors (such as the administration) that prevent the "proper" functioning of art in high schools, and exemplary approaches to art teaching.

DeLemos, Pedro. THE ART TEACHER. Worcester, Mass.: Davis Publications, 1946. 154 p.

Gaitskell, Charles Dudley, and Gaitskell, Margaret R. ART EDUCATION DURING ADOLESCENCE. New York: Harcourt, Brace & Co., 1954. 116 p. Illus. Biblio.

Reports on a six-year study of research in Canadian schools and makes suggestions for working with adolescents and for curricular development.

Gooch, Peter H. IDEAS FOR ART TEACHERS. New York: Van Nostrand Reinhold Co., 1972. 176 p. Illus., some color. Biblio.

A reference book of ideas and art techniques suitable for use with children between the ages of nine and fifteen.

Howell, Youldon, ed. ART AND THE ADOLESCENT. Eighth Yearbook of the National Art Education Association. Kutztown, Pa.: National Art Education Association, 1957. 77 p. Illus. Biblio. Paper.

See entry on p. 17.

Klar, Walter Hughes. REPORT OF THE COMMITTEE ON ART EDUCATION IN THE HIGH SCHOOLS OF THE UNITED STATES. Providence, R.I.: Bear Press for the Federated Council on Art Education, 1935. 134 p. Paper.

> The committee used a questionnaire to investigate the following: (1) What is the value of art as a social movement? (2) What is the value of art education as a public school subject? (3) What do high school students report they learn in art classes? (4) What do they see as the function of art in their homes? (5) What do college students think they learned in high school art classes? (6) What value do art schools place on high school art classes? and (7) How does the high school art teacher rate art classes in the secondary schools?

Lally, Ann M., ed. ART IN THE SECONDARY SCHOOL. Washington, D.C.: National Art Education Association, 1961. 102 p. Biblio., pp. 97–102.

Lanier, Vincent. TEACHING SECONDARY ART. Scranton, Pa.: International Textbook Co., 1964. 181 p. Illus. Biblio.

> Prepared as a college textbook for art education majors, this book points out various approaches to teaching with no distinction made between junior high and senior high school. There are helpful bibliographies, including state and city curriculum guides, plus an appendix listing research in secondary school art education.

Linderman, Earl W. TEACHING SECONDARY SCHOOL ART: DISCOVERING ART OBJECTIVES, ART SKILLS, ART HISTORY, ART IDEAS. Dubuque, Iowa: Wm. C. Brown Co., 1971. 243 p. Biblio., pp. 239–43. Paper.

> Discusses the characteristics of secondary school students, and what makes a good teacher as well as skills and lesson planning. Includes statements by artists about becoming an artist and a list of suggested books for a high school art library.

MacDonald, Helen Rosabelle. ART AS EDUCATION: THE STUDY OF ART IN SECONDARY SCHOOLS. New York: Henry Holt & Co., 1941. 309 p. Illus. Index.

> Based on her experiences in New York City's secondary schools, the author writes about art in the high school from appreciation to studio. In one chapter she discusses the unrelated aspects of school and life. There are also discussions of "creative teaching" and the "artist-teacher," and a course of study.

Mazinga, Theophilos M. EXPLORING WITH MATERIALS: A STUDIO HAND-BOOK. Kampala, Uganda: Department of Education, Makerere University, 1972. 58 p. Biblio. Paper.

Munro, Thomas. ART AND ADOLESCENCE. Worcester, Mass.: Worcester Art Museum, 1932. 67 p.

National Art Education Association. ART EDUCATION: SENIOR HIGH SCHOOL. Washington, D.C.: 1972. 99 p. Biblio. Paper.

> A general view of art teaching in high schools by a task force of art educators headed by Angela Paterakis. Emphasis is on education of the art teacher, community, and alternative approaches including school-without-walls, the art museum, and other areas.

Nicholas, Florence Williams; Heyne, Carl J., Jr.; Lee, Margaret M.; and Trilling, Mabel B. ART FOR YOUNG AMERICA. 3d ed. Peoria, Ill.: Chas. A. Bennett Co., 1946. 286 p. Illus., some color. Index. Biblio.

> Primarily art appreciation, this book has a chapter about nature and another about the home as well as those to be expected-- painting, sculpture, architecture, and color sections.

Palmer, Frederick. ART AND THE YOUNG ADOLESCENT. New York and Oxford: Pergamon Press, 1970. 136 p. Illus., part color.

> The author makes suggestions for using the elements of art in various ways--some very original. In addition he discusses three dimensional work with adolescents.

Perrot, Georges. ART HISTORY IN THE HIGH SCHOOL. Translated by Sarah Wool Moore. Syracuse, N.Y.: C.W. Bardeen, 1900. 108 p.

Pierce, Anne E., and Hilpert, Robert S. INSTRUCTION IN MUSIC AND ART. Washington, D.C.: Government Printing Office, 1933. 68 p. Paper.

> Discusses trends in secondary schools, art subject matter correlation with other subjects, courses of study, and measurement and research.

Portchmouth, John. SECONDARY SCHOOL ART. London: Studio Vista, 1971. 144 p. Illus., some color. Index. Biblio., pp. 138-43.

> Suggests working arrangements in the art room, sources for art in other subject matter areas, evaluation of the child's work and grading, and the characteristics of adolescents eleven to eighteen years of age.

Prang Educational Co. ART EDUCATION FOR HIGH SCHOOLS. New York: 1908. 346 p. Illus., some color. Index.

> This book contains an extensive and clear explanation of perspective and a section on architectural drawing as well as chapters on design, ornamentation, and art history.

Stoddard, George D. THE ARTS IN SECONDARY EDUCATION. Washington, D.C.: National Foundation on the Arts and the Humanities, 1970. 261 p.

Art education curriculum development in secondary schools.

Wachowiak, Frank, and Hodge, David. ART IN DEPTH: A QUALITATIVE PROGRAM FOR THE YOUNG ADOLESCENT. Scranton, Pa.: International Textbook Co., 1970. 180 p. Illus., part color. Biblio., pp. 151-63.

Walton, Edith C. ART TEACHING IN SECONDARY SCHOOLS. London: Batsford, 1953. 179 p. Illus.

Winslow, Leon Loyal. ART IN SECONDARY EDUCATION. New York: McGraw-Hill Book Co., 1941. 396 p. Index.

Written for high school art teachers, this book suggests how art experiences may be carried out in school. There are sections about the role of art in society, economy, art and the individual, and the importance of art in education.

Chapter 11

HIGHER EDUCATION

Ackerman, Rudy S. THE RELATIONSHIP OF MOTIVATION AND EVALUATION TO THE PROCESS AND PRODUCT IN THE ART WORK OF COLLEGE STUDENTS. Washington, D.C.: Office of Education, Department of Health, Education and Welfare, 1967. 192 p.

Association of American Colleges. COLLEGE INSTRUCTION IN THE ARTS. New York: n.d. 25 p. Paper.

> Generalized statements about college art teaching obviously recorded at an association meeting.

_____. PROCEEDINGS. New York: 1941. 149 p.

> A transcript of the 1941 association meeting devoted to the arts on liberal arts campuses.

Brown, John Nicholas. REPORT OF THE COMMITTEE ON THE VISUAL ARTS AT HARVARD UNIVERSITY. Cambridge, Mass.: Harvard University, 1956. 155 p.

> Brown chaired this committee which reported on the Harvard art curriculum and made recommendations for change.

College Art Association of America. A STATEMENT ON THE PRACTICE OF ART COURSES. New York: n.d. 5 p. Paper.

> An argument for teaching studio art in college.

_____. THE VISUAL ARTS IN HIGHER EDUCATION. New York: 1966. 97 p.

Council on Higher Education in the American Republics. THE ARTS AND THE UNIVERSITY. New York: Institute of International Education, 1964. 48 p.

> Excerpts from a 1964 symposium of college administrators from North and South America.

Danes, Gibson A. CHANCELLOR'S PANEL ON UNIVERSITY PURPOSES.
BACKGROUND PAPER ON THE ARTS, SOCIETY AND EDUCATION. Purchase:
State University of New York, 1948. 19 p. Paper.

> A philosophical statement of the purposes of the University at Pur-
> chase.

Davies, Henry. ART IN EDUCATION AND LIFE: A PLEA FOR THE MORE
SYSTEMATIC CULTURE OF THE SENSE OF BEAUTY. Columbus, Ohio: R.G.
Adams & Co., 1914. 334 p. Index. Biblio.

> Davies discusses taste, theatre, and democracy.

Dennis, Lawrence E., and Jacob, Renate M., eds. THE ARTS IN HIGHER
EDUCATION. San Francisco: Jossey-Bass, 1968. 157 p. Index.

> Concerned with the imbalance between the arts and sciences in
> higher education, the authors in this book explore the place of the
> arts in a democracy, college admission policies, art teaching prob-
> lems, testing, and art and technology.

Eaton, Daniel Cady. THE STUDY OF THE ARTS OF DESIGN IN AMERICAN
COLLEGES. New Haven, Conn.: Tuttle, Morehouse & Taylor, Printers, 1882.
21 p. Paper.

> A general essay about art in colleges.

Federated Council on Art Education. REPORT OF THE COMMITTEE ON ART
INSTRUCTION IN COLLEGES AND UNIVERSITIES. New York: 1927. 69 p.
Biblio. Paper.

> Much of the material in this report is based on a questionnaire
> the Federation distributed. It deals with college entrance credit
> for art courses taken in high school, college art degrees, and
> general problems of instruction.

Feldman, Edmund Burke, ed. ART IN AMERICAN HIGHER INSTITUTIONS.
Washington, D.C.: National Art Education Association, 1970. 112 p.

> Feldman compiled eleven papers on the state of art education at
> the university level.

File, Sister M. Jeanne. A CRITICAL ANALYSIS OF CURRENT CONCEPTS OF
ART IN AMERICAN HIGHER EDUCATION. Washington, D.C.: Catholic Uni-
versity of America Press, 1958. 107 p. Index. Biblio.

> The author examines the theories of Plato, Aquinas, Kant, and
> others in terms of contemporary concepts. She then looks at edu-
> cation with those concepts in mind.

Gould, Samuel B.; Schuman, William; Matter, Mercedes; Maslow, Abraham H; and Meyerson, Martin. THE ARTS AND EDUCATION: A NEW BEGINNING IN HIGHER EDUCATION. New York: Mary Reynolds Babcock Foundation and New York State Council on the Arts, 1968. 31 p. Paper.

> Essays about art in higher education by a state university chancellor, the president of Lincoln Center, an art department chairman, a psychologist, and a college president. No art educators are included.

Hornsey College of Art. THE HORNSEY AFFAIR. London: Penguin Books, 1969. 220 p. Paper.

> Written by the students and staff of Hornsey College, this book is about the May 1968 student revolution at Hornsey.

Hunter, Sam. A SURVEY, ANALYSIS AND PROPOSAL FOR ACTION FOR THE DEVELOPMENT OF THE VISUAL ARTS IN PUBLIC HIGHER EDUCATION IN MASSACHUSETTS. Boston: Massachusetts Advisory Council on Education, 1969. 177 p. Biblio. Paper.

> A detailed examination of art education in Massachusetts colleges and universities in the framework of prevailing conditions in art education across the nation.

Joint Committee of the National Advisory Council on Art Education and the National Council for Diplomas in Art and Design. THE STRUCTURE OF ART AND DESIGN EDUCATION IN THE FURTHER EDUCATION SECTOR. Report of a Joint Committee of the National Advisory Council on Art Education and the National Council for Diplomas in Art and Design. London: Her Majesty's Stationery Office, 1970. 63 p. Paper.

> This study of art education in England deals with art schools, art in general education, and community relations.

Labatut, Jean. THE UNIVERSITIES' POSITION WITH REGARD TO THE VISUAL ARTS. Princeton, N.J.: Princeton University Press, 1944. 32 p.

> The author's views on teaching the visual arts.

Madge, Charles, and Weinberger, Barbara. ART STUDENTS OBSERVER. London: Faber and Faber, 1973. 282 p. Illus. Index.

> An examination of present day art education in English art schools.

Mahoney, Margaret, ed. THE ARTS ON CAMPUS, THE NECESSITY FOR CHANGE. Greenwich, Conn.: New York Graphic Society, 1970. 143 p. Illus. Biblio.

> The need for change in how undergraduates are taught art and current practices in the field is discussed.

Manzella, David Bernard. EDUCATIONISTS AND THE EVISCERATION OF THE VISUAL ARTS. Scranton, Pa.: International Textbook Co., 1963. 97 p. Paper.

> This somewhat bitter account of college art education is based on the author's observations on how art is being taught in elementary and secondary schools.

Massachusetts Institute of Technology. ART EDUCATION FOR SCIENTIST AND ENGINEER. Cambridge: M.I.T. Press, 1957. 48 p. Illus. Paper.

> Looks at the role of visual arts education in the education of scientists and engineers at the Massachusetts Institute of Technology.

Morrison, Jack. THE RISE OF THE ARTS ON THE AMERICAN CAMPUS. New York: McGraw-Hill Book Co., 1973. 236 p.

Nimmons, George C. NEED FOR ART TRAINING IN COLLEGE AND ITS AP-PLICATION IN AFTER LIFE. Higher Education Circular, no. 27. Washington, D.C.: Government Printing Office, 1923. 7 p. Paper.

> The author feels that fine arts should be an integral part of a student's college education.

Read, Herbert Edward. PLACE OF ART IN A UNIVERSITY. London: Oliver and Boyd, 1931. 28 p. Paper.

> Compares the German and British systems of art education. Britain was found wanting in this inaugural lecture at the University of Edinburgh.

Richmond, Sir W.B. UNIVERSITIES AND ART-TEACHING. London: Oxford University Press, 1911. 23 p.

> A lecture about the value of working in materials to gain a greater understanding and appreciation of "Beauty."

Ritchie, Andrew Carnduff. THE VISUAL ARTS IN HIGHER EDUCATION. New Haven, Conn.: College Art Association and Yale University Press, 1966. 195 p.

> A report on the teaching of art history, the practice of art and the state of the college art museum in the United States.

Rusk, William Sener. METHODS OF TEACHING THE FINE ARTS. Chapel Hill: University of North Carolina Press, 1935. 156 p.

> See entry on p. 64.

Smith, E. Baldwin. THE STUDY OF THE HISTORY OF ART IN COLLEGES AND UNIVERSITIES OF THE UNITED STATES. Princeton, N.J.: Princeton University Press, 1912. 45 p. Paper.

A list of art history courses taught in 400 colleges and universities across the country.

Stevens, David H. THE CHANGING HUMANITIES: AN APPRAISAL OF OLD VALUES AND NEW USES. New York: Harper & Brothers, 1953. 272 p.

A general look at the humanities in American colleges and universities.

Stewart, David C., ed. FILM STUDY IN HIGHER EDUCATION. Washington, D.C.: American Council on Education, 1966. 174 p. Illus. Biblio. Paper.

Contains descriptions of film courses taught by the authors and a list of film distributors, archives, libraries, and film societies. The authors are mostly concerned with film appreciation.

Summerson, Sir John. WHAT IS A PROFESSOR OF ART? Hull, England: University of Hull Publications, 1961. 21 p. Paper.

The author sees the art historian as a key figure in higher education in art.

Waldstein, Charles. THE STUDY OF ART IN UNIVERSITIES. New York: Harper & Brothers, 1896. 129 p.

The author believes a wide general education best suits the artist.

White, Barbara Ehrlich, and White, Leon S. WOMEN'S CAUCUS OF THE COLLEGE ART ASSOCIATION SURVEY OF THE STATUS OF WOMEN IN 164 ART DEPARTMENTS IN ACCREDITED INSTITUTIONS OF HIGHER EDUCATION. New York: College Art Association, 1973. 8 p.

White, John. ART HISTORY AND EDUCATION. Hull, England: University of Hull Publications, 1962. 23 p. Paper.

The author feels art history will be more important in the future and discusses the problems of art historians in the educational establishment.

Ziegfeld, Ernest Herbert. ART IN THE COLLEGE PROGRAM OF GENERAL EDUCATION. New York: Bureau of Publications, Teachers College, Columbia University, 1953. 239 p. Index. Biblio., pp. 225-29.

The first two parts of this study discuss general education and the role of the arts in human life. The last section integrates the two and discusses the implications for college art education.

Chapter 12

CONTINUING EDUCATION

American Association of University Women. ART IN THE TOWN. Washington, D.C.: 1949. 65 p. Illus. Paper.

> Discusses how the organization works with the arts in several communities, large and small.

_____. BRANCH HANDBOOK IN THE ARTS. Washington, D.C.: 1946. 34 p. Illus. Paper.

> A guide for women who want to become active in the arts. The community is stressed.

_____. STATE ART PROGRAM. Washington, D.C.: 1948. 48 p. Illus. Paper.

> A history and report of the various state art organizations of the Association of University Women.

ART EDUCATION FOR ADULTS. Pasadena, Calif.: Pasadena City Schools, 1954. 18 p.

Burnett, M.H., and Hopkins, L.T., eds. ENRICHED COMMUNITY LIVING. Wilmington, Del.: State Department of Public Instruction, 1936. 235 p. Paper.

> Parents became more interested in the regular art activities of the public schools when they became involved in an adult art and music program.

Faulkner, Ray N., and Davis, Helen E. TEACHERS ENJOY THE ARTS. Washington, D.C.: American Council on Education, 1943. 57 p. Paper.

> A report on art programs in five summer workshops for teachers, with suggestions for conducting similar workshops stressing studio work as a valuable means of in-service education for all teachers.

Goldman, Freda H. THE ARTS IN HIGHER ADULT EDUCATION: A SECOND REVIEW OF PROGRAMS. Boston: Center for the Study of Liberal Education for Adults, 1966. 75 p. Index. Paper.

> A review of arts education programs offered by American universities to adults. Covered are drama, music, painting, sculpture, writing, dance, film, television, and radio.

_____. UNIVERSITY ADULT EDUCATION IN THE ARTS. Boston: Center for the Study of Liberal Education for Adults, 1961. 72 p. Paper.

> Describes arts programs in visual arts, music, writing, drama, dance, film, radio, and television taught by extension divisions and evening colleges.

Kohlhoff, Ralph, and Reis, Joseph. ADULT AND EXTENSION ART EDUCATION. Madison: University of Wisconsin Press, 1966. 66 p.

> Program development in the visual arts for adults.

Mearns, Hughes. CREATIVE ADULT. New York: Doubleday and Co., 1940. 123 p.

Moore, Janet Gaylord. THE MANY WAYS OF SEEING. New York: World Publishing Co., 1968. 141 p. Illus., color. Index. Biblio.

> This art appreciation book tells us how to look at a picture and discusses the artist's materials and techniques. There are chapters about the traveler abroad and at home, amateur artists, and the collector.

Robertson, Elizabeth Wells. ART TRAINING IN PREPARATION FOR ADULT LEISURE. Washington, D.C.: National Education Association of the United States, 1933. 18 p. Paper.

Sunderland, Jacqueline Tippett. OLDER AMERICANS AND THE ARTS. Washington, D.C.: Administration on Aging, 1973. 68 p.

> Enrichment education in the fine arts for older citizens.

Wriston, Barbara. ADULT EDUCATION IN THE ART INSTITUTE OF CHICAGO. Chicago: Art Institute, 1969. 9 p. Paper.

Zetterberg, Hans L. MUSEUMS AND ADULT EDUCATION. London: International Council of Museums, 1968. 116 p.

Chapter 13

MUSEUM ART EDUCATION

Axson, Stockton, et al. ART MUSEUMS AND SCHOOLS: FOUR LECTURES DELIVERED AT THE METROPOLITAN MUSEUM OF ART. New York: Charles Scribner's Sons, 1913. 144 p.

> Lectures by Stockton Axson, Kenyon Cox, Granville Stanley Hall, and Oliver S. Tonks on how teachers of English, art, history, and the classics might use the museum.

Bloomberg, Marguerite. AN EXPERIMENT IN MUSEUM INSTRUCTION. Washington, D.C.: American Association of Museums, 1929. 38 p.

Borrison, Mary Jo. LET'S GO TO AN ART MUSEUM. New York: G.P. Putnam's Sons, 1960. 97 p.

Boston Public Library. ART AND EDUCATION. Boston: 1966. 47 p. Index.

> Three addresses delivered at a symposium at the Wiggin Gallery of the Boston Library in 1966. "Art in a Library" deals with art education.

Buffalo Fine Arts Academy. PRELIMINARY REPORT ON TECHNICAL ASPECTS OF SECONDARY SCHOOL PROJECT FOR SEASON 1939-1940. Buffalo, N.Y.: 1940. Illus.

> A visual and written record of exhibitions of the work of high school youngsters held in the Albright-Knox Art Gallery.

Carnegie Corporation of New York. MEMORANDUM ON THE REPORT OF THE ADVISORY GROUP ON MUSEUM EDUCATION. New York: 1932. 22 p. Paper.

> Contains a section on children's museums.

Museum Art Education

Chubb, Ernest Charles. MUSEUMS AND ART GALLERIES AS EDUCATIONAL AGENTS. Pretoria, South Africa: Carnegie Corp. Visitors' Grants Committee, 1929. 48 p.

>The author looks at educational work in Canadian and U.S. museums and makes suggestions for South Africa based on his observations.

Clauss, Walter. SCHOOLS AND MUSEUMS. Albany: State Educational Department, State University of New York, 1968. 47 p.

Conference of Art Museum Educators. EDUCATION IN THE ART MUSEUM: PROCEEDINGS. New York: Association of Art Museum Directors, 1972. 85 p.

Connolly, Louise. THE EDUCATIONAL VALUE OF MUSEUMS. Newark, N.J.: Newark Museum Association, 1914. 38 p.

D'Amico, Victor Edmund. EXPERIMENTS IN CREATIVE ART TEACHING; A PROGRESS REPORT ON THE DEPARTMENT OF EDUCATION, 1937-1960. New York: Museum of Modern Art, 1960. 64 p. Illus. Paper.

>A report issued on the occasion of the twentieth year of the department of education at the Museum of Modern Art. Discusses the creative teacher, competitions in art, the gifted child, the People's Art Center, and the Children's Art Carnival.

Davis, Robert T. THE ART MUSEUM AND THE SECONDARY SCHOOL. Buffalo, N.Y.: Albright-Knox Art Gallery, 1939. 56 p.

_____. EDUCATIONAL ACTIVITIES OF ART MUSEUMS. Buffalo, N.Y.: Albright-Knox Art Gallery, 1938. 32 p.

>This is an analysis of questionnaires answered by forty-one art museums in the United States.

Diamond, Robert M. PROGRAMMED INSTRUCTION IN AN ART GALLERY. New York: Fund for the Advancement of Education, 1966. 23 p. Paper.

>Programmed art education instruction in a museum.

Dorr, Dalton. ART MUSEUMS AND THEIR USES. Philadelphia: E. Stern & Co., 1881. 15 p. Paper.

Folds, Thomas M. THE ROLE OF THE MUSEUM IN THE LIFE OF ADULTS AND SCHOOL CHILDREN. New York: International Council of Museums, 1968. 104 p.

Fox, Daniel M. ENGINES OF CULTURE, PHILANTHROPY AND ART MU-
SEUMS. Madison: State Historical Society of Wisconsin, 1963. 90 p. In-
dex. Biblio. Paper.

Discusses art museums and art history instruction.

Grove, Richard. THE MUSEUM COMMUNITY, NEW ROLES AND POSSIBILI-
TIES FOR ART EDUCATION. New York: Institute for the Study of Art in
Education, 1969. 68 p.

A conference report about the role museums can play in art educa-
tion.

_____. SOME PROBLEMS IN MUSEUM EDUCATION. Burlington: University
of Vermont, 1966. 36 p.

HANDS-ON MUSEUMS: PARTNERS IN LEARNING. New York: Educational
Facilities Laboratories, 1975. 44 p. Illus. Biblio. Paper.

A look at some children's museums in the United States.

Hausman, Jerome J. THE MUSEUM AND THE ART TEACHER. Washington,
D.C.: George Washington University and the National Gallery, 1966. 30 p.
Paper.

Evaluates a six-week summer program for high schoolers conducted
by George Washington University at the National Gallery to illus-
trate how art teachers might use museum resources. Art education
resources, in-service teacher education, and curriculum planning
were central to the experiment.

Hayes, Bartlett H., Jr. A STUDY OF THE RELATION OF MUSEUM ART EX-
HIBITIONS TO EDUCATION. Washington, D.C.: Office of Education, De-
partment of Health, Education and Welfare, 1967. 54 p.

International Council of Museums, Committee for Education. MUSEUMS AND
TEACHERS. Paris: UNESCO, n.d. 34 p. Paper.

Concerned with the use of museums by teachers, this booklet deals
with both student teachers and in-service teachers. General in-
terest museums are discussed as well as art museums.

Larrabee, Eric. MUSEUMS AND EDUCATION. Washington, D.C.: Smith-
sonian Institute, 1967. 220 p.

Facilities, programs, and learning processes in museums.

Levenson, Minnie G. A GENERATION OF ART EDUCATION FOR CHILDREN
AT THE WORCESTER ART MUSEUM. Foreword by Charles Henry Sawyer. Wor-
cester, Mass.: Worcester Art Museum, 1946. 27 p. Illus. Paper.

Describes the museum's programs and its relation to the public schools. There is a commentary by the curator of children's education about layman's misconceptions of art education.

Low, Theodore Lewis. THE EDUCATIONAL PHILOSOPHY AND PRACTICE OF ART MUSEUMS IN THE UNITED STATES. New York: Bureau of Publications, Teachers College, Columbia University, 1948. 245 p. Biblio.

A thorough survey of art education as conducted by various museums across the country.

_____. THE MUSEUM AS A SOCIAL INSTRUMENT. New York: Metropolitan Museum of Art, 1942. 27 p.

Marcouse, Rene, ed. EDUCATION IN MUSEUMS. Paris: UNESCO, 1968. 181 p.

_____. THE LISTENING EYE; TEACHING IN AN ART MUSEUM. London: Her Majesty's Stationery Office, 1961. 14 p. Illus. Bibliographic footnotes.

Melton, Hollis, comp. MUSEUMS WITH FILM PROGRAMS. New York: Educational Films Library Association, 1974. 21 p. Paper.

Moore, Eleanor M. YOUTH IN MUSEUMS. Philadelphia: University of Pennsylvania Press, 1941. 153 p.

Munro, Thomas, and Grimes, Jane. EDUCATIONAL WORK AT THE CLEVELAND MUSEUM OF ART. 2d rev. ed. Cleveland, Ohio: Museum of Art, 1952. 89 p.

Aims and methods in art museum education and a detailed description of the Cleveland program. The first edition, written by Munro, was published in 1940.

Museum of Modern Art. CREATIVE ART FOR CHILDREN, YOUNG PEOPLE, SCHOOLS. New York: 1951. 26 p. Illus.

National Endowment for the Arts. MUSEUM PROGRAM, GUIDELINES, 1974. Washington, D.C.: National Council on the Arts, 1974. 42 p. Paper.

Description of government aid available to museums.

Newark Museum. PICTURES BY CHILDREN. Newark, N.J.: 1936. 50 p. Illus. Paper.

Art teaching methods used in museums to produce pictures.

Perkins, Charles Callahan. ART IN EDUCATION. New York: Nation Press, 1870. 6 p. Paper.

> See entry on p. 60.

Pope-Hennessy, John W. THE CONTRIBUTION OF MUSEUMS TO SCHOLAR-SHIP. New York: Metropolitan Museum of Art, 1965. 126 p.

Powell, Lydia. THE ART MUSEUM COMES TO THE SCHOOL. Foreword and conclusion by Thomas Munro. New York: Harper & Brothers Publishers, 1944. 160 p. Illus.

> A report of a three-year project encouraging closer working rela-tionships between schools and museums in five cities in the United States.

Ramsey, Grace F. EDUCATIONAL WORK IN MUSEUMS OF THE UNITED STATES. New York: H.W. Wilson Co., 1938. 197 p.

Rea, Paul M. THE MUSEUM AND THE COMMUNITY. Lancaster, Pa.: Science Press, 1932. 78 p.

Toledo Museum of Art. CHILDREN AND ART. Toledo, Ohio: 1973. Illus. Paper. 32 p.

> An issue of the museum magazine, MUSEUM NEWS, devoted to a description of how children use the museum.

Winstanley, Barbara R. CHILDREN AND MUSEUMS. Oxford: Basil Black-well, 1967. 125 p. Illus. Index. Biblio.

> How teachers and children can make the best use of museums.

Worcester Art Museum. A GENERATION OF ART EDUCATION FOR CHIL-DREN AT THE WORCESTER ART MUSEUM, 1911-1946. Worcester, Mass.: 1946. 27 p. Illus. Paper.

> See entry on p. 117.

Chapter 14

ART IN GENERAL EDUCATION AND INTERDISCIPLINARY ART EDUCATION

ART IN GENERAL EDUCATION

American Education Fellowship. Commission on the Secondary School Curriculum. Committee on the Function of Art in General Education. THE VISUAL ARTS IN GENERAL EDUCATION; A REPORT. By Victor Edmund D'Amico. New York: D. Appleton-Century, 1940. 166 p.

> A study of the adolescent, the kinds of art activities which interest him, art teacher qualifications and preparation, how a teacher should evaluate students' work, and the role of art in a democracy.

Bassett, Richard, ed. THE OPEN EYE IN LEARNING, THE ROLE OF ART IN GENERAL EDUCATION. Cambridge, Mass.: M.I.T. Press, 1969. 216 p. Index. Biblio.

> Essays about art education by Zarkin, Rice, Sizer, Taylor, and others in elementary school through college including plans for studio and art history courses. The authors perceive the art program as child-centered more than art-centered.

Conference on the Contribution of Art and Science to the Content of General Education. ART, SCIENCE AND EDUCATION; A REPORT. London: Joint Council for Education through Art, 1958. 120 p. Illus.

Desmeules, Raynald, ed. ARTS EDUCATION FOR THE GENERAL PUBLIC. Toronto: Canadian Conference on the Arts, 1970. 117 p.

Eddy, Junius. THE UPSIDE DOWN CURRICULUM. New York: Ford Foundation, 1970. 18 p. Paper.

> Reflections on the arts in general education.

Progressive Education Association. THE VISUAL ARTS IN GENERAL EDUCA-
TION. New York: 1939. 98 p.

> Victor D'Amico, Belle Boas, Thomas Munro, and others contrib-
> uted to this committee report which examines the evolution of
> art education, adolescent art experiences, the preparation of art
> teachers, and the evaluation of art teaching.

Strickler, Fred. AN ART APPROACH TO EDUCATION. New York: A.G.
Seiler, 1941. 216 p.

> Dealing with art as a part of general education, this book has a
> chapter about the art teacher.

United Nations Educational, Scientific and Cultural Organization. THE ARTS
AND CRAFTS IN GENERAL EDUCATION AND COMMUNITY LIFE. Report on
the UNESCO seminar held in Tokyo, Japan, 1954. Paris: 1955. 18 p. Paper.

_____. THE VISUAL ARTS IN GENERAL EDUCATION. Report on the Bristol
seminar, United Kingdom, 1951. Paris: 1952. 55 p.

INTERDISCIPLINARY ART EDUCATION

Adler, Richard R., ed. HUMANITIES PROGRAMS TODAY. New York: Cita-
tion Press, 1970. 280 p.

> A collection of essays dealing with integration of arts in the cur-
> riculum.

ARTS IMPACT, INTERDISCIPLINARY MODEL PROGRAMS IN THE ARTS FOR CHIL-
DREN AND TEACHERS. Washington, D.C.: Office of Education, Department of
Health, Education and Welfare, 1973. 47 p. Paper.

> A report of selected experimental arts programs in Ohio, Oregon,
> California, Pennsylvania, and Alabama. In all instances the
> evaluators found that children in the programs did better in other
> subjects because of their arts experiences, came to school more
> regularly than other students, developed a more positive self-image
> and in general became happier, more useful citizens.

Barkan, Manual. NEW DIRECTIONS IN ART EDUCATION, REPORT OF THE
INTERNATIONAL SYMPOSIUM. Washington, D.C.: National Art Education
Association, 1967. 113 p.

> This conference held in Yugoslavia in July 1966 was concerned
> with an interdisciplinary approach to the visual arts and curriculum
> building.

Burchard, J.E. ART EDUCATION FOR SCIENTIST AND ENGINEER. Cambridge, Mass.: M.I.T. Press, 1957.

Chambers, Maude Lillian. THE RELATION OF THE SPACE ARTS TO SOCIAL STUDIES. Menasha, Wis.: George Banta Publishing Co., 1934. 58 p. Biblio. Paper.

> Art used in teaching social studies.

DeLong, Patrick D. ART AND MUSIC IN THE HUMANITIES. Englewood Cliffs, N.J.: Prentice-Hall, 1966. 244 p. Illus.

_____. ART IN THE HUMANITIES. Englewood Cliffs, N.J.: Prentice-Hall, 1970. 150 p. Illus.

> See entry on p. 160.

Gardner, Howard. THE ARTS AND HUMAN DEVELOPMENT. New York: Wiley & Sons, 1973. 395 p.

> The author draws on philosophy, education, psychology, and the humanities in this interdisciplinary approach to the development of children's art.

Gingrich, Donald. RELATING THE ARTS. New York: Center for Applied Research in Education, 1974. 63 p. Biblio.

Glace, Margaret F.S. ART IN THE INTEGRATED PROGRAM. Nashville, Tenn.: Cullom and Ghertner Co., 1934. 93 p.

> An argument for the use of art in the classroom for fourth, fifth, and sixth graders and specific suggestions as to how to integrate it with other subjects.

Greenberg, Polly, and Epstein, Bea. BRIDGE-TO-READING; ART, CRAFTS, AND CARPENTRY. Morristown, N.J.: General Learning Corp., 1973. 152 p.

Hartman, Gertrude, and Shumaker, Ann, eds. CREATIVE EXPRESSION, THE DEVELOPMENT OF CHILDREN; ART, MUSIC, LITERATURE AND DRAMATICS. New York: John Day Co., 1932. 350 p. Illus. Biblio.

> Attempts to integrate visual art and literature with the performing arts.

Irwin, Manley E. THE INTEGRATION OF THE CURRICULUM THRU THE ARTS. Washington, D.C.: National Education Association, 1935. 87 p.

KALEIDOSCOPE 12: ARTS AND HUMANITIES. Boston: Massachusetts Department of Education, 1974. 61 p. Illus. Paper.

Descriptions of arts and humanities programs in Massachusetts; many of them interdisciplinary and media based.

Munro, Thomas. THE ARTS AND THEIR INTERRELATIONS. 2d ed. New York: Liberal Arts Press, 1969. 559 p. Illus.

Theories of art as expressed by philosophers, psychologists, and critics.

Perry, Kenneth. AN EXPERIMENT WITH A DIVERSIFIED SCHOOL ART PROGRAM. New York: Bureau of Publications, Teachers College, Columbia University, 1941. 147 p.

See entry on p. 136.

Plaisted, T.M. AN INTEGRATED COURSE IN ART APPRECIATION. Los Angeles: Fox Printing Co., 1935. 76 p.

Rieser, Dolf. ART AND SCIENCE. New York: Van Nostrand Reinhold Co., 1972. 96 p. Illus. Biblio.

An interesting and useful book for a teacher who is trying to draw parallels between art and science. There are discussions of visual perception, the unconscious mind, and art forms in nature.

Schneider, Dawn E. CORRELATED ART. Scranton, Pa.: International Textbook Co., 1951. 196 p. Illus.

Art ideas for the social studies classroom teacher.

Tidwell, Kenneth W. FIELD TRIAL OF WISCONSIN DESIGN FOR READING SKILL DEVELOPMENT AND CEMREL AESTHETIC EDUCATION PROGRAM. Washington, D.C.: National Center for Educational Research and Development, 1972. 128 p.

Learning to read by using art activities and methods.

Winslow, Leon Loyal. THE INTEGRATED SCHOOL ART PROGRAM. Rev. ed. New York and London: McGraw-Hill Book Co., 1949. 422 p. Illus., part color. Index. Biblio.

In the preface the author states that the purpose of this book is: " . . . to indicate how subject matter is to be made use of in learning; to provide a point of view in art education and a foundation in techniques. . . ." He does so by discussing the role of art in the school curriculum (elementary through high school) and by making concrete suggestions. There is a chapter about school museums, and several specialized annotated bibliographies.

Wittich, Eugene, and Erickson, Robert, eds. THE UNIFIED ARTS PROGRAM IN THE LABORATORY SCHOOL. Chicago: University of Chicago, 1956. 187 p.

> A summary of the group action of specialized teachers in art, industrial arts, homemaking, and music in developing the curriculum of this particular school.

Young, Laura N., and Hayes, Bartlett H., Jr., eds. A SYLLABUS FOR THE RESEARCH PROGRAM IN EDUCATION THROUGH VISION. Washington, D.C.: Office of Education, 1967. 180 p.

> Suggested art activities and curriculum guides for interdisciplinary art education.

Chapter 15

INTERNATIONAL ART EDUCATION

GENERAL

Dickey, Edward Montgomery O'Rorke. INDUSTRY AND ART EDUCATION ON THE CONTINENT. London: H.M. Stationery Office, 1934. 135 p.

International Bureau of Education. TEACHING OF ART IN PRIMARY AND SECONDARY SCHOOLS. Geneva, Switzerland: UNESCO, 1955. 312 p.

 A comparative study of the teaching of art in sixty-five countries based on responses to a questionnaire sent to ministries of education.

Stanfield, Nancy F. A HANDBOOK OF ART TEACHING IN TROPICAL SCHOOLS. London: Evans Brothers, 1957. 192 p. Illus.

 A series of ordinary art lessons for children. The only part that seems pertinent to the tropics is the materials section.

UNESCO. ART EDUCATION: AN INTERNATIONAL SURVEY. Paris: 1972. 109 p. Illus., part color.

 Twelve countries report on the visual arts in general education, the professional artist's education, the art teacher's education, art in the community, and the production and use of art education materials.

Ziegfeld, Edwin, ed. EDUCATION AND ART, A SYMPOSIUM. Paris: UNESCO, 1953. 129 p. Illus., part color. Biblio., pp. 121-23.

 A symposium about the nature of art education and its ways and means. International in scope, there are articles by Henri Matisse, Jean Piaget, Herbert Read, Marion Dix, and Edwin Ziegfeld.

AFRICA

Fasuyik, T.A. CULTURAL POLICY IN NIGERIA. Paris: UNESCO, 1973.
63 p.

Art education seen in terms of the history and culture of Nigeria.

Leonard, Mary K., and Adenuga, Adeyemi. ART FOR NIGERIAN CHILDREN:
WITH EMPHASIS ON THE CREATIVE USE OF LOCAL MATERIAL. Sanngo,
Ibadan: African Education Press, 1966. 58 p. Illus. Index. Biblio.

There are practical suggestions for African teachers about setting
up art rooms and making supplies and equipment from local materi-
als (dyes and brushes) as well as suggestions for art activities in
this book.

Lewis, David. THE NAKED EYE. Capetown, South Africa: Paul Koston,
1946. 68 p. Illus. Index. Biblio.

The chapter about art education in South Africa deals with Cizek's
methods and their relationship to art teaching in African schools.

McKenzie, J.C. ART TEACHING FOR PRIMARY SCHOOLS IN AFRICA.
Nairobi: Oxford University Press, 1966. 55 p. Illus. Biblio.

There is a section on making supplies and equipment (for example,
paint from the soil and brushes from twigs and animal hair) in this
book written for African teachers.

Oxley, O.J.P. ART EDUCATION IN THE UNITED STATES. Pretoria, South
Africa: Carnegie Corp. Visitors' Grants Committee, 1930. 48 p. Paper.

A look at American art education along the East Coast and an es-
say about art education in Africa by an African visitor to the
United States.

AUSTRALIA

Miller, Mary D. CHILD ARTISTS OF THE AUSTRALIAN BUSH. London:
George G. Harrap and Co., 1952. 80 p. Illus.

A teacher's sensitive record of the development and work of a
group of aboriginal children.

Richardson, Evelyn S. IN THE EARLY WORLD. New York: Pergamon Press,
1969. 217 p. Illus. Paper.

A description of creative teaching in all areas of the curriculum
over an eight-year period in a New Zealand primary school. The
teacher used art activities as a core for working with children.

Smith, Bernard William, ed. EDUCATION THROUGH ART IN AUSTRALIA.
Introduction by Herbert Read. Melbourne: Melbourne University Press, 1958.
95 p. Illus.

> Australian thought concerning the place and practice of art in edu-
> cation by people active in the field.

BALI

Belo, Jane. BALINESE CHILDREN'S DRAWING. Joargang, Bali: Overdruk
hit Djawa, 1937. 13 p. Illus. Paper.

> An interesting discussion of the role of art in the Bali of 1937 and
> a description of an art experiment the author carried out with
> children who had not had art in school. Their drawings were ex-
> pressionistic and the children became more observant and skilled
> with practice.

FRANCE

Cultural Services of the French Embassy. THE STUDY OF ART IN FRANCE.
New York: 1957. 75 p. Index. Paper.

> A list of art schools, libraries, collections, art history courses,
> and magazines for both crafts and fine arts in France. There is
> a brief history of art instruction.

Tudor Publishing Co. INTRODUCTION TO THE VISUAL ARTS. New York:
1968. 190 p. Illus., some color.

> A book by French art education teachers about their methods.

GERMANY

Haney, James Parton. ART AND INDUSTRIAL TRAINING IN GERMANY.
New York: New York City Board of Education, 1915. 86 p. Illus.

> A hard look at art education in Germany by the Director of High
> School Art in New York City. He even noted the size of class-
> rooms.

Ott, Richard. THE ART OF CHILDREN. Preface by Herbert Read. New York:
Pantheon Books, 1952. 8 p. Illus., part color. Paper.

> Reproductions (25) from the author's Munich America House school
> and an explanation of his theory and practice of art teaching.
> He thinks untrained artists are better teachers than art educators.

GREAT BRITAIN

Great Britain, Ministry of Education. ARTS AND CRAFTS IN THE SCHOOLS OF WALES. London: Her Majesty's Stationery Office, 1956. 89 p. Illus. Paper.

> A discussion of the place of the arts in the elementary and secondary schools of Wales. There are chapters on teacher education and art appreciation.

Piper, David Warren. READINGS IN ART AND DESIGN EDUCATION: AFTER COLDSTREAM. London: Davis-Poynter, 1973. 164 p.

> A hard look at art and design education in England and Wales between 1963 and 1973.

Scottish Committee of the Council for Art and Industry. EDUCATION FOR THE CONSUMER, ART IN GENERAL EDUCATION IN SCOTLAND. Edinburgh, Scotland: His Majesty's Stationery Office, 1935. 63 p. Illus. Paper.

> Art education in Scotland from elementary through teacher education. There are sections about why art doesn't receive its due in schools, museum education, and school equipment.

Thornton, Alfred Henry Robinson. THE DIARY OF AN ART STUDENT OF THE NINETIES. London: Sir Isaac Pitman & Sons, 1938. 106 p. Illus. Index.

> An impression of the English art world during the last decade of the nineteenth century written from a diary the author kept as a student. There is emphasis on the influence of French painting.

INDIA

Hellier, Gay. INDIAN CHILD ART. New York: Oxford University Press, 1951. 160 p. Illus. Index. Biblio.

> The author discusses teaching art to Indian children. He writes about methods, teacher education, drawing, painting, and crafts.

Jeswani, K.K. ART IN EDUCATION. New Delhi: Atma Ram, 1967. 194 p. Illus.

Pillai, K.S., ed. SHANKAR'S CHILDREN'S ART NUMBER 1960. New Delhi: N.R. Gopolakrishnan, 1960. 228 p. Illus., some color. Paper.

> Children's writings and visual art from around the world.

_____. SHANKAR'S CHILDREN'S ART NUMBER 1965. New Delhi: K.V. Shambhu, Publisher, 1965. 188 p. Illus., some color. Paper.

Stories and visual art by children from around the world.

_____. SHANKAR'S WEEKLY: CHILDREN'S ART NUMBER 1956. New Delhi: R.P. Nayar, Publisher, 1956. 216 p. Illus., some color. Paper.

Contains drawings, paintings (some in color), stories, and poems by children selected from thousands of entries from all over the world.

SOVIET UNION

Beskin, Osip. THE PLACE OF ART IN THE SOVIET UNION. New York: American Russian Institute, 1936. 31 p. Biblio. Paper.

A general look at art in Russia; also contains a discussion on art education.

Bryce, Mayo J., ed. FINE ARTS EDUCATION IN THE SOVIET UNION. Washington, D.C.: Department of Health, Education and Welfare, 1963. 74 p. Illus. Biblio. Paper.

A description of visual art, music, and dance education in both general and specialized schools in Russia by an American delegation that spent a month in that country.

Morton, Miriam. THE ARTS AND THE SOVIET CHILD: THE ESTHETIC EDUCATION OF CHILDREN IN THE USSR. New York: Free Press, 1972. 400 p. Illus. Index. Biblio.

In the chapter on the visual arts in this book about literature, music, dance, and visual arts education for children in Russia, the author discusses special art schools and the arts curriculum in the general school.

Roerich, Nikolai Konstantinovich. ADAMANT. New York: Corona Mundi, 1922. 139 p.

Inspirational essays about art and beauty by a Russian expatriate.

Socialist Publication Society. EDUCATION AND ART IN SOVIET RUSSIA. New York: 1919. 64 p. Paper.

It's art for the people.

Tupitsin. DRAWINGS BY SOVIET CHILDREN. N.p.: n.d. Unpaged. Illus., color.

Reproductions of water colors by Soviet children with a short explanatory text.

SPAIN

Spanish Child Welfare Association of America. THEY STILL DRAW PICTURES! Introduction by Aldous Huxley. New York: 1938. 71 p. Illus.

A collection of pictures drawn by Spanish children during the civil war.

SWEDEN

Sparre, Louis Pehrgreve. LECTURES ON ART EDUCATION. Bloomfield Hills, Mich.: Cranbrook Academy of Art, 1932. 17 p. Paper.

A speech on Swedish art education.

Chapter 16

RESEARCH

Aiken, Henry David. TEACHING AND LEARNING IN THE ARTS. Research Monograph no. 4. Washington, D.C.: National Art Education Association, 1970. 30 p. Paper.

An essay about teaching art appreciation by a philosophy professor from Brandeis.

Anway, Mary Jane, and MacDonald, Theodore. RESEARCH IN ART EDUCATION: THE DEVELOPMENT OF PERCEPTION IN ART PRODUCTION OF KINDERGARTEN STUDENTS. Washington, D.C.: Office of Education, Department of Health, Education and Welfare, 1971. 131 p.

Ary, Donald. INTRODUCTION TO RESEARCH IN EDUCATION. New York: Holt, Rinehart and Winston, 1972. 226 p.

Barron, Frank. ARTISTS IN THE MAKING. New York: Seminar Press, 1972. 239 p. Index. Biblio.

A psychological research study to help understand the development of the young artist. Deals with talent, creativity, and aesthetic judgment. Much of the material is based on personal interviews.

_____. AN EYE MORE FANTASTICAL. Introduction by Kenneth R. Beittel. Research Monograph no. 3. Washington, D.C.: National Art Education Association, 1967. 24 p. Paper.

Beittel, Kenneth R. ALTERNATIVES FOR ART EDUCATION RESEARCH: INQUIRY INTO THE MAKING OF ART. Dubuque, Iowa: Wm. C. Brown Co., 1973. 141 p. Illus. Biblio. Paper.

Carter, Martha R., and Fox, William H. ART IN THE ELEMENTARY SCHOOLS OF INDIANA. Bloomington, Ind.: Division of Research and Field Services, 1950. 83 p. Biblio. Paper.

This research paper is a report on a study undertaken to obtain information directly from classroom teachers about art instruction in

Indiana elementary schools. The researchers found there was a wide range of practices. Some schools had no art programs, others had rich ones; in some schools art was taught by a specialist; in others by classroom teachers. By and large the study reflected common practices in the United States.

Child, Irvin Long. DEVELOPMENT OF SENSITIVITY TO ESTHETIC VALUES. New Haven, Conn.: Yale University, 1964. 130 p. Paper.

Picture-study upgraded. The study is based on making choices between reproductions of art works.

Eisner, Elliot W., and Ecker, David W. READINGS IN ART EDUCATION. Waltham, Mass.: Blaisdell Publishing Co., 1966. 468 p. Illus. Index. Biblio.

A compilation of articles related to research and current trends in art education.

Force, Lorraine S. AN EXPERIMENTAL STUDY TO EXAMINE THE RESPONSES OF SIXTH GRADE STUDENTS TO PROGRAMMED INSTRUCTION AND EVALUATION INSTRUMENTS DESIGNED TO CORRESPOND TO SELECTED ABILITY TRAIT VARIABLES. Washington, D.C.: Office of Education, Department of Health, Education and Welfare, 1967. 186 p. Paper.

Hausman, Jerome J., ed. REPORT OF THE COMMISSION ON ART EDUCATION. Washington, D.C.: National Art Education Association, 1965. 149 p.

See entry on p. 52.

Hess, Robert P., et al. THE USE OF ART IN COMPENSATORY EDUCATION PROJECTS: AN INVENTORY. Chicago: University of Chicago Press, 1966. 112 p.

Compendium of research projects and persons directing the programs in which art education plays either a major or minor role. Brief descriptions of projects.

Hine, Frances D. A PILOT STUDY OF EVALUATION METHODS RELATIVE TO THE DEVELOPMENT OF VISUAL AWARENESS IN THE FIELD OF ART WITH NINE- AND TEN-YEAR-OLD CHILDREN ATTENDING FOURTH GRADE. Washington, D.C.: Office of Education, Department of Health, Education and Welfare, 1970. 79 p. Paper.

Hoffa, Harlan. AN ANALYSIS OF RECENT RESEARCH CONFERENCES IN ART EDUCATION. Washington, D.C.: Office of Education, Department of Health, Education and Welfare, 1969. 86 p. Paper.

Hyman, Ray. CREATIVITY AND THE PREPARED MIND. Research Monograph no. 1. Reston, Va.: National Art Education Association, 1975. 32 p. Paper.

See entry on p. 149.

Kensler, Gordon. PRECONFERENCE EDUCATION RESEARCH TRAINING PRO-
GRAM FOR DESCRIPTIVE RESEARCH IN ART EDUCATION. Washington, D.C.:
National Art Education Association, 1971. 109 p.

> Art education research methodology.

_____, ed. OBSERVATION: A TECHNIQUE FOR ART EDUCATORS. Wash-
ington, D.C.: National Art Education Association, 1971. 102 p. Illus.
Biblio. Paper.

> Discusses in terms of case studies, variety of observations, identi-
> fying a problem, and measurement.

Kilpatrick, W.H. SOME BASIC CONSIDERATIONS AFFECTING SUCCESS IN
TEACHING ART. New York: Bureau of Publications, Teachers College, Co-
lumbia University, 1931. 138 p.

Lanier, Vincent. DOCTORAL RESEARCH IN ART EDUCATION. Rev. ed.
Eugene: University of Oregon, 1968. 101 p. Paper.

> A list of the doctoral dissertations completed in the United States
> and Canada between 1930 and 1960.

McWhinnie, Harold J. THE EFFECTS OF A LEARNING EXPERIENCE UPON
PREFERENCE FOR COMPLEXITY AND ASYMMETRY; VARIABLES OF PERCEP-
TUAL FIELD INDEPENDENCE, AND THE ABILITY TO HANDLE VISUAL IN-
FORMATION. Washington, D.C.: Office of Education, Department of
Health, Education and Welfare, 1969. 249 p.

Mattil, Edward L. A SEMINAR IN ART EDUCATION FOR RESEARCH AND
CURRICULUM DEVELOPMENT. University Park: Pennsylvania State University,
1966. 433 p.

> A seminar to focus attention on five problem areas in art educa-
> tion. Those areas are defined as: (1) philosophical, (2) sociologi-
> cal, (3) content, (4) educational-psychological, and (5) curricu-
> lum.

Mellinger, Bonnie Eugenie. CHILDREN'S INTERESTS IN PICTURES. New York:
Teachers College, Columbia University, 1932. 52 p. Illus., schematic draw-
ings and charts.

> A statistical research study to determine whether children prefer
> realistic or stylized drawings.

Michael, John Arthur. A HANDBOOK FOR ART INSTRUCTORS AND STU-
DENTS BASED UPON CONCEPTS AND BEHAVIORS. New York: Vantage
Press, 1970. 223 p. Illus. Biblio., pp. 221-23.

The results of a research study to try to see what makes the artist different from his peers. From the 213 artists who answered this questionnaire, the author draws conclusions about their childhood, aims and purposes as professional artists, and methods of working.

Mittler, Gene A. AN INSTRUCTIONAL STRATEGY DESIGNED TO OVER-COME THE ADVERSE EFFECTS OF ESTABLISHED STUDENT ATTITUDES TO-WARD WORKS OF ART. Washington, D.C.: National Institute of Education, 1974. 104 p.

An art appreciation research study concerned with behavior change and changing attitudes.

Morrison, Jeanette Gertrude. CHILDREN'S PREFERENCES FOR PICTURES COM-MONLY USED IN ART APPRECIATION COURSES. Chicago: University of Chicago Press, 1935. 55 p. Illus. Biblio., p. 53.

In this art appreciation research project the author found that pri-mary grade children like a wider range of pictures than previously thought; boys and girls like different types of pictures; children like narrative pictures; pictures of childhood do not appeal to them; and taste changes from grade to grade.

Mouly, George J. THE SCIENCE OF EDUCATIONAL RESEARCH. New York: Van Nostrand Reinhold Co., 1970. 196 p.

National Art Education Association. COLLEGE AND UNIVERSITY ACCEP-TANCE OF HIGH SCHOOL ART CREDITS FOR ADMISSION. Washington, D.C.: 1968. Unpaged. Paper.

A list of colleges and universities that accept art credits toward admission.

National Education Association. MUSIC AND ART IN THE PUBLIC SCHOOLS. Washington, D.C.: 1963. 88 p.

A survey of more than 700 schools to determine who teaches music and art, what the facilities are like, the time allotted to each, and what the course of study contains.

National Research Center of the Arts. ARTS AND THE PEOPLE: A SURVEY OF PUBLIC ATTITUDE AND PARTICIPATION IN THE ARTS AND CULTURE IN NEW YORK STATE. New York: Cranford Wood, 1973. 24 p. Paper.

Perry, Kenneth Frederick. AN EXPERIMENT WITH A DIVERSIFIED ART PRO-GRAM. New York: Bureau of Publications, Teachers College, Columbia Uni-versity, 1943. 163 p. Biblio.

A study to isolate the basic problems in art teaching and a de-scription of how a school set about solving them. Areas covered are administration, workshop organization, and curriculum.

Rouse, Mary J. ART PROGRAMS IN NEGRO COLLEGES. Bloomington: Indiana University, 1967. 88 p. Paper.

A research report on a study to identify the most pressing problems of art education in Negro colleges.

_____. THE DEVELOPMENT OF A DESCRIPTIVE SCALE FOR ART PRODUCTS. Bloomington: School of Education, Indiana University, 1967. 42 p. Biblio. Paper.

A research study to identify and define characteristics usually thought to be present in most kinds of art products. It identified twenty characteristics.

Van Dalen, Deobold B. UNDERSTANDING EDUCATIONAL RESEARCH. New York: McGraw-Hill Book Co., 1966. 212 p.

Woodruff, Asahel D. PRECONFERENCE EDUCATION RESEARCH PROGRAM IN ART EDUCATION. Washington, D.C.: National Art Education Association, 1969. 38 p.

The preconference participants were concerned with behavioral change, research, training programs, and evaluation.

Chapter 17

MEASUREMENT

Burns, Robert C., and Kaufman, S. Harvard. ACTIONS STYLES AND SYM-
BOLISM IN KINETIC FAMILY DRAWINGS: AN INTERPRETIVE MANUAL.
New York: Brunner-Mazel Publishers, 1972. 304 p.

> Psychological interpretations of child art with a focus on children's
> drawings of family members in motion as a diagnostic tool.

Burt, Cyril. MENTAL AND SCHOLASTIC TESTS. London: P.S. King &
Sons, 1927.

> The drawing section contains an analysis of the reactions of chil-
> dren to form and color.

Christensen, Erwin O., and Karwoski, Theodore. A TEST IN ART APPRECIA-
TION: A PRELIMINARY REPORT. Art-Psychology Bulletin, no. 3. Grand
Forks: University of North Dakota, 1925. 77 p.

> This art-psychology research team found, among other things, that
> art appreciation is a matter of education. The test they used was
> developed to "measure native ability to appreciate art as well as
> the results of teaching." They intended the instrument to be used
> with elementary pupils but tested it on college students.

_____. A TEST IN ART APPRECIATION: SECOND REPORT. Art-Psychology
Bulletin, no. 4. Grand Forks: University of North Dakota, 1926. 76 p.

> The authors report on the results of further uses of the art appre-
> ciation test they devised in 1925.

Dennis, Wayne. GROUP VALUES THROUGH CHILDREN'S DRAWINGS. New
York: John Wiley and Sons, 1966. 147 p.

> Psychological interpretations of children's art.

Eng, Helga. THE PSYCHOLOGY OF CHILD AND YOUTH DRAWINGS. New
York: Humanities Press, 1957. Illus.

> The author traces the development of drawing from age nine to

twenty-four in an attempt to determine why and how one draws. She sees children's drawings as an expression of their mental development and discusses their drawings in relation to folk art.

_____. THE PSYCHOLOGY OF CHILDREN'S DRAWINGS FROM THE FIRST STROKE TO THE COLOURED DRAWING. 2d ed. London: Routledge and Kegan Paul, 1954. 223 p. Illus., part color.

Goodenough, Florence L. MEASUREMENT OF INTELLIGENCE BY DRAWING. New York: Harcourt, Brace & World, 1926. 177 p.

A scale for the measurement of intelligence by examination of a child's drawing of a man. A high degree of correlation was found with standard intelligence tests.

Harris, Dale B. CHILDREN'S DRAWINGS AS MEASURES OF INTELLECTUAL MATURITY: A REVISION AND EXTENSION OF THE GOODENOUGH DRAW-A-MAN TEST. New York: Harcourt, Brace & World, 1963. 367 p.

A restandardization of the Florence L. Goodenough scale plus a new Draw-A-Woman scale; survey of the literature relating to children's drawings; and a test manual. Accompanying the text are: "Goodenough-Harris Drawing Test"; "Manual for the Goodenough-Harris Drawing Test"; and "Quality Scale Cards."

Hautt, Max L. THE HAUTT ADAPTATION OF THE BENDER GESTALT TEST. 2d ed. New York: Grune and Stratton, 1969. 192 p.

Psychological interpretation of child art.

Kline, Linus Ward. THE KLINE-CAREY MEASURING SCALE FOR FREE HAND DRAWING. Baltimore, Md.: Johns Hopkins Press, 1958. 61 p. Biblio.

Koppits, Elizabeth M. THE BENDER GESTALT TEST FOR YOUNG CHILDREN. New York: Grune and Stratton, 1970. 187 p.

Psychological interpretation of child art.

_____. PSYCHOLOGICAL EVALUATION OF CHILDREN'S HUMAN FIGURE DRAWINGS. New York: Grune and Stratton, 1968. 341 p.

Landsman, Myril, and Dillard, Harry. EVANSTON EARLY IDENTIFICATION SCALE MANUAL. Chicago: Folletti Educational Corp., 1967. 48 p. Paper.

Lindquist, E.F., ed. EDUCATIONAL MEASUREMENT. Washington, D.C.: American Council on Education, 1951. 235 p.

Lindvall, C.M. MEASURING PUPIL ACHIEVEMENT AND APTITUDE. New York: Harcourt, Brace & World, 1967. 196 p.

McAdory, Margaret. THE CONSTRUCTION AND VALIDATION OF AN ART TEST. New York: Bureau of Publications, Teachers College, Columbia University, 1929. 35 p. Biblio.

A test designed to measure art appreciation.

Machover, Karen. PERSONALITY PROJECTION IN THE DRAWING OF THE HUMAN FIGURE: A METHOD OF PERSONALITY INVESTIGATION. Springfield, Ill.: Charles C. Thomson Co., 1957. 181 p.

_____. PSYCHOLOGICAL EVALUATIONS OF CHILDREN'S HUMAN FIGURE DRAWINGS. Springfield, Ill.: Charles E. Thomson Co., 1949. 110 p.

Manual, H.T. TALENT IN DRAWING: AN EXPERIMENTAL STUDY OF THE USE OF TESTS TO DISCOVER SPECIAL ABILITY. Bloomington, Ill.: Public School Publishing Co., 1919. 152 p.

Meier, Norman Charles. THE MEIER ART TESTS: 1: ART JUDGEMENT. Iowa City: University of Iowa, 1940. 100 p. Illus.

Slightly distorted reproduction of a painting alongside the same picture correctly printed. The object is to choose the real one.

Meier, Norman Charles, and Seashore, Carl E. THE MEIER-SEASHORE ART JUDGMENT TEST. Iowa City: University of Iowa, Bureau of Educational Research Service, 1928. 103 p.

Naumberg, Margaret. STUDIES OF THE FREE ART EXPRESSION OF BEHAVIOUR PROBLEM CHILDREN AND ADOLESCENTS AS A MEANS OF DIAGNOSIS AND THERAPY. New York: Coolidge Foundation Publications, 1947. 225 p. Illus.

Discusses the use of creative art products as diagnostic devices.

Oldham, Hilda Wally. CHILD EXPRESSION IN COLOUR AND FORM. London: John Lane, The Godley Head, 1940. 156 p. Illus.

Drawings as a register of a child's mental or emotional development. Includes a chapter on art and play.

Pelton, Robert. HANDWRITING AND DRAWINGS REVEAL YOUR CHILD'S PERSONALITY. New York: Hawthorne Publishing Co., 1973. 130 p. Illus.

Pressey, L.W., and Knauber, A.J. ART ABILITY TEST. Columbus: Ohio State University, 1927. 98 p.

Measurement

Psychological Corporation. THE MEASUREMENT OF ARTISTIC ABILITIES: A SURVEY OF SCIENTIFIC STUDIES IN THE FIELD OF GRAPHIC ARTS. New York: 1933. 90 p. Annotated biblio., 19 p. Paper.

Looks at art tests in use and discusses related research.

Remmlein, Madaline [Kintec]. THE MEASUREMENT OF ARTISTIC ABILITIES: A SURVEY. New York: Psychological Corp., 1933. 90 p. Biblio., pp. 74-90.

Describes the various tests developed concerning visual artistic ability.

Schildkrait, M. HUMAN FIGURE DRAWING IN ADOLESCENCE. New York: Brunner-Mazel, 1973. 260 p.

Drawing as an aid to diagnosing adolescent psychological problems.

Siceloff, Margaret [McAdory], and Woodyard, Ella. VALIDITY AND STANDARDIZATION OF THE MCADORY ART TEST. New York: Teachers College, Columbia University, 1933. 32 p.

Speer, Robert K. MEASUREMENT OF APPRECIATION IN POETRY, PROSE, AND ART, AND STUDIES IN APPRECIATION. New York: Bureau of Publications, Teachers College, Columbia University, 1929. 77 p.

Attempts to create an instrument to measure appreciative functions in elementary grade children.

Chapter 18

CURRICULUM BUILDING

Baumgarner, Alice A.D. CONFERENCE ON CURRICULUM AND INSTRUC-
TION DEVELOPMENT IN ART EDUCATION: A PROJECT REPORT. Washing-
ton, D.C.: National Art Education Association, 1967. 129 p. Illus. Paper.

> A report of the fall 1966 conference concerning the role of the
> arts and factors that effect change and instructional improvement
> in education.

Dement, L.W. HORACE MANN CURRICULUM. New York: Teachers Col-
lege, Columbia University, 1917. 18 p. Paper.

Devers, Diana Dee, ed. CHILDREN AND THE ARTS. Washington, D.C.: Office
of Education, Department of Health, Education and Welfare, 1967. 160 p.

> Summer workshops and curriculum development.

Diamond, Robert M., and Lindquist, Marlene H. PROGRAMMED ART IN ELE-
MENTARY AND SECONDARY SCHOOLS. Washington, D.C.: Office of Edu-
cation, Department of Health, Education and Welfare, 1968. 42 p.

> Curriculum development and evaluation in programmed art educa-
> tion.

Hardiman, George, and Zernica, T. CURRICULAR CONSIDERATIONS FOR
VISUAL ARTS EDUCATION. New York: Stipes, 1974. 26 p. Paper.

Kilpatrick, W.H. REMAKING THE CURRICULUM. New York: Newson Publi-
cations, 1936. 112 p.

Krug, Edward A. THE SECONDARY SCHOOL CURRICULUM. New York:
Harper and Brothers, 1960. 126 p.

Lester, Robert M. ART TEACHING EQUIPMENT FOR COLLEGES AND SEC-
ONDARY SCHOOLS. New York: Carnegie Corp., 1937. 31 p.

Discusses the fact that the Carnegie art teaching sets, first distributed in 1926, were still being used in the late 1930s.

Mattil, Edward L. A SEMINAR IN ART EDUCATION FOR RESEARCH AND CURRICULUM DEVELOPMENT. University Park: Pennsylvania State University, 1966. 445 p.

See entry on p. 135.

National Art Education Association. CURRICULUM GUIDES IN ART EDUCATION. Reston, Va.: 1975. 63 p.

A listing and description of curriculum guides for art, kindergarten through twelfth grade, from various school systems.

New York [State] University Bureau of Elementary Curriculum Development. ART APPRECIATION FOR ELEMENTARY SCHOOLS. Albany: 1968. 62 p. Illus.

Owatonna Art Education Project. ART UNITS FOR GRADES 1 TO 3. Minneapolis: University of Minnesota Press, 1944. 64 p. Biblio.

An art curriculum based on the home, clothes, farming, the school, American Indians, and machines.

_____. ART UNITS FOR GRADES 4 TO 6. Minneapolis: University of Minnesota Press, 1944. 67 p. Biblio.

These units from the Owatonna course of study are concerned with: the community, how to make a magazine, artists and industry, the medieval world, architecture, homes, and gardens. The bibliographies at the end of each chapter include books for both pupils and teachers.

_____. ART UNITS FOR THE HIGH SCHOOL: GRAPHIC ART. Minneapolis: University of Minnesota Press, 1944. 100 p. Biblio. (books and films). Paper.

These units written by Owatonna teachers and used in the project schools are presented philosophically, yet are practical. Areas covered are painting, photography, printing, and advertising.

_____. ART UNITS FOR THE HIGH SCHOOL: THE HOME. Minneapolis: University of Minnesota Press, 1944. 92 p. Biblio. (books and films). Paper.

Units of study about house, interior, and garden design.

_____. ART UNITS FOR THE HIGH SCHOOL: THE URBAN COMMUNITY. Minneapolis: University of Minnesota Press, 1944. 80 p. Biblio. (books and films). Paper.

These units are concerned with community planning, industrial design, and commercial architecture.

Peck, Ruth L., and Aniello, Robert S. WHAT CAN I DO FOR AN ART LES-
SON? A PRACTICAL GUIDE FOR THE ELEMENTARY CLASSROOM TEACHER.
West Nyack, N.Y.: Parker Publishing Co., 1966. 224 p. Illus. Index.

Art lessons using standard media for kindergarten through grade six.

Prang Company. THE PRANG COURSE IN ART EDUCATION FOR PRIMARY,
INTERMEDIATE AND GRAMMAR SCHOOLS. Boston: Prang Educational Co.,
1893. 45 p. Illus. Paper.

Directed to teachers, this book presents a simple art curriculum
dealing for the most part with drawing. Some attention is paid to
modelling, color, and "making."

Prang, Louis; Hicks, Mary Dana; and Clark, John S. COLOR INSTRUCTION:
SUGGESTIONS FOR A COURSE OF INSTRUCTION IN COLOR FOR PUBLIC
SCHOOLS. Boston: Prang Educational Co., 1893. 187 p. Illus.

Suggested color exercises (using specific colors at specified times
of the year) for grades one through seven.

Rice, Norman L. PREPARATORY STUDY FOR A HIGH SCHOOL CURRICULUM
IN THE FINE ARTS FOR ABLE STUDENTS. Pittsburgh: Carnegie Institute of
Technology, 1964. 21 p. Paper.

The report of a study to develop a rationale and suggest a series
of courses for a five-year fine arts program for gifted high school
students.

Smith, Ralph Alexander. THE ARTS AND CAREER EDUCATION: TOWARD
CURRICULUM GUIDELINES. Urbana: University of Illinois Bureau of Edu-
cational Research, 1974. 65 p. Paper.

Curriculum development for career guidance in the fine arts.

Taylor, Frank D.; Artuso, Alfred A.; and Hewett, Frank M. CREATIVE ART
TASKS FOR CHILDREN. Denver, Colo.: Zone Publishing Co., 1970. Paper.

See entry on p. 207.

Tompkins, A. George. PASTEL FOR THE STANDARDS. London: Sir Isaac
Pitman & Sons, 1928. 85 p. Illus., color.

A two-year drawing course in using pastels.

Whitford, William Garrison. EDUCATION 274: INTRODUCTION TO THE
TEACHING OF ART. Chicago: University of Chicago, 1934. 41 p. Biblio.

Outline of an influential art education course.

_____. WHAT IS ART AND WHY SHOULD IT BE IN THE SCHOOL CURRIC-ULUM? New York: Related Arts Service, 1946. 18 p.

A brief discussion of what constitutes art and an analysis of an art curriculum.

Chapter 19

CREATIVITY AND CREATIVE DEVELOPMENT

Abt, Lawrence Edwin, and Rosner, Stanley, eds. CREATIVE EXPERIENCE.
New York: Dell Publishing Co., 1972. 112 p. Index. Biblio. Paper.

Six scholars (Arnheim, Henle, Deutsch, Drews, Hoptroder, and
Slochowner) examine creativity, each from the vantage point of
his own professional specialty; aesthetic, cognitive, developmental,
humanistic, philosophical, and psychoanalytic. The editors trace
ideas common to all in a concluding chapter.

Anderson, Harold H., ed. CREATIVITY AND ITS CULTIVATION. New York:
Harper and Row Publishers, 1959. 135 p. Paper.

Andrews, Michael F., ed. AESTHETIC FORM AND EDUCATION. Syracuse,
N.Y.: Syracuse University Press, 1958. 105 p. Illus. Biblio.

Essays by Fanger, Hausman, Shiselin, Taylor, and others from the
fields of art and art education on creativity. Contains photographs
of the authors.

Barkan, Manual, and Mooney, Ronald L. THE CONFERENCE ON CREATIVITY:
A REPORT TO THE ROCKEFELLER FOUNDATION. Columbus: Ohio State Uni-
versity Press, 1953. 87 p. Paper.

Beittel, Kenneth R. EFFECT OF SELF-REFLECTIVE TRAINING IN ART ON
THE CAPACITY FOR CREATIVE ACTION. Washington, D.C.: National Art
Education Association, 1968. 16 p. Paper.

A report of the author's study of "strategies" of behavior in artistic
production.

Brittain, W. Lambert, ed. CREATIVITY AND ART EDUCATION. Washington,
D.C.: National Art Education Association, 1964. 146 p. Biblio.

Lowenfeld, Taylor, Torrance, Beittel, Burkhart, and others have
written twelve articles from STUDIES IN ART EDUCATION that
illustrate research dealing with creativity in art.

_____. VIKTOR LOWENFELD SPEAKS ON ART AND CREATIVITY. Washington, D.C.: National Art Education Association, 1970. 64 p. Paper.

Lowenfeld's speeches about the importance of individuality and art expression published after the author's death.

Burkhart, Robert Christopher. SPONTANEOUS AND DELIBERATE WAYS OF LEARNING. Scranton, Pa.: International Textbook Co., 1962. 112 p. Illus.

Burton, William, and Heffernan, Helen. THE STEP BEYOND: CREATIVITY. Washington, D.C.: National Art Education Association, 1964. 64 p. Paper.

The authors distinguish between creativity and discovery and relate expression with personality.

Butler, Reginald Cotterell. CREATIVE DEVELOPMENT: FIVE LECTURES TO ART STUDENTS. New York: Horizon Press, 1963. 88 p.

Essays about the way creative development occurs first delivered at the Slade School, London, in 1961. Butler suggests the sequence of conditions he considers advantageous for the artist's growth, considers the dangers of historical knowledge and explains how the plastic arts differ from other arts.

Cary, Joyce. ART AND REALITY: WAYS OF THE CREATIVE PROCESS. Garden City, N.Y.: Doubleday and Co., 1961. 210 p.

Caudwell, Howard. THE CREATIVE IMPULSE IN WRITING AND PAINTING. London: Macmillan and Co., 1951. 118 p. Illus.

Eisner, Elliot W. THINK WITH ME ABOUT CREATIVITY. Dansville, N.Y.: F.A. Owen Publishing Co., 1964. 46 p. Biblio.

Eisner discusses research studies that show what progress has been made in fields relevant to art teaching.

Getzels, Jacob W., and Csikszentmihalyi, Milhaly. CREATIVE THINKING IN ART STUDENTS; AN EXPLORATORY STUDY. Chicago: University of Chicago, 1964. 202 p. Illus. Biblio., pp. 140-55.

The authors were interested in defining the artist's function in society and the role creativity plays. Among other things they found that art education students differ in value orientation and personality characteristics from other art students.

Getzels, Jacob W., and Jackson, Philip. CREATIVITY AND INTELLIGENCE. New York: John Wiley and Sons, 1963. 124 p.

Compares children who are highly creative to ones with a high
I.Q. The results indicate that creative ability and high I.Q. are
by no means the same. Includes case studies.

Griffiths, Richard. A STUDY OF IMAGINATION IN EARLY CHILDHOOD;
AND ITS FUNCTION IN MENTAL DEVELOPMENT. London: Kegan Paul,
1945. 96 p.

Hyman, Ray. CREATIVITY AND THE PREPARED MIND. Introduction by Man-
ual Barkan. Washington, D.C.: National Art Education Association, 1965.
32 p.

Institute of Contemporary Art. CONFERENCE ON CREATIVITY AS A PRO-
CESS. Boston: 1956. 94 p. Illus. Biblio., pp. 12-14.

Kubie, Lawrence. NEUROTIC DISTORTIONS OF THE CREATIVE PROCESS.
New York: Noonday Press, 1961. 132 p. Paper.

Lowenfeld, Viktor, ed. THE MEANING OF CREATIVITY. Kutztown, Pa.:
Eastern Arts Association, State Teachers College, 1954. 27 p. Paper.

A research bulletin with articles about creativity by J. P. Guil-
ford, Herbert Read, Lambert Brittain, Kenneth Beittel, Ernest
Ziegfeld, and others.

Lytton, Hugh. CREATIVITY AND EDUCATION. New York: Schocken Books,
1972. 133 p. Biblio.

Contains articles by Guilford, Jung, Koestlers, Kubie, MacKinnan,
Trilling, and others. There is a section called "Madness and
Genius" in which the author suggests that contrary to popular
belief, psychotherapy may increase creativity. Also there is a
comparison of artistic and scientific creativity, and a discussion
of convergent and divergent thinking.

MacLeish, Archibald. ART EDUCATION AND THE CREATIVE PROCESS. New
York: Museum of Modern Art, 1954. 11 p. Paper.

The author feels that education cannot produce creative artists.

Miel, Alice. CREATIVITY: INVITATIONS AND INSTANCES. Belmont, Calif.:
Wadsworth Publishing Co., 1961. 69 p.

Milner, Marion. ON NOT BEING ABLE TO PAINT. Foreword by Anna
Freud. New York: International Universities Press, 1967. 184 p. Illus. In-
dex. Biblio.

A personal narrative of the author's quest for creative involvement in painting. It is an open, honest account written with great sensitivity and feeling.

Osborn, Alex F. APPLIED IMAGINATION: PRINCIPLES AND PROCEDURES OF CREATIVE THINKING. New York: Charles Scribner's Sons, 1957. 132 p.

Rugg, Harold F. IMAGINATION. New York: Harper and Row Publishers, 1963. 262 p. Illus. Biblio.

Stein, Morris I., and Heinze, Shirley J. CREATIVITY AND THE INDIVIDUAL. Glencoe, Ill.: Free Press, 1960. 67 p.

Tolces, Toska [Sadie]. CREATIVE DISCIPLINES, EXPLORATIONS IN AWARE-NESS. Portland, Maine: Bond Wheelwright Co., 1956. 115 p.

A statement of her personal art teaching philosophy, this book by a musician stresses creative development through the use of materials. Includes sections about artists working habits illustrated through their writings, the teachers task, and a case study tracing creative growth of a child studying piano.

Tomas, Vincent, ed. CREATIVITY IN THE ARTS. Englewood Cliffs, N.J.: Prentice-Hall, 1964. 210 p. Index.

Torrance, Ellis Paul. EDUCATION AND THE CREATIVE POTENTIAL. Minneapolis: University of Minnesota Press, 1964. 147 p. Index. Biblio.

The author discusses children's creativity; conditions for creative growth, mental health problems of highly creative children, creativity influenced by culture, and religion and creative thinking.

_____. GUIDING CREATIVE TALENT. Englewood Cliffs, N.J.: Prentice-Hall, 1962. 110 p. Biblio. Index.

The author uses the MINNESOTA TESTS OF CREATIVE THINKING to identify creative talent and suggests original approaches for handling problems in creative thinking.

_____. REWARDING CREATIVE BEHAVIOR: EXPERIMENTS IN CLASSROOM CREATIVITY. Englewood Cliffs, N.J.: Prentice-Hall, 1965. 353 p. Index. Biblio.

Torrance, Ellis Paul, and Myers, Richard E. CREATIVE LEARNING AND TEACHING. New York: Dodd, Mead and Co., 1970. 343 p.

Suggests that creative teaching causes creative learning.

Weems, Barbara L. CREATIVITY AND ART; A REVIEW OF THE LITERATURE. Philadelphia: Philadelphia Museum College of Art, Department of Art Education, 1964. 87 p. Paper.

Weismann, Donald L. LANGUAGE AND VISUAL FORM. Austin: University of Texas Press, 1968. 122 p. Illus., color.

> An interesting record of the personal act of creation being ex-. amined and recorded as it occurs when the artist worked simultaneously in painting and writing.

Wilt, Miriam Elizabeth. CREATIVITY IN THE ELEMENTARY SCHOOL. New York: Appleton-Century-Crofts, 1959. 72 p. Illus. Index. Biblio. Paper.

> Discusses creative expression (in terms of the visual arts, writing, and music) as a means of communication. The author presents a point of view in this "non-methods" book and points out common denominators of various creative endeavors, i.e., readiness, activities, media, and self-evaluation.

Yochim, Louise Dunn. PERCEPTUAL GROWTH IN CREATIVITY. Scranton, Pa.: International Textbook Co., 1967. 265 p. Illus. Index. Glossary. Biblio.

> A study of creativity in the visual arts, and the teacher's role. Includes an analysis of paintings as criteria for evaluation of children's growth, and a review of the literature about creativity.

Chapter 20

EXCEPTIONAL AND DISADVANTAGED CHILDREN

Alkema, Chester Jay. ART FOR THE EXCEPTIONAL. Boulder, Colo.: Pruett Publishing Co., 1971. 100 p. Index. Biblio.

Using art with handicapped children.

Andersen, Linda. CLASSROOM ACTIVITIES FOR HELPING PERCEPTUALLY HANDICAPPED CHILDREN. New York: Center for Applied Research in Education, 1974. 61 p. Illus. Biblio.

The nature of perception and learning are discussed. Suggests specific activities for specific needs.

Barclay, Doris L. ART EDUCATION FOR THE DISADVANTAGED CHILD. Washington, D.C.: National Art Education Association, 1969. 30 p. Illus. Biblio. Paper.

Includes articles by anthropologists, educators, and psychiatrists about using art to help disadvantaged children reprinted from 1968 and 1969 issues of the National Art Education Association publication, ART EDUCATION.

Bloom, Benjamin S.; Davis, Allison; and Hess, Robert. COMPENSATORY EDUCATION FOR CULTURAL DEPRIVATION. New York: Holt, Rinehart, and Winston, 1965. 126 p. Index.

Chicago, University of. School of Education. Urban Child Center. THE USE OF ART IN CONTEMPORARY EDUCATION PROJECTS, AN INVENTORY. Chicago: University of Chicago Press, 1966. 111 p. Biblio.

Defines the culturally disadvantaged and their visual experience and suggests that art activities are a good means of education. There is a list of programs in operation across the country and sample lesson plans.

Cohen, Harold L. MEASURING THE CONTRIBUTION OF THE ARTS IN THE EDUCATION OF DISADVANTAGED CHILDREN. Washington, D.C.: Office of Education, Department of Health, Education and Welfare, 1968. 192 p.

Behavioral objectives are stressed in this research report.

Eisner, Elliot. A COMPARISON OF THE DEVELOPMENTAL DRAWING CHAR-
ACTERISTICS OF CULTURALLY ADVANTAGED AND CULTURALLY DISADVAN-
TAGED CHILDREN. Washington, D.C.: Office of Education, Department of
Health, Education and Welfare, 1967. Illus.

Gaitskell, Charles D., and Margaret R. ART EDUCATION FOR SLOW LEAR-
NERS. Peoria, Ill.: Charles A. Bennett Co., 1953. 46 p. Illus. Paper.

Based on a three-year study involving 575 retarded children, this
pamphlet discusses art education and presents observations and con-
clusions about using art with slow learners.

Havighurst, Robert J. A SURVEY OF THE EDUCATION OF GIFTED CHIL-
DREN. Supplementary Educational Monograph, no. 83. Chicago: University
of Chicago, 1955. 36 p. Paper.

Lindsay, Zaidee. ART AND THE HANDICAPPED CHILD. New York: Van
Nostrand Reinhold Co., 1972. 140 p. Illus.

Art activities for children with learning disabilities.

_____. ART IS FOR ALL; ARTS AND CRAFTS FOR LESS ABLE CHILDREN.
New York: Taplinger Publishing Co., 1968. 111 p. Illus.

Printing, sculpture, sewing, painting, and other art related activi-
ties with exceptional children.

Lisenco, Yasha. ART NOT BY EYE. New York: American Foundation for the
Blind, 1971. 114 p. Illus. Biblio. Paper.

Using art to work with blind children and adults is discussed.

McFee, June King. CREATIVE PROBLEM SOLVING ABILITIES IN ART OF
ACADEMICALLY SUPERIOR ADOLESCENTS. Washington, D.C.: National Art
Education Association, 1968. 23 p.

Mooney, Ross L., and Smilansky, Sara. AN EXPERIMENT IN THE USE OF
DRAWING TO PROMOTE COGNITIVE DEVELOPMENT IN DISADVANTAGED
PRESCHOOL CHILDREN IN ISRAEL AND THE UNITED STATES. Washington,
D.C.: National Center for Educational Research and Development, 1973.
200 p.

A cross-cultural study of disadvantaged preschool children in which
art activities were the methods used to stimulate cognitive devel-
opment.

Murphy, Judith, and Gross, Ronald. THE ARTS AND THE POOR. Washington, D.C.: Department of Health, Education and Welfare, 1968. 42 p. Paper.

> Conference papers and speeches, transcripts and panel discussions, summaries of projects, and reports of work groups about art and the poor.

National Art Education Association. ART FOR THE ACADEMICALLY TALENTED STUDENT. Washington, D.C.: 1961. 112 p.

National Education Association. THE IDENTIFICATION AND EDUCATION OF THE ACADEMICALLY TALENTED STUDENT IN THE AMERICAN SECONDARY SCHOOL. Report of the Invitational Conference on the Academically Talented Secondary School Pupil. Washington, D.C.: 1958. 46 p. Paper.

National Education Association, and American Association of School Administrators. Educational Policies Commission. EDUCATION OF THE GIFTED. Washington, D.C.: 1950. 112 p.

National Society for the Study of Education. EDUCATION FOR THE GIFTED. Fifty-seventh yearbook, part 2. Chicago: University of Chicago Press, 1958. 78 p.

New York. State University of. Bureau of Secondary Curriculum Development. FIFTY-SIX PRACTICES FOR THE GIFTED FROM SECONDARY SCHOOLS OF NEW YORK. Albany: 1958. 98 p. Biblio.

Pattemore, Arnel W. ART AND CRAFTS FOR SLOW LEARNERS. New York: Instructor Publications, 1969. 48 p. Paper.

Randall, Arne W. ART FOR EXCEPTIONAL CHILDREN. Lubbock, Tex.: ABC Letter and Printing Service, 1956. 104 p. Biblio.

> There is a chapter on gifted children in this book about handicapped and mentally retarded children.

Rose, Hanna Toby. A SEMINAR ON THE ROLE OF THE ARTS IN MEETING THE SOCIAL AND EDUCATIONAL NEEDS OF THE DISADVANTAGED. Washington, D.C.: Department of Health, Education and Welfare, 1967. 286 p.

> An exploration of the relationships between the arts and poverty. Existing programs are examined and recommendations are made for action in the future.

Scheifele, Marian. THE GIFTED CHILD IN THE REGULAR CLASSROOM; PRACTICAL SUGGESTIONS FOR TEACHING. New York: Teachers College, Columbia University, 1953. 110 p.

Severino, D. Alexander. IDENTIFYING AND MOTIVATING THE CHILD GIFTED IN ART. Cincinnati, Ohio: National Association for Gifted Children, 1959. 7 p. Biblio. Paper.

Silver, Rawley A. A DEMONSTRATION PROJECT IN ART EDUCATION FOR DEAF AND HARD OF HEARING CHILDREN AND ADULTS. New York: Society for the Deaf, 1967. 66 p. Paper.

Silverman, Ronald H., and Hoepfner, Ralph. DEVELOPING AND EVALUATING ART CURRICULA SPECIFICALLY DESIGNED FOR DISADVANTAGED YOUTH. Washington, D.C.: Office of Education, Department of Health, Education and Welfare, 1969. 97 p.

Steinhoff, Carl R. SUMMER PROGRAM IN MUSIC AND ART FOR DISADVAN-TAGED PUPILS IN PUBLIC AND NON-PUBLIC SCHOOLS. New York: Center for Urban Education, 1966. 39 p. Paper.

Sykes, Kim C. CREATIVE ARTS AND CRAFTS FOR CHILDREN WITH VISUAL HANDICAPS. Louisville, Ky.: American Printing House for the Blind, 1974. 48 p.

Art content activities for visually handicapped children; and lesson guides for teachers.

Taba, H., and Elkins, D. TEACHING STRATEGIES FOR THE DISADVANTAGED. Chicago: Rand McNally and Co., 1966. 48 p. Paper.

Trevor-Roper, Patrick. THE WORLD THROUGH BLUNTED SIGHT. New York: Bobbs-Merrill Co., 1970. 191 p. Illus. Index. Biblio.

This record of attempts to trace the influence of altered vision on personality should be of interest to teachers.

Uhlin, Donald M. ART FOR EXCEPTIONAL CHILDREN. Dubuque, Iowa: William C. Brown, 1973. 160 p. Paper.

Art as a tool to sensitize and promote child growth.

Wedermeyer, Avaril, and Cejka, Joyce. CREATIVE IDEAS FOR TEACHING EX-CEPTIONAL CHILDREN. Denver, Colo.: Lane Publishing Co., 1970. 110 p. Paper.

This book, whose authors teach handicapped children, contains about a hundred projects that teachers can use in the classroom.

Ziegfeld, Edwin, ed. ART FOR THE ACADEMICALLY TALENTED STUDENT IN THE SECONDARY SCHOOL. Washington, D.C.: National Art Education As-sociation, 1961. 112 p. Biblio. Paper.

This report of a 1959 conference on academically talented adoles-

cents discusses the nature of art and the importance of including it in the school program for academically talented students. It also contains suggested activities for program planning and curriculum outlines of some experimental programs.

Chapter 21

ART APPRECIATION

Aiken, Henry David. LEARNING AND TEACHING IN THE ARTS. NAEA Research Monograph, no. 4. Washington, D.C.: National Art Education Association, 1970. 30 p. Paper.

See entry on p. 133.

Bacon, Dolores. PICTURES EVERY CHILD SHOULD KNOW. New York: Doubleday, Page and Co., 1908. 132 p. Illus.

Bailey, Henry Turner. PLEASURE FROM PICTURES. Chicago: American Library Association, 1926. 112 p. Illus.

Baily, Harriet Thorpe. REPORT OF THE COURSE IN APPRECIATION OF GERMAN, ENGLISH AND FRENCH PAINTING GIVEN BY MISS ABBOTT AT THE METROPOLITAN MUSEUM OF ART. New York: 1933. 86 p. Biblio., p. 3.

Beatty, John W. APPRECIATION OF ART FOR YOUNG PEOPLE. Pittsburgh: Carnegie Institute, 1917. 196 p. Illus.

Bennett, Charles Alpheus. ART TRAINING FOR LIFE AND FOR INDUSTRY. Peoria, Ill.: Manual Arts Press, 1923. 61 p.

Art appreciation and industry.

Berlin Photographic Co. ART IN THE SCHOOLROOM. New York: 1902. 16 p. Illus. Paper.

Emphasizes the importance of art appreciation in the curriculum.

Berry, Ana M. FIRST BOOK OF PAINTINGS. New York: Franklin Watts, 1960. 64 p. Illus.

_____. UNDERSTANDING ART. New York: Studio Publications, 1952. 136 p. Illus.

Contains essays about art principles, vision, realism, Oriental art, and sculpture.

Branch, John E. PICTURE STUDY IN SCHOOLS. Sydney, Aust.: William Applegate Gullick, 1913. 84 p. Illus. Paper.

Reproductions of paintings and brief discussions of the artists for teacher use in class.

Caffin, Charles H. A CHILD'S GUIDE TO PICTURES. New York: Baker and Taylor Co., 1908. 64 p.

_____. HOW TO STUDY PICTURES. New York: Century Co., 1906. 110 p.

Casey, William C. MASTERPIECES IN ART. Chicago: A. Flanagan Co., 1915. 258 p.

This art appreciation manual for elementary teachers is interesting historically. The fact that picture study warranted a book, when none on art work was available, as well as the author's choice of pictures, tells us a great deal about art education priorities.

Collins, Frank Henry. PICTURE STUDY: A MANUAL FOR TEACHERS. New York: Brown-Robertson Co., 1923. 60 p. Biblio.

A history of painting and biographical notes about artists by the author who was then director of drawing for New York City public schools.

Cox, George James. ART FOR AMATEURS AND STUDENTS. 2d ed. Garden City, N.Y.: Doubleday, Doron & Co., 1931. 207 p.

This art appreciation for the layman is historically interesting in that it is based on Arthur Dow's "Composition."

DeLong, Patrick D. ART IN THE HUMANITIES. Englewood Cliffs, N.J.: Prentice-Hall, 1970. 158 p. Index. Paper.

A general art appreciation textbook with a chapter about art and play.

Ecker, David W. IMPROVING THE TEACHING OF ART APPRECIATION. Columbus: Ohio State University Research Foundation, 1966. 340 p. Illus.

In addition to course descriptions and discussions of classroom techniques, there is a history of art appreciation in the public schools by Bob Saunders. The author's central concerns were teaching methods and developing curriculum in this research study.

Emery, Martin S. HOW TO ENJOY PICTURES. Boston: Prang Educational Co., 1898. 86 p. Illus.

Farnum, Royal Bailey. EDUCATION THROUGH PICTURES: THE TEACHER'S GUIDE TO PICTURE STUDY. New York: Art Extension Society, 1928. 132 p. Biblio.

> The author gives reasons for using reproductions of art works, and suggests questions the teacher can ask children about them.

_____. LEARNING MORE ABOUT PICTURES: A TEACHER'S HANDBOOK OFFERING A COMPLETE PROGRAM OF ART APPRECIATION, WITH SPECIAL EMPHASIS ON THE REQUIREMENTS OF ELEMENTARY EDUCATION. Rev. ed. Westport, Conn.: Artext Prints, 1957. 100 p. Illus. Biblio., p. 100.

Faulkner, Roy Nelson; Ziegfeld, Edwin; and Hill, Gerald. ART TODAY: AN INTRODUCTION TO THE FINE AND FUNCTIONAL ARTS. 4th ed. New York: Holt, Rinehart and Winston, 1964. 567 p. Illus. Index. Annotated biblio. Glossary.

> This tightly-organized art appreciation book for college use discusses art in terms of art and design objects, the use of materials, and man's reaction to the work. The end of each chapter contains an annotated bibliography.

Hastie, W. Reid, and Schmidt, Christian. ENCOUNTER WITH ART. New York: McGraw-Hill Book Co., 1969. 463 p. Illus., color. Index. Biblio.

> This art appreciation book for college students takes an interdisciplinary approach and the contemporary scene is taken as a starting point for showing art as a product of the age and culture in which it was created. Discusses how the artist sees the world, how he works, creativity, and evaluation of art.

Hayward, F. Howard. THE LESSON IN APPRECIATION. New York: Macmillan, 1922. 102 p.

Heckman, Albert William. PAINTINGS OF MANY LANDS AND AGES. Westport, Conn.: Art Extension Press, 1925. 70 p. Paper.

> An art appreciation "picture study" course.

Hurll, Estelle May. HOW TO SHOW PICTURES TO CHILDREN. New York: Houghton Mifflin Co., 1914. 138 p. Illus. Biblio.

> Addressed to mothers and teachers, this book explores the ways pictures may be used to enrich a child's life. One chapter describes a game called "picture-posing."

Kibbie, Delia E., et al. PICTURE STUDY FOR ELEMENTARY SCHOOLS. Eau Claire, Wis.: Eau Claire Book and Stationery Co., 1928. 126 p.

Klar, Walter Hughes, and Dillaway, Theodore M. THE APPRECIATION OF PICTURES. New York: Brown-Robertson, 1930. 117 p.

> Discusses pictorial elements and presents a series of art appreciation lessons for grades one through twelve.

Knobler, Nathen. THE VISUAL DIALOGUE: AN INTRODUCTION TO THE APPRECIATION OF ART. New York: Holt, Rinehart and Winston, 1967. 342 p. Illus., some color. Index. Biblio., pp. 335-37.

> Art is seen as a language of communication in this art appreciation text for college students.

Kuh, Katherine. ART HAS MANY FACES. New York: Harper & Brothers Publishers, 1951. 185 p. Illus., some color.

> A thoughtful art appreciation book for college use written from the point of view of the artist's use of materials and environmental influences.

Lafarge, John. GREAT MASTERS. Freeport, N.Y.: Books for Libraries Press, 1968. 249 p. Illus.

> Lives of seven artists including Houkusai.

Lowe, Florence. ART EXPERIENCES: STUDIES FOR FIFTH GRADE ART APPRECIATION. Austin: University of Texas, 1935. 92 p. Biblio., pp. 81-82.

_____. FIFTY STUDIES FOR ELEMENTARY ART APPRECIATION. Austin: University of Texas, 1933. 62 p. Biblio.

_____. PICTURE STUDY IN ELEMENTARY GRADES. Austin: University of Texas, 1936. 43 p. Paper.

Lowery, Bates. THE VISUAL EXPERIENCE. Englewood Cliffs, N.J.: Prentice-Hall, 1961. 272 p. Illus. Index.

> This art appreciation book for college students discusses art from the points of view of the observer, the artist, and the critic.

Myers, Bernard. LESSONS IN APPRECIATION. Jersey City, N.J.: National Committee for Art Appreciation, 1937. 116 p.

Neale, Oscar W. PICTURE STUDY IN THE GRADES. Stevens Point, Wis.: O.W. Neale Publishing Co., 1925. 447 p. Illus.

Language lessons are suggested for use in connection with each picture shown the children.

Orr, Jeanne. A DEVELOPMENTAL CONFERENCE TO ESTABLISH GUIDELINES FOR PILOT PROGRAMS FOR TEACHING THE CONCEPTS OF ART APPRECIATION WHICH ARE BASIC IN THE GENERAL EDUCATION OF ALL PUBLIC SCHOOL STUDENTS. Columbus: Ohio State University Press, 1967. 118 p.

Pepper, Stephen Coburn. PRINCIPLES OF ART APPRECIATION. New York: Harcourt Brace, 1949. 326 p. Illus., part color.

Stresses pleasure in art. The section on the psychology of art appreciation should be of interest to art teachers.

Plummer, Gordon S. CHILDREN'S ART JUDGMENT: A CURRICULUM FOR ELEMENTARY ART APPRECIATION. Dubuque, Iowa: Wm. C. Brown Co., 1974. Illus. Index. Biblio. Paper.

Specific suggestions for art appreciation lessons. Contains bibliographies of books, visual resources, and publishers.

Smith, Janet K. DESIGN: AN INTRODUCTION. New York: Ziff-Davis Publishing Co., 1946. 170 p. Index. Biblio. Glossary.

An art appreciation book for college students which attempts to define art and discusses its elements. There is a section on child art.

Stephenson, Sam C. PICTURE STUDIES REQUIRED BY COURSES OF STUDY FOR ELEMENTARY SCHOOLS. Lincoln, Nebr.: Lincoln School Supply Co., 1925. 159 p. Illus.

Selected paintings for children in grades one through eight, with a biography of the artist, and questions about the pictures.

Whitford, William Garrison, and Liek, Edna B. ART APPRECIATION FOR CHILDREN. New York: Scott, Foresman & Co., 1936. 224 p. Index. Annotated biblio.

An art appreciation course including lesson plans.

Wilson, Lucy Langdon Williams. PICTURE STUDY IN THE ELEMENTARY SCHOOLS: PART 1, PRIMARY GRADES. London: Macmillan and Co., 1909. 190 p. Illus.

A teacher's manual for a picture study textbook.

Chapter 22

RELIGION

Barbour, Russell B., and Barbour, Ruth. RELIGIOUS IDEAS FOR ARTS AND CRAFTS. Philadelphia: Christian Education Press, 1959. 95 p. Illus. Index. Biblio. Paper.

> Discusses the role of art in religion and religious education along with suggested art projects for children.

Boeve, Edgar. CHILDREN'S ART AND THE CHRISTIAN TEACHER. St. Louis, Mo.: Concordia Publishing House, 1966. 200 p. Illus. Index. Biblio.

> Explores the principles and history of Christian art education as well as examines the physical and psychological prerequisites for art education. Other areas discussed are classrooms and school display, motivation, classroom problems, evaluation, and sequence in art education.

Jewish Education Committee. ART IN OUR CLASSROOMS. New York: 1963. 98 p. Illus.

> Multi-media and transparencies are discussed as well as other art experiences for children in this book dealing with art in Jewish education.

Newport, Sister Esther, ed. CATHOLIC ART EDUCATION: THE NEW TRENDS. Washington, D.C.: Catholic University of America, 1958. 214 p. Biblio. Paper.

> Proceedings of a workshop where Viktor Lowenfeld talked about evaluation of art activities.

Zimmer, Sister Augusta. ART IN CATHOLIC SECONDARY EDUCATION: THE PROCEEDINGS OF THE WORKSHOP ON ART IN CATHOLIC SECONDARY SCHOOLS. Washington, D.C.: Catholic University of America Press, 1953. 189 p. Illus. Biblio.

> Papers by Catholic art educators about the Catholic philosophy of art, shaping character through the arts, symbolism, and other areas of art taught in Catholic high schools.

_____ . ART TODAY IN CATHOLIC SECONDARY EDUCATION: THE PRO-
CEEDINGS OF THE WORKSHOP ON ART IN CATHOLIC SECONDARY
SCHOOLS. Washington, D.C.: Catholic University of America Press, 1954.
202 p. Biblio.

> A collection of conference papers about silk screen, design, draw-
> ing, watercolor, spiritual growth, Catholic philosophy in advertising
> art, and other topics.

Chapter 23
ART TEACHER EXAMINATIONS
AND CAREER GUIDANCE

ART TEACHER EXAMINATIONS

Arco Publishing Co. TEACHER OF FINE ARTS: HIGH SCHOOL AND JUNIOR
HIGH SCHOOL. New York: 1966. Unpaged.

A cram book for the art teacher's license examination, both regu-
lar and substitute.

Great Britian. Board of Education. ART EXAMINATION PAPERS AND EX-
AMINERS'S REPORTS. London: His Majesty's Stationery Office, 1915-- . Paper.

_____ . EXAMINATION PAPERS AND EXAMINER'S REPORTS FOR THE ART
EXAMINATIONS, 1912/1914. London: His Majesty's Stationery Office,
1913. 65 p.

General examinations on art and industrial art.

Great Britain. Department of Education and Science. EXAMINATION IN
ART: QUESTION PAPERS. London: His Majesty's Stationery Office, n.d.
Illus.

The title varies. There are one hundred ninety-one examinations
in art, examiners reports, awards, and examination papers. There
is a separate booklet for each year.

1915-1917	1949-1950-1951-1952-1953
1923-1925	1954-1955-1956
1927-1928	1957-1958-1959-1960
1930-1932-1933	1961-1962-1963
1934-1935-1936	1964-1965-1966
1937-1938	1967-

CAREER GUIDANCE

Barkin, Leonard. CAREERS IN ART. Buffalo, N.Y.: Rochester Institute of
Technology, 1962. 112 p.

Bawen, William Thomas. ART AS A VOCATION. Report of a conference called by the U.S. Commissioner of Education and held in cooperation with the annual convention of the American Federation of Arts at St. Louis, Mo., May 22, 1923. Washington, D.C.: Government Printing Office, 1923. 18 p. Biblio.

Biegeleisen, Jacob I. CAREERS IN COMMERCIAL ART. New York: E.P. Dutton and Co., 1952. 124 p.

Farnum, Royal Bailey. THE FINE AND APPLIED ARTS. Rev. ed. Cambridge, Mass.: Bellman Publishing Co., 1958. 39 p. Illus. Paper.

> This pamphlet describes what professional and commercial artists do. There is a section on education and an art school directory. The first edition was published in 1941.

Greenleaf, Walter James. GUIDANCE LEAFLETS: ART. U.S. Office of Education Leaflet no. 20. Washington, D.C.: Government Printing Office, 1932. 13 p. Illus.

_____. OCCUPATIONS AND CAREERS. New York: McGraw-Hill Book Co., 1955. 232 p.

Holden, Donald. ART CAREER GUIDE: A GUIDANCE HANDBOOK FOR ART STUDENTS, TEACHERS, VOCATIONAL COUNSELORS AND JOB HUNTERS. New York: Watson-Guptill Publications, 1973. 304 p. Index.

> Written for high school students, this book gives the prospective art student a good basic feeling of the art world, including art teaching. Contains a school directory.

Institute for Research. ART AS A CAREER. Chicago: 1940. Unpaged. Illus. Paper.

> Describes various jobs in the visual arts.

JOBS IN ART. Chicago: Science Research Associates, 1966. 118 p.

Lariar, Lawrence. CAREERS IN CARTOONING. New York: Dodd, Mead and Co., 1950. 97 p.

Levy, Florence Nightingale. ART EDUCATION IN THE CITY OF NEW YORK. New York: School Art League, 1938. 148 p.

> A study made for guidance purposes of all art education activities in New York City. Included are W.P.A. classes, private art schools, colleges, and public schools.

_____. CHOOSING A LIFE CAREER IN THE DESIGN ARTS. Washington, D.C.: Federated Council on Art Education, 1936. 32 p.

Lewis, John N.C. COMMERCIAL ART AND INDUSTRIAL DESIGN. Illustrated by John Mansbridge. London: Robert Ross & Co., 1945. 64 p. Biblio.

> Describes the training required for and jobs in commercial and industrial design. There is a chapter about education.

McCausland, Elizabeth; Vaughan, Dana P.; and Farnum, Royal Bailey. ART PROFESSIONS IN THE UNITED STATES. New York: Cooper Union for the Advancement of Science and Art, 1950. 109 p. Paper.

> Discusses art education in eighty selected schools, experiences of Cooper Union alumni (including a section about professional women), and job opportunities in art.

Metropolitan Museum of Art. ART EDUCATION: AN INVESTIGATION OF THE TRAINING AVAILABLE IN NEW YORK CITY FOR ARTISTS AND ARTISANS. New York: 1916. 46 p.

> Intended to be used as a vocational guide, this pamphlet reports on a study of industries in which art played a part. In addition, there is a list of art schools and museum art courses.

National Art Education Association. CAREERS IN ART. Reston, Va.: 1975. 8 p. Biblio. Paper.

> This pamphlet discusses career opportunities in various art fields.

National Association of Schools of Art. CAREERS IN ART AND A GUIDE TO ART STUDIES. Washington, D.C.: 1972. 16 p. Paper.

Neblette, Charles B. CAREERS IN PHOTOGRAPHY. Rochester, N.Y.: Rochester Institute of Technology, 1965. 32 p. Paper.

New York Regional Art Council. CHOOSING A LIFE CAREER IN THE DESIGN ARTS: A DISCUSSION OF VOCATIONAL GUIDANCE PROBLEMS. New York: National Alliance of Art and Industry, 1932. 70 p.

> Discusses design and design education.

Price, Charles Matlack. SO YOU'RE GOING TO BE AN ARTIST. New York: Watson-Guptill, 1946. 97 p.

Rochester Institute of Technology. CAREERS IN THE CRAFTS. Rochester, N.Y.: 1953. 67 p.

Templeton, David, ed. TEACHING ART AS A CAREER. Washington, D.C.: National Art Education Association, 1971. 12 p. Paper.

A pamphlet which outlines art education as a career.

Chapter 24

SUPERVISION AND STUDENT TEACHING OF ART

Andrews, Lois O. STUDENT TEACHING. New York: Center for Applied Research in Education, 1964. 34 p. Paper.

Association for Student Teaching. MENTAL HEALTH AND TEACHER EDUCATION. Washington, D.C.: 1967. 86 p. Paper.

Bishop, Leslie J. SEMINAR FOR IMPROVING THE EFFECTIVENESS OF SUPERVISORS IN ART EDUCATION. Washington, D.C.: National Art Education Association, 1970. 222 p. Illus. Paper.

> This research report contains an essay by Les Levine about "software" and other essays by art educators about media and aesthetic education.

Burkhart, Robert Christopher, and Neil, Hugh M. IDENTITY AND TEACHER LEARNING. Scranton, Pa.: International Textbook Co., 1968. 210 p.

> Each of the eight chapters of this book intended for student teachers and supervisors is preceded by a question for which the student must formulate an answer.

Gray, Wellington B. STUDENT TEACHING IN ART. Scranton, Pa.: International Textbook Co., 1960. 154 p. Index. Biblio.

> Offers student teachers positive suggestions about methodology, relations with other school personnel, classroom management, planning, and evaluation. Includes sample job inquiry letters and a statement of professional ethics.

Green, Lewis S. SUPERVISION OF THE SPECIAL SUBJECTS. Milwaukee, Wis.: Bruce Publishing Co., 1922. 116 p.

Heilman, Horace F. LEGAL CERTIFICATION REQUIREMENTS TO TEACH AND SUPERVISE ART IN THE PUBLIC SCHOOLS OF FIFTY STATES AND DISTRICT OF COLUMBIA. Washington, D.C.: Office of Education, Department of Health, Education and Welfare, 1967. 32 p. Paper.

Supervision & Student Teaching of Art

Hubbard, Guy. ART IN THE HIGH SCHOOL. Belmont, Calif.: Wadsworth Publishing Co., 1967. 307 p. Biblio. Illus.

> Written for student art teachers on the history and purposes of art education; the relationship of art education to visual perception; the ways we think; the various roles art teachers are asked to play in the school and community; and the high school art curriculum, including evaluation.

Jessup, Walter A. THE SOCIAL FACTORS AFFECTING SPECIAL SUPERVISION IN THE PUBLIC SCHOOLS OF THE UNITED STATES. New York: Teachers College, Columbia University, 1911. 42 p. Paper.

Kirby, C. Valentine. THE BUSINESS OF TEACHING AND SUPERVISING THE ARTS. Chicago: Abbott Educational Co., 1927. 73 p. Illus. Biblio., pp. 57-63.

> Although out-dated in some aspects the basic information here is useful, including a short history of art in the schools. Discusses practical and theoretical aspects of art teaching. One chapter is entitled "Selling Art Education."

Morrow, Mary Lou. HELP! FOR ELEMENTARY SCHOOL SUBSTITUTES AND BEGINNING TEACHERS. Philadelphia: Westminster Press, 1974. 144 p. Illus.

National Art Education Association. OBSERVATION: A TECHNIQUE FOR ART EDUCATORS. Report on Preconference Education Research Training Program for Descriptive Research in Art Education. Washington, D.C.: 1971. 102 p. Illus.

_____. SUPERVISION: MANDATE FOR CHANGE. Reston, Va.: 1971. 222 p. Paper.

> Report of the NAEA "Seminar for Improving the Effectiveness of Supervisors in Art Education."

New York. State University of. A HANDBOOK FOR THE BEGINNING ART TEACHER. Buffalo, N.Y.: 1959. 40 p. Biblio.

> This book, which grew out of an art education seminar at the State University at Buffalo, is concerned with the structure of the New York State Department of Education, curriculum building, graduate study; also makes suggestions on how to go about getting a job.

Paston, Herbert S. LEARNING TO TEACH ART. Lincoln, Nebr.: Professional Educators Publications, 1973. 106 p. Biblio., pp. 103-6. Paper.

> In this guide for student teachers in elementary and secondary schools the author discusses discipline, supervisors, observation, and the art teaching profession.

South Carolina State Department of Education. ADMINISTRATOR'S HANDBOOK FOR ART EDUCATION. Columbia, S.C.: 1972. 49 p.

Wen, Chao-t'ung. HOW TO SUPERVISE CHILDREN IN CREATIVE DRAWING. Shanghai, China: Commercial Press, 1948. 78 p. Biblio., pp. 78-79. Illus.

Chapter 25

ARTISTS AS TEACHERS

ARTISTS IN THE CLASSROOM. Hartford, Conn.: Connecticut Commission on
the Arts, 1973. 143 p. Illus. Paper.

 A documentation of Connecticut's artists-in-the-schools project.

Goldwater, Robert, and Treves, Marco. ARTISTS ON ART: FROM THE XIV
TO THE XX CENTURY. New York: Pantheon Books, 1945. 500 p. Illus.
Index. Biblio.

 This book, an anthology of writings by artists about the artist's
 role, may be of interest and use to teachers. Contains portraits
 of the artists.

HANS HOFMANN. Introduction by Sam Hunter. New York: Harry N.
Abrams, 1966. 227 p. Illus.

 Five essays about painting and surprisingly enough, sculpture.

Hoyland, Francis. ALIVE TO PAINT. London: Oxford University Press, 1967.
108 p. Illus.

 The author writes of his life as an artist and teacher. He feels
 teaching, contact with other artists, and looking at great paintings
 helped him grow as an artist, to better understand the art of paint-
 ing in general and his own talent in particular.

Leondar, Barbara. THE ARTS IN ALTERNATIVE SCHOOLS: SOME OBSERVA-
TIONS. Cambridge, Mass.: School of Education, Harvard University, 1972.
23 p. Paper.

 Suggests that alternative schools tend to be conservative, but have
 introduced the professional artist (that is, someone other than an
 art education professional), in the education of children.

Madeja, Stanley S. THE ARTIST IN THE SCHOOL: A REPORT ON THE
ARTIST-IN-RESIDENCE PROJECT. St. Louis, Mo.: Central Midwestern Re-
gional Educational Laboratory, 1970. 103 p. Illus.

Michael, John Arthur. ARTISTS' IDEAS ABOUT ART AND THEIR USE IN EDU-CATION. Oxford, Ohio: Miami University Press, 1966. 182 p.

New York University. THE NEW YORK PAINTER, A CENTURY OF TEACHING: MORSE TO HOFMANN. New York: New York University Press, 1967. 107 p. Illus. Biblio.

> This exhibition catalog contains short biographic essays about each painter represented in the exhibition with an emphasis on his teaching career. Also includes a chronology chart which links teacher and student.

Phillips Academy. EUROPEAN ARTISTS TEACHING IN AMERICA. Andover, Mass.: 1941. 64 p. Illus. Paper.

> Catalog of a show held at Phillips Academy to illustrate the influence of European artists on American art education and art. Each artist--Albers, Annot, Boyer, Drewes, Grosz, Hayter, Jaccobi, Moholy-Nagy, Ozenfant, Seligman, Sepeshy, Simkhovitch, Taubes and Zeibe--writes about his teaching experiences.

Schiff, Bennett. ARTISTS IN SCHOOLS. Washington, D.C.: Office of Education, Department of Health, Education and Welfare, 1973. 192 p. Illus.

> A report on the National Endowment for the Arts and Office of Education's jointly sponsored Artists-in-Schools Program.

Shahn, Ben. THE SHAPE OF CONTENT. Cambridge, Mass.: Harvard University Press, 1957. 131 p. Illus.

> In these lectures delivered at Harvard, Shahn talks about the role of the artist in college, his education, and explains one of his paintings.

Chapter 26

TEACHING PROCESSES AND MATERIALS

AIR ART AND EVENT-STRUCTURES

Halprin, Lawrence, and Burns, Jim. TAKING PART: A WORKSHOP AP-
PROACH TO COLLECTIVE CREATIVITY. Cambridge, Mass.: M.I.T. Press,
1974. 328 p. Illus. Paper.

> A handbook for participation and group work to change the environ-
> ment through concentrated creative effort.

Piene, Otto. MORE SKY. Cambridge, Mass.: M.I.T. Press, 1970. 96 p.
Illus. Paper.

> A lively, enjoyable, and useful book about using various aspects
> of the environment in participation-art with children.

Streeter, Tal. ART OF THE JAPANESE KITE. New York and Tokyo: Weather-
hill, 1974. 181 p. Illus., some color. Biblio.

> An exciting book about Japanese kites with instructions for making
> and flying your own. Beautiful and well written.

ARCHITECTURE

Barnes, E.A., and Young, B.M. CHILDREN AND ARCHITECTURE. New York:
Bureau of Publications, Teachers College, Columbia University, 1932. 106 p.

Saarinen, Eliel. ADDRESS. Bloomfield Hills, Mich.: Cranbrook Academy of
Art, 1931. 17 p. Paper.

> About architecture and education.

Trogler, George E. BEGINNING EXPERIENCES IN ARCHITECTURE: A GUIDE
FOR THE ELEMENTARY SCHOOL TEACHER. New York: Van Nostrand Rein-
hold Co., 1972. 143 p. Illus. Biblio.

Deals with experiencing space and structure through physical class-
room activities. In addition, there is a section on appreciation
of architecture.

CLAY

Berensohn, Paulus. FINDING ONE'S WAY WITH CLAY. New York: Simon
& Schuster, 1972. 159 p. Illus., some color. Biblio. Glossary.

A beautiful, gentle book written by a potter-teacher about the use
and "humanness" of clay. There is a section about utilizing the
natural color of clay and another on firing.

Cowley, David. WORKING WITH CLAY AND PLASTER. New York: Watson-
Guptill Publications, 1973. 96 p. Illus.

Tells how to cast plaster forms from clay models, with a chapter
devoted to working with children.

Crofton, Kathleen. CLAY. London: Educational Supply Association, 1955.
29 p. Illus. Paper.

The use of clay to extend general knowledge as well as for person-
al expression.

Krum, Josephine. HAND BUILT POTTERY. Scranton, Pa.: International Text-
book Co., 1960. 97 p. Illus. Biblio.

Explores the use of clay as an educational medium.

Petrie, Maria Zimmern. MODELLING. Leicester, England: Dryad Press,
1959. 45 p. Illus.

Modelling for children and adults with a section on casting. There
is a discussion of the developmental stages in a child's use of clay.

Rottger, Ernst. CREATIVE CLAY DESIGN. New York: Reinhold Publishing
Co., 1963. 96 p. Illus.

Children work with clay.

Suspensky, Thomas. CERAMIC ARTS IN THE SCHOOL PROGRAM. Worcester,
Mass.: Davis Publications, 1974. 96 p. Illus.

Clay construction in the classroom.

COLOR

Bradley, Milton. COLOR IN THE SCHOOL-ROOM. Springfield, Mass.: Mil-

ton Bradley Co., 1890. 103 p. Illus.

> In this book about teaching color to children there is a section on color blindness.

Gale, Ann Van Nice. CHILDREN'S PREFERENCES IN COLOR. Chicago: University of Chicago Press, 1933. 78 p.

Oldham, Hilda Walley. CHILD EXPRESSION IN COLOR AND FORM. London: John Lane Publisher, 1940. 96 p.

> See entry on p. 141.

Sargent, Walter. THE ENJOYMENT AND USE OF COLOR. New York: Charles Scribner's Sons, 1932. 136 p.

COSTUMING

Boyes, Janet. MAKING PAPER COSTUMES. Cambridge, Mass.: Plays, 1974. 88 p. Illus.

> Descriptions of costumes made from various kinds of paper.

Peters, Joan, and Sutcliffe, Anna. MAKING COSTUMES FOR SCHOOL PLAYS. Cambridge, Mass.: Plays, 1971. 108 p.

> Provides information about making costumes for school plays, including selection of materials, pattern making, sewing, and so forth.

CRAFTS

Brown, Mamie E. ELEMENTARY HANDCRAFTS FOR ELEMENTARY SCHOOLS. New York: Exposition Press, 1956. 104 p. Illus.

> Things to do with children including maps, raffia, and shells.

Bryce, Mayo J., and Green, Harry B. TEACHER'S CRAFT MANUAL. San Francisco: Fearon Publishing, 1956. 79 p. Illus.

> Craft activities for elementary classroom teachers.

Cresse, Else Bartlett. CREATIVE CRAFTS WITH ELEMENTARY CHILDREN. Dansville, N.Y.: F.A. Owen Publishing Co., 1963. 79 p. Illus.

Dorsey, Elsie. CREATIVE ART AND CRAFTS FOR THE CLASSROOM. Toronto: School Aide and Text Book Publishing Co., 1955. 88 p. Illus.

> Art activities for children.

Glenister, S.H. THE TECHNIQUE OF HANDICRAFT TEACHING. London, Toronto, Wellington, and Sydney: George G. Harrap and Co., 1953. 154 p.

A manual for handicraft teachers dealing with class control, supervision, visual aids, and slow learners.

Horn, George. CRAFTS FOR TODAY'S SCHOOLS. Worcester, Mass.: Davis Publications, 1972. 142 p. Illus.

Ideas, tools, and materials for crafts with children.

International Bureau of Education. THE TEACHING OF HANDICRAFTS IN SECONDARY SCHOOLS. Publication no. 123. Geneva, Switzerland: International Bureau of Education and UNESCO, 1950. 142 p.

Information from forty-one countries on the place of the handicrafts in secondary schools.

Knapp, Harriet E. DESIGN APPROACH TO CRAFTS. Springfield, Mass.: Holden Publishing Co., 1945. 128 p. Illus.

In this book directed to secondary art teachers, the author discusses design and ways and means of improving understanding, and suggests ways to stimulate creative work through individual interpretation and expression.

Laxton, Michael. USING CONSTRUCTION MATERIALS: London: Van Nostrand Reinhold Co., 1974. 96 p. Illus., some color.

The author takes a comprehensive look at the advantages of using resistant materials and at how they can be introduced to children. He examines children at work, tools, skills and craftsmanship, and offers suggestions for teacher use of constructional materials.

Mattil, Edward L. MEANING IN CRAFTS. Englewood Cliffs, N.J.: Prentice-Hall, 1971. 237 p. Illus.

The author, concerned with the fullest possible development of the individual child, presents craft ideas for use in the classroom to expand the child's problem-solving ability and stimulate his emotional and intellectual growth.

Moseley, Spencer; Johnson, Pauline; and Koenig, Hazel. CRAFTS DESIGN: AN ILLUSTRATED GUIDE. Belmont, Calif.: Wadsworth Publishing Co., 1962. 436 p.

Craft work in paper, weaving, textiles, leather, clay, and enamels, with a history of each.

Murphy, Corrine, ed. EXPLORING THE HANDCRAFTS. New York: Girl Scouts of the U.S.A., 1955. 102 p.

> Discusses a wide range of materials and media that may be used in youth organization work, and the values and purposes of the art experience.

Powers, Margaret. A BOOK OF LITTLE CRAFTS. Peoria, Ill.: Manual Arts Press, 1942. 96 p.

> Simple crafts, mostly for primary grades.

Robertson, Seonaid Mairi. CRAFT AND CONTEMPORARY CULTURE. London: UNESCO, 1960. 168 p.

_____. CREATIVE CRAFTS IN EDUCATION. Foreword by Herbert Read. London: Routledge & Kegan Paul, 1952. 286 p. Illus.

> A sensitive and wise book concerning the role of crafts in education and everyday life. Includes sections on bookmaking, clothing, and drama.

Roukes, Nicholas. CLASSROOM CRAFT MANUAL. San Francisco: Fearon Publishers, 1960. 64 p. Illus. Paper.

> A how-to-do-it book ranging from paper to clay and weaving. Written for teachers.

Tomlinson, Reginald R. CRAFTS FOR CHILDREN. New York: Studio Publications, 1935. 120 p. Illus.

> A historical and philosophical discussion of the role of crafts in childhood education with practical classroom suggestions.

TRAINING IN ART AND HANDICRAFTS. London: I. Pittman & Sons, 1922. 128 p. Illus.

> Many short sets of instructions, written by a good many people, about drawing, crafts in education, handwriting, basket work, paper, and toy making.

CRAYONS

Boylston, Elise Reid. CREATIVE EXPRESSION WITH CRAYONS. Worcester, Mass.: Davis Publications, 1953. 100 p. Illus., some color.

> Approaches child development through the use of crayons. The author discusses how children think and work and suggests methods of motivation and guidance.

Horn, George F. THE CRAYON: VERSATILE MEDIUM FOR CREATIVE EX-
PRESSION. Worcester, Mass.: Davis Publications, 1969. 96 p. Illus.

Kampmann, Lothar. CREATING WITH CRAYONS. New York: Van Nostrand
Reinhold Co., 1967. 76 p. Illus., color. Index.

> Crayon techniques for use with children.

Laliberte, Norman, and Moegelon, Alex. PAINTING WITH CRAYON: HIS-
TORY AND MODERN TECHNIQUES. New York: Reinhold Publishing Co.,
1967. 119 p. Illus., part color.

> There is a section on working with children in this book which
> treats crayon as a bona fide art medium.

DESIGN

Baranski, Matthew. GRAPHIC DESIGN: A CREATIVE APPROACH. Scranton,
Pa.: International Textbook Co., 1960. 97 p.

> The theme is creative expression and individual interpretation
> rather than technical skills, and the author undertakes the task
> of stimulating children to express their thoughts, ideas, and feel-
> ings through the use of a variety of common tools and materials.

Cataldo, John W. GRAPHIC DESIGN AND VISUAL COMMUNICATION.
Scranton, Pa.: International Textbook Co., 1966. 296 p. Illus., some color.

> Deals with typography, visual/verbal language, contemporary art,
> psychology of art, graphic form and expression, offset reproduction,
> education, and publications.

De Sausharez, Maurice. BASIC DESIGN: THE DYNAMICS OF VISUAL FORM.
New York: Reinhold Publishing Co., 1968. 96 p. Illus., part color. Biblio.,
p. 6.

Emerson, Sybil. DESIGN: A CREATIVE APPROACH. Foreword by Viktor
Lowenfeld. Scranton, Pa.: International Textbook Co., 1957. 125 p. In-
dex. Annotated biblio.

> A general design book suggesting experimental projects.

Friend, Leon, and Hefter, Joseph. GRAPHIC DESIGN. New York: McGraw-
Hill Book Co., 1936. 407 p. Index. Annotated biblio. Glossary.

> A survey of graphic design including a chapter on graphic art education.

Haney, James Parton. CLASSROOM PRACTICE IN DESIGN. Peoria, Ill.:
Manual Arts Press, 1907. 143 p. Illus.

> Classroom methods for the teaching of design.

Kahn, Ely Jacques. DESIGN IN ART AND INDUSTRY. New York: Charles Scribner's Sons, 1935. 204 p. Illus.

>Emphasizes the importance of design in the artist's work and in his education. The author approaches design from an Oriental point of view and applies those ideas and concerns to American and European schools.

Kranz, Stewart Duane, and Fisher, Robert. THE DESIGN CONTINUUM. New York: Reinhold Publishing Co., 1966. 151 p. Illus., some color. Index. Annotated biblio. Glossary.

>This book puts forth a theory about how to see order in the confusing array of objects in our everyday life. There is a section dealing with art school design courses.

Sneum, Gunnar. TEACHING DESIGN AND FORM. New York: Reinhold Publishing Co., 1967. 125 p. Illus., part color.

Willcocks, Charles B. DESIGN EDUCATION. London: Art and Industry, 1945. 132 p.

DRAMATICS

D'Amico, Victor E. THEATER ART. Peoria, Ill.: Manual Arts Press, 1931. 106 p. Illus.

Gillies, Emily. CREATIVE DRAMATICS FOR ALL CHILDREN. Washington, D.C.: Association for Childhood Education International, 1973. 64 p. Illus. Biblio. Paper.

>Sensory education using drama.

Heinig, Ruth Beall, and Stillwell, Lyda. CREATIVE DRAMATICS FOR THE CLASSROOM TEACHER. Englewood Cliffs, N.J.: Prentice-Hall, 1974. 96 p. Illus.

Snook, Barbara. MAKING MASKS FOR SCHOOL PLAYS. Cambridge, Mass.: Plays, 1972. 94 p. Illus.

>Ideas and instructions for mask making.

Ward, Winifred. PLAYMAKING WITH CHILDREN. New York: Appleton-Century-Crofts, 1957. 116 p. Illus.

DRAWING

Ayer, Fred Carleton. THE PSYCHOLOGY OF DRAWING WITH SPECIAL REF-
ERENCE TO LABORATORY TEACHING. Baltimore: Warwick and York, 1916.
186 p.

> Study is concerned with drawing as a skill to be used in service
> of science rather than as an expressive part of art. Suggests a
> positive parallel between verbal expression and drawing. One
> chapter is devoted to the relationship of drawing to intellectual
> development, and another to analysis of the finished drawing.

Bailey, Henry Turner. NATURE DRAWING. New York: Atkinson, Mentzer
Co., 1910. 46 p.

Bailey, Henry Turner, and Sargent, Walter. AN OUTLINE OF LESSONS
IN DRAWING FOR UNGRADED SCHOOLS. Boston: Wright & Potter Printing
Co., 1895. 64 p. Illus.

> A guide for teachers of rural schools who, the authors presumed,
> knew little about art and had no supplies and equipment.

Beck, Otto Walter. SELF-DEVELOPMENT IN DRAWING. New York: G.P.
Putnam's Sons, 1928. 96 p.

Beittel, Kenneth. MIND AND CONTEXT IN THE ART OF DRAWING. New
York: Holt, Rinehart and Winston, 1972. 274 p. Illus. Index.

> A compilation of the author's art education research over a ten-
> year period concerned with psychology, philosophy, and the crea-
> tive act using drawing as a core.

Biber, Barbara. CHILDREN'S DRAWINGS: FROM LINES TO PICTURES. 3d
ed. New York: Bank Street College of Education Publications, 1967. 45 p.
Illus.

> A clear, concise discussion of the drawings of young children.

Blake, Vernon. DRAWING FOR CHILDREN AND OTHERS. 1927. Reprint.
London: Humphrey Milford, 1944. 116 p.

Boston School Committee. REPORT OF THE COMMITTEE ON DRAWING.
Boston: Rockwell and Churchill, City Printers, 1893. 53 p.

> The majority report consists of a narrative of what was happening
> in art education (that is, drawing) in the schools. Of more inte-
> rest is the minority report which includes a proposed curriculum.

Brooklyn, Board of Education. REPORT OF THE SPECIAL COMMITTEE ON

DRAWING IN THE PUBLIC SCHOOLS OF THE CITY OF BROOKLYN. Brooklyn: 1874. 14 p. Paper.

The document reports that drawing was a "favorite exercise" in the schools, compliments all concerned with an art exhibition of children's work, and makes a strong argument for art in the schools.

Butler, N.M. DRAWING IN THE PUBLIC SCHOOLS. Washington, D.C.: Bureau of Education, 1874. 96 p.

Clarke, Isaac Edwards. DRAWING IN PUBLIC SCHOOLS: THE PRESENT RELATION OF ART TO EDUCATION IN THE UNITED STATES. Washington, D.C.: Government Printing Office, 1874. 56 p.

This report of the U.S. Commissioner of Education is a survey of institutions offering art education.

Colby, Lou Eleanor. TALKS ON DRAWING, PAINTING, MAKING, DECORATING FOR PRIMARY TEACHERS. Chicago: Scott, Foresman & Co., 1909. 143 p. Illus., some color.

The emphasis is on drawing in this art education handbook for teachers of small children. Also touches on watercolor painting, clay work, and presents charming doll houses and furniture made from cardboard and wood.

Dennis, Wayne. GROUP VALUES THROUGH CHILDREN'S DRAWINGS. New York: John Wiley & Sons, 1966, 96 p. Illus.

See entry on p. 139.

Dewey, John. THE PSYCHOLOGY OF DRAWING. New York: Bureau of Publications, Teachers College, Columbia University, 1919. 18 p.

Three articles presenting a philosophical basis for the teaching of the arts.

Di Leo, Joseph H. YOUNG CHILDREN AND THEIR DRAWINGS. New York: Brunner & Mazel Publishers, 1970. 386 p. Illus. Index. Biblio.

The first section of this book is devoted to a discussion of normal children's drawings. The second part deals with drawing as a diagnostic aid.

Dwight, Mary Ann. INTRODUCTION TO THE STUDY OF ART. New York: D. Appleton and Co., 1856. 278 p.

Mostly about drawing, but there are sections on taste, style, and the symbolic meaning of color.

Farnum, Royal Bailey, et al. PRACTICAL DRAWING BOOKS. Chicago: Practical Drawing Co., 1924. 38 p.

Fitz, H.G. FREE-HAND DRAWING IN EDUCATION. New York: D. Appleton and Co., 1897. 11 p. Paper.

> A reaction to a statement made by the Head Inspector of the Regents of New York State who said that for the twenty years during which drawing had been a part of the curriculum in the public schools "the results are not much of anything." The author sets out to prove him wrong.

Grezinger, Wolfgang. SCRIBBLING, DRAWING, PAINTING: THE EARLY FORMS OF THE CHILD'S PICTORIAL CREATIVENESS. Translated by Ernst Kaiser and Eithne Wilkins. Preface by Herbert Read. London: Faber and Faber, 1955. 142 p. Illus., some color.

> In this direct, straightforward book the author discusses the child's symbolic form language, and his own educational specialty--bi-manual drawing.

Hall, James. WITH BRUSH AND PEN: A MANUAL OF THE NEWER AND MORE ARTISTIC PHASES OF PUBLIC SCHOOL. New York: J.C. Witter Co., 1897. 74 p. Illus. Paper.

> This book is a plea for a more liberal art curriculum and in itself is a course of drawing study suitable for elementary and high school.

Hicks, Mary Dana. THE USE OF MODELS. Boston: Prang Educational Co., 1886. 197 p. Illus.

> Still life and object drawing for the elementary grades.

Johnstone, William. CHILD ART TO MAN ART. New York: Macmillan, 1941. 143 p. Illus.

> After a short discussion of art and teaching, the author concentrates on picture making with children. The emphasis is on drawing, but he does deal with photomontage, collage, writing, and printing.

Kaupelis, Robert. LEARNING TO DRAW. New York: Watson-Guptill Publications, 1966. 97 p.

McCarthy, Stella Agnes. CHILDREN'S DRAWINGS. Baltimore: Williams and Wilkins Co., 1924. 126 p.

Mendelowitz, Daniel E. DRAWING: THE STUDY GUIDE. New York: Holt, Rinehart and Winston, 1966. 153 p. Illus.

> A book of drawing lessons using various media for teacher use with students.

Nicolaides, Kimon. THE NATURAL WAY TO DRAW. New York: Houghton Mifflin, 1941. 146 p.

NORMAL DRAWING CLASS. Boston: Prang Educational Co., 1891. 61 p. A correspondence course for teachers.

Peale, Rembrandt. GRAPHICS: A MANUAL OF DRAWING AND WRITING FOR THE USE OF SCHOOLS AND FAMILIES. New York: Peaslee, 1835. 132 p.

Pond, Gordon G. A GUIDE FOR ART STUDENTS. Dubuque, Iowa: Wm. C. Brown Co., 1958. 51 p. Illus.

A handbook for beginning college art students dealing with drawing. Also there is a nod to painting and a chapter about how to present work.

Rottger, Ernst, and Klante, Dieter. CREATIVE DRAWING: POINT AND LINE. New York: Reinhold Publishing Co., 1963. 144 p. Illus.

Rottger, Ernst; Klante, Dieter; and Salzmann, Friedrich. SURFACES IN CREA- TIVE DRAWING. New York: Van Nostrand Reinhold Co., 1970. 119 p. Illus., part color.

Sargent, Walter, and Miller, Elizabeth. HOW CHILDREN LEARN TO DRAW. Boston: Ginn & Co., 1916. 112 p.

Schildkrout, Martin S.; Shenker, I.R.; and Sonnenblick, M. HUMAN FIGURE DRAWINGS IN ADOLESCENCE. New York: Brunner-Mazel, Publishers, 1972. 151 p. Illus.

Sherman, Hoyt L. DRAWING BY SEEING. New York: Hinds, Hayden & Eldredge, 1947. 77 p. Illus.

A report on a drawing experiment that became a part of the edu- cation program in the art department of Ohio State.

Smith, Walter. INDUSTRIAL DRAWING IN PUBLIC SCHOOLS. Boston: Prang Educational Co., 1875. 110 p.

_____. TEACHERS MANUAL OF FREE HAND DRAWING AND DESIGNING AND GUIDE TO SELF-INSTRUCTION. Boston: Prang Educational Co., 1873. 89 p.

Thompson, Beatrice Terzian. DRAWINGS BY HIGH SCHOOL STUDENTS. New York: Reinhold Publishing Co., 1966. 97 p.

Todd, Jessie Madel. DRAWING IN THE ELEMENTARY SCHOOL. Chicago: University of Chicago Press, 1931. 103 p.

Venall, John W.T. SCHOOL DRAWING IN ITS PSYCHOLOGICAL ASPECT. London: Blackie and Sons, 1912. 124 p.

ENVIRONMENT

Ashbee, Barbara. ART IN THE OUT OF DOORS. Washington, D.C.: National Wildlife Federation, 1973. 23 p. Paper.

Elementary art education using nature as a source.

Davis, David. TEACHING ART IN THE URBAN OUT-OF-DOORS. Washington, D.C.: Bureau of Elementary and Secondary Education, 1974. 19 p. Paper.

Minnesota Environmental Sciences Foundation. NATURE'S PART IN ART: AN ENVIRONMENTAL INVESTIGATION. Washington, D.C.: National Wildlife Federation, 1972. 20 p. Paper.

Learning activities for children relating science and art.

Nixon, Arne S. CHILD'S RIGHT TO THE EXPRESSIVE ARTS. Washington, D.C.: Association for Childhood Education International, 1969. 12 p. Paper.

The author writes about environments that encourage creativity in children.

Pattemore, Arnel W. ART AND ENVIRONMENT: AN ART RESOURCE FOR TEACHERS. New York: Van Nostrand Reinhold Co., 1974. 143 p. Illus., some color. Index. Biblio.

Discusses art with children using ecology, communication (media, advertising, film), people, and architecture as a basis for art activities.

Peck, Ruth L. ART LESSONS THAT TEACH CHILDREN ABOUT THEIR NATURAL ENVIRONMENT. West Nyack, N.Y.: Parker Publishing Co., 1973. 282 p. Illus. Index.

Suggestions for art lessons using the usual classroom art materials based on various aspects of the environment such as weather, planets, cities, animals, and so on.

Robertson, Seonaid Mairi. USING NATURAL MATERIALS. New York: Van Nostrand Reinhold Co., 1974. 84 p. Illus., some color. Paper.

The emphasis of this book is on the variety of natural materials

around us (shells, pebbles, plants, clay, straw, wood) and the child's personal response to them. Written for elementary teachers, it encourages looking, searching, and discovering.

Sterling, Vicki. NATURE'S ART. Washington, D.C.: Bureau of Elementary and Secondary Education, 1972. 132 p.

Environmental art education for children.

FIBERS AND FABRICS

Beitler, Ethel Jane. CREATE WITH YARN. Scranton, Pa.: International Text-book Co., 1964. 196 p. Illus.

Stitchery and rug hooking for elementary and secondary school use.

Crofton, Kathleen. FIBRES. London: Educational Supply Association, 1955. 17 p. Illus. Paper.

Natural and synthetic fibers as a basis for textile work with children.

Enthoven, Jacqueline. STITCHERY FOR CHILDREN: A MANUAL FOR TEACH-ERS, PARENTS, AND CHILDREN. New York: Reinhold Book Co., 1968. 172 p. Illus., some color.

Discusses stitchery from preschool through high school.

Federated Council on Art Education. TEXTILE DESIGN. New York: 1936. 48 p. Illus. Biblio. Paper.

Who, what, where, why, and how about textile designing. There is a list of schools offering courses and degrees.

Krevitsky, Nik. STITCHERY: ART AND CRAFT. New York: Reinhold Publishing Co., 1966. 120 p. Illus.

Laliberte, Norman, and McIlhany, Sterling. BANNERS AND HANGINGS: DESIGN AND CONSTRUCTION. New York: Reinhold Publishing Co., 1966. 92 p. Illus.

Milne, Rae. THREADS AND FABRICS. London: Educational Supply Association, 1955. 33 p. Illus. Paper.

Spinning, weaving, and stitchery for children.

Rainey, Sarita R. WEAVING WITHOUT A LOOM. Worcester, Mass.: Davis Publications, 1966. 132 p. Illus.

Procedures for using a variety of yarns and fibers in a variety of
weaving processes.

Shears, Alice, and Fielding, Joan E. APPLIQUE. New York: Watson-Guptill
Publications, 1973. 144 p. Illus., some color. Index. Biblio. Glossary.

How to make quilts, coverlets, wall hangings, flags, and banners
with a special chapter on applique.

FILM

Anderson, Yvonne. MAKE YOUR OWN ANIMATED MOVIES: YELLOW BALL
WORKSHOP TECHNIQUES. Boston: Little, Brown and Co., 1970. 101 p.
Illus.

_____. TEACHING FILM ANIMATION TO CHILDREN. New York: Van
Nostrand Reinhold Co., 1970. 112 p. Illus., some color. Index.

Describes traditional and unorthodox methods of making animated
films with youngsters five to eighteen years of age.

Byrne, Daniel J. GRAFILM: AN APPROACH TO A NEW MEDIUM. New
York: Van Nostrand Reinhold Co., 1970. 96 p. Illus.

Suggests six ways to make a film: (1) story boards; (2) drawing on
clear leader; (3) moving the camera over a large art reproduction;
(4) form pieces of art; (5) animation; and (6) a combination of the
above techniques.

Fensch, Thomas. FILMS ON CAMPUS: CINEMA PRODUCTION IN COLLEGES
AND UNIVERSITIES. New York: Barnes, 1970. 534 p. Illus.

This survey of campus filmmaking in the United States describes
courses and philosophies at several universities and colleges.

Field, Robert D. THE ART OF WALT DISNEY. New York: Macmillan,
1942. 290 p. Illus. Index.

Certainly not an art education book by most definitions, but an
entertaining, useful description of movie animation.

Harcourt, Peter, and Theobald, Peter, eds. FILM MAKING IN SCHOOLS
AND COLLEGES. London: British Film Institute, 1967. 110 p. Illus.
Paper.

Film teachers describe their methods of using films in different sub-
ject matter areas.

Kennedy, Keith. FILM MAKING IN CREATIVE TEACHING. New York: Watson-Guptill Publications, 1973. 144 p. Illus. Index. Biblio.

In this book about film as communication, the author lists equipment needed for working with film in education and describes various filmmaking processes.

Koch, Christian, and Powers, John, eds. FILM CONFERENCE: SELECTED ESSAYS. Washington, D.C.: National Endowment for the Humanities, 1974. 327 p. Paper.

Essays about film, film criticism, and aesthetic education.

Lanier, Vincent. THE IMAGE OF THE ARTIST IN PICTORIAL CINEMA. Washington, D.C.: Office of Education, Department of Health, Education and Welfare, 1968. 51 p.

Larson, Roger. A GUIDE FOR FILM TEACHERS TO FILMMAKING BY TEEN-AGERS. New York: Department of Cultural Affairs, 1968. 48 p. Illus. Paper.

Discusses operating a film club.

Larson, Roger, and Meade, Ellen. YOUNG FILMMAKERS. New York: E.P. Dutton and Co., 1969. 190 p. Illus. Index. Biblio.

Filmmaking with and without a camera, cameras, scripts, editing, and other areas of filmmaking are discussed.

Lidstone, John, and McIntosh, Don. CHILDREN AS FILM MAKERS. New York: Van Nostrand Reinhold Co., 1970. 96 p. Illus.

Everything a teacher needs to know to set up a filmmaking program: what cameras to use and how they work; methods of editing and splicing; animation and titling; adding sound; setting up a film festival.

Lowndes, Douglas. FILM MAKING IN SCHOOLS. New York: Watson-Guptill Publications, 1973. 128 p. Illus. Index.

Surveys the basic hardware of 8mm and 16mm filmmaking and discusses the role film can play in the school curriculum.

Ontario Institute for Studies in Education. Art Committee. EXPERIMENT WITH FILMS IN THE ART CLASSROOM. Toronto: 1970. 25 p. Illus. Paper.

Film used to explore social problems, to initiate interdisciplinary work, to study the environment, and to produce animated images. Some attention is paid to developing the child's self-image.

Rynew, Arden. FILMMAKING FOR CHILDREN. New York: Pflaum/Standard, 1971. 59 p. Illus. Glossary

> The first part of this book discusses filmmaking in education; the second section is a production handbook.

Schillaci, Anthony, and Culkin, John M., eds. FILMS DELIVER: TEACHING CREATIVELY WITH FILM. New York: Citation Press, 1970. 198 p. Illus. Biblio. Index. Paper.

> A look at how to use film and television effectively in the class-room, at every level and in all curriculum areas. Includes practical advice on such fundamentals as finding the film one needs and setting up equipment.

FINGER PAINTING

Betts, Victoria Bedford. EXPLORING FINGER PAINT. Worcester, Mass.: Davis Publications, 1963. 132 p. Illus.

> Exploration of the history of fingerpainting and how to go about doing it.

Enriquez, Sancho. FINGER PAINTING. Manila, Philippines: Albiva Publishing House, 1950. 24 p. Illus. Paper.

Kellogg, Rhoda. FINGER PAINTING IN THE NURSERY SCHOOL. San Francisco: Golden Gate Nursery School, 1955. 90 p. Illus. Paper.

> The book is the end product of a study of more than 400 children over a six-year period the author did of young children using finger paint. She touches upon the importance of a creative atmosphere, the teacher's role, and the ways in which children approach their work.

_____. THE HOW OF SUCCESSFUL FINGER PAINTING. Palo Alto, Calif.: Fearon Publishers, 1958. 32 p. Paper.

Shaw, Ruth Faison. FINGERPAINTING AND HOW TO DO IT. 2d ed. New York: Art for All, 1947. 48 p. Illus. Biblio. Paper.

> A rather charming "how-it's-done" book by the "inventor" of finger-painting. One wishes for more history of the medium; Shaw merely whets our appetite.

FOUND MATERIAL

Association for Childhood Education International. BITS AND PIECES: IMA-

GINATIVE USES FOR CHILDREN'S LEARNING. Washington, D.C.: 1967. 72 p.

> Found objects, leftovers and giveaways to increase children's skills and learning.

D'Amico, Victor Edmund, and Buchman, Arlette. ASSEMBLAGE: A NEW DIMENSION IN CREATIVE TEACHING IN ACTION. New York: Museum of Modern Art, 1972. 230 p. Illus.

> A report of seventy-eight assemblage teaching projects undertaken by Buchman with children from age four to fourteen. There is a section on group work.

Malcon, Dorothea. ART FROM RECYCLED MATERIALS. Worcester, Mass.: Davis Publications, 1974. 128 p. Illus.

> How to use discarded materials for art projects.

Meilach, Dona Z. CREATING ART FROM ANYTHING: IDEAS, MATERIALS, TECHNIQUES. Chicago: Reilly & Ler, 1968. 119 p. Illus., part color.

> A survey of easily accessible nonart materials for use in the arts. Presents photographic and written how-to essays using the work of professional and amateur artists, and students.

Perry, Evadna Kraus. ART ADVENTURES WITH DISCARD MATERIALS. New York: Noble & Noble, 1933. 180 p. Illus.

Rasmussen, Henry, and Grant, Art. SCULPTURE FROM JUNK. New York: Reinhold Publishing Co., 1967. 96 p. Illus.

> Sculptures made from discarded material.

Reed, Carl, and Orze, Joseph. ART FROM SCRAP. Worcester, Mass.: Davis Publications, 1960. 89 p. Illus. Paper.

> A book of projects including sculpture, graphics, mosaics, puppets, masks, collage, and jewelry for school children using limited tools, materials, and space. Includes recipes and formulas and a project and materials chart.

Reed, Carl, and Towne, Burt. SCULPTURE FROM FOUND MATERIAL. Worcester, Mass.: Davis Publications, 1974. 95 p. Illus., some color.

> The authors view their book about found materials as a visual resource for children.

JEWELRY AND METAL CRAFT

Davidson, P.W. EDUCATIONAL METAL CRAFT. New York: Longmans Green & Co., 1913. 113 p.

Martin, Charles, and D'Amico, Victor [Edmund]. HOW TO MAKE MODERN JEWELRY. New York: Museum of Modern Art, 1949. 67 p.

LETTERING

Cataldo, John W. LETTERING: A GUIDE FOR TEACHERS. 4th ed., enl. Worcester, Mass.: Davis Publications, 1966. 96 p. Illus.

_____. WORDS AND CALLIGRAPHY FOR CHILDREN. New York: Reinhold Book Co., 1969. 60 p. Illus., part color.

A beautiful, luxurious picture book of children's art work. The children were encouraged to use letters, words, poetry, prose and numbers as expressive elements complete within themselves.

Richardson, Marion Elaine. WRITING AND WRITING PATTERNS. London: University of London Press, 1949. 89 p. Illus., part color.

On the relationship between handwriting and creative expression.

Tannahill, Sallie Belle. P'S AND Q'S OF LETTERING. 2d ed. New York: Doubleday, Doran and Co., 1939. 109 p. Biblio.

Considers lettering to be an art form. Sections about teaching lettering, linoleum block printing, lettering tools, and other related topics.

Warde, Beatrice Lamberton Becker. TYPOGRAPHY IN ART EDUCATION. Leicester, Engl.: Association of Art Institutions and the National Society for Art Education, 1946. 20 p. Paper.

The author feels that typography should be used to illustrate the basic principles of industrial design and to teach appreciation.

MOSAICS

Argiro, Larry. MOSAIC ART TODAY. Scranton, Pa.: International Textbook Co., 1961. 87 p.

Historical and technical aspects of mosaic making.

Jenkins, Louisa, and Mills, Barbara. THE ART OF MAKING MOSAICS. New

York: Van Nostrand Reinhold Co., 1957. 132 p. Illus. Index. Biblio.

> There is a chapter about children's work in this book on how to make mosaics.

Timmons, Virginia Gayheart. DESIGNING AND MAKING MOSAICS. Worcester, Pa.: Davis Publications, 1971. 108 p.

> Instructions for making mosaics from many different kinds of materials.

MOVEMENT

Cherry, Clare. CREATIVE MOVEMENT FOR THE DEVELOPING CHILD: A NURSERY SCHOOL HANDBOOK FOR NON-MUSICIANS. 2d ed. Belmont, Calif.: Fearon Publishers, 1974. 88 p. Biblio. Paper.

> Discusses more than 200 rhythmic activities for use with the preschool child, and presents materials for singing, listening, and other musical experiences. The author is concerned with creativity and believes the environment enhances it. There is much material about the maturation of the preschool child.

Lidstone, John, and Wiener, Jack. CREATIVE MOVEMENT FOR CHILDREN. New York: Van Nostrand Reinhold Co., 1969. 112 p. Illus.

> Over 300 photographs of children and an accompanying text outline an approach to movement education in which the natural feelings and movements of the child are united in the act of dancing. Of interest to art educators because there are insights here into the ways in which children express themselves and explore space not as yet adequately investigated by developmental psychologists.

MURALS

Randall, Arne W. MURALS FOR SCHOOLS: SHARING CREATIVE EXPERIENCES. Worcester, Mass.: Davis Publications, 1956. 100 p. Illus. Biblio.

> Contains a short history of the mural as an expressive form. Discusses the creation of various types of murals in school. There are sections on the use and care of materials and equipment and one relating the mural to other subject areas.

Rogouin, Mark, and Burton, Marie. MURAL MAKING. Cambridge, Mass.: Public Art Workshop, 1970. 50 p.

> A manual about working with children and murals in the classroom and the community.

Rosenberg, Lilli Ann Killen. CHILDREN MAKE MURALS AND SCULPTURE: EXPERIENCES IN COMMUNITY ART PROJECTS. New York: Reinhold Book Co., 1968. 132 p. Illus., some color.

> The author draws upon her experience as director of the Henry Street Settlement art department for a large part of this book about children and art objects in the community.

PAINTING

Cooke, Hereward Lester. PAINTING LESSONS FROM THE GREAT MASTERS. New York: Watson-Guptill Publications, n.d. 239 p. Illus., color. Index.

> The author suggests one way to learn to paint is to look at master painting.

Halvorsen, Ruth E., and Randall, Arne W. PAINTING IN THE CLASSROOM. Worcester, Mass.: Davis Publications, 1962. 132 p. Illus.

> See entry on p. 197.

Horne, Lois Thomasson. PAINTING FOR CHILDREN: A COLLECTION OF PAINTINGS DONE IN THE CLASSROOM BY CHILDREN FROM FIVE TO TWELVE. New York: Reinhold Book Co., 1968. 104 p. Illus., part color. Index.

> Discusses children, the teacher, materials, technique, motivation, and specific paintings of individual children.

Katz, Elias. CHILDREN'S PREFERENCES FOR TRADITIONAL AND MODERN PAINTINGS. New York: Teachers College, Columbia University, 1944. 136 p.

O'Hara, Eliot. ART TEACHER'S PRIMER. New York: Minton, Balch and Co., 1939. 180 p. Illus.

> A series of painting assignments.

Petterson, Henry, and Gerring, Ray. EXPLORING WITH PAINT. New York: Reinhold Publishing Co., 1964. 68 p. Illus.

> Motivation and philosophy are underplayed in this book about painting with children.

Pluckrose, Henry Arthur. INTRODUCING ACRYLIC PAINTING. New York: Watson-Guptill Publications, 1973. 96 p. Illus.

> Simple methods for using acrylic paint in projects with young people.

Randall, Arne W., and Halvorsen, Ruth Elise. PAINTING IN THE CLASS-
ROOM: A KEY TO CHILD GROWTH. Worcester, Mass.: Davis Publications,
1962. 132 p. Illus.

Various ways of painting and displaying pictures.

Timmons, Virginia Gayheart. PAINTING IN THE SCHOOL PROGRAM. Wor-
cester, Mass.: Davis Publications, 1968. 135 p. Illus., some color.

Discusses subject matter, motivation, contemporary art trends, media
and technique, art room organization, and evaluation in this book
primarily intended for junior and senior high school art teachers.

Torche, Judith. ACRYLIC AND OTHER WATER-BASE PAINTS FOR THE ARTIST.
New York: Sterling Publishing Co., 1967. 80 p. Index. Biblio.

Suggestions for the use of acrylic paints including a course outline
and list of supplies.

PAPER AND CARDBOARD

Alkema, Chester Jay. CREATIVE PAPER CRAFTS. New York: Sterling Pub-
lishing Co., 1967. 179 p.

Simple paper projects for elementary school children.

Becker, Edith. ADVENTURES WITH SCISSORS AND PAPER. Scranton, Pa.:
International Textbook Co., 1966. 98 p. Illus.

Presents a variety of techniques to demonstrate the versatility of
paper and its potential for creative expression by children. Pro-
cedures and activities of art teachers are presented with the intent
of fostering an exploratory attitude leading to individual interpre-
tation and problem solving.

Cizek, Franz. CHILDREN'S COLORED PAPER WORK. New York: G.E.
Stechert & Co., 1927. 42 p. Illus., part color.

Cox, Christabel R. CUT PAPER WORK. Peoria, Ill.: Chas. A. Bennett Co.,
1951. 75 p. Illus.

Picture making by cutting and pasting paper.

Fabri, Ralph. SCULPTURE IN PAPER. New York: Watson-Guptill Publica-
tions, 1966. 165 p. Illus. Index.

Shows three-dimensional objects to make with students. Includes
chapters on the commercial possibilities of paper sculpture and
its use in education.

Hughes, Toni. HOW TO MAKE SHAPES IN SPACE. New York: E.P. Dutton & Co., 1955. 217 p. Illus.

Shows three-dimensional work with paper and scrap materials.

Johnson, Pauline. CREATING WITH PAPER. Seattle: University of Washington Press, 1967. 207 p. Illus. Biblio.

Many exciting ways of using paper to make sculpture for teachers and students use. Presents techniques, with illustrations, from all parts of the world.

Johnston, Mary Grace. PAPER SCULPTURE. Worcester, Mass.: Davis Publishing Co., 1952. 24 p. Illus. Paper.

A how-to paper sculpture book for teachers.

Krinsky, Norman, and Berry, Bill. PAPER CONSTRUCTION FOR CHILDREN. New York: Reinhold Publishing Co., 1966. 97 p. Illus.

Kuwabara, Minoru; Hayashi, Kenzo; and Kumamoto, Takanori. CUT AND PASTE. New York: Ivan Obolensky, 1958. 48 p. Illus. Paper.

An attractive book profusely illustrated with photographs of Japanese children's work that stresses color.

Leeming, Joseph. FUN WITH PAPER. New York: J.B. Lippincott Co., 1939. 98 p. Illus.

How to make 125 things with paper. Includes puzzles and tricks as well as objects.

Lidstone, John. BUILDING WITH CARDBOARD. New York: Van Nostrand Reinhold Co., 1968. 96 p. Illus.

Demonstrates with photographs and detailed writing how the techniques of working with cardboard--measuring, cutting, scoring, gluing--can be put to use in creative ways.

Meilach, Dona, and Ten Hoor, Elvie. COLLAGE AND FOUND ART. New York: Reinhold Publishing Co., 1964. 68 p. Illus.

Pauli, Anna E., and Mitzit, Margaret S. PAPER FIGURES. Peoria, Ill.: Chas. A. Bennett Co., 1957. 102 p. Paper.

A how-to-do-it guide for teachers. Includes a section on wire and paper.

Rainey, Sarita. TISSUE PAPER ACTIVITIES. Worcester, Mass.: Davis Publications, 1971. 34 p. Paper.

Rainey, Sarita R., and Pattemore, Arne. WAYS WITH PAPER. Worcester, Mass.: Davis Publications, 1971. 34 p. Paper.

Rottger, Ernst. CREATIVE PAPER DESIGN. New York: Reinhold Publishing Co., 1961. 95 p. Illus.

PAPIER MACHE

Betts, Victoria Bedford. EXPLORING PAPIER MACHE. Worcester, Mass.: Davis Publications, 1955. 132 p. Illus.

> Discusses processes for both hollow and solid papier mache forms. Emphasis is on simplicity and working creatively with a variety of "graded" materials from the simplest forms to complex ones.

Lorrimar, Betty. CREATIVE PAPIER MACHE. New York: Watson-Guptill, 1975. 104 p. Illus., some color.

> Materials and various techniques of papier mache.

PHOTOGRAPHY

Cooke, Robert. DESIGNING WITH LIGHT ON PAPER AND FILM. Worcester, Mass.: Davis Publications, 1969. 86 p. Illus.

> Processes and techniques of using light as a picture-making element.

Holter, Patra. PHOTOGRAPHY WITHOUT A CAMERA. New York: Van Nostrand Reinhold Co., 1972. 144 p. Illus.

> Photography using light-sensitive paper and chemicals.

Meiselas, Susan. LEARN TO SEE. Cambridge, Mass.: Polaroid Corp., 1974. 123 p.

> The author speaks of teaching students how to see images, how to grasp forms and structural relationships which lie behind mental concepts. She presents a way of using the camera as a tool to develop perceptual and linguistic skills.

Suid, Murray. PAINTING WITH THE SUN: A FIRST BOOK OF PHOTOGRAPHY. New York: Educational Design, 1970. 52 p.

PLAY

Dewey, John. "Play and Imagination in Relation to Early Education." SCHOOL JOURNAL 58 (27 May 1899): 589. KINDERGARTEN MAGAZINE 11 (June 1899): 636-40.

A paper read by Dewey at the School of Psychology, held at Kindergarten College, Chicago, in April of 1899.

Frank, Lawrence K. PLAY IS VALID. Washington, D.C.: Association for Childhood Education International, 1968. 8 p. Paper.

Gordon, Ira J.; Guinagh, Barry; and Jester, R. Emile. CHILD LEARNING THROUGH CHILD PLAY. New York: St. Martin's Press, 1972. 116 p. Illus.

Play activities for young children including projects in the visual arts such as pattern making, crayon, paints, and blocks.

PLASTER-OF-PARIS

Meilach, Dona Z. CREATING WITH PLASTER. Chicago: Reilly & Lee Co., 1966. 73 p. Illus.

Discusses the use of plaster as a casting material and suggests projects for children.

POSTERS

Barish, Matthew. THE KID'S BOOK OF CARDS AND POSTERS. Englewood Cliffs, N.J.: Prentice-Hall, 1973. 96 p. Illus.

Horn, George F. POSTERS. Worcester, Mass.: Davis Publications, 1964. 96 p. Illus.

Designing, making, and reproducing posters.

Schoenoff, Herbert, and Schoenoff, Kurt. POSTER MAKING IN THE ELEMENTARY SCHOOL. New York: Row, Peterson and Co., 1948. 67 p. Illus.

PRINTMAKING

Andrews, Michael F. CREATIVE PRINTMAKING. Englewood Cliffs, N.J.: Prentice-Hall, 1964. 98 p. Illus. Biblio. Glossary.

Printmaking is looked at according to processes: relief, stencil, photographic, and intaglio, and in terms of creativity and aesthetic experience.

Dow, Arthur Wesley. "Printing From Wood Blocks." INTERNATIONAL STUDIO 59 (July 1916): 15-26.

Erikson, Janet, and Sproul, Adelaide. PRINTMAKING WITHOUT A PRESS. New York: Reinhold Publishing Co., 1966. 96 p. Illus.

Garbaty, Norman. PRINT MAKING WITH A SPOON. New York: Reinhold Publishing Co., 1960. 69 p. Illus.

> Describes twelve methods of relief printing.

Greenberg, Samuel. MAKING LINOLEUM CUTS. New York: Stephen Daye Press, 1947. 126 p. Illus. Biblio.

> A book about making block prints with a short essay discussing their use in school.

Pattemore, Arnel W. PRINTMAKING ACTIVITIES FOR THE CLASSROOM. Worcester, Mass.: Davis Publications, 1966. 110 p. Illus.

> A book of printmaking techniques for use with children. Includes a chapter on teaching printmaking and another on equipment and how to set up a printmaking room.

Rothenstein, Michael. RELIEF PAINTING. New York: Watson-Guptill Publications, 1970. 224 p. Illus. Index.

> This handsome book is a complete guide to relief printing with a chapter devoted to teaching--both children and adults. It is illustrated with student and professional work from around the world.

Russ, Stephen. FABRIC PRINTING BY HAND. London: Studio Vista, 1964. 97 p. Illus.

Stilwell, K.M. SCHOOL PRINT SHOP. Chicago: Rand McNally and Co., 1919. 69 p.

Vaughn, S.J. PRINTING AND BOOKBINDING FOR SCHOOLS. Peoria, Ill.: Manual Arts Press, 1914. 103 p.

PUPPETS

Baird, Bill. THE ART OF THE PUPPET THEATRE. New York: Macmillan, 1965. 86 p. Illus.

Binyon, Helen. PUPPETRY TODAY. London: Studio Vista, 1965. 96 p. Illus.

Bodor, John. CREATING AND PRESENTING HAND PUPPETS. New York: Reinhold Publishing Co., 1967. 96 p. Illus. Biblio. Glossary.

A guide to setting up a hand puppet project in a classroom. Each section of the book contains easy-to-follow directions for each aspect of the development of a puppet play, including: choosing and preparing a script, constructing and manipulating puppets, building a stage, making scenery, and putting on a show. Includes sample scripts by sixth-grade children. The bibliography includes a list of supplies and filmstrips.

Educational Puppetry Association. THE PUPPET BOOK: A PRACTICAL GUIDE TO PUPPETRY IN SCHOOLS, TRAINING COLLEGES AND CLUBS. London: Faber and Faber, 1965. 186 p.

Hoben, Alice. THE BEGINNER'S PUPPET BOOK. New York: Barnes & Noble, 1938. 103 p.

Hopper, Grizella. PUPPET MAKING THROUGH THE GRADES. Worcester: Davis Publications, 1966. 64 p.

A brief introduction to making fifteen different kinds of puppets, costumes, and plays using everyday material.

Kampmann, Lothar. CREATING WITH PUPPETS. New York: Van Nostrand Reinhold Co., 1974. 96 p. Illus.

Instructions--graded according to children's ages--for making many different kinds of puppets from various materials.

Lanchester, Waldo. HAND PUPPETS AND STRING PUPPETS. Peoria, Ill.: Chas. A. Bennett Co., 1953. 44 p. Paper.

Discusses the essential details of making puppets, dressing and manipulating them, and staging a play.

Mills, Walter H., and Dunn, Louis M. MARIONETTES, MASKS, AND SHADOWS. Garden City, N.Y.: Doubleday, Doran & Co., 1928. 126 p. Biblio.

The history of marionettes, masks, and shadow puppets, and how to make them.

Nicol, W.D. PUPPETRY. Oxford: Oxford University Press, 1962. 132 p. Illus.

Snook, Barbara. PUPPETS. London: B.T. Batsford, 1965. 97 p. Illus.

SCULPTURE

Bunch, Clarence. ACRYLIC FOR SCULPTURE AND DESIGN. New York: Van Nostrand Reinhold Co., 1972. 144 p. Illus. Index. Biblio.

This, the first book about acrylic, examines the material in terms of the history of sculpture and design and looks at contemporary work as well. There are sections about hand and machine working the material.

Hall, Margaret P. TERRACOTTA MODELLING FOR SCHOOLS. New York: Alec Tiranti, 1954. 96 p. Illus.

Leyh, Elizabeth. CHILDREN MAKE SCULPTURE. New York: Van Nostrand Reinhold Co., 1970. 134 p. Illus.

Sargent, Walter. MODELLING IN PUBLIC SCHOOLS. New York: Hammett, 1909. 108 p.

TOYS

Caney, Steven. TOY BOOK. New York: Workman Publishing Co., 1972. 176 p. Illus.

Includes fifty toys that work and are fun for parents and children to make.

Early, Mabel. TOY MAKING. New York: Studio Publications, 1945. 38 p.

Rees, Elizabeth Lodge. A DOCTOR LOOKS AT TOYS. Springfield, Ill.: Charles C. Thomas Publisher, 1961. 188 p. Illus. Index.

Discusses toys for both normal and handicapped children, and the history of toys.

VIDEO AND OTHER MEDIA

Association for Childhood Education International and Center for Understanding Media. CHILDREN ARE CENTERS FOR UNDERSTANDING MEDIA. New York: 1973. 96 p. Biblio.

Ideas for involving children as photographers, filmmakers, video-tapers, and sound-seekers.

KALEIDOSCOPE 9: MEDIA PROGRAMS. Boston: Department of Education, 1974. 59 p. Illus. Paper.

Descriptions of media centers, teacher resources, special programs, filmmaking, mass media, and television used with children.

Lanier, Vincent. THE USES OF NEWER MEDIA IN ART EDUCATION PROJ-ECTS. Washington, D.C.: National Art Education Association, 1966. 94 p. Illus. Biblio.

A report of a five-day symposium where fifty art educators and four media specialists studied the impact of educational technology on art instruction. Levels explored were elementary through college.

Laybourne, Kit, ed. DOING THE MEDIA. New York: New York Center for Understanding Media, 1972. 228 p.

Provides guidelines for film-media programs and suggests curricula in film, video, photography, and sound.

Zelmer, A.C. Lynn. COMMUNITY MEDIA HANDBOOK. Metuchen, N.J.: Scarecrow Press, 1973. 241 p. Illus. Index. Biblio.

Street theatre is included in this book about how to use media in the community.

WIRE

Brommer, Gerald. WIRE SCULPTURE AND OTHER THREE-DIMENSIONAL CONSTRUCTION. Worcester, Mass.: Davis Publications, 1968. 128 p. Illus. Index.

Projects with wire, wood, cardboard, and paper for use with children.

Lidstone, John. BUILDING WITH WIRE. New York: Van Nostrand Reinhold Co., 1972. 96 p. Illus., with photos.

An in-depth exploration of ways in which children can express themselves by constructing wire sculpture and jewelry with the simplest of materials and equipment. These projects involve the child in open-ended design activities.

WOOD

Crofton, Kathleen. WOOD. London: Educational Supply Association, 1955. 17 p. Illus. Paper.

Suggestions for working with wood with children. Slanted toward appreciation, thereof.

Griffith, Irving S. WOODWORK FOR SECONDARY SCHOOLS. Peoria, Ill.: Manual Arts Press, 1916. 123 p.

Laliberte, Norman, and Jones, Maureen. WOODEN IMAGES. New York: Reinhold Publishing Co., 1966. 136 p. Illus.

Leeming, Joseph. FUN WITH WOOD. New York: J.B. Lippincott Co., 1942. 87 p. Illus.

Lidstone, John. BUILDING WITH BALSA WOOD. New York: Van Nostrand Reinhold Co., 1965. 62 p. Illus., some color.

> The creative possibilities of balsa wood as a medium are fully explored. Easy-to-follow instructions illustrated by sequential photographs introduce students and teachers alike to numerous ways of working with balsa wood. The emphasis is on open-ended projects and individual creativity.

Metcalf, Harlan G. WHITTLIN', WHISTLES AND THINGAMAJIGS. Cambridge, Mass.: Stackpole Books, 1974. 188 p.

> Nature crafts.

Patrick, Sara. TOOLS FOR WOODWORKING IN ELEMENTARY SCHOOLS. New York: Industrial Arts Cooperative Service, 1941. 18 p.

Roettger, Ernst. CREATIVE WOOD DESIGN. New York: Reinhold Publishing Co., 1961. 96 p. Illus.

Taylor, Jeanne. CHILD'S BOOK OF CARPENTRY. New York: Greenberg Publisher, 1948. 132 p. Illus.

Teller, Raphael. WOODWORK: A BASIC MANUAL. Boston: Little, Brown and Co., 1974. 142 p.

> An introduction to woodworking.

Chapter 27
TEACHER RESOURCE MATERIALS

GENERAL INTEREST

College Art Association of America. Resources and Planning Committee. A LIST OF THE NEEDS OF VISUAL ARTS IN HIGHER EDUCATION. A report submitted to the board of directors of the College Art Association by the Resources and Planning Committee, February 1966: James Watroue, Otto Wittman, and Seymour Slive (chairman). New York: 1966. 27 p. Paper.

 Teaching aids for art history and studio classes in colleges and museum classes.

Taylor, Frank D.; Artuso, Alfred A.; and Hewett, Frank M. CREATIVE ART TASK CARDS. Denver, Colo.: Love Publishing Co., 1971. 144 cards. Paper.

 Designed for individualized pupil art work, these 144 "tasks" cards contain illustrated instructions for one activity per card.

AUDIOVISUAL

Atkinson, Norman J. MODERN TEACHING AIDS: A PRACTICAL GUIDE TO AUDIO-VISUAL TECHNIQUES IN EDUCATION. London: Maclaren and Sons, 1966. 208 p. Illus. Index. Glossary.

 There is a chapter about making your own audiovisual aids.

Brown, James W.; Lewis, Richard B.; and Harcleroad, Fred F. A-V INSTRUCTION: MATERIALS AND METHODS. New York: McGraw-Hill Book Co., 1959. 554 p.

Erickson, Carlton W.H. FUNDAMENTALS OF TEACHING WITH AUDIOVISUAL TECHNOLOGY. New York: Macmillan, 1965. 384 p.

Hulfish, James W., Jr., ed. AUDIO-VISUAL EQUIPMENT DIRECTORY. Fairfax, Va.: National Audio-Visual Association, 1966. 340 p.

Teacher Resource Materials

BULLETIN BOARDS AND EXHIBITION TECHNIQUES

Carmel, James H. EXHIBITION TECHNIQUES, TRAVELING AND TEMPORARY. New York: Reinhold Publishing Co., 1962. 97 p.

> Covers planning and design, costs, lighting, packaging, and transportation of exhibits.

Hayett, Will. DISPLAY AND EXHIBIT HANDBOOK. New York: Reinhold Publishing Co., 1967. 102 p.

> A handbook on planning exhibits and information on storage and the use of posters and display panels.

Horn, George F. HOW TO PREPARE VISUAL MATERIAL FOR SCHOOL USE. Worcester, Mass.: Davis Publications, 1963. 153 p.

_____. VISUAL COMMUNICATION: BULLETIN BOARDS, EXHIBITS, VISUAL AIDS. Worcester, Mass.: Davis Publications, 1973. 164 p. Illus.

> How to create exhibits and visual aids for school use.

Minor, Ed. SIMPLIFIED TECHNIQUES FOR PREPARING VISUAL INSTRUCTIONAL MATERIALS. New York: McGraw-Hill Book Co., 1962. 123 p. Illus.

Randall, Reino, and Haines, Edward C. BULLETIN BOARDS AND DISPLAY. Worcester, Mass.: Davis Publications, 1961. 72 p. Illus. Biblio.

Warren, Jefferson T. EXHIBIT METHODS. New York: Sterling Publishing Co., 1972. 80 p. Illus., some color. Index.

> Suggestions for creating school and museum exhibits.

FOLIOS AND REPRODUCTIONS

Allen, Robert J. LIFE IN 18TH CENTURY ENGLAND. Boston: Museum of Fine Arts, n.d. 38 p. Illus. Paper.

> Contains forty-two black-and-white reproductions on stiff paper and an essay about eighteenth-century England for classroom use.

Anderson, Florence. MEMORANDUM ON THE USE OF ART AND MUSIC STUDY MATERIAL. New York: Carnegie Corp., 1941. 27 p.

> A narrative report dealing with the use of the Carnegie school art and music sets.

Boston Museum of Fine Arts. GREEK ATHLETICS AND FESTIVALS IN THE FIFTH CENTURY. Boston: n.d. 40 plates (oversized) and booklet. Paper.

> Contains forty black-and-white reproductions on stiff paper for classroom use and a teacher guide booklet.

Boyd, Catherine. THE FRENCH RENAISSANCE. Boston: Museum of Fine Arts, 1955. 47 p. Illus. Paper.

> Contains forty-two black-and-white reproductions on stiff paper and an essay about the French Renaissance for school use.

Bureau of University Travel. LIST OF REPRODUCTIONS ISSUED IN CONNECTION WITH THE SECOND YEAR'S COURSE OF OUTLINES FOR THE STUDY OF ART. Boston: 1904. 18 p. Illus. Paper.

> Suggested pictures to use in teaching each month of the year.

_____. OUTLINES FOR THE STUDY OF ART, ART REPRODUCTIONS, LECTURES, TRAINING AND RESEARCH CLASSES. Boston: 1904. 30 p. Paper.

> There is a short essay about the importance of art in education and descriptions of teaching aids available from the bureau.

Canaday, John. METROPOLITAN SEMINARS IN ART. New York: Metropolitan Museum of Art, 1958. Portfolios.

Carnegie Corporation of New York. CARNEGIE ART REFERENCE SET FOR COLLEGES. New York: Rudolf Lesch Fine Arts, 1939. 117 p. Illus. Biblio., pp. 113-17.

Daniel, Greta. USEFUL OBJECTS TODAY: TEACHING PORTFOLIO NO. 4. New York: Museum of Modern Art, 1955. 14 p. Illus.

> A generalized discussion of design principles and reproductions of well designed utilitarian household objects. Also contains forty black-and-white plates on doubleweight paper.

D'Harnoncourt, Rene. MODERN ART OLD AND NEW: TEACHING PORTFOLIO NO. 3. New York: Museum of Modern Art, 1950. 2 p. Illus.

> Contains forty black-and-white plates on doubleweight paper. Contrasts art objects, old and new, from many epochs and countries. Aim is to show kinship between works from different times and cultures. Plates are arranged so that each ancient work is followed by a comparable modern one.

Fansler, Roberta Murray. CATALOGUE OF THE FINE ARTS FOR SECONDARY SCHOOLS. Rev. ed. New York: Carnegie Corp., 1936. 246 p.

> A handbook about the use of the Carnegie art study set distributed to selected secondary schools.

_____. AN INDEX TO THE SET OF FINE ARTS TEACHING AND REFERENCE MATERIAL FOR SECONDARY SCHOOLS. New York: Carnegie Corp., 1933. 225 p. Index.

> Books and reproductions for use in high school art classes.

Lidstone, John; Lewis, Stanley; and Brody, Sheldon. REINHOLD VISUALS: AIDS FOR TEACHING. New York: Van Nostrand Reinhold Co., 1968-74. Illus., black-and-white and color. 10 portfolios of annotated plates and accompanying booklets. 16 p. each.

> Each portfolio is calculated to produce lively discussion to reinforce understanding of the universal application of art elements, to suggest unfolding levels of insight, and to stimulate the viewer to take a new look at art and environment. The following subjects are covered: Portfolio 1: Line; 2: Mass; 3: Organization; 4: Surface; 5: Color; 6: Movement; 7: Perception; 8: Space; 9: Light; 10: Fantasy.

National Gallery of Art. A CATALOGUE OF REPRODUCTIONS AND PUBLICATIONS. Washington, D.C.: 1970. 80 p. Paper.

> A list of slides, post cards, books, recordings, reproductions of paintings, sculptures, and jewelry available for purchase from the National Gallery. There is a section about materials designed especially for classroom use.

Osborn, E.C., ed. MODERN SCULPTURE. Teaching Portfolio No. 1. New York: Museum of Modern Art, 1947. 8 p. Illus.

> Contains forty black-and-white plates on doubleweight paper of sculpture since 1900.

_____. TEXTURE AND PATTERN. Teaching Portfolio No. 2. New York: Museum of Modern Art, 1949. 2 p. Illus.

> Contains forty black-and-white plates on doubleweight paper which heighten sensitivity to texture and pattern in nature and art.

Saunders, Robert J. ABRAMS MULTI-PURPOSE SCHOOL ARTPRINT PROGRAM. SERIES A, B, AND C. New York: American Book Co., 1972.

> Includes manual and twenty reproductions in each set.

Tschabasou, Nahum, ed. TEACHER MANUAL FOR THE STUDY OF ART HISTORY AND RELATED COURSES. New York: American Library Color Slides Co., 1964. 513 p.

> Catalog of over 70,000 slides which can be purchased from the company.

Williams, Franklin B., Jr. ELIZABETHAN ENGLAND. Boston: Museum of Fine Arts, n.d. 32 p. Illus. Paper.

> This teaching set consists of an essay about Elizabethan England and forty-one black-and-white reproductions on stiff paper.

FILMS, FILMSTRIPS, AND SLIDES

DeLaurier, Nancy. SLIDE BUYERS GUIDE. New York: College Art Association, 1974. 103 p. Index. Paper.

> Tells where to buy slides--complete with addresses and prices--from around the world.

Educational Media Council. ART AND MUSIC. New York: McGraw-Hill Book Co., 1964. 235 p.

> A list of films about art and music.

Humphreys, Alfred W. FILMS ON ART. Washington, D.C.: National Art Education Association, 1965. 32 p. Paper.

> An ABC listing of films about art and artists and how-to films for teacher use with children.

Lanier, Vincent. SLIDES AND FILMSTRIPS ON ART. Washington, D.C.: National Art Education Association, 1967. 40 p. Paper.

> A list of filmstrips and slides and their producers.

Petrini, Sharon, and Bromberger, Troy-John. A HANDLIST OF MUSEUM SOURCES FOR SLIDES AND PHOTOGRAPHS. Santa Barbara: University of California, 1972. 148 p. Paper.

> A subject list of slides available from museums around the world.

FREE AND INEXPENSIVE MATERIALS

Aubrey, Ruth H. SELECTED FREE MATERIALS FOR CLASSROOM TEACHERS. Belmont, Calif.: Fearon Publishers, 1972. 135 p.

Detroit Schools. Department of Art Education. FREE AND INEXPENSIVE REFERENCE MATERIALS. Detroit: Board of Education, 1957. 16 p. Paper.

Field Enterprises. SOURCES OF FREE AND INEXPENSIVE EDUCATIONAL MATERIALS. Chicago: Educational Division, Merchandise Mart Plaza, 1955. 23 p. Paper.

Suttles, Patricia H., ed. ELEMENTARY TEACHERS' GUIDE TO FREE CURRIC-
ULUM MATERIALS. Randolph, Wis.: Educators Progress Service, 1974. 395 p.

TELEVISION

Barkan, Manual, and Chapman, Laura H. GUIDELINES FOR ART INSTRUCTION
THROUGH TELEVISION FOR THE ELEMENTARY SCHOOL. Bloomington, Ind.:
National Center for School and College Television, 1967. 97 p. Illus.

National Center for School and College Television. INSTRUCTIONAL TELE-
VISION IN ART EDUCATION. Bloomington, Ind.: 1966. 12 p. Paper.

Schwartz, Alice M. IMAGES AND THINGS: GUIDE AND PROGRAM NOTES.
Bloomington, Ind.: National Instruction Television Center, 1972. 160 p.

> Suggestions for the use of television in art education of elementary
> children.

OTHER MEDIA

Fortress, Karl E. THE PREPARATION OF A LIBRARY OF TAPED INTERVIEWS
WITH AMERICAN ARTISTS, ON PROBLEMS OF PROFESSIONAL CONCERN,
AS RESOURCE MATERIAL FOR FACULTY AND STUDENTS OF ART ON THE
LEVEL OF HIGHER EDUCATION. Washington, D.C.: Office of Education,
Department of Health, Education and Welfare, n.d. 13 p.

Jacobs, Norman, ed. CULTURE FOR THE MILLIONS: MASS MEDIA IN
MODERN SOCIETY. New York: Van Nostrand Reinhold Publishing Co.,
1959. 97 p.

Kellogg, Rhoda. RHODA KELLOGG CHILD ART COLLECTION: HOW YOUNG
CHILDREN TEACH THEMSELVES TO DRAW. Washington, D.C.: Microcard Edi-
tions, 1967. Microfilm.

> Drawings (8,000) of children ages twenty-four to forty months on
> microfilm.

Chapter 28
FACILITIES FOR TEACHING ART

GENERAL INTEREST

ART ROOMS FOR NEW SCHOOL BUILDINGS. Baltimore, Md.: Division of Art Education, 1951. 36 p. Paper.

Educational Facilities Laboratories. THE PLACE OF THE ARTS IN NEW TOWNS. New York: 1973. 72 p. Illus. Paper.

Eriksen, Aase. LEARNING ABOUT THE BUILT ENVIRONMENT. New York: Educational Facilities Laboratories, 1974. 68 p. Paper.

 This catalog of resources for elementary and secondary teachers contains annotations of publications and descriptions of programs.

Friedberg, M. Paul. RECYCLING A GARAGE. Detroit: High Scope Educational Research Foundation, 1973. 68 p. Illus. Paper.

 Traces the development of a building from a garage to an educational facility.

National Art Education Association. PLANNING FACILITIES FOR ART INSTRUCTION. Washington, D.C.: 1962. 44 p. Illus. Biblio. Paper.

 Describes the supporting facilities necessary for implementing an art program.

National Council on Schoolhouse Construction. GUIDE FOR PLANNING SCHOOL PLANTS. East Lansing, Mich.: 1958. 254 p.

 Basic approach is to plan each special facility (such as art) for local needs, community, population, and curriculum; and to avoid stock plans.

Perkins, Lawrence B. WORK PLACE FOR LEARNING. New York: Reinhold Publishing Co., 1957. 63 p. Illus.

Gives insights and models for the support and planning of art programs and facilities.

Taylor, James L.; Bryce, Mayo; and Koury, Rose E. SPACE AND FACILITIES FOR ART INSTRUCTION. Washington, D.C.: Department of Health, Education and Welfare, 1963. 66 p. Illus. Biblio. Paper.

Discusses outdoor and indoor art education facilities for both elementary and secondary schools.

EARLY CHILDHOOD

Le Corbusier. NURSERY SCHOOLS. Translated by Eleanor Levieux. New York: Orion Press, 1968. 88 p. Illus.

In this, his last work, Le Corbusier considers the ideal learning environment for children who lived in his famous "Radiant City." He wanted them to live free and open.

Osmon, Fred Linn. PATTERNS FOR DESIGNING CHILDREN'S CENTERS. New York: Educational Facilities Laboratories, 1975. 128 p. Illus. Biblio. Paper.

Planning for early childhood education.

SCHOOLS FOR EARLY CHILDHOOD. New York: Educational Facilities Laboratories, 1970. 55 p. Illus. Biblio. Paper.

A visual and written report of exemplary nursery schools and their facilities across the country.

Taylor, James L. FUNCTIONAL SCHOOLS FOR YOUNG CHILDREN. Washington, D.C.: Government Printing Office for the Office of Education, Department of Health, Education and Welfare, 1961. 81 p.

Designed to help the architect interpret the needs of young children and their school program in relation to space, arrangement, and facilities.

ELEMENTARY

Dean, Joan. ROOM TO LEARN: A PLACE TO PAINT. New York: Citation Press, 1973. 48 p. Illus. Paper.

Practical suggestions about classroom and furniture arrangement for art teaching.

_____. ROOM TO LEARN: WORKING SPACE. New York: Citation Press, 1972. 48 p. Illus. Paper.

> This book was designed to help teachers improve and adapt their working environments. It is full of suggestions for making the most of the space available, for adapting existing furniture, and for improvising what is nonexistent.

Seaborne, Malcolm. PRIMARY SCHOOL DESIGN. London: Routledge & Kegan Paul, 1974. 196 p. Illus.

Taylor, Ann, and Vlastos, George C. SCHOOL ZONE: LEARNING EN- VIRONMENTS FOR CHILDREN. New York: Van Nostrand Reinhold Co., 1975. 96 p. Illus. Paper.

> Explores ideas for designing and building indoor and outdoor learn- ing environments that use the curriculum as the design determinant for architectural systems which help teach children concepts from the various disciplines. It is a lively, exciting book full of prac- tical and innovative suggestions.

SECONDARY

Architectural Record. BUILDING TYPES: HIGH SCHOOLS. New York: F.W. Dodge Corp., 1939. 139 p.

ART ROOMS: SECONDARY SCHOOLS. Edinburgh, Scot.: Her Majesty's Stationery Office, 1964. 13 p. Paper.

> Practical suggestions about art room planning including location, types and sizes of rooms, provisions for display, lighting, storage, furniture, and equipment.

Engelhardt, N.L., and Leggett, Stanley. "Arts and Crafts Studios." In PLAN- NING SECONDARY SCHOOL BUILDINGS, pp. 152-57. New York: Reinhold Publishing Co., 1949.

> Describes facilities for art rooms in general and for the small- and medium-sized high school specifically. These facilities grouped either in one room or spread through a suite of related rooms in- clude: space for creative expression, storage, washroom and sink, exhibit and display, discussion and study, library, and print storage facilities.

National Association of Secondary School Principals. ART ROOMS AND EQUIPMENT. Washington, D.C.: 1961. 48 p. Paper.

SECONDARY SCHOOL DESIGN: DESIGNING FOR ARTS AND CRAFTS. Lon- don: Her Majesty's Stationery Office, 1967. 48 p. Illus. Paper.

Practical suggestions for secondary school art studios.

Schultz, Larry T. STUDIO ART: A RESOURCE FOR ARTIST-TEACHERS. New York: Van Nostrand Reinhold Co., 1973. 103 p. Illus., some color.

Organization of studio space for high school art classes.

HIGHER EDUCATION

Benson, E.M. A PILOT STUDY OF ART FACILITIES AT SIX COLLEGES AND UNIVERSITIES. Brooklyn, N.Y.: Pratt Institute, 1966. 53 p. Illus. Biblio. Paper.

.Compares art facilities at Cleveland Institute of Art, Massachusetts Institute of Technology, New York University, Pratt Institute, Sarah Lawrence College, and the University of Michigan. The purpose of the comparison was to define issues that underline curricular and space decision making in the visual arts.

Council for Art and Industry. EDUCATION FOR THE CONSUMER: ART IN ELEMENTARY AND SECONDARY EDUCATION. London: His Majesty's Stationery Office, 1935. 38 p. Illus. Paper.

A discussion of teacher education and school equipment.

PLAYGROUNDS

Coates, Gary J., ed. ALTERNATIVE LEARNING ENVIRONMENTS. Stroudsburg, Pa.: Dowden, Hutchinson & Ross, 1974. 387 p. Illus. Index. Biblio.

Includes "Space Place" by Stanley Madeja and several articles about play and playgrounds in addition to more general school plans.

MAKING PLACES, CHANGING SPACES, IN SCHOOLS, AT HOME AND WITHIN OURSELVES: FARALLONES SCRAPBOOK. Point Reyes Station, Calif.: Farallones Designs, 1971. 144 p. Illus. Paper.

There are sections on geometry and dome building, building playgrounds, working with trash, and ways to change classrooms in this book by both teachers and students.

PLACES AND THINGS FOR EXPERIMENTAL SCHOOLS. New York: Educational Facilities Laboratories, 1972. 133 p. Illus. Index. Paper.

Includes sections about playgrounds and making your own classroom furniture.

Sharkey, Tony. BUILDING A PLAYGROUND. Washington, D.C.: Advisory for Open Education, 1970. 116 p. Paper.

Children and teachers build a playground.

Chapter 29
FINANCING ART EDUCATION

Central Hanover Bank and Trust Co. FINE ARTS IN PHILANTHROPY. New York: 1937. 61 p. Paper.

There is a section about art in the schools in this book about how the money given by banking institutions is used.

Eddy, Junius. A REVIEW OF FEDERAL PROGRAMS SUPPORTING THE ARTS IN EDUCATION. New York: Ford Foundation, 1970. 141 p.

National Endowment for the Arts. EXPANSION ARTS PROGRAM. Washington, D.C.: 1975. 11 p. Paper.

Funding assistance guidelines for community-based arts projects.

_____. GUIDE TO PROGRAMS (1973). Washington, D.C.: 1973. 60 p. Paper.

A description of the National Endowment and information about its programs.

_____. NEW DIMENSIONS FOR THE ARTS, 1971-1972. Washington, D.C.: 1973. 135 p. Illus. Paper.

Brief reports about funded arts programs in operation. The art education ones are about artists in schools, college entrance, administration fellowships, and alternative education.

_____. PROGRAMS FOR THE NATIONAL ENDOWMENT FOR THE ARTS THROUGH AUGUST 30, 1968. Washington, D.C.: 1968. Several booklets bound together. Paper.

Descriptions of arts programs funded by the National Endowment.

_____. PROGRAMS OF THE NATIONAL COUNCIL ON THE ARTS AND THE NATIONAL ENDOWMENT FOR THE ARTS, OCTOBER 1965 THROUGH APRIL

1970. Washington, D.C.: National Endowment for the Arts, 1970. Var. pag. Paper.

Arts programs in the United States funded federally, both completed and in operation.

_____. PROGRAMS OF THE NATIONAL ENDOWMENT FOR THE ARTS, 1969. Washington, D.C.: 1969. Unpaged. Paper.

A list of arts projects funded in 1969 by the federal government. Very little money went to art education.

_____. PROGRAMS OF THE NATIONAL ENDOWMENT FOR THE ARTS THROUGH OCTOBER 1969. Washington, D.C.: 1969. Unpaged.

Reports of projects in the arts across the country, both in progress and completed, funded by the National Endowment.

_____. VISUAL ARTS PROGRAM GUIDELINES, 1973. Washington, D.C.: National Council on the Arts, 1973. 27 p. Paper.

Announcements of federal funds available for individual artists and craftsmen and organizations.

Chapter 30

ART EDUCATION TEXTBOOKS

Bland, Jane Cooper. ART FOR CHILDREN. Chicago: Field Enterprises, 1954. 138 p. Illus., some color. Index.

>An art appreciation book for children in grades four and higher consisting chiefly of illustrations with short explanatory text and some suggestions for things children can make. Also includes art by children.

Burke, B. Ellen. THE McBRIDE LITERATURE AND ART BOOKS. New York: D.H. McBride & Co., 1900-1902.

>Textbooks for children in grades one to eight and teachers' manuals using picture study to teach reading and writing.

Clark, John Spencer; Hicks, Mary Dana; and Perry, Walter S. PRELIMINARY MANUAL FOR THE PRANG ELEMENTARY COURSE IN ART INSTRUCTION. New York: Prang Educational Co., 1897. Illus.

>Courses of study for children ages three to eight. Emphasizes perspective, drawing, and picture study. The following books are included:

>Book 3 & 4, Fourth Year. 69 p.
>Book 5 & 6, Fifth Year. 70 p.
>Book 7 & 8, Sixth Year. 77 p.
>Book 9 & 10, Seventh Year. 72 p.
>Book 11 & 12, Eighth Year. 76 p.

_____. TEACHERS' MANUAL FOR THE PRANG ELEMENTARY COURSE IN ART INSTRUCTION. New York: Prang Educational Co., 1898. Illus.

>A general discussion about art education is included in these teachers' manuals for the classroom material issued by Prang.

>Book 1 & 2, Third Year. 190 p. Illus. Index.
>Book 3 & 4, Fourth Year. 190 p. Illus. Index.
>Book 5 & 6, Fifth Year. 200 p. Illus. Index.

Collins, Mary Rose., and Riley, Olive C. ART APPRECIATION FOR JUNIOR AND SENIOR HIGH SCHOOLS. New York: Harcourt, Brace and Co., 1932. 334 p. Illus. Biblio.

> Written as a textbook for junior and senior high school students, this book approaches art appreciation through actual art experiences. It touches on almost all aspects of art.

Davis, Beverly Jeanne. CHANT OF THE CENTURIES: A HISTORY OF THE HUMANITIES. Austin, Tex.: W.S. Benson & Co., 1969. 200 p. Illus.

> This history of the humanities for high school students is written in an abbreviated manner. Includes a teachers' manual.

Ellsworth, Maud. ART FOR THE HIGH SCHOOL. Syracuse, N.Y.: L.W. Singer Co., 1957. 96 p. Illus., some color. Biblio. Paper.

> An art appreciation and studio problem textbook for junior or high school pupils.

_____. GROWING WITH ART: THE TEACHER'S BOOK, BOOKS ONE THROUGH EIGHT. Chicago: Benjamin H. Sanborn & Co., 1950-51. 16 p. Paper.

> Hints about using GROWING WITH ART textbooks with children in grades one through eight.

Ellsworth, Maud, and Andrews, Michael F. GROWING WITH ART. 8 vols. Chicago: Benjamin H. Sanborn & Co., 1950-51. 64 p. Illus.

> Art textbooks for grades one through eight.

Eitner, Lorenz. ART APPRECIATION. Minneapolis, Minn.: Burgess Publishing Co., 1961. 131 p. Illus.

> An art appreciation workbook for high school students or college freshmen covering everything from the "meaning of the word 'art'" to the environment.

Fearing, Kelly; Beard, Evelyn; and Martin, Clyde Inez. THE CREATIVE EYE. 2 vols. Austin, Tex.: W.S. Benson & Co. 127 p. Illus.

> Beautifully illustrated art appreciation books for upper grades and high school students. Volume one is primarily concerned with environment; volume two with the elements of art.

Froehlich, Hugo B., and Snow, Bonnie E. TEXTBOOKS OF ART EDUCATION. 7 vols. Boston: Prang Educational Co., 1904-5. Illus., some color.

> Book 1: FIRST YEAR. 72 p.
>
> > Concerned with appreciation of beauty in nature. Suggests a few simple weaving and modeling activities for children.

Book 2: SECOND YEAR. 72 p.

Discusses art appreciation through nature study and contains a few simple activities for the children to do.

Book 3: THIRD YEAR. 82 p.

Still a lot of appreciation of "beauty" through nature, but more attention paid to making things. Geometric shapes somewhat stressed.

Book 4: FOURTH YEAR. 98 p.

Many of the art activities are clearly related to nature and mostly have to do with drawing and design.

Book 5: FIFTH YEAR. 98 p.

Pays formal attention to the elements of design.

Book 6: SIXTH YEAR. 104 p.

Many suggestions for drawing out of doors and still life, and for measuring distances and planning. Contains suggested exercises for the child to do at home.

Book 7: SEVENTH YEAR. 126 p.

Suggests landscape drawing from photographs, geometry, working drawings of machinery, and design work.

Heyne, C.J., Jr., et al. ART FOR YOUNG AMERICA. 3d ed. Peoria, Ill.: Chas. A. Bennett Co., 1962. 286 p. Illus.

See entry on p. 104.

Hicks, John. THE "INDIVIDUAL" ART COURSE. New York: Phillips, 1908. 112 p.

This design book was prepared for the Dalton school.

Hicks, Mary Dana. ART INSTRUCTION IN THE PRIMARY GRADES: A MANUAL FOR TEACHERS (SECOND YEAR). Illustrated by Edith Clark Chadwick. Boston: Prang Educational Co., 1899. 157 p.

This book, one of a series for the elementary grades published by Prang, is amazingly modern. The author suggests body movement as an activity as well as using color and form, modeling with clay, working with paper, sewing, painting, and drawing.

Hicks, Mary Dana, and Locke, Josephine C. THE PRANG PRIMARY COURSE IN ART EDUCATION: FIRST PRIMARY YEAR. Boston: Prang Educational Co., 1892. 168 p. Illus.

Basically a course of study about form in art for young children in which drawing plays a key role. However, there are sections on

materials that illustrate form (in which the authors encourage chil-
dren to handle the objects) and paper folding.

Hubbard, Guy, and Rouse, Mary J. ART: MEANING, METHOD, AND
MEDIA. Westchester, Ill.: Benefic Press, 1972. 128 p. Illus., part color.

A book of art lessons, including a couple about making maps, for
youngsters.

Jefferson, Blanche, et al. MY WORLD OF ART SERIES. 6 vols. Boston:
Allyn and Bacon, 1963-64.

Also publishes teacher's manuals for this series.

Kainz, Luise C., and Riley, Olive L. EXPLORING ART. New York: Har-
court, Brace & World, 1947. 267 p. Illus.

An art appreciation textbook for high school students based on the
no longer existent New York City freshman year "required art"
course.

Karel, Leon C. AVENUES TO THE STARS. Kirksville, Mo.: Simpson Pub-
lishing Co., 1966. 331 p. Illus.

A related arts textbook for secondary school.

Littlejohns, John, and Horth, A.C. ALLIED ARTS AND CRAFTS. 4 vols.
Vol. 1: JUNIOR COURSE, FIRST YEAR; Vol. 2: JUNIOR COURSE, SECOND
YEAR; Vol. 3: JUNIOR COURSE, FOURTH YEAR; Vol. 4: JUNIOR COURSE,
FIFTH YEAR. London: Sir Isaac Pitman & Sons, 1930. 24 p. each. Illus.,
some color. Paper.

How-to-do-it activities directed to children, mostly having to do
with paper and book making.

Loughran, Bernice B. ART EXPERIENCES: AN EXPERIMENTAL APPROACH.
New York: Harcourt, Brace & World, 1963. 154 p. Illus.

A design workbook for high school students.

Nicholas, Florence Williams, et al. ART FOR YOUNG AMERICANS. Peoria,
Ill.: Manual Arts Press, 1946. 286 p.

A text for beginning high school art and home economics classes.
Emphasis is on appreciation.

Ocvirk, Otto G., et al. ART FUNDAMENTALS, THEORY AND PRACTICE.
Dubuque, Iowa: William C. Brown Co., 1960. 169 p. Illus.

Designed for high school or beginning college students, this art
appreciation text is organized using art elements as its core.

Price, Charles Matlack, and Bishop, A. Thornton. ART SCHOOL SELF-TAUGHT. New York: Greenberg Publisher, 1952. 439 p. Illus. Index. Biblio.

A "self-help" book for young people with exercises and test questions. Discusses drawing, design, illustration, typography, photography, fashion, and window design.

Ramusen, Henry N. ART STRUCTURE. New York: McGraw-Hill Book Co., 1950. 109 p. Illus. Index. Biblio.

An art appreciation text written for high school and beginning college students dealing with basic art elements.

Riley, Olive L. YOUR ART HERITAGE. New York: McGraw-Hill Book Co., 1952. 320 p.

An art history survey textbook for high school students.

Rowland, Kurt F. LEARNING TO SEE. 5 vols. New York: Van Nostrand Reinhold Co., 1968-70. 48 p. each. Illus., color. Paper.

This series of five sequenced picture books, pupil workbooks, and teachers' manuals deals with pattern, form, movement, rhythm, and visual communication.

Ruffini, Elise Erna, and Knapp, Harriet E. NEW ART EDUCATION. 9 vols. Sandusky, Ohio: American Crayon Co., 1944. 40 p. each. Illus., some color. Paper.

Each book in this series of textbooks for children follows the same format. In each there are suggestions of things to do, a color activity, picture study, and sections about art in the community, art used with other school subjects, and art and vacation time.

Taylor, Joshua Charles. LEARNING TO LOOK: A HANDBOOK FOR THE VISUAL ARTS. Rev. ed. Chicago: University of Chicago Press, 1957. 152 p. Illus.

The handbook used in the art portion of the first humanities course at the University of Chicago.

Van Homrigh, C.M.B. INTRODUCTION TO ART AND CRAFT. San Francisco: Tri-Ocean Books, 1965. 119 p. Illus., color. Biblio., p. 115.

Mostly art appreciation.

Chapter 31

CHILDREN'S ART BOOKS

Abisch, Rozland. ART IS FOR YOU. Illustrated by Boche Kaplan. New York: David McKay, 1967. 48 p. Grades 2-5.

 Things to make.

_____. IF I COULD, I WOULD. Plainfield, N.J.: Mulberry Press, 1972. 26 p. Grades 2-4.

Ackley, Edith F. MARIONETTES: EASY TO MAKE! FUN TO USE! Illustrated by Marjorie Flack. Philadelphia: J.B. Lippincott Co., 1939. 56 p. Grades 5-9.

 Includes patterns and five marionette plays.

Adkins, Jan. TOOL CHEST. New York: Walker and Co., 1973. 48 p. Illus. Grades 5 and up.

 A beautifully designed book explaining the purpose and use of woodworking tools.

Adler, Irving, and Adler, Ruth. HOUSES: FROM CAVES TO SKYSCRAPERS. New York: John Day Co., 1965. 78 p. Illus. Grades 3-6.

Alden, Carella. FROM EARLY AMERICAN PAINT BRUSHES: COLONY TO NATION. New York: Parents Magazine Press, 1971. 42 p. Illus. Grades 4-6.

_____. ROYAL PERSIA: TALES AND ART OF IRAN. New York: Parents Magazine Press, 1972. 87 p. Illus. Grades 4-6.

 Persian art with explanations of the meaning and use of decorative detail.

_____. SUNRISE ISLAND: A STORY OF JAPAN AND ITS ARTS. New York: Parents Magazine Press, 1971. 47 p. Illus. Grades 4-6.

Allen, Agnes. THE STORY OF SCULPTURE. Illustrated by Jack Allen. Rockaway Park, N.Y.: Roy Publications, 1958. 161 p. Grades 6-9.

From Stone Age carvings to contemporary works.

_____. STORY OF YOUR HOME. Levittown, N.Y.: Transatlantic Arts, 1951. 44 p. Illus. Grades 4-7.

Ayer, Margaret. MADE IN THAILAND. New York: Alfred A. Knopf, 1964. 44 p. Illus. Grades 7 and up.

Bailey, Carolyn S. CHILDREN OF THE HANDICRAFTS. New York: Viking Press, 1946. 48 p. Grades 4-8.

_____. PIONEER IN AMERICA. Illustrated by Grace Paull. New York: Viking Press, 1944. 52 p. Grades 3-6.

Baker, Denys V. YOUNG POTTER. New York: Frederick Warne & Co., 1963. 64 p. Illus. Grades 5-9.

Baker, Eugene. I WANT TO BE AN ARCHITECT. Illustrated by F. Palm. Chicago: Children's Press, 1969. Unpaged. Grades Kindergarten-3.

Ball, W.W. FUN WITH STRING FIGURES. Reprint. New York: Dover Publications, 1971. 32 p. Paper. Grades Kindergarten-3.

Barfoot, Audrey I. HOMES IN GREAT BRITAIN. Chester Springs, Pa.: Dufour Editions, 1963. 111 p. Illus. Grades 7 and up.

Barger, Bertel. NATURE AS DESIGNER. Scranton, Pa.: International Textbook Co., 1966. 64 p. Grades 5-7.

Barnes, William A. A WORLD FULL OF HOMES. New York: McGraw-Hill Book Co., 1953. 94 p. Grades 4-6.

Barr, Beryl. WONDERS, WARRIORS, AND BEASTS ABOUNDING: HOW THE ARTIST SEES HIS WORLD. Foreword by Thomas P. Hoving. Garden City, N.Y.: Doubleday and Co., 1967. 128 p. Illus. Grades 5-9.

A book on art and aesthetics in which the author discusses various styles of artists from different cultures who portray the heavens, animals, and warriors.

Barrish, Mattheu. THE KIDS BOOK OF CARDS AND POSTERS. Englewood Cliffs, N.J.: Prentice-Hall, 1973. 96 p. Index. Biblio. Illus., some color. Ages 7 and up.

This guide to greeting card and poster making includes an illustrated history of cards and posters as well as instructions about how to make them.

Batchelder, Marjorie H. PUPPET THEATRE HANDBOOK. New York: Harper & Row Publishers, 1947. 94 p. Illus. Grades 7-9.

Covers aspects of constructing puppets and writing and performing puppet plays.

Batterberry, Michael. ART OF THE EARLY RENAISSANCE. New York: McGraw-Hill Book Co., 1970. 106 p. Illus., some color. Grades 7-9.

Discusses artists and techniques as well as individual works. Most of the material is organized by region or city.

_____. ART OF THE MIDDLE AGES. New York: McGraw-Hill Book Co., 1972. 211 p. Illus. Grades 9-12.

_____. CHINESE AND ORIENTAL ART. New York: McGraw-Hill Book Co., 1969. 116 p. Illus. Grades 7 and up.

_____. TWENTIETH CENTURY ART. Edited by Howard Smith. New York: McGraw-Hill Book Co., 1973. 136 p. Illus. Paper. Grades 9 and up.

Batterberry, Michael, and Ruskin, Ariane. CHILDREN'S HOMAGE TO PICASSO. New York: Abrams, 1972. 106 p. Illus. Grade 5 and up.

A collection of drawings about bullfighting the children of Vallauris gave Picasso, and some of his own work in this book about the artist and bullfighting.

_____. PRIMITIVE ART. Foreword by Howard Conant. New York: McGraw-Hill Book Co., 1973. 64 p. Illus., color. Ages 12 and up.

A history of primitive art in the Americas, Africa, and Oceana.

Bauer, John I.H. NATURE IN ABSTRACTION. New York: Macmillan, 1958. 86 p. Grades 6-9.

Baumann, Hans. CAVES OF THE GREAT HUNTERS. Rev. ed. New York: Pantheon Books, 1962. 97 p. Grades 5 and up.

Beiter, Ethel Jane. CREATE WITH YARN. Scranton, Pa.: International Textbook Co., 1964. 102 p. Grades 4-7.

Children's Art Books

Belves, Pierre, and Mathey, Francois. ENJOYING THE WORLD OF ART. New York: Lion Press, 1966. Unpaged. Illus. Grades 1 and up.

_____. HOW ARTISTS WORK: AN INTRODUCTION TO TECHNIQUES OF ART. Translated by Alice Bach. New York: Lion Press, 1967. 107 p. Illus. Grades 3-12.

> Too bad the discussions of art techniques don't match the excellent reproductions in this book.

Bendick, Robert, and Bendick, Jeanne. FILMING WORKS LIKE THIS. New York: McGraw-Hill Book Co., 1970. 110 p. Illus. Grades 6-9.

> Step-by-step filmmaking for children.

Bergere, Thea, and Bergere, Richard. FROM STONES TO SKYSCRAPERS. New York: Dodd, Mead & Co., 1960. 116 p. Illus. Grades 7-9.

_____. THE STORY OF ST. PETER'S. New York: Dodd, Mead & Co., 1966. 101 p. Illus. Glossary. Index. Biblio. Grades 8 and up.

> A detailed account of the plans, and the changes and development of St. Peter's Basilica over thirteen centuries.

Berry, Ana M. ART FOR CHILDREN. London: Studio, n.d. 150 p. Illus., some color. Paper. Grades 3-7.

> A charming art appreciation book for children based on the themes of beauty, games, ships, angels, fairies, and portraits. The art works chosen to be illustrated are unusual and the color prints especially beautiful.

Biegeleisen, Jacob I. CAREERS & OPPORTUNITIES IN COMMERCIAL ART. New York: E.P. Dutton & Co., 1963. 160 p. Illus. Grades 7 and up.

Bogen, Constance. A BEGINNER'S BOOK OF PATCHWORK, APPLIQUE & QUILTING. New York: Dodd, Mead & Co., 1974. 157 p. Index. Illus. Grades 6 and up.

Bonner, Mary G. MADE IN CANADA. New York: Alfred A. Knopf, 1943. 64 p. Illus. Grades 4-9.

Borten, Helen. DO YOU SEE WHAT I SEE? Illustrated by Helen Borten. Eau Claire, Wis.: Abelard-Schuman, 1959. 48 p. Grades Kindergarten-2.

> Basic elements of visual composition, line, shape, and color, and the emotional responses they evoke.

_____. PICTURE HAS A SPECIAL LOOK. Illustrated by Helen Borten. New York: Abelard-Schuman, 1961. 48 p. Grades Kindergarten-3.

Boy Scouts of America. ARCHITECTURE. North Brunswick, N.J.: 1966. 147 p. Illus. Paper. Grades 6-12.

Brenner, Barbara. FACES. Illustrated by George Ancona. New York: E.P. Dutton & Co., 1970. Unpaged. Grades Preschool-1.

Bridgman, George B. CONSTRUCTIVE ANATOMY. Illustrated by George B. Bridgman. New York: Sterling Publishing Co., 1967. 116 p. Grades 8 and up.

Bright, Robert. I LIKE RED. Garden City, N.Y.: Doubleday and Co., 1955. Unpaged. Grades Kindergarten-3.

Brommer, Gerald F. WIRE SCULPTURE & OTHER THREE DIMENSIONAL CON-STRUCTION. Worcester, Mass.: Davis Publications, 1968. 97 p. Illus. Grades 8 and up.

See entry on p. 204.

Bulla, Clyde. WHAT MAKES A SHADOW? New York: Thomas Y. Crowell Co., 1962. 42 p. Grades 2-5.

Burns, William A. WORLD FULL OF HOMES. Illustrated by Paula Hutchison. New York: McGraw-Hill Book Co., 1953. 48 p. Grades 5 and up.

Carter, Katherine. TRUE BOOK OF HOUSES. Illustrated by George Rhoads. Chicago: Children's Press, 1957. 34 p. Grades Kindergarten-4.

Celender, Donald. MUSICAL INSTRUMENTS IN ART. Minneapolis, Minn.: Lerner Publications, 1966. 111 p. Illus. Grades 5-11.

Chamoux, Francois. GREEK ART. Greenwich, Conn.: New York Graphic Society, 1966. 156 p. Illus. Grades 9 and up.

Chandler, Anna C. STORY-LIVES OF MASTER ARTISTS. Philadelphia: J.B. Lippincott Co., 1953. 255 p. Illus. Grades 7-9.

Lives of artists charmingly written for children.

Chase, Alice Elizabeth. FAMOUS ARTISTS OF THE PAST. New York: Platt & Munk Publications, 1964. 124 p. Illus. Grades 4 and up.

Selected artists with whom the author believes children should be familiar.

Children's Art Books

_____. FAMOUS PAINTINGS: AN INTRODUCTION TO ART FOR YOUNG PEOPLE. New York: Platt & Munk Publications, 1962. 96 p. Illus. Grades 5 and up.

> The author selected paintings for discussion that she feels every child should know.

_____. LOOKING AT ART. New York: Thomas Y. Crowell Co., 1966. 119 p. Illus. Grades 7-9.

> An informative, but above all imaginative, book about art for young people. There is a clear definition of art and an excellent chapter on the problems of space in painting.

Cheney, Sheldon W. STORY OF MODERN ART. New York: Viking Press, 1958. 214 p. Illus. Grades 9 and up.

Chernoff, Goldie Taub. CLAY-DOUGH PLAY-DOUGH. New York: Walker and Co., 1970. 24 p. Illus., color. Grades Kindergarten-3.

> A recipe for clay dough and suggestions of things to make and do with it.

_____. JUST A BOX? New York: Walker and Co., 1973. 24 p. Illus., color. Ages 4-8.

> Things to make from boxes.

_____. PEBBLES AND PODS: A BOOK OF NATURE CRAFTS. New York: Walker and Co., 1973. 24 p. Illus., color. Ages 4-8.

> Craft projects from nature.

Cobb, Vicki. ARTS AND CRAFTS YOU CAN EAT. Illustrated by Peter Zippman. Philadelphia: J.B. Lippincott Co., 1974. 128 p. Grades 3-7.

> Instructions for drawing, painting, printing, molding, and carving edible materials to create culinary and artistic delights.

Cogniat, Raymond. MONET AND HIS WORLD. New York: Viking Press, 1966. 143 p. Illus. Ages 10 and up.

> Monet's life, illustrated with a half-dozen photographs of the artist and reproductions of his paintings.

Colby, Charles B. EARLY AMERICAN CRAFTS: TOOLS, SHOPS AND PRODUCTS. New York: Coward, McCann & Geoghegan, 1967. 116 p. Illus. Grades 3 and up.

Comins, Jeremy. ART FROM FOUND OBJECTS. New York: Lothrop, Lee & Shepard Co., 1974. 128 p. Index. Glossary. Ages 10 and up.

> Vacuum forming is included along with more ordinary found object art projects.

_____. LATIN AMERICAN CRAFTS AND THEIR CULTURAL BACKGROUNDS. New York: Lothrop, Lee & Shepard Co., 1974. 128 p. Illus. Index. Biblio. Glossary. Ages 10 and up.

> Discusses various Latin American crafts such as metal relief, wood and cloth work, and then suggests similar projects for children to do.

Comstock, Nan, and Wyckoff, Jean, eds. MCCALL'S GOLDEN DO-IT BOOK. Illustrated by William Dugan. Racine, Wis.: Western Publishing Co., 1960. 118 p. Grades 3 and up.

Coombs, Charles I. WINDOW ON THE WORLD; THE STORY OF TELEVISION PRODUCTION. New York: World Publishing Co., 1965. 125 p. Illus. Grades 5-9.

> An attempt to let the reader in on behind-the-scenes television production.

Cooper, Margaret. THE INVENTIONS OF LEONARDO DA VINCI. New York: Macmillan, 1965. 124 p. Illus. Grades 8-10.

Cornelius, Sue, and Cornelius, Chase. CITY IN ART. Minneapolis, Minn.: Lerner Publications, 1966. 138 p. Illus. Grades 5-11.

Craven, Thomas. THE RAINBOW BOOK OF ART. New York: World Publishing Co., 1972. 157 p. Illus. Grades 5 and up.

> Art history from caveman to modern times.

Cutler, Katherine N. FROM PETALS TO PINECONES: A NATURE ART AND CRAFT BOOK. Illustrated by Giulio Maestro. New York: Lothrop, Lee & Shepard Co., 1969. 128 p. Index. Biblio. Grades 4 and up.

> Art activities for holidays using material from nature.

Cutler, Katherine, and Bogle, Kate Cutler. CRAFTS FOR CHRISTMAS. New York: Lothrop, Lee & Shepard Co., 1974. 96 p. Illus. Index. Ages 8 and up.

> Decorations and gifts children can make from natural and discarded materials. There is a section on food and another about what to do with used Christmas cards.

Daniels, Harvey, and Turner, Silvie. EXPLORING PRINTMAKING FOR YOUNG

PEOPLE. New York: Van Nostrand Reinhold Co., 1972. 95 p. Illus., some color. Biblio. Glossary. Grades 5-9.

> An attractive, intelligent book for young people that explains the instruments and techniques used in intaglio, silkscreen, and lithography.

Davidow, Ann. LET'S DRAW ANIMALS. New York: Grosset & Dunlap, 1960. 110 p. Illus. Paper. Grades 1-5.

Davies, Rita. LET'S MAKE A PICTURE. Edited by Henry Pluckrose. New York: Van Nostrand Reinhold Co., 1972. 97 p. Illus. Paper. Grades 1-5.

_____. LET'S PAINT. Edited by Henry Pluckrose. New York: Van Nostrand Reinhold Co., 1972. Illus. Paper. Grades 1-5.

Deacon, Eileen. IT'S FUN TO MAKE PICTURES. Illustrated by Belinda Lyon. New York: Grosset & Dunlap Publishers, 1972. 60 p. Ages 8 and up.

> Using materials such as paints, eggshells, and seeds, to make pictures.

De Brouwer, A. CREATING WITH FLEXIBLE FOAM. New York: Sterling Publishing Co., 1971. 48 p. Illus. Grades 4 and up.

De Mare, Vanessa, and De Mare, Eric. YOUR BOOK OF PAPER FOLDING. Levittown, N.Y.: Transatlantic Arts, 1969. 64 p. Grades 7 and up.

Devlin, Harry. WHAT KIND OF A HOUSE IS THAT? Illustrated by Harry Devlin. New York: Parents Magazine Press, 1969. 76 p. Grades 5 and up.

Deyrup, Astrith. TIE DYEING AND BATIK. New York: Doubleday and Co., 1974. 63 p. Illus. Biblio. Ages 10 and up.

> Various tie dyeing and batik techniques for children, including the use of crayon and tempera as well as more complicated methods.

Downer, Marion. DISCOVERING DESIGN. New York: Lothrop, Lee & Shepard Co., 1947. 104 p. Illus. Grades 2-4.

> An art appreciation book dealing with the elements of design as illustrated in nature.

_____. ROOF OVER AMERICA. New York: Lothrop, Lee & Shepard Co., 1967. 75 p. Illus. Biblio. Grades 4 and up.

> Presents a survey of American architectural history from the seventeenth century, using the roof as a unifying theme.

_____. THE STORY OF DESIGN. New York: Lothrop, Lee & Shepard Co., 1964. 114 p. Grades 3-6.

Du Bourguet, Pierre M. COPTS. New York: Crown Publications, n.d. Grades 7 and up.

Eiseman, Albert. CANDIDO. Illustrated by Lilian Obligado. New York: Macmillan, 1967. Unpaged. Grades Kindergarten-2.

Emberley, Ed. ED EMBERLEY'S DRAWING BOOK OF ANIMALS. Illustrated by Ed Emberley. Boston: Little, Brown and Co., 1970. 107 p. Grades 2 and up.

_____. PUNCH & JUDY: A PLAY FOR PUPPETS. Illustrated by Ed Emberley. Boston: Little, Brown and Co., 1965. Grades 1-5.

A history of Punch introduces this centuries-old play.

Feder, Carol. THE CANDLEMAKING DESIGN BOOK. New York: Franklin Watts, 1974. 128 p. Index. Illus., some color. Grades 6 and up.

Instructions for designing and making candles for all occasions.

Fisher, Leonard Everett. ARCHITECTS. Illustrated by Leonard Everett Fisher. New York: Franklin Watts, 1970. 48 p. Grades 4-6.

_____. THE ART EXPERIENCE: OIL PAINTING. New York: Franklin Watts, 1973. 58 p. Index. Glossary. Illus., some color. Grades 7 and up.

A book about the technique of oil painting.

Fitzgerald, Charles P. CHINA: A SHORT CULTURAL HISTORY. New York: Praeger Publications, 1954. 197 p. Illus. Paper. Grades 10 and up.

Fletcher, Helen Jill. STRING PROJECTS. Garden City, N.Y.: Doubleday and Co., 1974. 62 p. Illus. Ages 10 and up.

Technique of working with string.

Flexner, James T. THE DOUBLE ADVENTURE OF JOHN SINGLETON COPLEY: FIRST MAJOR PAINTER OF THE NEW WORLD. Boston: Little, Brown and Co., 1969. 110 p. Illus. Grades 7 and up.

Floethe, Louise L. THOUSAND AND ONE BUDDHAS. Illustrated by Richard Floethe. New York: Farrar, Straus & Giroux, 1967. 42 p. Grades Preschool-3.

Forte, Nancy. WARRIOR IN ART. Minneapolis, Minn.: Lerner Publications, 1966. 112 p. Illus. Grades 5-11.

Fowler, Virginia. POTTERYMAKING. Garden City, N.Y.: Doubleday and Co., 1974. 64 p. Index. Illus., with photographs by the author.

Frankel, Lilian, and Frankel, Godfrey. CREATING FROM SCRAP. New York: Sterling Publishing Co., 1962. 48 p. Illus. Grades 3-8.

Frankenstein, Alfred. WORLD OF COPLEY. New York: Time-Life Books, 1970. 106 p. Illus. Grades 5 and up.

Freedgood, Lillian. AN ENDURING IMAGE: AMERICAN PAINTING FROM 1665. New York: Thomas Y. Crowell, 1970. 387 p. Biblio. Index. Illus.

A survey of American painting with the emphasis on individual artists.

_____. GREAT ARTISTS OF AMERICA. New York: Thomas Y. Crowell, 1963. 128 p. Illus. Grades 9-12.

Fukuda, Kenichi. SUNNY ORIGAMI: ANGEL BOOK. San Francisco: Japan Publications Trading Center, 1971. 44 p. Illus. Paper. Grades 1-6.

_____. SUNNY ORIGAMI: BOWWOW BOOK. San Francisco: Japan Publications Trading Center, 1968. 44 p. Illus. Paper. Grades 1-6.

_____. SUNNY ORIGAMI: THE LIFE OF SHINRAN SHONIN. San Francisco: Japan Publications Trading Center, 1974. 44 p. Illus. Paper. Grades 1-6.

_____. SUNNY ORIGAMI: LION BOOK. San Francisco: Japan Publications Trading Center, 1971. 42 p. Illus. Paper. Grades 1-6.

_____. SUNNY ORIGAMI: SWAN BOOK. San Francisco: Japan Publications Trading Center, 1969. 48 p. Illus. Paper. Grades 1-6.

Gilbert, Dorothy. CAN I MAKE ONE: A CRAFT BOOK FOR THE PRE-SCHOOL CHILD. Illustrated by Dorothy Gilbert. Levittown, N.Y.: Transatlantic Arts, 1970. Unpaged. Age preschool.

Gilbreath, Alice. CANDLES FOR BEGINNERS TO MAKE. New York: William Morrow & Co., 1975. 64 p. Illus. Ages 8-12.

Candle making projects, simple to complex.

_____. MAKING COSTUMES FOR PARTIES, PLAYS AND HOLIDAYS. New York: William Morrow & Co., 1974. 96 p. Illus. Ages 8-12.

_____. SPOUTS, LIDS AND CANS. New York: William Morrow & Co., 1973. 48 p. Illus. Ages 8-12.

How to use scrap to make things.

Gill, Bob. WHAT COLOR IS YOUR WORLD? New York: Ivan Obolensky, 1963. 26 p. Grades Kindergarten-3.

Girl Scouts of the USA. MAKE WAY FOR THE ARTS. New York: n.d. 32 p. Paper. Grades 9 and up.

Gladston, M.J. A CARROT FOR A NOSE: THE FORM OF FOLK SCULPTURE ON AMERICA'S CITY STREETS AND COUNTRY ROADS. New York: Charles Scribner's Sons, 1974. 72 p. Illus., some color. Ages 12 and up.

Glendinning, Sally. THOMAS GAINSBOROUGH: ARTIST OF ENGLAND. Champaign, Ill.: Garrard Publishing Co., 1969. Illus. 96 p. Grades 5-7.

Glubok, Shirley. ART AND ARCHEOLOGY. Illustrated by Gerard Nook. New York: Harper & Row Publishers, 1966. 48 p. Grades 3-7.

A brief discussion of archeology, with photographs of sites throughout the world.

_____. ART OF AFRICA. Illustrated by Alfred H. Tamarin. New York: Harper & Row Publishers, 1965. 48 p. Grades 3 and up.

_____. THE ART OF AMERICA FROM JACKSON TO LINCOLN. New York: Macmillan, 1973. 48 p. Illus. Ages 10 and up.

_____. ART OF AMERICA IN THE EARLY TWENTIETH CENTURY. New York: Macmillan, 1974. 48 p. Illus. Ages 8 and up.

Painting, architecture, sculpture, and photography in the United States from 1900 to 1939.

_____. THE ART OF AMERICA IN THE GILDED AGE. New York: Macmillan, 1974. 48 p. Illus. Ages 10 and up.

There is an interesting section on photography in this art history book for children, covering the period from the Civil War to the close of the nineteenth century. However, it seems misleading to publish paintings and sculpture in one color--pale green or yellow--as is done in this book and others in this series.

Children's Art Books

_____. ART OF ANCIENT EGYPT. New York: Atheneum Publications, 1962. 48 p. Illus. Grades 3 and up.

Primarily a pictorial history of early Egyptian civilization.

_____. ART OF ANCIENT GREECE. New York: Atheneum Publications, 1963. 48 p. Illus. Grades 2 and up.

_____. ART OF ANCIENT MEXICO. Illustrated by Gerard Nook. New York: Harper & Row Publishers, 1968. 48 p. Grades 3-7.

_____. ART OF ANCIENT PERU. Illustrated by Alfred H. Tamarin. New York: Harper & Row Publishers, 1966. 48 p. Grades 3 and up.

_____. THE ART OF ANCIENT ROME. New York: Harper & Row Publishers, 1965. 40 p. Illus. Grades 2-6.

_____. THE ART OF CHINA. New York: Macmillan, 1973. 48 p. Illus. Grades 4 and up.

A glimpse of the arts of China and brief discussions of Chinese inventions of porcelain, silk, and lacquer.

_____. ART OF COLONIAL AMERICA. Illustrated by Gerard Nook. New York: Macmillan, 1970. 48 p. Grades 4 and up.

_____. ART OF THE ESKIMO. New York: Harper & Row Publishers, 1964. 48 p. Illus. Grades 2-6.

_____. THE ART OF THE ETRUSCANS. New York: Harper & Row Publishers, 1967. 40 p. Illus. Grades 2-5.

Another in a series of books in which the color of the reproductions has to do with the design of the book, and has no relationship to the work illustrated.

_____. THE ART OF INDIA. New York: Macmillan, 1969. 48 p. Illus. Grades 5-8.

_____. ART OF JAPAN. Illustrated by Gerard Nook. New York: Macmillan, 1970. 40 p. Grades 4 and up.

_____. ART OF LANDS IN THE BIBLE. New York: Atheneum Publications, 1963. 26 p. Illus. Grades 2 and up.

_____. THE ART OF THE NEW AMERICAN NATION. Illustrated by Gerard Nook. New York: Macmillan, 1972. 32 p. Grades 4 and up.

_____. ART OF THE NORTH AMERICAN INDIAN. New York: Harper & Row Publishers, 1964. 24 p. Illus. Grades 2-6.

_____. THE ART OF THE NORTHWEST COAST INDIANS. New York: Macmillan, 1975. 48 p. Illus. Ages 10 and up.

_____. ART OF THE OLD WEST. Illustrated by Gerard Nook. New York: Macmillan, 1971. Grades 4 and up.

_____. ART OF THE SOUTHWEST INDIANS. Illustrated by Gerard Nook. New York: Macmillan, 1971. 48 p. Grades 4 and up.

There are many beautiful photographs of Indian work in this clearly written book.

_____. THE ART OF THE SPANISH IN THE UNITED STATES AND PUERTO RICO. New York: Macmillan, 1972. 48 p. Illus. Grades 4 and up.

The traditions and culture, the art and architecture of the Spanish in the New World. Half of the book is devoted to New Mexico.

Golden, Grace B. MADE IN ICELAND. Illustrated by Loreen de Waard. New York: Alfred A. Knopf, 1958. 110 p. Grades 7 and up.

Goldstein, Harriet I., and Goldstein, Vetta. ART IN EVERYDAY LIFE. New York: Macmillan, 1954. 97 p. Illus. Grades 7 and up.

Gombrich, Ernst H. THE STORY OF ART. Rev. ed. New York: Phaidon Press, 1961. 462 p. Illus., some color. Grades 6-9.

A scholarly survey of art history for young people.

Gould, Heywood. SIR CHRISTOPHER WREN: RENAISSANCE ARCHITECT, PHILOSOPHER AND SCIENTIST. New York: Franklin Watts, 1970. 106 p. Illus. Grades 7 and up.

Gracza, Margaret Y. BIRD IN ART. Minneapolis, Minn.: Lerner Publications, 1966. 72 p. Illus. Grades 5-7.

An introduction to art principles and techniques using the bird as a theme.

Children's Art Books

Graves, Charles P. GRANDMA MOSES: FAVORITE PAINTER. Illustrated by Victor Mays. Champaign, Ill.: Garrard Publishing Co., 1969. 97 p. Grades 4-7.

Greenfeld, Howard. MARC CHAGALL. Chicago: Follett Publishing Co., 1968. 42 p. Illus. Grades 5 and up.

Grigson, Geoffrey. SHAPES AND PEOPLE; A BOOK ABOUT PICTURES. New York: Vanguard Press, 1969. 97 p. Illus., some color. Grades 7-10.

> Through the use of excellently chosen examples of drawings and paintings, the author discusses how the works of artists from various periods and cultures captured the activities and moods of the people.

Grigson, Geoffrey, and Grigson, Jane. MORE SHAPES AND STORIES. New York: Vanguard Press, 1967. 72 p. Illus., some color. Grades 7-10.

> Another in the series of beautifully designed picture books by the authors which contain reproductions of little and well known works of art. Dreams and fantasy is the central theme.

Grimm, Gretchen. CREATIVE ADVENTURES IN ARTS AND CRAFTS. New York: Macmillan, 1962. 86 p. Illus. Grades 4-6.

Habenstrett, Barbara. CITIES IN THE MARCH OF CIVILIZATION. New York: Franklin Watts, 1974. 128 p. Index. Biblio. Illus., some color. Grades 7 and up.

Halacy, D.S., Jr. YOUR CITY TOMORROW. New York: Four Winds Press, 1973. 192 p. Index. Illus. Grades 5 and up.

> A book about cities of the past, present, and future, plus some suggested solutions to current urban problems.

Halsey, Ashley, Jr. ILLUSTRATING FOR MAGAZINES. New York: Sterling Publishing Co., 1968. 68 p. Illus. Paper. Grades 9-12.

> Vocational guide for high school students.

Hamm, Jack. DRAWING THE HEAD AND FIGURE. New York: Grosset & Dunlap, 1963. 120 p. Illus. Grades 7-9.

> How to do it.

_____. HOW TO DRAW ANIMALS. Illustrated by Jack Hamm. New York: Grosset & Dunlap, 1965. 120 p. Index. Grades 7 and up.

Hammond, Penny, and Thomas, Katrina. MY SKYSCRAPER CITY. Garden City, N.Y.: Doubleday and Co., 1963. 68 p. Illus.

Hart, Tony. THE YOUNG LETTERER: HAND LETTERING WITH BRUSH AND PEN. A HOW-IT-IS-DONE BOOK OF LETTERING. New York: Frederick Warne & Co., 1966. Illus. Grades 7-12.

Hautzig, Esther R. LET'S MAKE PRESENTS: EASY AND INEXPENSIVE GIFTS FOR EVERY OCCASION. Illustrated by Ray Skibinski. New York: Thomas Y. Crowell, 1962. 150 p. Index. Grades 4 and up.

Simple craft objects for children to make.

Hawkinson, John. MORE TO COLLECT AND PAINT FROM NATURE. Chicago: Albert Whitman and Co., 1964. 40 p. Grades 4 and up.

How to use the water color brush.

_____. PASTELS ARE GREAT. Chicago: Albert Whitman & Co., 1968. 48 p. Illus., some color. Grades 3 and up.

How to use pastels.

Heady, Eleanor. MAKE YOUR OWN DOLLS. New York: Lothrop, Lee & Shepard Co., 1974. 96 p. Index. Illus. Ages 8 and up.

A manual of doll making, from clothes pins to corn husks.

Helfman, Harry. CREATING THINGS THAT MOVE: FUN WITH KINETIC ART. New York: William Morrow & Co., 1975. 48 p. Illus. Ages 8-12.

Includes nine kinetic art projects with detailed instructions.

_____. MAKING DESIGNS BY CHANCE. Illustrated by Harry Helfman. New York: William Morrow & Co., 1974. 48 p. Ages 8-12.

Chance two dimensional design activities for children.

Higeboom, Amy. FAMILIAR ANIMALS AND HOW TO DRAW THEM. New York: Vanguard Press, 1962. 86 p. Illus. Grades 1-4.

_____. FOREST ANIMALS AND HOW TO DRAW THEM. New York: Vanguard Press, 1964. 92 p. Illus. Grades 1-4.

_____. SEA ANIMALS AND HOW TO DRAW THEM. New York: Vanguard Press, 1960. 86 p. Illus. Grades 1-4.

_____. WILD ANIMALS AND HOW TO DRAW THEM. New York: Vanguard Press, 1947. 84 p. Illus. Grades 1-4.

Higgins, Reynold. MINOAN AND MYCENAEAN ART. New York: Praeger Publications, 1967. 128 p. Illus. Paper. Grades 10 and up.

Highlights for Children. MORE CREATIVE CRAFT ACTIVITIES. Columbus, Ohio: 1973. 187 p. Grades 1-6.

Hiller, Carl E. BABYLON TO BRASILIA: THE CHALLENGE OF CITY PLAN-NING. Boston: Little, Brown and Co., 1972. 109 p. Biblio. Glossary. Illus., photographs and drawings of city plans. Ages 10 and up.

> This book deals with why, how, and where cities developed and the causes of their deterioration. There are examples of urban renewal, past and present; and the author discusses the most noted planners of the world as well as the New Town.

_____. CAVES TO CATHEDRALS: ARCHITECTURE OF THE WORLD'S GREAT RELIGIONS. Photographs by Carl E. Hiller. Boston: Little, Brown and Co., 1974. 138 p. Biblio. Illus. Glossary. Ages 10 and up.

> Included in this book are summaries of the tenets of each of six major religions (Hinduism, Buddhism, Shinto, Judaism, Christianity, and Islam) and illustrations of how places of worship are shaped by beliefs, manner of worship, place, time, and materials.

_____. FROM TEPEES TO TOWERS: A PHOTOGRAPHIC HISTORY OF AMERI-CAN ARCHITECTURE. Photographs by Carl E. Hiller. Boston: Little, Brown and Co., 1967. 106 p. Biblio. Glossary. Illus. Ages 10 and up.

> Traces the development of American architecture from the dwellings of the Indians to modern skyscrapers. Text and photographs show the influence of the Old World on the New as well as examples of each historical style, and representative works by leading archi-tects of each period.

Hillyer, Virgil, and Huey, E.G. A CHILD'S HISTORY OF ART. Rev. ed. New York: Appleton-Century-Crofts, 1951. 465 p. Illus. Index. Grades 5-9.

> There's a chapter entitled "Some Very Poor Painters."

_____. FINE ART: THE LAST TWO HUNDRED YEARS. New York: Mere-dith Press, 1966. 126 p. Illus., some color.

> Uses reproductions of seldom seen works of art in this survey of European and American art.

Hirsch, Carl S. PRINTING FROM A STONE; THE STORY OF LITHOGRAPHY. New York: Viking Press, 1967. 152 p. Illus. Biblio. Grades 7-10.

> The history of lithography (as an art medium and as a commercial printing technique) and its cultural role.

Hirsh, Diana. THE WORLD OF TURNER. New York: Time-Life Books, 1969. 148 p. Illus. Grades 9 and up.

Hoag, Edwin. AMERICAN HOUSES: COLONIAL, CLASSIC, AND CONTEMPORARY. Philadelphia: J.B. Lippincott Co., 1964. 128 p. Illus. Grades 7-9.

Holder, Glenn. TALKING TOTEM POLES. New York: Dodd, Mead & Co., 1973. 58 p. Index. Biblio. Illus. Ages 10 and up.

Indian lore.

Hollmann, Clide. FIVE ARTISTS OF THE OLD WEST. New York: Hastings House, 1965. 48 p. Biblio. Illus. Ages 8 and up.

The artists are Catlin, Bodmer, Miller, Russell, and Remington.

Holme, Bryan. DRAWINGS TO LIVE WITH. New York: Viking Press, 1966. 97 p. Illus. Grades 5-10.

Reproductions of prehistoric, classic, impressionistic, and abstract drawings. Included also are twentieth-century cartoons.

Holme, Geoffrey. THE CHILDREN'S ART BOOK. 2d ed. New York and London: Studio, 1957. 108 p. Illus. Ages 3-5.

Stodgy.

Honda, Isao. ORIGAMI FESTIVAL. San Francisco: Japan Publications Trading Center, 1970. 32 p. Illus. Paper. Grades 1-6.

_____. ORIGAMI FOLDING FUN: KANGAROO BOOK. San Francisco: Japan Publications Trading Center, 1972. 46 p. Illus. Paper. Grades 1-6.

_____. ORIGAMI FOLDING FUN: PONY BOOK. San Francisco: Japan Publications Trading Center, 1974. 42 p. Illus. Paper. Grades 1-6.

_____. ORIGAMI HOLIDAY. San Francisco: Japan Publications Trading Center, 1975. 36 p. Illus. Grades 1-6.

Honour, Alan. TORMENTED GENIUS: THE STRUGGLES OF VINCENT VAN GOGH. New York: William Morrow and Co., 1967. 114 p. Biblio. Illus., some color. Ages 10 and up.

Van Gogh's life well told.

Horizon Magazine Editors. GOLDEN BOOK OF THE RENAISSANCE. Racine, Wis.: Western Publishing Co., 1961. 110 p. Illus. Grades 7 and up.

Children's Art Books

_____. LEONARDO DA VINCI. New York: Harper & Row Publishers, 1965. 112 p. Illus. Grades 6-9.

Leonardo the artist, engineer, and thinker.

Houck, Carter. WARM AS WOOL, COOL AS COTTON: NATURAL FIBERS AND HOW TO WORK WITH THEM. New York: Seabury Press, 1975. 114 p. Index. Biblio. Illus. Grades 3-6.

Howard, Sylvia W. TIN-CAN CRAFTING. New York: Sterling Publishing Co., 1959. 96 p. Illus. Grades 10 and up.

Howell, Ruth, and Strong, Arline. THE DOME PEOPLE. New York: Atheneum Publications, 1974. 126 p. Illus. Ages 10 and up.

An account of a group of teenagers who built a geodesic dome.

Hughes, Toni. HOW TO MAKE SHAPES IN SPACE. New York: E.P. Dutton and Co., 1955. 48 p.

See entry on p. 198.

Hunt, Kari, and Carlson, Bernice W. MASKS AND MASK MAKERS. Nashville, Tenn.: Abingdon Press, 1961. 48 p. Grades 5 and up.

Masks in primitive and modern societies.

Jacobs, David. MASTER PAINTERS OF THE RENAISSANCE. New York: Viking Press, 1968. 211 p. Illus. Grades 7 and up.

Jacobs, David, and Branner, Robert. MASTER BUILDERS OF THE MIDDLE AGES. New York: American Heritage Publishing Co., 1969. 168 p. Biblio. Illus., some color. Grades 6 and up.

Focuses on the development of Gothic architecture and the lives of the artisans, laborers, and churchmen involved.

Jacobs, Herbert. FRANK LLOYD WRIGHT: AMERICA'S GREATEST ARCHITECT. New York: Harcourt, Brace & World, 1965. 223 p. Illus. Index. Grades 10 and up.

An interesting study of Frank Lloyd Wright, with a good many candid photographs by a journalist who knew him for a number of years.

Jaffe, Hans L. WORLD OF THE IMPRESSIONISTS. New York: Hammond, 1969. 36 p. Illus. Grades 1 and up.

Jagendorf, Moritz. PENNY PUPPETS, PENNY THEATRE AND PENNY PLAYS. Illustrated by Fletcher Clark. Boston: Plays, 1966. 110 p. Grades 3 and up.

The process of making puppets and giving plays is explained and illustrated in this book.

Janson, Horst Woldemer, and Cauman, Samuel. HISTORY OF ART FOR
YOUNG PEOPLE. New York: Harry N. Abrams, 1972. 136 p. Illus.,
some color. Glossary. Biblio. Index. Grades 7 and up.

A comprehensive survey of western painting, sculpture, and archi-
tecture from prehistoric to present day.

Janson, Horst Woldemer, and Janson, Dora J. STORY OF PAINTING FOR
YOUNG PEOPLE: FROM CAVE PAINTING TO MODERN TIMES. New York:
Harry N. Abrams, 1962. 148 p. Grades 7-9.

Jarecka, Louise I. MADE IN POLAND: LIVING TRADITIONS OF THE
LAND. Illustrated by M.S. Nowicki. New York: Alfred A. Knopf, 1949.
102 p. Grades 7 and up.

Johnson, Lillian. PAPIER-MACHE. New York: David McKay Co., 1958.
48 p. Illus. Grades 6 and up.

Jones, Edward H., Jr., and Jones, Margaret S. ARTS AND CRAFTS OF THE
MEXICAN PEOPLE. Pasadena: Ritchie Ward Press, 1971. 111 p. Illus.
Grades 4-6.

Jones, Emrys, and Van-Zandt, Eleanor. THE CITY: YESTERDAY, TODAY
AND TOMORROW. Garden City, N.Y.: Doubleday and Co., 1974. Illus.,
some color. Biblio. Index. Ages 12 and up.

Historically looks at cities and marketplaces as centers of power
and as social organisms.

Jupo, Frank. A PLACE TO STAY: MAN'S HOME THROUGH THE AGES.
Illustrated by Frank Jupo. New York: Dodd, Mead & Co., 1974. 112 p.
Illus. Ages 7-10.

How houses are constructed.

Karasz, Mariska. ADVENTURE IN STITCHES. New York: Funk & Wagnall
Co., 1959. 48 p.

Kelder, Diane. FRENCH IMPRESSIONISTS AND THEIR CENTURY. New York:
Praeger Publications, 1973. 56 p. Illus. Grades 4-6.

Kelen, Emery, ed. LEONARDO DA VINCI'S ADVICE TO ARTISTS. New
York: Thomas Nelson, 1974. 124 p. Illus. with Leonardo's drawings. Bib-
lio. Papér. Ages 12 and up.

Contains reproductions of Da Vinci's drawings.

Kerina, Jane. AFRICAN CRAFTS. Illustrated by Tom Feelings. New York: Lion Press, 1970. 76 p. Grades 2-6.

Kessler, Ethel. ARE YOU SQUARE? Garden City, N.Y.: Doubleday and Co., 1966. 32 p. Illus. Grades 2-6.

Kessler, Leonard. ART IS EVERYWHERE. New York: Dodd, Mead and Co., 1958. 52 p. Illus. Grades 3-6.

An art instruction book for children.

_____. WHAT'S IN A LINE? New York: William R. Scott, 1961. 57 p. Illus. Grades 3-6.

Kielty, Bernadine. MASTERS OF PAINTING. Garden City, N.Y.: Doubleday and Co., 1964. 110 p. Illus. Grades 7 and up.

Art history for young people.

King, Mary Louise. A HISTORY OF WESTERN ARCHITECTURE. New York: Henry Z. Walck, 1967. 126 p. Illus. Grades 7-9.

Discusses architecture in terms of social and political conditions that characterized the times.

Kinney, Jean, and Kinney, Cleo. HOW TO MAKE 19 KINDS OF AMERICAN FOLK ART FROM MASKS TO TV COMMERCIALS. New York: Atheneum Publications, 1974. 132 p. Illus. Ages 10 and up.

There is a short history of each craft or activity presented (for example, sandpainting, masks, games) and suggestions for things children can make or do using the craft.

Kinser, Charleen. OUTDOOR ART FOR KIDS. Chicago: Follett Publishing Co., 1975. 97 p. Illus., some color. Ages 8 and up.

Marvelous things to do outside with mud, wind, and snow.

Kirn, Ann. FULL OF WONDER. New York: World Publishing Co., 1959. 97 p. Illus. Grades 3-6.

Klein, Arthur H., and Klein, Mina C. GREAT STRUCTURES OF THE WORLD. Illustrated by Joseph Cellini. New York: World Publishing Co., 1971. 128 p. Grades 5 and up.

_____. KATHE KOLLWITZ; LIFE IN ART. New York: Holt, Reinhart and Winston, 1972. 126 p. Illus. Biblio. Index. Grades 8 and up.

A biography.

_____. PETER BRUEGEL THE ELDER, ARTIST OF ABUNDANCE. New York: Macmillan, 1968. 110 p. Illus. Grades 7 and up.

The life, art, and times of this sixteenth-century artist.

_____. TEMPLE BEYOND TIME: THE STORY OF THE SITE OF SOLOMON'S TEMPLE AT JERUSALEM. New York: Van Nostrand Reinhold Co., 1970. 97 p. Grades 7 and up.

Krey, August Charles. A CITY THAT ART BUILT. Minneapolis: University of Minnesota Press, 1936. 148 p. Illus.

A history of Florence as shaped by its art.

Laing, Martha. GRANDMA MOSES: THE GRAND OLD LADY OF AMERICAN ART. Edited by D. Steve Rahmas. Charlotteville, Va.: SamHar Press, 1972. 124 p. Paper. Grades 7-9.

Lamprey, Louise. ALL THE WAYS OF BUILDING. Illustrated by H. Carter. New York: Macmillan, 1933. 116 p. Grades 7 and up.

Lavine, Sigmund A. FAMOUS AMERICAN ARCHITECTS. New York: Dodd, Mead & Co., 1967. 102 p. Illus. Grades 7 and up.

_____. HANDMADE IN ENGLAND: THE TRADITION OF BRITISH CRAFTS-MEN. New York: Dodd, Mead & Co., 1968. 124 p. Illus. Grades 9 and up.

_____. THE HOUSES THE INDIANS BUILD. New York: Dodd, Mead & Co., 1975. 110 p. Illus. Index. Ages 10 and up.

Leacroft, Helen, and Leacroft, Richard. BUILDINGS OF ANCIENT EGYPT. New York: William R. Scott, 1963. 128 p. Grades 5-10.

_____. BUILDINGS OF ANCIENT GREECE. New York: William R. Scott, 1966. 128 p. Illus. Grades 5-10.

Describes how the Greeks built their homes, temples, and public buildings from prehistoric times until the decline of their culture.

_____. BUILDINGS OF ANCIENT MAN. Reading, Maine: Addison-Wesley Publishing Co., 1973. 132 p. Illus., some color. Index. Ages 9 and up.

_____. BUILDINGS OF ANCIENT ROME. New York: William R. Scott, 1969. 124 p. Illus. Grades 5-10.

Leeming, Joseph. FUN FOR YOUNG COLLECTORS. Illustrated by Jessie Robinson. Philadelphia: J.B. Lippincott Co., 1953. 111 p. Grades 4-9.

Levey, Michael. CONCISE HISTORY OF PAINTING FROM GIOTTO TO CEZANNE. New York: Praeger Publications, 1962. 156 p. Illus. Grades 10 and up.

_____. HISTORY OF WESTERN ART. New York: Praeger Publications, 1968. 210 p. Illus. Paper. Grades 10 and up.

Liebers, Arthur. JOBS IN CONSTRUCTION. New York: Lothrop, Lee & Shepard Co., 1973. 116 p. Grades 5 and up.

Lightbody, Donna M. EASY WEAVING. New York: Lothrop, Lee & Shepard Co., 1974. 97 p. Illus. Index. Biblio. Glossary. Ages 10 and up.

A history of weaving and a series of weaving projects for youngsters to do.

Liman, Ellen, and Panter, Carol. DECORATING YOUR ROOM: A DO-IT-YOURSELF GUIDE. New York: Franklin Watts, 1974. 86 p. Illus., some color. Grades 5 and up.

Floor, ceilings, walls, windows--the whole shebang and how to go about it.

Lionni, Leo. LITTLE BLUE AND LITTLE YELLOW. Illustrated by Leo Lionni. New York: Astor-Honor, 1959. Unpaged. Grades Preschool-1.

The characters are blobs of color in this story intended to give young children an awareness of color.

Liston, Robert A. THE UGLY PALACES: HOUSING AMERICA. New York: Franklin Watts, 1974. 124 p. Biblio. Index. Grades 7 and up.

Lopshire, Robert. HOW TO MAKE FIBERS. Westminster, Md.: Random House, 1964. 132 p. Illus.

Lynch, John. HOW TO MAKE MOBILES. New York: Viking Press, 1953. 96 p. Illus. Paper. Grades 4 and up.

Macagy, Douglas, and Macagy, Elizabeth. GOING FOR A WALK WITH A LINE: A STEP INTO THE WORLD OF MODERN ART. Garden City, N.Y.: Doubleday and Co., 1973. 110 p. Foreword by Vincent Price. Paper. Grades 3 and up.

Rousseau to Klee for kids.

McKinney, Roland J. FAMOUS OLD MASTERS OF PAINTING. New York: Dodd, Mead & Co., 1951. 135 p. Illus. Grades 7-9.

McKown, Robin. THE WORLD OF MARY CASSATT. New York: Thomas Y. Crowell, 1973. 132 p. Illus. Biblio. Grades 8 and up.

> The life of Mary Cassatt.

McLanathan, Richard. IMAGES OF THE UNIVERSE, LEONARDO DA VINCI: THE ARTIST AS SCIENTIST. Garden City, N.Y.: Doubleday and Co., 1966. 146 p. Illus. Biblio. Grades 8 and up.

> Leonardo Da Vinci's notebooks as a basis for understanding the artist-scientist.

_____. THE PAGEANT OF MEDIEVAL ART AND LIFE. Philadelphia: Westminster Press, 1970. 132 p. Illus. Biblio. Grades 7 and up.

> A scholarly art history for young people.

Malcolmson, Anne, ed. WILLIAM BLAKE: AN INTRODUCTION. New York: Harcourt Brace Jovanovich, 1967. 197 p. Illus., some color. Biblio. Grades 8 and up.

> Selections of Blake's writing and painting as a guide to his symbolism.

Madian, Jon. BEAUTIFUL JUNK: A STORY OF THE WATTS TOWERS. Boston: Little, Brown and Co., 1968. 36 p. Illus. Grades 2-6.

Mahoney, Bertha E., and Whitney, Elinor. CONTEMPORARY ILLUSTRATORS OF CHILDREN'S BOOKS. Boston: Book Shop for Boys and Girls, 1930. 124 p. Illus.

> Contains a brief sketch about each of the modern illustrators and a list of books they illustrated.

Manchel, Frank. MOVIES AND HOW THEY ARE MADE. Englewood Cliffs, N.J.: Prentice-Hall, 1968. 148 p. Illus., line drawings. Glossary. Grades 7 and up.

> Follows a film from the first plot idea through its Hollywood opening and discusses producing, directing, writing, casting, shooting, editing, and other aspects of filmmaking.

_____. TERRORS OF THE SCREEN. Englewood Cliffs, N.J.: Prentice-Hall, 1970. 156 p. Grades 7 and up.

_____. WHEN MOVIES BEGAN TO SPEAK. Englewood Cliffs, N.J.: Prentice-Hall, 1969. 156 p. Grades 7 and up.

_____. WHEN PICTURES BEGAN TO MOVE. Englewood Cliffs, N.J.: Prentice-Hall, 1969. 144 p. Illus. Biblio. Grades 7 and up.

The history of motion pictures from the discovery of photography in the nineteenth century to the development of sound in 1927.

_____. YESTERDAY'S CLOWNS: THE RISE OF FILM COMEDY. New York: Franklin Watts. 128 p. Illus. Grades 6 and up.

Manley, S. ADVENTURES IN MAKING: THE ROMANCE OF CRAFTS A-ROUND THE WORLD. New York: Vanguard Press, 1959. 147 p. Grades 6-9.

Marcus, Rebecca B. PREHISTORIC CAVE PAINTINGS. New York: Franklin Watts, 1968. 68 p. Illus., with photographs. Grades 5-8.

An introduction to Cro-Magnon cave art of France and Spain.

Marks, Mickey Klar. OP-TRICKS: CREATING KINETIC ART. Philadelphia: J.B. Lippincott Co., 1972. 42 p. Illus. Paper. Grades 5-9.

_____. PAINTING FREE: LINES, COLORS, AND SHAPES. New York: Dial Press, 1965. 42 p. Illus., some color. Glossary.

Not just how-to-paint but how-to-make specific paintings, such as "Sea Cow," "Desert Sunrise," and others.

_____. SAND SCULPTURING. New York: Dial Press, 1963. 48 p. Illus., with photographs. Grades Kindergarten-9.

_____. SLATE SCULPTURING. New York: Dial Press, 1963. 48 p. Illus. Grades 4-8.

Techniques and directions for making slate sculpture.

Marshall, Anthony D. AFRICA'S LIVING ARTS. New York: Franklin Watts, 1970. 110 p. Illus. Grades 7 and up.

Martindale, Andrew. GOTHIC ART. New York: Praeger Publishing Co., 1967. 124 p. Paper. Grades 10 and up.

Mayhew, Martin, and Mayhew, Cherille. FUN WITH ART. Edited by Elizabeth Gundrey. New York: Scroll Press, 1973. 68 p. Illus. Grades 2-8.

Meilach, Dona Z. THE ARTIST'S EYE. Chicago: Henry Regnery Co., 1972. 112 p. Illus., some color. Grades 6-8.

See entry on p. 52.

_____. CREATING ART FROM ANYTHING. Chicago: Reilly & Lee Co., 1968. 106 p. Illus. Grades 7 and up.

See entry on p. 193.

Meinhardt, Carl. SO YOU WANT TO BE AN ARCHITECT. New York: Harper & Row Publishers, 1969. 116 p. Illus. Grades 9 and up.

Vocational guidance for youngsters.

Meyer, Carolyn. CHRISTMAS CRAFTS. New York: Harper & Row Publishers, 1974. 196 p. Illus. Ages 10 and up.

Day-by-day craft projects associated with the Christmas season.

_____. PEOPLE WHO MAKE THINGS: HOW AMERICAN CRAFTSMEN LIVE AND WORK. New York: Atheneum Publications, 1975. 128 p. Illus. Ages 12 and up.

Gives a brief history of each of eight crafts and introduces two or three people presently working in that particular area.

_____. SAW, HAMMER, AND PAINT. New York: William Morrow & Co., 1969. 134 p. Illus. Ages 12 and up.

This guide to woodworking for children offers instructions for making fifteen projects and discusses wood finishes.

Michelsohn, David Reuben, and the editors of Science Book Associates. THE CITIES IN TOMORROW'S WORLD: CHALLENGES TO URBAN SURVIVAL. New York: Julian Messner, 1973. 124 p. Illus. Index. Biblio. Ages 12 and up.

Explains the problems of our cities, and considers ways in which technology can provide better housing, untangle the traffic snarls, silence the noise, and clean up the air.

Mills, John Fitz Maurice. TREASURE KEEPERS. Garden City, N.Y.: Doubleday and Co., 1974. 134 p. Illus., some color. Index. Glossary. Ages 12 and up.

Looks at the world's greatest museums, discusses how they developed and their present-day activities and problems.

Miyawaki, Tatsuo. HAPPY ORIGAMI: BUTTERFLY BOOK. San Francisco: Japan Publications Trading Center, 1974. 32 p. Illus. Paper. Grades 7 and up.

_____. HAPPY ORIGAMI: SWALLOW BOOK. San Francisco: Japan Publications Trading Center, 1975. 46 p. Illus. Paper. Grades 7 and up.

_____. HAPPY ORIGAMI: TORTOISE BOOK. San Francisco: Japan Publications Trading Center, 1973. 34 p. Illus. Grades 7 and up.

_____. HAPPY ORIGAMI: WHALE BOOK. San Francisco: Japan Publications Trading Center, 1969. 32 p. Illus. Paper. Grades 7 and up.

_____. JOLLY ORIGAMI: ELEPHANT BOOK. Illustrated by Tatsuo Miyawaki. San Francisco: Japan Publications Trading Center, 1968. 38 p. Paper. Grades Kindergarten-6.

_____. ORIGAMI LAND: BIRDIE BOOK. San Francisco: Japan Publications Trading Center, 1967. 42 p. Illus. Paper. Grades 1-6.

_____. ORIGAMI LAND: BOSSY BOOK. San Francisco: Japan Publications Trading Center, 1970. 42 p. Illus. Paper. Grades 1-6.

_____. ORIGAMI LAND: ROOSTER BOOK. San Francisco: Japan Publications Trading Center, 1971. 36 p. Illus. Paper. Grades 1-6.

_____. ORIGAMI PLAYTIME. San Francisco: Japan Publications Trading Center, 1974. 32 p. Illus. Grades 1-6.

_____. POP-UP ORIGAMI. San Francisco: Japan Publications Trading Center, 1968. 44 p. Illus. Grades 1-6.

Mondale, Joan A. POLITICS IN ART. Illustrated by Vicki Hall. Minneapolis, Minn.: Lerner Publishing Co., 1972. 124 p. Grades 5-12.

Moore, Janet Gaylord. THE MANY WAYS OF SEEING: AN INTRODUCTION TO THE PLEASURES OF ART. New York: World Publishing Co., 1969. 112 p. Illus. Grades 8 and up.

Invites young readers to expand their awareness through art.

Moore, Lamont. THE FIRST BOOK OF ARCHITECTURE. New York: Franklin Watts, 1961. 110 p. Illus.

Noble themes--God, man, courage, and sacrifice--as seen in sculpture.

Morton, Brenda. NEEDLEWORK PUPPETS. Boston: Plays, 1964. 48 p. Illus. Grades 1-6.

Munzer, Martha and Vogel, Helen. BLOCK BY BLOCK. New York: Alfred A. Knopf, 1973. 179 p. Illus. Index. Biblio.

Using New York City neighborhoods community art is described in this art-sociology book.

Murray, Linda. HIGH RENAISSANCE. New York: Praeger Publishing Co., 1967. 112 p. Illus. Paper. Grades 10 and up.

_____. LATE RENAISSANCE AND MANNERISM. New York: Praeger Publishing Co., 1967. 110 p. Illus. Paper. Grades 10 and up.

Myller, Rolf. FROM IDEA INTO HOUSE. New York: Atheneum Publications, 1974. 148 p. Illus. Glossary. Ages 12 and up.

How a house is planned.

Myron, Robert. PREHISTORIC ART. New York: Grossett & Dunlap, 1967. 138 p. Illus. Grades 7 and up.

Myron, Robert, and Sundell, Abner. ART IN AMERICA: FROM COLONIAL DAYS THROUGH THE NINETEENTH CENTURY. New York and London: Crowell-Collier Press, 1969. 210 p. Illus. Grades 7-10.

A survey tracing the development of American art and architecture forms from European styles.

_____. MODERN ART IN AMERICA. New York: Macmillan, 1971. 228 p. Illus. Grades 7 and up.

Chronologically organized, this history of American art in the twentieth century includes painting, sculpture, and architecture. Both individual artists and art movements are discussed.

Naylor, Penelope. BLACK IMAGES: THE ART OF WEST AFRICA. Illustrated with photographs by Lisa Little. Garden City, N.Y.: Doubleday and Co., 1970. 44 p. Biblio. Ages 10 and up.

A picture book relating African verse to sculpture.

Nelson, Roy P., and Ferris, Byron. FELL'S GUIDE TO COMMERCIAL ART. New York: Frederick Fell, 1972. 142 p. Grades 10 and up.

Vocational guidance.

Newcomb, Covelle. LEONARDO DA VINCI, PRINCE OF PAINTERS. New York: Dodd, Mead & Co., 1965. 126 p. Illus. Grades 9 and up.

Noble, Iris. CAMERAS AND COURAGE: MARGARET BOURKE-WHITE. New York: Julian Messner, 1973. 132 p. Grades 7 and up.

_____. FREDERICK LAW OLMSTED: PARKS DESIGNER. New York: Julian Messner, 1974. 142 p. Grades 7 and up.

Children's Art Books

_____. LEONARDO DA VINCI: THE UNIVERSAL GENIUS. New York: W.W. Norton and Co., 1965. 137 p. Illus. Biblio. Grades 5-8.

This life of Leonardo reads like an adventure novel.

Oppenheim, Joanne. HAVE YOU SEEN HOUSES? Reading, Mass.: Young Scott Books, 1973. 46 p. Illus. Ages 4-8.

A picture book of houses around the world.

Paine, Roberta. LOOKING AT ARCHITECTURE. New York: Lothrop, Lee & Shepard Co., 1974. 110 p. Illus. Index. Glossary. Biblio. Ages 8-12.

A history of architecture.

_____. LOOKING AT SCULPTURE. New York: Lothrop, Lee & Shepard Co., 1968. 112 p. Illus. Glossary. Biblio. Grades 7-10.

Defines sculpture and then discusses examples of three-dimensional and relief sculpture.

Payne, G.C. ADVENTURES WITH SCULPTURE. New York: Frederick Warne & Co., 1971. 97 p. Illus. Ages 10 and up.

How to make sculpture from various and sundry materials.

Pels, Gertrude. EASY PUPPETS: MAKING AND USING HAND PUPPETS. Illustrated by Albert Pels. New York: Thomas Y. Crowell Co., 1951. 122 p. Grades 3-6.

Pflug, Betsy. PINT-SIZE FUN. New York: J.B. Lippincott Co., 1972. Unpaged. Illus. Grades 3-6.

Things to make from milk cartons.

Phillips, Brian. A TRIP TO THE ZOO. New York: Lantern Press, 1962. Unpaged. Illus. Grades 3-6.

Philpott, Alexis R. LET'S LOOK AT PUPPETS. Chicago: Albert Whitman & Co., 1966. 124 p. Illus., drawings. Grades 4-8.

A general history of puppets.

_____. LET'S MAKE PUPPETS. New York: Van Nostrand Reinhold Co., 1972. 97 p. Illus. Paper. Grades 1-5.

_____. MODERN PUPPETRY. Boston: Plays, 1967. 109 p. Illus. Grades 5 and up.

Plate, Robert. JOHN SINGLETON COPLEY: AMERICA'S FIRST GREAT ART-IST. New York: David McKay Co., 1969. 136 p. Illus. Grades 7 and up.

Plummer, Beverly. EARTH PRESENTS. New York: Atheneum Publications, 1974. 122 p. Illus. Index. Biblio. Ages 12 and up.

Arts and crafts projects that are directly related to the earth.

Pollack, Peter. UNDERSTANDING PRIMITIVE ART: SULA'S ZOO. Illustrated by Ron Perkins. New York: Lion Press, 1969. 36 p. Grades 3-9.

Post, Henry, and McTwigam, Michael. CLAY PLAY: LEARNING GAMES FOR CHILDREN. Englewood Cliffs, N.J.: Prentice-Hall, 1973. 97 p. Illus. Ages 8 and up.

Numerous games and projects with clay.

Postle, Joy. DRAWING BIRDS. New York: Grosset & Dunlap, 1974. 86 p. Grades 7 and up.

Powell, T.G. PREHISTORIC ART. New York: Praeger Publishing Co., 1966. 137 p. Illus. Paper. Grades 10 and up.

Pratson, Frederick J. THE SPECIAL WORLD OF THE ARTISAN. Boston: Houghton Mifflin Co., 1974. 126 p. Illus., photographs. Ages 10 and up.

Gives us glimpses into the lives and work of five artisans: a printer, wood sculptor, glass-blower, weaver, and instrument maker.

Price, Christine. MADE IN ANCIENT EGYPT. New York: E.P. Dutton and Co., 1972. 112 p. Illus. Biblio. Grades 6 and up.

A chronological study of Egyptian culture through examining tombs, temples, sculpture, pottery, and artifacts.

_____. MADE IN ANCIENT GREECE. Illustrated by Christine Price. New York: E.P. Dutton and Co., 1967. 112 p. Biblio. Grades 7 and up.

An introduction to Greek art which discusses architecture, sculpture, painting, pottery, coins, and jewelry.

_____. MADE IN THE MIDDLE AGES. Illustrated by Christine Price. New York: E.P. Dutton and Co., 1961. 124 p. Grades 7 and up.

_____. MADE IN THE RENAISSANCE. Illustrated by Christine Price. New York: E.P. Dutton and Co., 1963. 132 p. Grades 7 and up.

_____. MADE IN WEST AFRICA. New York: E.P. Dutton and Co., 1975. 110 p. Illus. Index. Biblio. Grades 5 and up.

African arts.

_____. STORY OF MOSLEM ART. Illustrated by Christine Price. New York: E.P. Dutton and Co., 1964. 106 p. Grades 7 and up.

Discusses the spread of Islamic art and the forces that shaped it.

Prideaux, Tom. WORLD OF WHISTLER. New York: Time-Life Books, 1970. 138 p. Illus. Grades 5 and up.

Priolo, Joan B. CERAMICS AND HOW TO DECORATE THEM. New York: Sterling Publishing Co., 1973. 97 p. Illus. Grades 9 and up.

Raboff, Ernest Lloyd, and Adeline, Peter. DA VINCI. Garden City, N.Y.: Doubleday and Co., 1971. Unpaged. Illus.

One of a series of beautifully designed and illustrated books by the authors.

_____. DURER. Garden City, N.Y.: Doubleday and Co., n.d. Unpaged. Illus. Grades 8-12.

_____. FREDERIC REMINGTON. Garden City, N.Y.: Doubleday and Co., 1973. Unpaged. Illus. Grades 3-6.

_____. HENRI DE TOULOUSE-LAUTREC. Garden City, N.Y.: Doubleday and Co., 1970. Unpaged. Illus. Grades 10 and up.

_____. HENRI ROUSSEAU. Garden City, N.Y.: Doubleday and Co., 1970. Unpaged. Illus. Grades 10 and up.

_____. MARC CHAGALL. Garden City, N.Y.: Doubleday and Co., 1968. Unpaged. Illus. Grades 4-6.

_____. MICHELANGELO. Garden City, N.Y.: Doubleday and Co., n.d. Unpaged. Illus. Grades 2-6.

_____. PABLO PICASSO. Garden City, N.Y.: Doubleday and Co., 1968. Unpaged. Illus. Grades 4-6.

_____. PAUL GAUGUIN. Garden City, N.Y.: Doubleday and Co., 1974. Unpaged. Illus., color. Grades 4-6.

_____. PAUL KLEE. Garden City, N.Y.: Doubleday and Co., 1968. Unpaged. Illus., some color. Grades 4-6.

A charming book that attempts to give the reader a sense of the "life" of Klee's paintings.

_____. PIERRE-AUGUSTE RENOIR. Garden City, N.Y.: Doubleday and Co., 1970. Unpaged. Illus. Grades 8 and up.

_____. RAPHAEL. Garden City, N.Y.: Doubleday and Co., 1971. Unpaged. Illus. Grades 3-7.

_____. REMBRANDT. Garden City, N.Y.: Doubleday and Co., n.d. Unpaged. Illus. Grades 8 and up.

_____. VELASQUEZ. Garden City, N.Y.: Doubleday and Co., n.d. Unpaged. Illus. Grades 8 and up.

_____. VINCENT VAN GOGH. Garden City, N.Y.: Doubleday and Co., 1974. Unpaged. Illus., color. Grades 4-6.

Color is used in the text as well as in the illustrations in this direct, open book about Van Gogh.

Ratchie, Carson I. SCRIMSHAW. New York: Sterling Publishing Co., 1972. 102 p. Illus. Grades 7 and up.

Razell, Arthur G., and Watts, K.G.O. SYMMETRY: EXPLORING MATHEMATICS. Garden City, N.Y.: Doubleday and Co., 1964. 146 p. Illus. Grades 5-7.

A pleasing book that presents the ideas of symmetry clearly. Certainly as appropriate to the art class as to the math class.

Razzi, James. JUST FOR KIDS: THINGS TO MAKE, DO AND SEE, EASY AS 1-2-3. New York: Parents Magazine Press, 1974. 61 p. Illus., some color. Grades Kindergarten-3.

Rena, N. AMERICAN HISTORY IN ART. Minneapolis, Minn.: Lerner Publications, 1969. 176 p. Grades 5-11.

_____. MEDICINE IN ART. Minneapolis, Minn.: Lerner Publications, 1970. 97 p. Illus. Grades 5-11.

Richards, Kenneth G. FRANK LLOYD WRIGHT. Chicago: Childrens Press, 1968. 112 p. Illus. Grades 6 and up.

Children's Art Books

Riley, Olive L. YOUR ART HERITAGE. 2d ed. New York: McGraw-Hill Book Co., 1963. 157 p. Grades 9 and up.

See entry on p. 223.

Ripley, Elizabeth. COPLEY: A BIOGRAPHY. Philadelphia: J.B. Lippincott Co., 1906. 124 p. Illus. Biblio. Grades 8 and up.

Glimpses of Copley's life seen through his pictures.

_____. DURER: PAINTINGS, ETCHINGS AND DRAWINGS BY ALBERT DURER. A BIOGRAPHY. Philadelphia: J.B. Lippincott Co., 1958. 118 p. Illus. Grades 7-9.

_____. GAINSBOROUGH. Philadelphia: J.B. Lippincott Co., 1964. 112 p. Illus. Grades 7-9.

_____. GOYA. New York: Henry Z. Walck, 1956. 110 p. Illus. Grades 8 and up.

_____. HOKUSAI: A BIOGRAPHY. Philadelphia: J.B. Lippincott Co., 1968. 132 p. Illus. Grades 7 and up.

_____. LEONARDO DA VINCI. New York: Henry Z. Walck, 1952. 112 p. Illus. Grades 7-9.

_____. MICHELANGELO. New York: Henry Z. Walck, 1953. 110 p. Illus. Grades 7-9.

_____. PICASSO: A BIOGRAPHY. Philadelphia: J.B. Lippincott Co., 1959. 134 p. Illus. Grades 7-9.

_____. REMBRANDT. New York: Henry Z. Walck, 1955. 110 p. Illus. Grades 8 and up.

_____. RODIN: A BIOGRAPHY. Philadelphia: J.B. Lippincott Co., 1966. 134 p. Illus. Biblio.

Rodin's life reflected in his sculpture.

_____. RUBENS. New York: Henry Z. Walck, 1957. 109 p. Illus.

_____. VELASQUEZ. New York: Henry Z. Walck, 1965. 127 p. Illus. Grades 7-9.

_____. VINCENT VAN GOGH. New York: Henry Z. Walck, 1954. 132 p. Illus. Grades 8 and up.

_____. WINSLOW HOMER. Philadelphia: J.B. Lippincott Co., 1963.
112 p. Illus. Grades 5-9.

Robinson, Ethel, and Robinson, Thomas. HOUSES IN AMERICA. New York:
Viking Press, 1936. 158 p. Illus. Grades 7-9.

> Regional architecture in the United States; colonial to present day.

Rockwell, Anne. THE BOY WHO DREW SHEEP. New York: Atheneum Pub-
lications, 1973. 138 p. Illus. Grades 6 and up.

> The story of Giotto.

_____. FILLIPPO'S DOME. New York: Atheneum Publications, 1967. 48 p.
Illus., line drawings. Grades 4 and up.

> It's really [Fillippo] Brunelleschi's.

_____. GLASS, STONES AND CROWN. Illustrated by Anne Rockwell.
New York: Atheneum Publications, 1968. 86 p. Illus. Grades 5 and up.

_____. PAINTBRUSH AND PEACEPIPE. Illustrated by Anne Rockwell. New
York: Atheneum Publications, 1971. 89 p. Illus. Grades 5-12.

Rodman, Selden, and Cleaver, Carole. HORACE PIPPIN: THE ARTIST AS A
BLACK AMERICAN. Garden City, N.Y.: Doubleday and Co., 1972. 168 p.
Illus.

_____. THE MIRACLE OF HAITIAN ART. Garden City, N.Y.: Doubleday
and Co., 1974. 175 p. Illus., some color. Index. Ages 12 and up.

Rogers, William Garland. MIGHTIER THAN THE SWORD: CARTOON, CARI-
CATURE, SOCIAL COMMENT. New York: Harcourt, Brace & World, 1969.
148 p. Illus. Biblio.

> History of the cartoon from the sixteenth century to the present
> day. There is a chapter devoted to Daumier.

_____. A PICTURE IS A PICTURE: A LOOK AT MODERN PAINTING. New
York: Harcourt, Brace & World, 1964. 176 p. Illus. Biblio.

> Discusses Cezanne, Van Gogh, cubism, dada, surrealism, non-
> objective art, and abstract expressionism.

_____. WHAT'S UP IN ARCHITECTURE: A LOOK AT MODERN BUILDINGS.
New York: Harcourt, Brace & World, 1965. 158 p. Grades 8-12.

Rose, Barbara. AMERICAN ART SINCE 1900. New York: Praeger Publishing
Co., 1967. 152 p. Illus. Paper.

_____. GOLDEN AGE OF DUTCH PAINTING. New York: Praeger Publishing Co., 1969. 168 p. Illus. Grades 8 and up.

Rosen, Sidney. WIZARD OF THE DOME: R. BUCKMINSTER FULLER, DESIGNER FOR THE FUTURE. Boston: Little, Brown and Co., 1969. 134 p. Illus. Grades 7 and up.

Ross, Laura. HOLIDAY PUPPETS. New York: Lothrop, Lee & Shepard Co., 1974. 106 p. Illus. Index. Ages 8 and up.

Puppets of various materials for many holidays.

Ross, Patricia F. MADE IN MEXICO: THE STORY OF A COUNTRY'S ARTS AND CRAFTS. Illustrated by Carlos Merida. New York: Alfred A. Knopf, 1952. 154 p. Grades 7 and up.

Roth, Richard. YOUR FUTURE IN ARCHITECTURE. New York: Rosen, Richards, 1974. 146 p. Grades 7-12.

Vocational guidance for high schools.

Rothenstein, John, et al., eds. ART ENCHCLOPEDIA. 24 vols. New York: Greystone Press, n.d. Illus. Grades 9 and up.

Ruskin, Ariane. ART OF THE HIGH RENAISSANCE. New York: McGraw-Hill Book Co., 1970. 157 p. Illus. Index. Grades 7 and up.

Discusses Italian painters and painting.

_____. HISTORY IN ART. New York: Franklin Watts, 1974. 224 p. Illus., some color. Grades 7 and up.

A history of art beginning with the Greeks.

_____. NINETEENTH CENTURY ART. New York: McGraw-Hill Book Co., 1968. 196 p. Illus. Index. Grades 8 up.

This history of nineteenth-century art is primarily devoted to painting.

_____. THE PANTHEON STORY OF ART FOR YOUNG PEOPLE. New York: Pantheon Books, 1964. 148 p. Illus. Grades 5-7.

A history of art from the cave man to modern times with a consideration of the motives and ideas influencing each period's painting and sculpture.

_____. PREHISTORIC AND ANCIENT ART OF THE NEAR EAST. New York:

McGraw-Hill Book Co., 1971. 214 p. Illus. Index. Grades 7-12.

> In this book about the prehistoric art of Africa and Europe and the art of Egypt and Mesopotamia in ancient times, the author includes cultural information that enriches the reader's understanding of the art forms.

_____. SEVENTEENTH AND EIGHTEENTH CENTURY ART. New York: McGraw-Hill Book Co., 1969. 168 p. Illus. Grades 5 and up.

Ruskin, Ariane, and Batterberry, Michael. GREEK AND ROMAN ART. New York: McGraw-Hill Book Co., 1970. 156 p. Illus. Paper. Grades 7 and up.

St. Tamara. ASIAN CRAFTS. New York: Lion Press, 1970. 48 p. Illus. Grades 2-6.

Samachson, Dorothy, and Samachson, Joseph. FIRST ARTISTS. Garden City, N.Y.: Doubleday and Co., 1970. 192 p. Illus. Grades 7-9.

Sattler, Helen Roney. JEWELRY FROM JUNK. Illustrated by Helen Roney Sattler. New York: Lothrop, Lee and Shepard Co., 1973. 97 p. Index. Ages 8 and up.

> Jewelry projects of bone, plastic, seeds, and other discarded materials.

_____. RECIPES FOR ART AND CRAFT MATERIALS. Illustrated by Helen Roney Sattler. New York: Lothrop, Lee and Shepard Co., 1973. 97 p. Index. Ages 10 and up.

Schegger, Theresia M. MAKE YOUR OWN MOBILES. Translated by Paul Kuttner. New York: Sterling Publishing Co., 1966. 116 p. Illus. Grades 5 and up.

Schinneller, James A. ART: SEARCH AND SELF-DISCOVERY. Scranton, Pa.: International Textbook Co., 1961. 112 p. Grades 6-9.

Schlein, Miriam. SHAPES. New York: William R. Scott, 1958. 48 p. Illus. Grades 3-6.

Schneider, Herman, and Schneider, Nina. HOW BIG IS BIG? New York: William R. Scott, 1950. 42 p. Illus. Grades 3-6.

Schwartz, Alvin. CENTRAL CITY SPREAD CITY: THE METROPOLITAN REGIONS WHERE MORE AND MORE OF US SPEND OUR LIVES. New York: Macmillan, 1973. 226 p. Illus. Index. Biblio. Ages 10 and up.

Using the words of the children who live there, the author takes
us into two communities--one the inner city and the other a suburb
a few miles away.

Scott, Guy. LET'S CRAYON. Edited by Henry Pluckrose. New York: Van
Nostrand Reinhold Co., 1972. 97 p. Illus. Paper. Grades 1-5.

Seidelman, James E., and Mintonye, Grace. CREATING MOSAICS. New
York and London: Crowell-Collier Press, 1967. 48 p. Illus., diagrams.
Grades 4-6.

How to do it.

_____. CREATING WITH CLAY. New York and London: Crowell-Collier
Press, 1967. 48 p. Illus. Grades 1-6.

The words accurately describe how to work with clay, but the
book doesn't provide any "feel" for the material.

_____. CREATING WITH PAINT. New York and London: Crowell-Collier
Press, 1967. 38 p. Illus., drawings. Grades 1-6.

Hints on how to begin painting and things to paint.

_____. CREATING WITH PAPER. New York: Macmillan, 1967. 44 p.
Grades 4-6.

_____. CREATING WITH PAPIER-MACHE. New York: Macmillan, 1971.
44 p. Grades 3-6.

_____. CREATING WITH WOOD. New York: Macmillan, 1969. 44 p.
Grades 5 and up.

_____. THE RUB BOOK. New York and London: Crowell-Collier Press,
1968. 26 p. Illus. Grades Kindergarten-3.

Jeff's adventures making rubbings. Charming.

_____. SHOPPING CART ART. Illustrated by Kaye Sherry. New York:
Macmillan, 1970. 64 p. Illus. Grades 3-6.

Shepard, Ernest H. DRAWN FROM MEMORY. Illustrated by Ernest H. Shep-
ard. Philadelphia: J.B. Lippincott Co., 1957. 48 p. Grades 4-6.

Shissler, Barbara Johnson. GEOMETRICAL PATTERNS. Levittown, N.Y.:
Transatlantic Arts, 1974. 42 p. Illus. Grades 4 and up.

_____. MASKS AND HOW TO MAKE THEM. Levittown, N.Y.: Transatlantic Arts, 1972. 48 p. Illus. Grades 4 and up.

_____. PAPER AIRPLANE BOOK. Illustrated by Barton Byron. New York: Viking Press, 1971. 110 p. Grades 4-6.

_____. SPORTS AND GAMES IN ART. Minneapolis, Minn.: Lerner Publishing Co., 1966. 110 p. Illus. Grades 5-7.

A selection of reproductions of works of art which uses sport as a theme.

_____. WORKER IN ART. Minneapolis, Minn.: Lerner Publishing Co., 1970. 97 p. Illus. Grades 5-11.

Slade, Richard. CARTON CRAFT. New York: S.G. Phillips, 1968. 48 p. Illus. Ages 10 and up.

Things to make from plastic bottles, yogurt containers, cardboard tubes, plates, and boxes.

_____. MODELING IN CLAY, PLASTER AND PAPIER-MACHE. New York: Lothrop, Lee & Shepard Co., 1967. 42 p. Illus., with photographs. Biblio. Grades 3 and up.

Staid how-to-do-it projects.

_____. PAPER AIRPLANES: HOW TO MAKE AIRPLANE MODELS FROM PAPER. New York: St. Martin's Press, 1971. 86 p. Illus.

_____. PATTERNS IN SPACE. Levittown, N.Y.: Transatlantic Arts, 1969. 64 p. Illus. Grades 5-9.

_____. TAKE AN EGG BOX: HOW TO MAKE SOME INTERESTING MODELS. Levittown, N.Y.: Transatlantic Arts, 1970. 64 p. Illus. Grades 4-7.

_____. TISSUE PAPER CRAFT. Levittown, N.Y.: Transatlantic Arts, 1969. 48 p. Illus. Grades 7 and up.

_____. TOYS FROM BALSA. Levittown, N.Y.: Transatlantic Arts, 1969. 62 p. Illus. Grades 7 and up.

_____. YOUR BOOK OF MODELLING. Levittown, N.Y.: Transatlantic Arts, 1968. 64 p. Grades 4 and up.

Slobodkin, Louis. FIRST BOOK OF DRAWING. Illustrated by Louis Slobodkin. New York: Franklin Watts, 1958. 48 p. Grades 4-6.

Children's Art Books

Smaridge, Norah. TRAILBLAZERS IN AMERICAN ARTS. Illustrated by Paul Frame. New York: Julian Messner, 1971. 36 p. Grades 4-6.

Sommer, Elyse. DESIGNING WITH CUTOUTS: THE ART OF DECOUPAGE. New York: Lothrop, Lee & Shepard Co., 1973. 124 p. Illus. Index. Biblio. Ages 8 and up.

> Many ways to do this eighteenth-century craft.

_____. MAKE IT WITH BURLAP. New York: Lothrop, Lee and Shepard Co., 1973. 96 p. Illus. Index. Ages 8 and up.

> How to work with burlap, and things to make including sculpture and toys.

Sorgman, Mayo. BRUSH AND PALETTE: PAINTING TECHNIQUES FOR YOUNG ADULTS. New York: Van Nostrand Reinhold Co., 1965. 132 p. Illus. Grades 7-12.

Spencer, Cornelia. HOW ART AND MUSIC SPEAK TO US. New York: John Day Co., 1968. 126 p. Illus. Grades 5-8.

_____. MADE IN JAPAN. Illustrated by Richard M. Powers. New York: Alfred A. Knopf, 1963. 118 p. Grades 7 and up.

Stearns, Monroe. MICHELANGELO. New York: Franklin Watts, 1970. 148 p. Illus. Grades 7 and up.

Stern, Philip Van Doren. THE BEGINNINGS OF ART. New York: Four Winds Press, 1973. 126 p. Illus. Index. Biblio. Ages 12 and up.

> Describes the Altimire, La Mouthe, Pech-Merk, and Lascaux caves and discusses how the paintings were produced.

Sternberg, Harry. COMPOSITION. New York: Grosset & Dunlap, 1970. 106 p. Illus. Grades 7 and up.

Stewart, John. FREDERIC REMINGTON: ARTIST OF THE WESTERN FRONTIER. New York: Lothrop, Lee and Shepard Co., 1971. 132 p. Illus. Grades 3-7.

Stone, David K. ART IN ADVERTISING. New York: Grosset & Dunlap, 1972. 124 p. Grades 7 and up.

Stone, Irving. GREAT ADVENTURE OF MICHELANGELO. Illustrated by Joseph Cellini. Garden City, N.Y.: Doubleday and Co., 1965. 128 p. Grades 5-9.

Straatveit, Tyyne, and Cort, Carolyn K. EASY ART LESSONS. Englewood Cliffs, N.J.: Prentice-Hall, 1971. 44 p. Grades Kindergarten-6.

Strache, Wolf. FORMS AND PATTERNS IN NATURE. New York: Pantheon Books, 1956. 96 p. Illus. Grades 4 and up.

Struchen, Jeanette. PABLO PICASSO: MASTER OF MODERN ART. New York: Franklin Watts, 1969. 148 p. Illus. Grades 7 and up.

Sullivan, George. UNDERSTANDING ARCHITECTURE. New York: Warne Frederick & Co., 1971. 122 p. Illus. Grades 6-11.

Talbot Rice, David. ART OF THE BYZANTINE ERA. New York: Praeger Publishing Co., 1963. 156 p. Illus. Grades 10 and up.

Talbot Rice, Tamara. ANCIENT ARTS OF CENTRAL ASIA. New York: Praeger Publishing Co., 1965. 148 p. Illus. Paper. Grades 10 and up.

Taylor, Theodore. PEOPLE WHO MAKE MOVIES. Garden City, N.Y.: Doubleday and Co., 1967. 197 p. Illus. Glossary. Paper. Grades 7-12.

How movies are made; explained through the various jobs of the people involved, i.e., director, film editor, and so forth.

Temko, Florence. FELT CRAFT. Garden City, N.Y.: Doubleday and Co., 1973. 112 p. Illus. Ages 10 and up.

Lots of things to make from felt.

_____. PAPER CUTTING. Garden City, N.Y.: Doubleday and Co., 1973. 106 p. Illus. Ages 10 and up.

Thiel, Philip. FREEHAND DRAWING: A PRIMER. Seattle: University of Washington Press, 1966. 116 p. Grades 10-12.

Todd, Leonard. TRASH CAN TOYS AND GAMES. New York: Viking Press, 1974. 124 p. Illus. Ages 10 and up.

Lots of interesting things to make from throw-away material.

Toor, Frances. MADE IN ITALY. Illustrated by Earle Goodenow. New York: Alfred A. Knopf, 1957. 132 p. Grades 7 and up.

Tritten, Gottfried. ART TECHNIQUE FOR CHILDREN. New York: Van Nostrand Reinhold Co., 1964. 97 p. Illus. Grades 7-9.

Children's Art Books

Unstead, R.J. HISTORY OF HOUSES. Chester Springs, Pa.: Dufour Editions, 1965. 102 p. Illus. Grades 7-10.

Walter, Fritz. WORKING IN METAL, LEATHER, CLAY AND OTHER MEDIA. New York: Taplinger Publishing Co. 87 p. Illus. Grades 8 up.

Warwick, Alan R. LET'S LOOK AT CASTLES. Chicago: Albert Whitman and Co., 1965. 82 p. Illus. Grades 4-8.

A sampling of castles through the ages.

Watson, Aldren A. COUNTRY FURNITURE. Illustrated by Aldren A. Watson. New York: Thomas Y. Crowell Co., 1974. 136 p. Index. Biblio. Ages 12 and up.

Describes the community in which the furniture maker worked, his workshop, and discusses the furniture he makes.

Weisgard, Leonard. TREASURES TO SEE: A MUSEUM PICTURE-BOOK. Illustrated by Leonard Weisgard. New York: Harcourt Brace Jovanovich, 1956. 42 p. Grades Kindergarten-3.

Explains the purpose of a fine arts museum and its divisions.

Weiss, Harvey. CERAMICS: FROM CLAY TO KILN. New York: William R. Scott Books, 1968. 64 p. Illus. Grades 5-9.

Some suggestions about the use of clay.

_____. CLAY, WOOD AND WIRE. New York: William R. Scott, 1956. 48 p. Illus. Grades 3-9.

How to make sculpture from a variety of objects. Illustrations are of art objects.

_____. COLLAGE AND CONSTRUCTION. Illustrated by Harvey Weiss. New York: William R. Scott, 1970. 48 p. Grades 4 and up.

_____. HOW TO MAKE YOUR OWN BOOKS. Illustrated by Harvey Weiss. New York: Thomas Y. Crowell Co., 1974. 44 p. Grades 5-12.

_____. HOW TO MAKE YOUR OWN MOVIES. Illustrated by Harvey Weiss. Reading, Maine: Addison-Wesley Publishing Co., 1973. 48 p. Grades 5 and up.

_____. LENS AND SHUTTER. Illustrated by Harvey Weiss. New York: William R. Scott, 1971. 48 p. Grades 5 and up.

_____. PAINT, BRUSH AND PALETTE. New York: William R. Scott, 1966. 48 p. Illus., some color. Grades 5-9.

Discusses color and suggests possible ways to paint.

_____. PAPER, INK AND ROLLER. New York: William R. Scott, 1958. 64 p. Illus. Biblio. Grades 5-9.

Transfer, relief, stencil, and other ways to print.

_____. PENCIL, PEN AND BRUSH. New York: Scholastic Book Services, 1974. 64 p. Illus. Paper. Grades 4-6.

_____. STICKS, SPOOLS AND FEATHERS. New York: William R. Scott, 1962. 64 p. Illus. Grades 4-7.

Includes 3-D objects to make from cast-off materials.

Weiss, Peter, and Weiss, Carol. CUTTING UP WITH PAPER. New York: Lothrop, Lee and Shepard Co., 1973. 48 p. Illus. Index. Ages 8 up.

Wheeler, Mortimer. ROMAN ART AND ARCHITECTURE. New York: Praeger Publications, 1964. 136 p. Illus. Paper. Grades 10 and up.

Whiteford, Andrew H. INDIAN ARTS. Illustrated by Vern Schaffer. Racine, Wis.: Western Publishing Co., 1970. 124 p. Paper. Grades 7 and up.

Willard, Charlotte. FAMOUS MODERN ARTISTS FROM CEZANNE TO POP ART. New York: Platt & Munk Publishing Co., 1971. 108 p. Illus. Grades 5 and up.

Williams, Diane. DEMONS AND BEASTS IN ART. Minneapolis, Minn.: Lerner Publishing Co., 1970. 142 p. Illus., some color. Grades 5-11.

Describes symbolic meanings of mythical creatures, demons, and beasts in painting and sculpture of various cultures and times.

Williams, Guy, and Gibson, A.V. YOUR BOOK OF WOODWORK. Levittown, N.Y.: Transatlantic Arts, 1969. 124 p. Illus. Grades 7 and up.

Wilson, Forrest. ARCHITECTURE: A BOOK OF PROJECTS FOR YOUNG ADULTS. New York: Van Nostrand Reinhold Co., 1968. 97 p. Grades 7 and up.

_____. WHAT IT FEELS LIKE TO BE A BUILDING. Illustrated by Forrest Wilson. Garden City, N.Y.: Doubleday and Co., 1969. 62 p. Grades 3-8.

Wise, William. CITIES OLD AND NEW. New York: Parents Magazine Press, 1973. 42 p. Illus. Index. Grades 2-4.

> Looks at the cultural, economic, and geographic expansion of cities from the earliest agricultural villages to the great cities of the modern world.

Wiseman, Ann. MAKING THINGS, THE HAND BOOK OF CREATIVE DISCOVERIES. Boston: Little, Brown and Co., 1973. 148 p. Biblio. Ages 12 and up.

> Many things to make including various kinds of weaving and stilts.

Wood, Paul W. PAINTING ABSTRACT LANDSCAPES. New York: Sterling Publishing Co., 1969. 124 p. Illus. Grades 8 and up.

_____. STAINED GLASS CRAFTING. Illustrated by Paul W. Wood. Rev. ed. New York: Sterling Publishing Co., 1971. 136 p. Grades 10 and up.

Wright, Lois A. WEATHERED WOOD CRAFT. New York: Lothrop, Lee and Shepard Co., 1973. 112 p. Illus. Index. Ages 8 and up.

> Ideas for objects that can be made from "found" wood.

Zarchy, Harry. LET'S MAKE A LOT OF THINGS. Illustrated by Harry Zarchy. New York: Alfred A. Knopf, 1948. 142 p. Grades 5 and up.

_____. LET'S MAKE MORE THINGS. Illustrated by Harry Zarchy. New York: Alfred A. Knopf, 1943. 158 p. Grades 5 and up.

> There is a section on nature study equipment as well as directions and working diagrams for papier mache, clay, plaster of Paris, and soap projects.

_____. LET'S MAKE SOMETHING. Illustrated by Harry Zarchy. New York: Alfred A. Knopf, 1941. 126 p. Grades 3-7.

Zechlin, Katharina. CREATIVE ENAMELLING & JEWELRY-MAKING. New York: Sterling Publishing Co., 1965. 154 p. Grades 10 and up.

Zuelke, Ruth. THE HORSE IN ART. Minneapolis, Minn.: Lerner Publications, 1965. 137 p. Illus. Grades 5-7.

> The horse from cave paintings to contemporary times in drawings, paintings, textiles, pottery, and sculpture.

AUTHOR INDEX

This index includes authors, editors, translators, compilers, associations, and other contributors to works cited in the text. Alphabetization is letter by letter.

Author Index

B

Bacon, Dolores 159
Bailey, Carolyn S. 226
Bailey, Henry Turner 27, 29, 42, 46, 49, 159, 184
Baily, Harriet Thorpe 159
Baird, Bill 201
Baker, Denys V. 226
Baker, Eugene 226
Baldwin, John 42
Ball, W.W. 226
Baltimore, Maryland. Board of School Commissioners 42
Bannon, Laura 76
Baranski, Matthew 182
Barbour, Russell B. 165
Barbour, Ruth 165
Barclay, Doris L. 153
Barfoot, Audrey I. 226
Barger, Bertel 226
Barish, Matthew 200
Barkan, Manual 11, 16, 17, 42, 76, 122, 147, 149, 212
Barkin, Leonard 167
Barnes, E.A. 177
Barnes, William A. 226
Barnes Foundation 42
Barr, Beryl 226
Barrish, Mattheu 226
Barron, Frank 133
Bassett, Richard 121
Batchelder, Marjorie H. 227
Battcock, Gregory 42
Batterberry, Michael 227, 259
Bauer, John I.H. 227
Baumann, Hans 227
Baumgarner, Alice A.D. 143
Bawen, William Thomas 168
Bayer, Herbert 34
Beard, Evelyn 220
Beatty, John W. 159
Beck, Otto Walter 184
Becker, Edith 197
Beelke, Ralph G. 1, 43
Beitler, Ethel Jane 189
Beittel, Kenneth 42, 52, 133, 147, 149, 184
Bell, Quentin 34
Belo, Jane 129
Belves, Pierre 228

Bendick, Jeanne 228
Bendick, Robert 228
Benedict, Agnes E. 14
Bennett, Charles Alpheus 27, 159
Benson, E.M. 216
Benton, Thomas Hart 19
Berensohn, Paulus 178
Bergere, Richard 228
Bergere, Thea 228
Berger-Hamerschlag, Margareta 101
Bergson, Henri 43
Berlin Photographic Co. 159
Berry, Ana M. 159-60, 228
Berry, Ava 76
Berry, Bill 198
Beskin, Osip 131
Besterman, Theodore 1
Bettelheim, Bruno 41
Betts, Victoria Bedford 192, 199
Biber, Barbara 184
Biegeleisen, Jacob I. 168, 228
Binyon, Helen 201
Birney, William 43
Bishop, A. Thornton 223
Bishop, Leslie J. 171
Blake, Vernon 184
Bland, Jane Cooper 71, 219
Blayney, Thomas L. 27
Bloom, Benjamin S. 5, 153
Bloom, Kathryn 57
Bloomberg, Marguerite 115
Boas, Belle 10-11, 77, 122
Bodor, John 201
Boeve, Edgar 165
Bogen, Constance 228
Bogle, Kate Cutler 231
Boime, Albert 34
Bone, Robert 222
Bonner, Mary G. 228
Bonser, Frederick G. 77
Borrison, Mary Jo 115
Borten, Helen 228-29
Boston Art Students Association 34
Boston Museum of Fine Arts 209
Boston Public Library 115
Boston School Committee 184
Bowefind, Ibby Hallam 77
Boyd, Catherine 209
Boyes, Janet 179
Boylston, Elise Reid 181
Boy Scouts of America 229
Bradley, Milton 178

Author Index

Author Index

Folds, Thomas M. 116
Force, Lorraine S. 134
Forte, Nancy 234
Fortress, Karl E. 212
Foster, Donald L. 2
Fowler, Virginia 234
Fox, Daniel M. 117
Fox, William H. 133
Franciscono, Marcel 35
Frank, Lawrence K. 200
Frankel, Godfrey 234
Frankel, Lilian 234
Frankenstein, Alfred 234
Fredette, Barbara W. 222
Freedgood, Lillian 234
Friedberg, M. Paul 213
Friend, Leon 182
Froehlich, Hugo B. 220
Fukuda, Kenichi 234
Fundaburk, Emma Lila 36

G

Gailer, Lionel 80
Gaitskell, Charles Dudley 51, 72, 80-81, 102, 154
Gaitskell, Margaret R. 72, 102, 154
Gale, Ann Van Nice 96, 179
Garbaty, Norman 201
Gardner, Howard 123
Geelhaar, Christian 36
Gerring, Ray 196
Getzels, Jacob W. 148
Gezari, Temima (Nimtzowitz) 51
Gibbs, Evelyn 81
Gibson, A.V. 265
Gilbert, Dorothy 234
Gilbreath, Alice 234-35
Gill, Bob 235
Gilles, Emily 183
Gingrich, Donald 123
Girl Scouts of the USA 235
Gitter, Lena L. 82
Glace, Margaret F.S. 14, 123
Gladston, M.J. 235
Glendinning, Sally 235
Glenister, S.H. 180 .
Glubok, Shirley 235-37
Golden, Grace B. 237
Goldman, Freda H. 114

Goldstein, Harriet I. 237
Goldstein, Vetta 237
Goldwater, Robert 175
Golomb, Claire 73
Gombrich, Ernst H. 237
Gooch, Peter H. 102
Goodenough, Florence L. 140
Goodman, Nelson 51
Gordon, Ira J. 82, 200
Gordon, Stephen F. 69
Gould, Heywood 237
Gould, Samuel B. 109
Gowan, John Curtis 3
Gracza, Margaret Y. 237
Grant, Art 193
Graves, Charles P. 238
Gray, Wellington B. 171
Great Britain, Board of Education 167
Great Britain, Department of Education and Science 167
Great Britain, Ministry of Education 130
Green, Arthur S. 82
Green, Harry B. 179
Green, Lewis S. 171
Greenberg, Bette 4
Greenberg, Murray 82
Greenberg, Pearl 82, 91
Greenberg, Polly 123
Greenberg, Samuel 201
Greenfield, Howard 238
Greenlear, Walter James 168
Gregg, Harold 68, 82
Grezinger, Wolfgang 186
Griffith, Irving S. 204
Griffiths, Richard 149
Griffiths, Roth 73
Grigson, Geofrey 238
Grigson, Jane 238
Grimes, Jane 118
Grimm, Gretchen 238
Grohmann, Will 36
Gropius, Ise 34
Gropius, Walter 34, 36
Gross, Ronald 155
Groszmann, Maximilian 51
Grove, Richard 117
Guilford, J.P. 149
Guinagh, Barry 200

Author Index

Author Index

Lord, Lois 88
Lorman, Alba 37
Lorrimar, Betty 199
Loughram, Bernice B. 222
Low, Theodore Lewis 118
Lowe, Florence 162
Lowenfeld, Viktor 10, 11, 13, 14, 53, 56-57, 149, 182
Lowery, Bates 162
Lowndes, Douglas 191
Luca, Mark 88
Lucas, Edna Louise 3
Lynch, John 246
Lytton, Hugh 149

M

Maass, John 36
McAdory, Margaret 141. See also Siceloff, Margaret McAdory
Macagy, Douglas 246
Macagy, Elizabeth 246
McCarthy, Stella Agnes 186
McCausland, Elizabeth 169
McCoy, Garnett 5
MacDonald, Helen Rosabelle 103
Macdonald, Stuart 30
MacDonald, Theodore 133
McFee, June King 89, 154
McGeary, Barbara 222
McGeary, Clyde 222
Machover, Karen 141
McIlhany, Sterling 189
McIlvain, Dorothy S. 89
McIntosh, Don 191
McIntyre, Barbara M. 74
McKenzie, J.C. 128
McKibben, Mary 11, 43, 52
McKinney, Roland J. 246
McKown, Robin 246
McLanathan, Richard 247
MacLeish, Archibald 149
McLeish, Minnie 89
McTwigam, Michael 253
McWhinnie, Harold J. 135
Madeja, Stanley S. 57, 175
Madge, Charles 109
Madian, Jon 247
Mahoney, Bertha 247
Mahoney, Margaret 109
Malcolmson, Anne 247

Malcon, Dorothea 193
Manchel, Frank 247-48
Manley, S. 248
Mansbridge, John 169
Manual, H.T. 141
Manzella, David Bernard 110
Marantz, Kenneth 3
Marcouse, Renee 57, 118
Marcus, Rebecca B. 248
Marks, Mickey Klar 248
Marquart, Marquerite 99
Marshall, Anthony D. 248
Marshall, Sybil 57, 89
Martin, Charles 194
Martin, Clyde Inez 220
Martindale, Andrew 248
Maslow, Abraham H. 109
Massachusetts Institute of Technology 110
Mathey, Francois 228
Mathias, Margaret E. 89-90
Matisse, Henri 127
Matter, Mercedes 109
Mattil, Edward L. 57, 135, 180
Mayhew, Cherille 248
Mayhew, Martin 248
Mays, Victor 238
Mazinga, Theophilos M. 103
Mead, Margaret 14
Meade, Ellen 191
Mearns, Hughes 52, 90, 114
Meier, Norman Charles 141
Meilach, Dona Z. 57, 193, 198, 200
Meinhardt, Carl 249
Meiselas, Susan 199
Mellinger, Bonnie Eugene 135
Melton, Hollis 118
Melzi, Kay 90
Mendelowitz, Daniel E. 58, 76, 90, 186
Mendelowitz, Daniel M. 90
Merritt, Helen 90
Metcalf, Harlan G. 205
Metropolitan Museum of Art 169
Meyer, Carolyn 249
Meyerson, Martin 109
Michael, John Arthur 99, 135, 176
Michelsohn, David Reuben 249
Mickesh, Verle 100
Miel, Alice 149

Author Index

S

Saarinen, Eliel 64, 177
St. Tamara 259
Salzmann, Friedrich 187
Samachson, Dorothy 259
Samachson, Joseph 259
Sargent, Walter 31, 49, _93_, 179, 184, 187, 203
Sattler, Helen Roney 259
Saunders, Robert J. 160, 210
Savage Eugene Francis 31
Sawer, Daisy D. 64, 93
Sawyer, Charles Henry 31, 117
Sawyer, John R. 93
Schaefer-Simmern, Henry W. 10, 53, _64-65_
Schecter, Pearl 11
Schedig, Walther 38
Schegger, Theresia M. 259
Scheifele, Marion 155
Schiff, Bennett 176
Schildkrait, M. 142
Schildkrout, Martin S. 187
Schillaci, Anthony 192
Schinneller, James A. 259
Schlein, Miriam 259
Schmidt, Christian 161
Schneider, Dawn E. 124
Schneider, Herman 259
Schneider, Nina 259
Schoenoff, Herbert 200
Schoenoff, Kurt 200
Schools Council Art and Craft Education Project 100
Schorr, Justin 65
Schrickel, Harr G. 7
Schultz, Harold Arthur 4, 52, 94
Schultz, Larry T. 216
Schuman, William 109
Schwartz, Alice M. 212
Schwartz, Alvin 259
Schwartz, Fred 65, 94
Scott, Guy 260
Scott, Thomas J. 6
Scottish Academy of Painting, Sculpture, and Architecture 38
Scottish Committee of the Council for Art and Industry 130
Seaborne, Malcolm 215
Seashore, Carl E. 141

Seidelman, James E. 260
Severino, D. Alexander 156
Seville, Renee 94
Shahn, Ben 176
Shand, P. Morton 36
Sharkey, Tony 216
Shaw, Ruth Faison 192
Shears, Alice 190
Shenker, I.R. 187
Shepard, Ernest H. 260
Sherman, Hoyt L. 187
Shinn, Victor 46
Shissler, Barbara Johnson 260-61
Shores, J. Harlan 94
Shumaker, Ann 83, 123
Siceloff, Margaret [McAdory] 142
Silver, Rawley A. 156
Silverman, Ronald H. 65, 156
Sims, Lowery S. 4
Skibinski, Ray 239
Skinner, B.F. 10
Skowhegan School 38
Slade, Richard 261
Sloan, A. Antolin 65
Sloan, John 65
Sloane, Joseph C. 66
Slobodkin, Louis 261
Smaridge, Norah 262
Smilansky, Sara 154
Smith, Bernard William 66, 129
Smith, E. Baldwin 111
Smith, F.V. 94
Smith, Grace Sands 84
Smith, Howard 227
Smith, James A. 94
Smith, Janet K. 163
Smith, Mary Elinore 69
Smith, Ralph Alexander 66, 145
Smith, Walter 66, 187
Smyth, Peter S. 95
Sneum, Gunnar 183
Snook, Barbara 183, 202
Snow, Aida Cannarsa 95
Snow, Bonnie E. 220-21
Sobodka, Grace 95
Socialist Publication Society 131
Sommer, Elyse 262
Sonnenblick, M. 187
Sorgman, Mayo 262
South Carolina State Department of Education 173

280

Author Index

Wyman, Jenifer D. 69

Y

Yochim, Louise Dunn 69, 151
Young, Arthur Raymond 4, 10, 16
Young, B.M. 177
Young, Laura 125

Z

Zaidenberg, Arthur 69

Zarachy, Harry 266
Zechlin, Katharina 266
Zelmer, A.C. Lynn 204
Zernica, T. 143
Zetterberg, Hans L. 114
Ziegfeld, Edwin 4, 11, 14, 16, 17,
 43, 52, 68, 69, 127, 156, 161
Ziegfeld, Ernest Herbert 111, 149
Zigrosser, Carl 54
Zimmer, Sister Augusta 165–66
Zippman, Peter 230
Zuelke, Ruth 266

TITLE INDEX

This index contains books, directories, guides, addresses and other sources cited in the text. Articles and journals are not included. In some cases titles have been shortened. Alphabetization is letter by letter.

A

Abrams Multi-Purpose School Artprint Program 210
Academies of Art 37
Academies of Art Past and Present 38
Academy and French Painting in the Nineteenth Century, The 34
Accent on Talent 38
Acrylic and Other Water-Base Paints for the Artist 197
Acrylic for Sculpture and Design 202
Actions, Styles and Symbolism in Kinetic Family Drawings 139
Adamant 131
Address. Cranbrook Academy of Art, 1931 177
Address Delivered by William Morris, An 58
Administration in the Arts 4
Administrative Economy of the Fine Arts, The 35
Administrator's Handbook for Art Education 173
Adult and Extension Art Education 114
Adult Education in the Art Institute of Chicago 114
Adventure in Stitches 243
Adventures in Making 248

Adventures with Scissors and Paper 197
Adventures with Sculpture 252
Aesthetic Concepts and Education 66
Aesthetic Element in Education, The 47
Aesthetic Form and Education 147
Aesthetics and Criticism in Art Education 66
Aesthetics and Problems of Education 66
African Crafts 244
Africa's Living Arts 248
Alive to Paint 175
Alkema's Complete Guide to Creative Art for Young People 75
All About Art 65
Allied Arts and Crafts 222
All the Arts for Every Child 57
All the Ways of Building 245
Alternative Learning Environments 216
Alternatives for Art Education Research 133
American Art Annual 5
American Art Directory, 1952-- 5
American Art Directory, 1936-37 9
American Artist Art School Directory 9
American Art Since 1900 257
American History in Art 255

Title Index

Title Index

Title Index

Title Index

N

Title Index

Title Index

Title Index

SUBJECT INDEX

Aspects of art education are listed as main entries within this index. Alphabetization is letter by letter.

Subject Index

Subject Index

making paper 179
for parties 235
for school plays 179, 235
Costuming 179
Course-of-study 77, 103-4
for elementary school 68
for high school 68
Craft 9-11, 53, 83
Crafts 67, 179-81, 239, 248
African 244
Asian 259
careers in 169
for Christmas 231, 249
and contemporary culture 181
early American 230
early childhood 74
in education 181
for elementary schools 179
in everyday life 181
felt 263
as general education 81
history of 180-81
in India 130
international 180
in Latin America 231
materials 13, 67
in Mexico 243
in nature 230-31
philosophical role of 181
and reading 123
in secondary schools 101, 180
and slow learners 155, 180
stained glass 266
teacher's manual 179
teaching techniques 180
tin can 242
tissue paper 261
for visually handicapped children 156
in Welsh schools 130
Craftsmen
American 249
British 245
Crayon 53, 83, 181-82, 260
and child development 181
creative expression with 181
painting with 181
techniques 182
Creative
adults 47
behavior 17

children, mental health problems of 150
development 147-51
through use of materials 150
of teacher 72
growth
case studies of 150
conditions for 150
experiences, nature of 100
expression 86
as communication 151
and design 182
learning 91
teacher 116
teaching 103, 150
thinking 149-50
writing 78, 186
for adults 114
Creativity 3, 4, 14, 17, 41, 54-55, 58, 60-63, 65, 67, 76, 81, 83, 90, 133, 147-51
artistic and scientific compared 149
case studies of 148
child growth in 50, 56, 150, 151
collective 177
conference on 147-48
cultivation of 147
and discovery 148
in early childhood 71
growth of 100
guiding 150
and intelligence 148
literature 151
neurotic distortions of 149
parents role in child's 57
in psychotherapy 149
in religion 150
research 148
role of materials in 93
sequence of conditions 148
Cultural deprivation 153
Cultural education 28
Curriculum 1, 48-50, 55-56, 67, 69, 86, 89-91, 93, 99, 119, 122, 136
analysis of 146
art appreciation 144
building 94, 122, 143-46
for career guidance 145
child-centered 60

color 145
design 66
development 102, 135
 in secondary schools 105
early childhood 74
for gifted students 145
guides 89, 144
 American Indians 144
 architecture 144
 city 103
 clothing 144
 farming 144
 home 144
 machines 144
 medieval world 144
 school 144
 state 103
Harvard 107
high school 172
Horace Mann High School 143
Owantonna Art Education Project
 Guides 144
planning 117
Prang Art Course 145
role of art in the 124
secondary school 143

D

Dance 10, 45, 80, 94
for adults 114
education in Russia 131
Decoupage 262
Democracy 11, 14, 16-17, 28, 41,
 45-46, 48, 108
role in art 121
Design 13, 64-65, 78, 87, 91, 93,
 104, 166, 182-83, 232
in art 183
classroom practice in 182
courses in art schools 183
and creative expression 182
education 183
elements 56, 66, 77
graphic 182
 art education 182
in industry 183
principles 77
psychology of 10
teaching 10, 183
 in secondary education 101

and visual communication 182
Developing art attitudes in early
 childhood 73
Developmental experiences in early
 childhood 74
Developmental growth 43
Dictionaries 6-7
Directories 4-6
 New York 6
 materials and equipment 20
Disadvantaged children 153-57
Discipline 11, 63, 172
Disney, Walt 190
Display 90, 92, 100, 165, 208
 in secondary schools 215
Divergent thinking 149
Dolls
 houses 185
 making 94
Drama 67, 83, 94, 181
 for adults 114
Dramatics 80, 183
 for children 183
 for classroom teachers 183
Draw
 how children learn to 187
 learning to 186-87
Draw-a-woman scale 140
Drawing 29, 46, 56, 58, 64, 82,
 88-91, 93, 95-96, 145, 166,
 181, 184-88, 212, 261
analysis of 184
animals 233, 238
architectural 104
of Balinese children 129
bimanual 186
birds 253
and cognitive development 154
course of study 186
as a diagnostic tool 139, 185
in early childhood 74
in elementary school 188
figures 65, 189, 238
free-hand 186-87, 263
heads 238
in high school 49
in India 130
industrial 187
Japanese 48
laboratory school, teaching of 184
lessons for ungraded schools 181
materials 58

Subject Index

Subject Index

Subject Index

Subject Index